# NEW ENGLAND / NEW SPAIN

*Portraiture in the Colonial Americas,*
*1492–1850*

Papers from the 2014 Mayer Center Symposium
at the Denver Art Museum

*Edited by Donna Pierce*

A publication of the Frederick and Jan Mayer Center
for Pre-Columbian and Spanish Colonial Art
at the Denver Art Museum

Frederick + Jan
**MAYER**
**CENTER**
Pre-Columbian +
Spanish Colonial
**A R T**

**DENVER**
**ART** MUSEUM

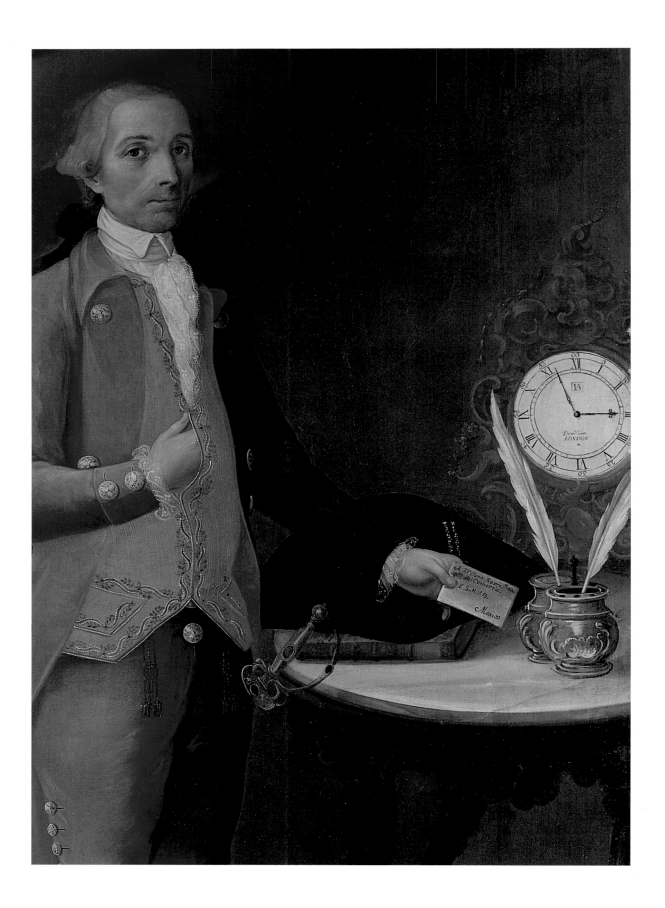

*Dedicated with affection and gratitude
to Jan Mayer and to the memory of Frederick Mayer
for their vision, passion, and generosity*

ISBN: 978-0914738-50-3

Library of Congress Control Number: 2016939346

Mayer Center for Pre-Columbian & Spanish Colonial Art at the Denver Art Museum
100 West 14th Avenue Parkway
Denver, CO 80204
http://mayercenter.denverartmuseum.org
www.denverartmuseum.org

Editor: Donna Pierce, with the assistance of Nancy Mann
Proofreader: Laura Caruso
Project management, design, and production: Julie Wilson Frick

Printed by O'Neil Printing, Phoenix, AZ.
Bound by Roswell Bookbinding, Phoenix, AZ.
Distributed by the University of Oklahoma Press, Norman, OK.

Front cover illustration: (detail) p. 114, fig. 11
Back cover illustration: (detail) p. 66, fig. 6
Frontispiece: (detail) p. 137, fig. 30

CONTRIBUTORS

| | |
|---|---|
| Michael A. Brown | *San Diego Museum of Art (San Diego, CA)* |
| Elizabeth Mankin Kornhauser | *The Metropolitan Museum of Art (New York, NY)* |
| Clare Kunny | *ArtMuse (Los Angeles, CA)* |
| Karl Kusserow | *Princeton University Art Museum (Princeton, NJ)* |
| James Middleton | *Independent Scholar (New York, NY)* |
| Paula Mues Orts | *National School of Conservation, Restoration and Museography (Mexico City, Mexico)* |
| Susan Rather | *University of Texas, Austin (Austin, TX)* |
| Michael J. Schreffler | *University of Notre Dame (Notre Dame, IN)* |
| Jennifer Van Horn | *George Mason University (Fairfax, VA)* |
| Kaylin Haverstock Weber | *Museum of Fine Arts, Houston (Houston, TX)* |

# Contents

# Foreword

The Denver Art Museum is indeed fortunate in being able to count among its greatest resources a Spanish Colonial collection rich in art from all over Latin America. Although the museum's Spanish Colonial collection might be said to have begun with Anne Evans's 1936 gift of a group of *santos* from southern Colorado and northern New Mexico, its true genesis should probably be credited to Otto Bach, who began his successful thirty-year tenure as the museum's director in 1944. Ignoring the advice of eastern colleagues to carve out a special niche in regional art, Bach boldly set out to build an encyclopedic museum of world art.

In 1968 Bach established the New World Department, which brought Pre-Columbian and Spanish Colonial objects from Latin America together. Within a year of its founding, the New World Department received the Frank Barrows Freyer Memorial Collection of seventeenth- and eighteenth-century colonial art from Peru and Bolivia. Assembled by María Engracia Freyer during the 1920s while her husband was chief of a United States naval mission to Peru, the collection received special export status in recognition of the Freyers' contributions. Another major acquisition was the spectacular 1990 gift of the Stapleton Foundation's extensive collection of colonial art from northern South America acquired between 1895 and 1914, a donation made possible by the Renchard family of Washington, D.C.

Since the early 1980s the New World Department flourished in every way through the interest and support of long-time museum trustee Frederick Mayer and his wife Jan. They assisted New World curators in courting donors throughout the country and built their own collections of Pre-Columbian and Spanish Colonial art intended to benefit the New World Department. With their financial support, the New World collections of more than five thousand objects were reorganized and reinstalled in their present galleries in 1993—making Denver, at the time, the only major museum in the country to have permanent galleries dedicated to both Pre-Columbian and Spanish Colonial art.

The growth of the New World collections and programming received a major boost with the enlightened endowment gift of Frederick and Jan Mayer. This gift made it possible to establish separate curatorial positions in Pre-Columbian and Spanish Colonial art and to underwrite the department's administrative costs, support staff, publications, and programs. As a result of the Mayers' generosity, the Denver Art Museum has the only curator dedicated exclusively to colonial Latin American art in the United States. I would like to thank Dr. Donna Pierce, former Frederick and Jan Mayer Curator of Spanish Colonial Art, for her dedicated leadership of the New World Department from 1999 to September 2015. Donna's accomplished scholarship, combined with her gift for finding topics that make Spanish Colonial art relevant to broad audiences today, has greatly raised the visibility of our collections and programs.

The Mayers also founded the Frederick and Jan Mayer Center for Pre-Columbian and Spanish Colonial Art at the Denver Art Museum, dedicated to increasing awareness and promoting scholarship in these fields by sponsoring academic activities including annual symposia, fellowships, study trips, research projects, conservation, and publications. Since 2001, Mayer Center symposia have taken place nearly every year. Co-organized by Donna Pierce and Emily Ballew Neff, Director of the Brooks Museum, Memphis, the 2014 Mayer Center symposium brought scholars from two fields of study together to investigate the topic "New England / New Spain: Portraiture in the Colonial Americas, 1492–1850." Those papers are presented in this volume.

Over the years, the Mayers generously supported the museum's larger mission at every turn. Since the untimely death of Frederick in 2007, Jan Mayer has continued his spirit of generosity and infectious enthusiasm for the museum. She has recently gifted the vast majority of their extensive Spanish Colonial collection and continues to encourage us forward in all ways. We offer warm thanks to her for her ongoing dedication to the museum as a whole and to the study of New World art in particular.

Christoph Heinrich
Frederick and Jan Mayer Director
Denver Art Museum

# Introduction and Acknowledgments

The Frederick and Jan Mayer Center for Pre-Columbian and Spanish Colonial Art at the Denver Art Museum sponsors annual symposia alternating between these fields of art. The fourteenth symposium in the series, entitled "New England / New Spain: Portraiture in the Colonial Americas, 1492–1850" was co-organized with Dr. Emily Ballew Neff, Director of the Brooks Museum, Memphis. We assembled an international group of scholars to present recent research on portraiture in the Spanish colony of New Spain (Mexico) and the British colonies of North America. Scholars presented tandem talks addressing the evolution of portraiture as well as the similarities and differences in the colonial experience of the two regions. This volume presents revised and expanded versions of essays presented at the symposium.

Michael J. Schreffler (University of Notre Dame) opens the volume with a discussion of the earliest figures to be represented in American portraiture, Aztec emperor Moctezuma, and the Spanish conqueror of Mexico, Hernán Cortés. Clare Kunny (Director, ArtMuse, Los Angeles) examines humanist portraits of Antonio de Mendoza (1490–1552), the first viceroy of Mexico, and relates them to European prototypes. Susan Rather (University of Texas, Austin) analyzes representations of nature in portrait paintings in colonial British America, and Karl Kusserow (Princeton University Art Museum) explores selfhood and surroundings in British American portraits.

Paula Mues Orts (National School of Conservation, Mexico City) examines portrait series commissioned and displayed in colonial Mexico by religious and civic organizations as claims to power and prestige. James Middleton (independent scholar, New York City) discusses the clothing and accessories seen in New Spanish portraiture that enable more precise dating of many paintings. Jennifer Van Horn (George Mason University) follows the trans-Atlantic travels of portraitist Joseph Blackburn from England to Bermuda, New England, and Ireland. Kaylin Haverstock Weber (Museum of Fine Arts, Houston) explores the career of American painter Benjamin West and his trans-Atlantic move from Boston to London.

Elizabeth Mankin Kornhauser (Metropolitan Museum of Art) discusses the New England painter Ralph Earl and his struggles to fashion a new portrait style for the young American republic. Michael A. Brown (San Diego Museum of Art) closes the volume by comparing the fate of portraiture from New England and New Spain in nineteenth- and early twentieth-century America.

We are grateful to these scholars for their participation in the symposium and their contributions to this publication. As an interdisciplinary study bringing together new research from scholarly areas that seldom overlap or interact, we hope this volume will serve as an important resource for scholars and enthusiasts of early modern history in general and in the art of the colonial Americas in particular.

I would like to acknowledge the staff of the New World Department for their efforts in organizing the symposium and the publication: Julie Wilson Frick, Mayer Center Program Coordinator, Jana Gottshalk and Jesse Ortega, former and current Curatorial Assistants, Anne Tennant, Research Associate, and Sabena Kull and Megan Robbins, former and current Research Interns. I thank my New World Department colleague, Margaret Young-Sánchez, former Frederick and Jan Mayer Curator of Pre-Columbian Art, for her support.

During the symposium Denver Art Museum Events, Audio-Visual, and Security staff provided significant and cheerful assistance.

In preparing this publication, I am grateful to Nancy Mann for her superb editing skills. Thanks are due to Museum Photographers Jeff Wells and Christine Jackson for their expert services and to Laura Caruso, Director of Publications, for ongoing advice and editing. We thank the staff of O'Neil Printing for production of this volume and the University of Oklahoma Press for distribution. My profound gratitude goes to Julie Wilson Frick, Mayer Center Program Coordinator, for book coordination, image gathering, compilation, contract negotiation, and most importantly, for the elegant and clean design of this and all Mayer Center symposia publications.

Special thanks are due to my symposium co-organizer and collaborator, Dr. Emily Ballew Neff.

After discovering our mutual interest in colonial portraiture, we developed plans for an exhibition and publication that would compare British and Spanish colonial portraits within a global context. Although the exhibition did not materialize, we still wanted to bring the two fields of study together in dynamic play through a Mayer Center symposium. The enthusiasm evident during the symposium indicates that continuing dialogue between the fields is warranted, and we hope that it will open up new lines of discovery and investigation in the study of the two regions of the colonial Americas set within a trans-Atlantic and global context.

Now retired after seventeen years at the Denver Art Museum, I am pleased to leave the outstanding Spanish Colonial collection in the capable hands of the ever-gracious Jorge Rivas Pérez, Frederick and Jan Mayer Curator of Spanish Colonial Art. I look forward with enthusiastic anticipation to the Spanish Colonial symposia, exhibitions, and publications he will produce in the future.

On behalf of all of us, I want to express our deepest gratitude to the late Frederick Mayer and his wife Jan for providing the opportunity to bring such a distinguished group of scholars together from different disciplines to share ideas. Creating an ongoing forum for scholarly exchange, along with the ability to publish the results, was a major part of the Mayers' vision and formed the basis of the founding of the Mayer Center for Pre-Columbian and Spanish Colonial Art and its programming. The Mayers personify ideal supporters, interested in all aspects of museums and the scholarship surrounding them. The DAM in general and the New World Department in particular have been blessed to have them as guardian angels. We dedicate this publication to the memory of Frederick Mayer and to the genuine enthusiasm of Jan Mayer, who attended every talk during the symposium.

Donna Pierce
Former Frederick and Jan Mayer Curator
of Spanish Colonial Art / Head of the New World
Department (until September 2015)
Denver Art Museum

# Cortés and Moctezuma
## Words, Pictures, and Likeness in Sixteenth-Century New Spain

*Michael J. Schreffler*

Among the most gripping historical narratives of early modernity are those of the invasions and conquests of Mexico and Peru by European fortune seekers in the early sixteenth century. Reports of these momentous events in the Americas were published in Seville, Venice, and other European printing centers, and in some cases they appeared in ink on paper not long after their authors wrote them, in the 1510s, 1520s, and 1530s. They were sold in bookshops in those same European centers and circulated widely. Perhaps the best known of these accounts are the reports of Hernán Cortés on the invasion and conquest of Aztec Mexico, addressed to the Holy Roman Emperor, Charles V.[1] Known in English as the Letters of Cortés, the conquistador's reports were printed in numerous editions and languages in the sixteenth century, to say nothing of subsequent centuries. First among them to appear on the book market was the account dated October 30, 1520, known as the Second Letter of Cortés. The printer Jacob Cromberger published it in Seville just two years later, in November 1522. Its title page (fig. 1) features a woodcut print depicting the report's primary intended reader, the young Charles V, as well as a description of its contents. Among those contents, the text notes, is a report on the city of Tenochtitlan, "built with marvelous artistry on a great lake," and ruled by "a very great Lord named Moctezuma."[2]

Likely encouraged by the widespread interest in Cortés's Second Letter among readers, the Seville printer Bartolomé Pérez published an account of the invasion and conquest of Inca Peru in 1534, shortly after the events it documented. Entitled *Verdadera relación de la conquista del Perú [True Report of the Conquest of Peru]*, it too names its author on the title page and refers to its intended reader: "Sent to His Majesty by Francisco de Xerez." A resident of Seville, Xerez served as secretary to Francisco Pizarro, the leader of the expedition to Peru. The woodcut image adorning the title page of Xerez's account (fig. 2) illustrates the dramatic moment recounted in detail by the

author in which Pizarro and his company first meet the Inca ruler Atahualpa at the highland settlement of Cajamarca. The image presents Atahualpa seated atop a litter as he meets and exchanges words with the Dominican friar Vicente de Valverde, a Dominican friar and member of Pizarro's cohort.[3]

The reports of Cortés, Xerez, and their contemporaries are the products of personal experience in parts of the Americas that would be claimed by their conquerors for the Holy Roman Emperor, and which came to be known, respectively, as the Viceroyalties of New Spain and Peru. The texts are engaging in their rich description of the movement of people, horses, and objects such as firearms, pearls, and gold vessels through rugged landscapes in Mesoamerica and the Andes. They tell absorbing tales of the encounters, some of them peaceable, others less so, between the members of the European campaigns of conquest and native communities that populated the pre-Hispanic Americas. Among the most vivid passages in these reports are those describing the physical settings of those encounters. In his Second Letter, for example, Cortés describes Aztec Tenochtitlan's soaring temples and vast plazas, and the magnificent palaces of Moctezuma. One of those palaces had "a very beautiful garden with some balconies that looked over it; and the facing and paving stones were all of jasper and very well worked."[4] In another of the palaces, Cortés writes, there was a large patio floored with tiles in a pattern like a chessboard.[5] There were rooms, he claims, "as large as six paces square" roofed with stones and well-made wooden latticework.[6]

Similarly, Xerez provides rich descriptions of places he, his superior, and their company encountered in the Andes of Peru. At the center of Cajamarca, where they first met Atahualpa, was a plaza "larger than any in Spain, surrounded by a wall, and entered by two doorways that open upon the streets of the town." The houses "are more than two hundred paces in length" and well built, being surrounded by walls three times the height

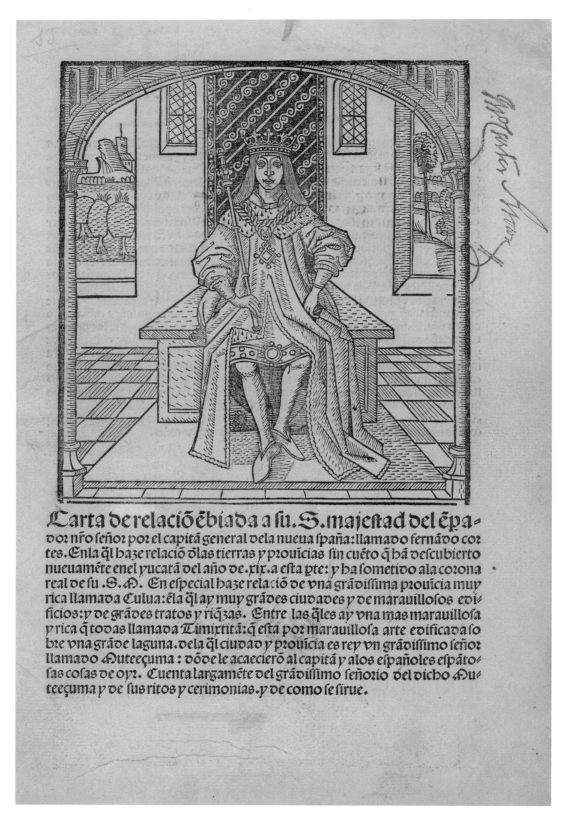

Fig. 1. Designer and artist unknown, Title page to Hernán Cortés, *Carta de relación.* . . . Seville, 1522. Ink on paper, 11¾ x 7¾ in. (29.8 x 19.7 cm). Photo: Courtesy of the John Carter Brown Library at Brown University.

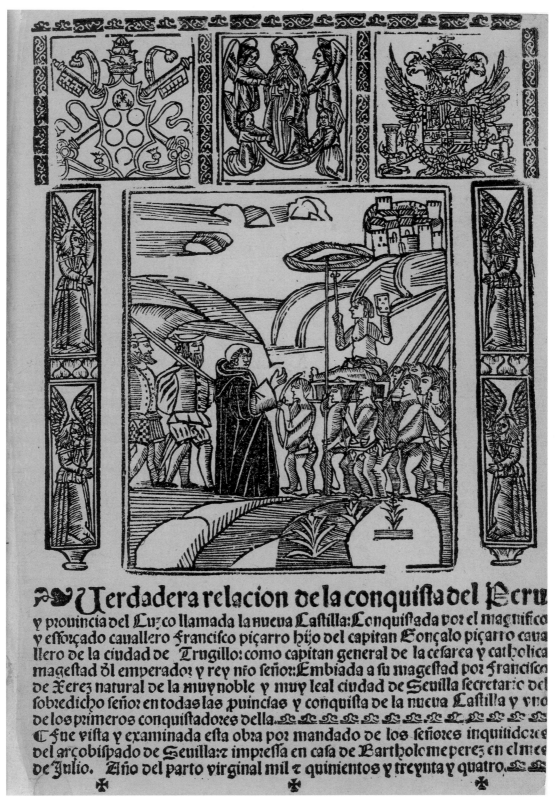

Fig. 2. Designer and artist unknown, Title page to Francisco de Xerez, *Verdadera relación de la conquista del Perú*. Seville, 1534. Ink on paper, 10¾ x 7⅜ in. (27.3 x 18.9 cm). Photo: Courtesy of the John Carter Brown Library at Brown University.

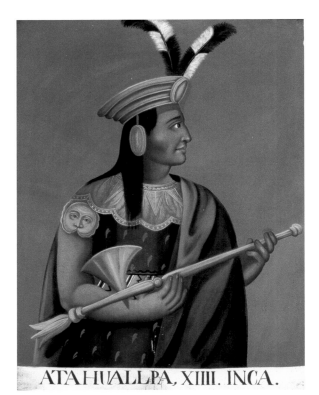

ATAHUALLPA, XIIII. INCA.

Fig. 3. Anonymous, *Atahuallpa, XIII. Inca*. Peru, late 1800s. Oil on canvas, 25½ x 19½ in. (64.8 x 49.5 cm). Denver Art Museum, Gift of Dr. Belinda Straight; 1977.45.15.

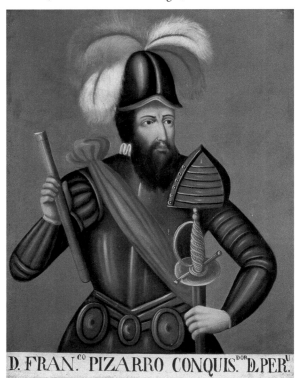

D. FRAN.ᶜᵒ PIZARRO CONQUIS.ᴰᴼᴿ D.PER.ᵁ

Fig. 4. Anonymous, *Don Francisco Pizarro, Conquistador del Perú*. Peru, late 1800s. Oil on canvas, 25½ x 19½ in. (64.8 x 49.5 cm). Denver Art Museum, Gift of Dr. Belinda Straight; 1977.45.16.

of a man and "in their patios there are fountains of water brought by channels for the service of these houses."[7] Here, and in passages throughout the reports by Xerez, Cortés, and their contemporaries, details like building materials, dimensions, and patterns allow the reader to construct vivid images of the settings for encounter and exchange, and for acts of civility as well as hostility.

Given such descriptive richness, the reader cannot help but wonder about the people who saw and wrote about these built environments and, at the same time, about the native people they encountered in the Americas. What did they look like? Our images of them are formed in large part by pictures, most of them produced long after the 1520s and 1530s, that use the conventions of portraiture to conjure visions of the protagonists of these fascinating tales. An example is the image of the Inca king Atahualpa in the collection of the Denver Art Museum, believed to have been painted in the nineteenth century (fig. 3). Its subject is the man whom Pizarro and his company recognized as the ruler of the Inca Empire when they encountered him in Cajamarca in the late 1520s. Shortly after their first meeting with him— illustrated on the title page to Xerez's *Verdadera relación*—they imprisoned him, demanded a ransom of gold and silver, and eventually killed him. The Denver painting shows the Inca king in three-quarters length, his head in profile against a sky-blue background. He wears a gold crown adorned with feathers, a large gold ear ornament, a patterned tunic, and a cape, and in his hands he holds a golden scepter in a way that suggests he is presenting it to a person outside of the pictorial space. The portrait is part of a series that includes other Inca kings as well as Pizarro (fig. 4), who is depicted holding a staff and wearing a suit of armor, a red sash, and a feathered helmet. The Denver series is related in its format and iconography to a number of late-colonial series of paintings of the Inca kings that have been interpreted as vehicles for promoting ideas about the noble ancestry of elite Andeans, who are thought to have been the primary patrons and owners of sets of paintings like these.[8]

For his part, the Aztec ruler Moctezuma II was portrayed in a number of images produced in the colonial period, among them the striking canvas

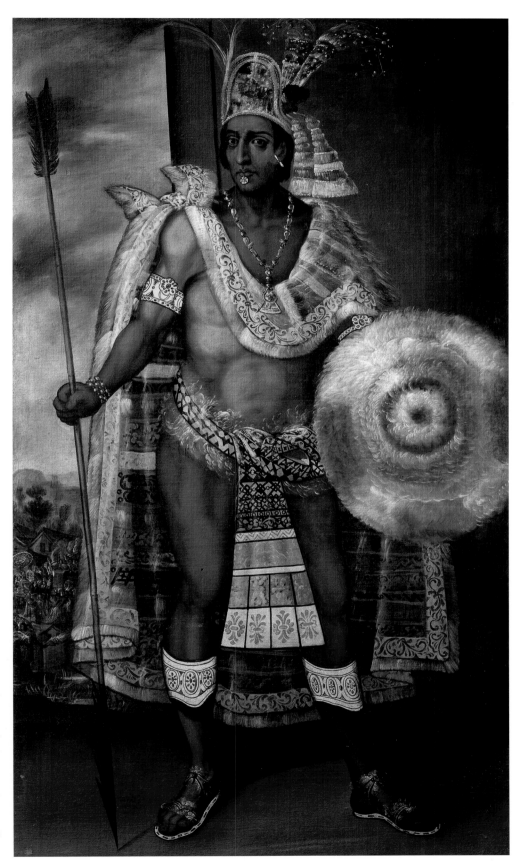

Fig. 5. Antonio Rodríguez (attributed), *Moctezuma II*. Mexico, 1680–1697. Oil on canvas, 71⅝ x 42 in. (182 x 106.5 cm). Museo degli Argenti, Florence, Italy. Photo: pbk, Berlin/Art Resource, NY.

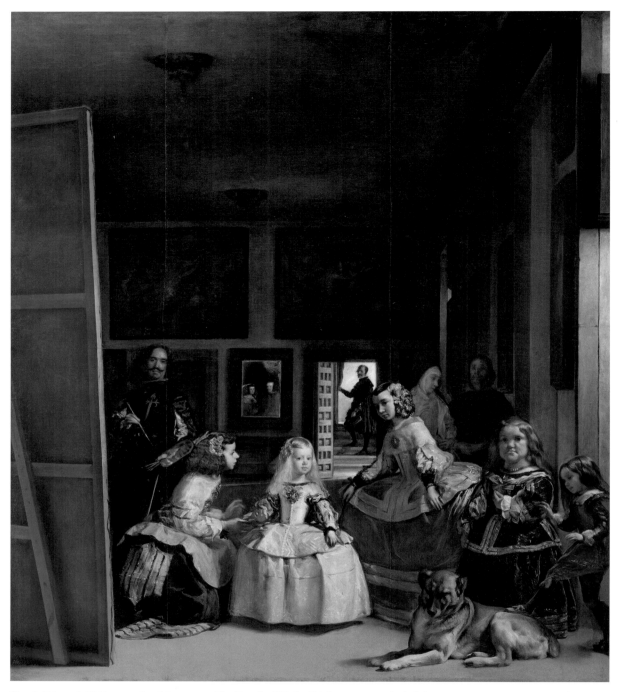

Fig. 6. Diego de Velázquez, *Las Meninas,* or *The Family of Philip IV*. Spain, circa 1656. Oil on canvas, 125¼ x 108⅝ in. (318 x 276 cm). Museo del Prado, Madrid, Spain. Photo: Museo Nacional del Prado/Art Resource.

attributed to the seventeenth-century Mexico City painter Antonio Rodríguez (fig. 5). The portrait shows the king in full length and nearly life size. He wears a colorful crown, a cape, and a loincloth, and he holds a spear and a shield made of feathers. The portrait may have been derived from earlier images of the Aztec king, including, perhaps, some made in the sixteenth century by native painters. It was sent from New Spain to Italy as a gift to Cosimo III, Grand Duke of Tuscany, near the end of the seventeenth century, and hangs today in the Medici Treasury in Florence.[9] These images and others of the native rulers of early sixteenth-century American empires are appealing cues for the imagination, and they function for us today as make-believe windows onto a place and time filled with wonder. They are not, however, products of the kind of eyewitness engagement that informs other kinds of portraits, in which a painter like Diego de Velázquez produces what could be called a true likeness, his eyes darting back and forth between the living subject of the portrait and the surface of the canvas on which he paints (fig. 6).

Those who were in a position to produce images informed by direct experience with Moctezuma, Atahualpa, and others in the early-sixteenth century Americas were people like Cortés, Xerez, and others who participated in the conquests of Mexico and Peru. These men were not painters, but their descriptive writings do sometimes construct literary portraits of notable figures they encountered. For example, some details about Moctezuma's appearance are preserved in the Second Letter of Cortés. His description of the Aztec ruler comes as the two catch their first glimpses of each other on a long causeway linking the island city of Tenochtitlan with the lakeshore. "Lord Moctezuma came out to receive us," Cortés writes, "along with about two hundred lords, all barefoot and dressed very richly in their way." Unlike his barefoot retainers, says Cortés, the Aztec emperor wore sandals, which may have resembled those painted by Antonio Rodríguez in his portrait of Moctezuma more than a century and a half later.[10]

As he recounts the events that followed, Cortés reveals a few other details about the Aztec ruler's appearance. He notes that as the two walked on the causeway into the city and, eventually, to one

of Moctezuma's palaces, he gave the Aztec king a necklace of pearls and cut glass, placing it around his neck. Like Moctezuma's sandals, perhaps the necklace, too, resembled the one in the painting by Antonio Rodríguez. A short time later, Cortés writes, he and Moctezuma sat on richly adorned platforms in a palace in Tenochtitlan engaging in conversation when the Aztec ruler

> lifted his clothing and showed me his body, saying, 'See here that I am flesh and bone like you and like everyone, and I am mortal and palpable.' Holding his arms and body with his own hands, he said 'See how they have lied to you.'[11]

The portrayal of Moctezuma in these passages from the Second Letter provides only a few details about his appearance, and centers on his clothing and upper body—in keeping with Cortés's broader tendency to describe people in a way that is, at times, frustratingly opaque. In some cases, he simply estimates their age. For example, in the Second Letter, he notes that in a place to the southeast of Tenochtitlan he called Amaqueruca, he met a group of lords including "a young man of about 25."[12] Similarly, in the report of 15 May 1522, also known as the Third Letter, he refers to Cuauhtemoc, regarded as the last of the Aztec kings, as "a boy of eighteen years of age."[13] And in the report also known as the Fifth Letter, he writes that during his company's travels far to the south of Tenochtitlan "we found in the forest a young man of about fifteen."[14] The fact that these descriptions are all of men is also characteristic of his reports, in which women are rarely mentioned.

In other instances, Cortés's descriptions of people focus on their clothing, as was the case with Moctezuma. In the Second Letter, he describes the elites of Cholula as wearing a kind of robe he calls an *albornoz* (burnoose), which he says is slightly different from those worn in Africa, although they are very similar in shape, material, and borders.[15] The elites of Tenochtitlan, he says, have "more manners and fineness in their way of dressing than any others of these provinces and cities."[16] This passage illustrates another descriptive tendency, to note the behavior or character of a person or group of people. In his Third Letter to the king, Cortés says that the residents of Xochimilco are

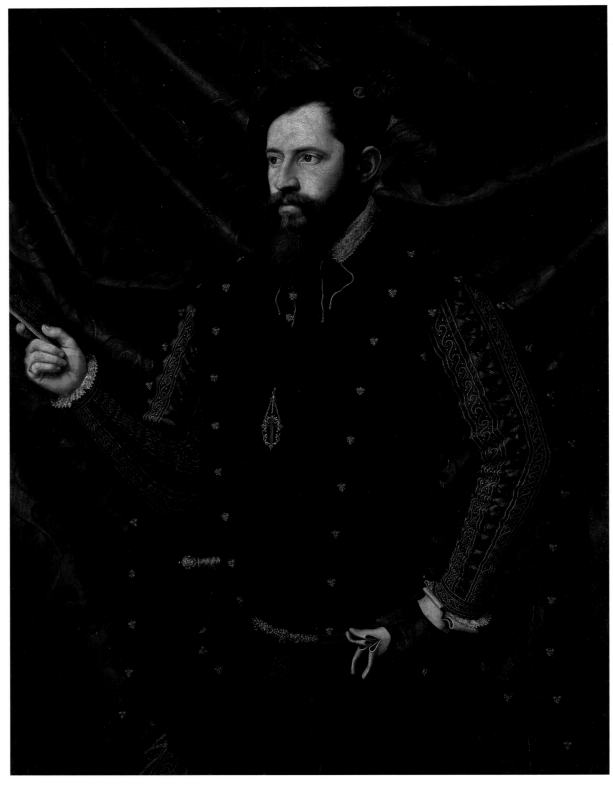

Fig. 7. Juan de Juanes, *Don Luis de Castellá y Vilanova*. Spain, circa 1560. Oil on wood, 41⅓ x 31½ in. (105 x 80 cm). Museo del Prado, Madrid, Spain. Photo: Erich Lessing/Art Resource, NY.

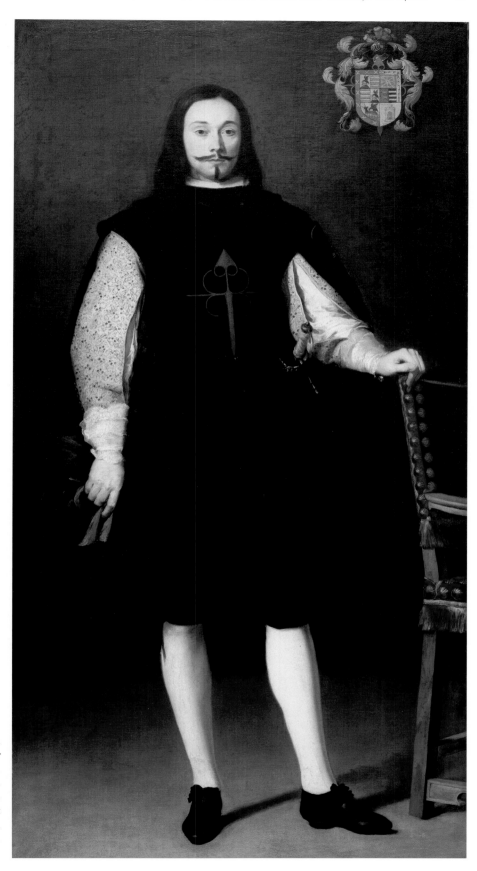

Fig. 8. Bartolomé Estéban Murillo, *Don Diego Félix de Esquivel y Aldama*. Spain, circa 1655–1660. Oil on canvas, 53⅝ x 50 in. (136.2 x 127 cm). Denver Art Museum, Gift of the Samuel H. Kress Foundation; 1961.67.

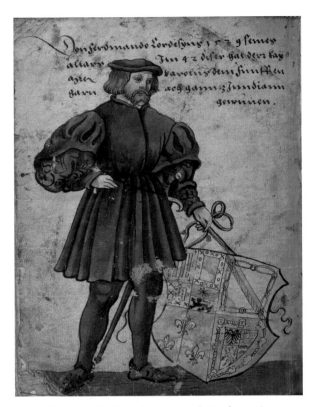

Fig. 9. Christoph Weiditz, *Don Fernando Cordesyus*. Germany, circa 1530. Ink and pigment on paper, 7⅞ x 5⅞ in. (15 x 20 cm). Germanisches Nationalmuseum, Nuremberg, Germany.

"brave-looking . . . all resolved to defend themselves or die."[17] In contrast, the natives of Copilco are "mostly peaceful, although somewhat timorous on account of the few dealings they have had with Spaniards."[18]

This reliance upon age, clothing, and character as markers of identity is in keeping with descriptive habits in the early modern "literary portrait," a mode of rhetoric that can be traced in Spanish historiography to fifteenth-century chronicles of Castilian kings and perhaps even earlier.[19] The markers of identity used in the Letters of Cortés also coincide with the iconography of early modern painted portraits, in which age and physical appearance are often signaled through facial features; social station through clothing, jewels, and other kinds of objects; and inner character through posture, gesture, and facial expression. Consider, for example, the portrait of Luis de Castellá y Vilanova, a noble from Valencia, attributed to the painter Juan de Juanes, and dated to the mid-sixteenth century (fig. 7). The subject's identity is signaled through his fine clothing, the book he holds, and the enamel pendant bearing the insignia of the Order of the Knights of Santiago that hangs from his chest. He is depicted as a man of both ideas and action, his seriousness indicative of his social position.

Similar in conception is Bartolomé Estéban Murillo's portrait of about a century later of Diego Félix de Esquivel (fig. 8). In this portrait, the subject's identity is further reinforced by the coat of arms, which floats in the upper right corner of the pictorial space. There are, then, ties that bind the descriptive language of Cortés to the conventions of painted portraiture in early modern Europe. But the descriptions of people in the Letters to the Holy Roman Emperor are, in most cases, not detailed enough to evoke for a reader the kind of image produced by painters like Juan de Juanes or Murillo. Cortés is most descriptive in cases where he conceives of people's appearance as a wondrous divergence from the order of nature.

Perhaps the best example of this comes in his description of one of Moctezuma's houses in Tenochtitlan, where there was "a room in which were men, women, and children who had, from birth, white faces and bodies and white hair, eyebrows, and eyelashes."[20] The contrast with his

spare portrayals of most other people suggests that for him, much of what he saw seemed natural and comprehensible, even though most of his encounters with native rulers must have required the use of translators or expressive gestures.

The concept of likeness is pervasive in his letters. Near what today is Puebla, for example, he saw "a better fortress than any there are in the middle of Spain, and fortified with walls and barbicans and pits."[21] The native settlement of Cempoala is

> much larger than Granada, and very much stronger, with as good buildings and many more people than Granada had when it was won, and very much better supplied with the goods of the land.[22]

Aztec Tenochtitlan, he says, is as big as Seville and Córdoba. It has shops "like pharmacies" and "like barbers," and among the fruits they sell in the market are "cherries and plums like those in Spain."[23] In light of this emphasis on similarities between the people, places, and things of New Spain and those of the Iberian peninsula, it is perhaps unsurprising that Cortés's literary portraits of Moctezuma and other people he encounters are relatively spare. The multiethnic, multiconfessional world of fifteenth-century Iberia provided plenty of variety of dress, language, and customs, and for Cortés, it seems, many of the people he saw in New Spain fit neatly and relatively unproblematically into that world.

In his letters to the Holy Roman Emperor, Cortés does not mention the portrait as an object—that is, a painted, sculpted, or drawn likeness of a person. Presumably he would have known of donor portraits in *retablos*, series of ruler portraits in municipal buildings, portrait medallions, coins, and independent portraits in a variety of media, and in both public and private settings.[24] In the years that followed the publication of the letters, Cortés himself would be the subject of a number of portraits, among them a medal and a drawing by the German engraver Christoph Weiditz (fig. 9) done during the conquistador's return to Spain in 1528, when he visited the court of Charles V in Toledo.

The closest reference to something like a portrait

in the letters of Cortés comes in an evocative passage from the Fourth Letter, where he describes an expedition in which a group of his men had gone out by ship to explore certain parts of New Spain. They had landed on a coast occupied by a hostile native community, and there, he writes, they met a grim end. When Cortés went to find the men, he said, he found only the skins of their faces, housed in what he called the "oratories" of the native community. The skins, he writes, were "preserved in such a way that many of them could be recognized."[25] Here, the recognition of the disembodied face mimics the operation of the painted or sculpted portrait, and the preserved skin of the face invites associations with the practice of flaying as well as the production of death masks.

The portrait as an object that presents a recognizable image of person plays a slightly more prominent role in the writings of Cortés's contemporary Bernal Díaz del Castillo. Díaz was also a participant in the conquest of Mexico, but his account was composed in the mid-sixteenth century and not printed until the early seventeenth century, when it was published posthumously in Madrid with a title that resonates with the report by Xerez. Entitled *Historia verdadera de la conquista de la Nueva España [True History of the Conquest of New Spain]*, it had a title page featuring an architectural frame adorned with a full-length portrait of a mature Cortés, on the left, and another of the Mercedarian friar Bartolomé Olmedo, on the right (fig. 10).

In Chapter 38 of the *Historia verdadera*, Díaz describes a scene he says occurred on Easter Sunday, 1519, near an island port near Veracruz that the Spanish called San Juan de Ulúa. There, a man Díaz identified as the governor of a community loyal to Moctezuma arrived with his entourage to greet Cortés and his company. Among those who accompanied the native governor, Díaz says, were some painters who were charged with making

> an image of the face, body, and features of Cortés and of all of the captains, and the soldiers, and the boats and sails and the horses . . . and even the two hounds, the artillery pieces, the cannonballs, and the entire army he had brought.

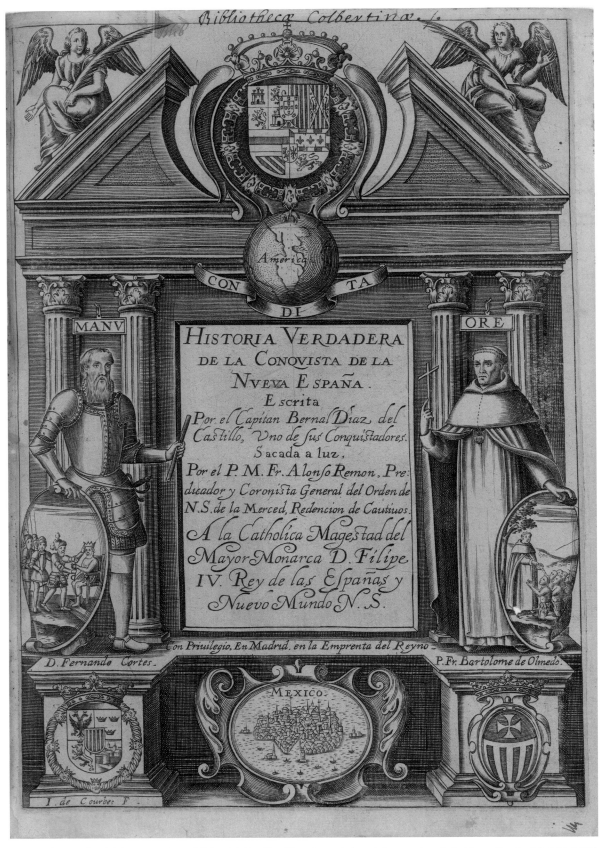

Fig. 10. de Courbes, Title page to Bernal Díaz del Castillo, *Historia verdadera de la conquista de la Nueva España*. Madrid, 1632. Ink on paper, 10⅝ x 7½ in. (27.1 x 19 cm). Photo: Courtesy of the John Carter Brown Library at Brown University.

Díaz says the painting the native artists made was then sent to Moctezuma, who is said to have marveled at their depiction of Cortés. He did so, the author claims, not because the image of the conquistador was so strange, or because it was so lifelike, for indeed, Moctezuma had not yet seen Cortés in person. Instead, he was amazed by the resemblance between the portrait of the conquistador and one of the native chiefs in his own retinue. Diaz himself confirms the resemblance, adding that because of it the Spanish began to call both men by the name "Cortés."[26]

The story of the two Cortéses cannot be taken at face value, for the history of art shows that images of people made by indigenous painters in Mesoamerica in or around 1519 would have been more like hieroglyphs and, thus, not very useful for conveying the kinds of precise details of physical appearance seen in portraits like those by Juan de Juanes or Antonio Rodríguez. In this story from the *Historia verdadera*, then, the portrait becomes an instrument through which the concept of likeness mediates encounters between the conquistadors and the native people of Mesoamerica. Just as Cortés wrote (and ordered his subordinates to write) descriptions of the people, places, and things they encountered, so too did Moctezuma, at least according to Díaz. The passage resonates with the recognition of similarity that is so pervasive in the Cortés letters and is wonderfully encapsulated in Moctezuma's most memorable declaration to Cortés: "I am flesh and bone like you." Here, the declaration, too, is part of a complex network of likenesses, for it calls to mind a Gospel passage in which Jesus Christ, after his resurrection, appears to his disciples and shows them his body, proclaiming that he is flesh and bone, and not a spirit.[27]

The idea of the portrait surfaces again in the *Historia verdadera* in Chapter 80, in which Moctezuma's ambassadors report to their king on some of the things they had learned about the Spanish. According to Díaz, Moctezuma asked them specifically about Pedro de Alvarado, a high-ranking member of Cortés's cohort. They replied, says Díaz, that "he was of very fine grace, as much in his features as in his person, and he was like the sun, and he was a captain." Their description of Alvarado, Díaz writes, was supported by a portrait:

"They took a lifelike representation of his description and face."[28] Diaz confirms the ambassadors' description of Alvarado to Moctezuma with his own assessment, noting that "Pedro de Alvarado was very good in body, thin, and in his features, and appearance, and in his face, as in his speech, in everything he was graceful."[29] Diaz provides this literary portrait as a way of confirming the accuracy of the visual portrait; but Diaz's text abounds with literary portraits that enliven their subjects in a way that those of Cortés do not. Consider, for example, his description of Moctezuma, which comes in Chapter 91 of the *Historia verdadera*:

> The great Moctezuma must have been about forty years of age, and of good stature, and well proportioned, and thin, and not fleshy, and his color was not very dark, but of the color and shade of an Indian, and he wore his hair not very long, but some was covering his ears, and he had little beard, dark and well kept, and scarce, and his face was somewhat long and cheerful, and good eyes, and he showed in his person a loving side and, when it was necessary, seriousness. He was very refined and clean, bathing once a day in the afternoon.[30]

Diaz conjures a more detailed vision of Moctezuma than does Cortés, who, as we have seen, writes in his Second Letter of little more than the Aztec ruler's sandals, his necklace, and his torso. But the Second Letter, despite its often thin literary portraits, not only gave rise to the production of visual portraits of Cortés himself but also served to disseminate the woodcut image on its 1522 title page (fig. 1).

That image shows Charles V, who would have been in his early twenties in 1522, seated in an interior space, and wearing a crown, a long robe, shoes, and a substantial necklace. In his right hand he holds a scepter. The maker of the woodcut may have tried to capture something of the Holy Roman Emperor's facial features, using line to suggest heavy-lidded eyes, a long nose, full lips, and prominent chin or jaw. In detail that plays with the sense of the word *portada* as both a title page and a portal, the king is framed by an arch supported by columns whose ornamented capitals are visible.

The iconography of this royal portrait is very generally related to other images of the seated Charles V. But in the woodcut print, certain details resonate with the passages in the text that refer not to Charles V, but to Moctezuma. Recall, for example, the description of one of the Aztec ruler's palaces, with its floor with tiles in a pattern like a chessboard, its garden with balconies looking over it, and the platforms (*estrados*) on which Cortés and Moctezuma sat and conversed. These instances of likeness between Moctezuma and Charles V might reasonably be understood as further elements of what the historian John Elliott called the "mental world" of Hernán Cortés—a set of reference points that included medieval legal codes such as the Siete Partidas, classical antiquity, contemporary romances, the Bible, and his training as a notary.[31] To this could be added a certain view of the world in which there is no "Other" but, instead, there are variations on a common humanity, which can be refined into an essentially true nature. Indeed, the portrait and, more generally, the idea of likeness, come to be seen as key concepts in the Holy Roman Emperor's claim on the Americas, and as agents in cultural transformation. In the material context of the Second Letter, the portrait of the king supports the idea that Moctezuma is like Charles V, just as Moctezuma's captain is like Charles V's captain, Cortés; just as Tenochtitlan is like Seville and Córdoba; and just as "New" Spain is like Spain.

## Notes

[1] Hernán Cortés, *Cartas de relación*, ed. Ángel Delgado-Gómez (Madrid: Editorial Castalia, 1993). On the printing and sale of early accounts of events in the Americas, see Carlos Alberto González Sánchez, Tristán Platt, and Bethany Aram, *New World Literacy: Writing and Culture across the Atlantic, 1500–1700* (Lewisburg, PA: Bucknell University Press, 2011); Daria Perocco, *Viaggiare e raccontare. Narrazione di viaggio ed esperienze di racconto tra Cinque e Seicento* (Alessandria: Edizioni dell'Orso, 1997).

[2] Hernán Cortés, *Carta de relación enbiada a su S. majestad* (Seville: Jacob Cromberger, 1522), 1r. "Que está por maravillosa arte edificada sobre una grande laguna . . . un grandissimo señor llamado Muteeçuma."

[3] Francisco de Xerez, *Verdadera relación de le conquista del Perú* (Seville: Bartolomé Pérez, 1534).

[4] Cortés, *Cartas*, "Segunda relación," 244: "un muy hermoso jardín con ciertos miradores que salían sobre él y los mármoles y losas dellos eran de jaspe muy bien obrados."

[5] Cortés, *Cartas*, "Segunda relación," 245: "Un gran patio losado de muy gentiles losas todo él hecho a manera de un juego de ajedrez."

[6] Cortés, *Cartas*, "Segunda relación," 245: "Y las casas eran hondas cuanto estado y medio y tan grandes como seis pasos en cuadra, y la mitad de cada una de estas casas era cubierta el soterrado de losas y la mitad que quedaba por cubrir tenía encima una red de palo muy bien hecha."

[7] Xerez, *Verdadera relación*, fol. 19r: "La plaza es mayor que ninguna de España . . . las casas della son de más de doscientos pasos en largo. Son muy bien hechas, cercadas de tapias fuertes, de altura de tres estados. . . . Las paredes dellos son de piedra de cantería muy bien labradas, y cercados estos aposentos por sí con su cerca de cantería y sus puertas, y dentro en los patios sus pilas de agua traída de otra parte por caños para el servicio destas casas."

[8] On the history of this tradition in portraiture, see Thomas B. F. Cummins et al., *Los Incas, reyes del Perú* (Lima: Banco de Crédito, 2005).

[9] Pablo Escalante Gonzalbo, "Portrait of Moctezuma," in Donna Pierce et al., *Painting a New World: Mexican Art and Life, 1521–1821* (Denver: Denver Art Museum, 2004), 171–177. On earlier portraits of Moctezuma, see Patrick Hajovsky, *On the Lips of Others: Moteuczoma's Fame in Aztec Monuments and Rituals* (Austin: University of Texas Press, 2015); Hajovsky, "André Thevet's 'True' Portrait of Moctezuma and Its European Legacy," *Word and Image* 25, no. 4 (2009): 335–352.

[10] Cortés, *Cartas*, "Segunda relación," 208: "Nos salió a rescebir aquel señor Muteeçuma con hasta ducientos señores, todos descalzos y vestidos de otra librea o manera de ropa ansimismo bien rica a su uso y más que la de los otros . . . el Muteeçuma iba calzado y los otros dos señores descalzos."

[11] Cortés, *Cartas*, "Segunda relación," 211: "Entonces alzó las vestiduras y me mostró el cuerpo diciendo: 'a mí veisme aquí que soy de carne y hueso como vos y como cada uno, y que soy mortal y palpable—asiéndose él con sus manos de los brazos y del cuerpo. Ved cómo os han mentido.'"

[12] Cortés, *Cartas*, "Segunda relación," 203–204: "Un señor mancebo de hasta veinte y cinco años."

[13] Cortés, *Cartas*, "Tercera relación," 413: "que era mancebo de edad de diez y ocho años."

[14] Cortés, *Cartas*, "Quinta relación," 585: "se hallo por unos montes un muchacho de hasta quince años."

[15] Cortés, *Cartas*, "Segunda relación," 195: "los honrados ciudadanos della todos traen albornoces encima de la otra ropa, aunque son diferenciados de los de Africa porque tienen maneras, pero en la hechura y tela y los rapacejos son muy semejables."

[16] Cortés, *Cartas*, "Segunda relación," 242: "La gente desta ciudad es de más manera y primor en su vestir y servicio que no la otra destas provinicas y ciudades."

[17] Cortés, *Cartas*, "Tercera relación," 356: "Mucha y muy lucida gente y muy determinados de se defender o morir."

[18] Cortés, *Cartas*, "Quinta relación," 535–536: "La gente, que estaba algo pacífica aunque temerosa por la poca conversación que habían tenido con los españoles."

[19] Sonia V. Rose, "The Great Moctezuma: A Literary Portrait in Sixteenth-Century Spanish American Historiography," in *Modelling the Individual: Biography and Portrait in the Renaissance*, ed. Karl Enenkel, Betsy de Jong-Crane, and Peter Liebregts (Amsterdam: Rodopi, 1998), 109–132.

[20] Cortés, *Cartas*, "Segunda relación," 245: "Tenía en esta casa un cuarto en que tenía hombres y mujeres y niños blancos de su nascimiento en el rostro y cuerpo y cabello y pestañas y cejas."

[21] Cortés, *Cartas*, "Segunda relación," 172: "Y en un cerro muy alto está la casa del señor con la mejor fortaleza que hay en la mitad de España y mejor cercada de muro y barbacanes y cavas."

[22] Cortés, *Cartas*, "Segunda relación," 184–185: "Es muy mayor que Granada y muy más fuerte y de tan buenos edificios y de muy mucha más gente que Granada tenía al tiempo que se ganó y muy mejor abastecida de las cosas de la tierra que es de pan, y de aves y caza y pescado de ríos y de otras legumbres y cosas que ellos comen muy buenas."

[23] Cortés, *Cartas*, "Segunda relación," 233–235: "Es tan grande la ciudad como Sevilla y Córdoba. . . . Hay casas como de boticarios donde se venden las medicinas hechas, ansi potables como unguentos y emplastos. Hay casas de barberos donde lavan y raspan las cabezas . . . hay hombres como los que llaman en Castilla ganapanes para traer cargas."

[24] On the early history of portrait painting in Spain, see Miguel Falomir Faus, "Sobre los orígenes del retrato y la aparición del 'pintor de corte' en la España bajomedieval," *Boletín de arte* 17 (1996): 177–195.

[25] Cortés, *Cartas*, "Cuarta relación," 471: "Y hallamos las caras propias de los españoles desholladas en sus oratorios, digo, los cueros dellas, curados en tal manera que muchos dellos se conoscieron."

[26] Diaz del Castillo, *Historia verdadera de la conquista de la Nueva España* (Madrid: 1632), 26: "Mandó pintar al natural rostro, duerpo, y facciones de Cortés, y de todos los capitanes, y soldados, y navios, y velas, e cavallos, y a Doña Marina, e Aguilar, hasta dos lebreles, e tiros, e pelotas, y todo el ejército que traíamos, e lo llevó a su señor." On this episode, see Michael Schreffler, "'Their Cortés and Our Cortés': Spanish Colonialism and Aztec Representation," *Art Bulletin* 91, no. 4 (Dec. 2009): 407–425.

[27] Luke 24:39.

[28] Díaz del Castillo, *Historia verdadera*, 1632, 57r: "Era de muy linda gracia, así en el rostro, como en su persona, y que parecía como el sol, y que era capitán, y demás desto se lo llevaron figurado muy al natural su dibujo y cara. . . ."

[29] Díaz del Castillo, *Historia verdadera*, 1632, 57r: "era de muy buen cuerpo, y ligero, y facciones, y presencia, y así en el rostro, como en el hablar, en todo era agraciado. . . ."

[30] Díaz del Castillo, *Historia verdadera*, 67v: "Sería el gran Montecuma de edad de hasta quarenta años, y de buena estatura, y bien proporcionado, e cenceño, e pocas carnes, y la color no muy moreno, sino propia color y matiz de Indio, y traía los cabellos no muy largos, sino quanto le cubrian las orejas, e pocas barbas, prietas y bien puestas, e raras, y el rostro algo largo e alegre e los ojos de buena manera, e mostraba en su persona en el mirar por un cabo amor, e quando era menester gravedad. Era muy pulido y limpio, bañanase cada día una vez a la tarde."

[31] J. H. Elliott, "The Mental World of Hernán Cortés," *Transactions of the Royal Historical Society*, Fifth Series, 17 (1967): 41–58.

# In His Own Image
## A Humanist Portrait of Antonio de Mendoza, First Viceroy of New Spain

*Clare Kunny*

Antonio de Mendoza (1490–1552) was the second son of Iñigo López de Mendoza (d. 1515), the second count of Tendilla and marquis of Mondejar. As powerful members of the *caballero* (military) class, the Mendozas served Castilian monarchs for centuries, especially in battles against the Muslims, and were royally recompensed.[1] In 1492 Tendilla was appointed governor of the Alhambra as a reward for his pivotal role in the reconquest of the Kingdom of Granada, the last Muslim stronghold in Spain. From 1492 to his death in 1515, Tendilla lived with his family in a Hispano-Moresque palace on the grounds of the Alhambra. Tendilla trained his sons in military arts, politics, and diplomacy, and he educated them as humanists.

The Mendozas gained power by serving the Crown with both sword and pen.[2] Castilian society in the fifteenth and sixteenth centuries fostered scholar-soldiers. For the Mendoza family, patronage of the arts was a way to cultivate political power and authority, as well as a means to establish dynastic identity through cultural and material projects. Tendilla's patronage concentrated on literature and architecture.[3] His protégé, the humanist writer Hernán Núñez, taught the Mendoza children Greek, Latin, and Arabic. In preparing his sons for the new imperial age, Tendilla educated them in the new ideas of the Renaissance, including Erasmian humanism, which was prevalent in Spanish institutions of higher learning, and the architectural style *a la romano*.[4] The Mendozas' advanced taste for architecture *a la romano* influenced Charles's advocacy of this Renaissance style—the Palace of Charles V on the grounds of the Alhambra being one important example—as an integral part of the imperial iconography.[5]

Five years after Charles's arrival in Spain in 1516, Antonio and his older brother Luis demonstrated their allegiance to the king by fighting to subdue the Comunero Revolts in Huescar. Charles rewarded them with royal appointments: Luis continued his father's duties as governor of the Alhambra and captain-general of the military forces of Granada, while Antonio was appointed imperial ambassador to Flanders, Hungary, England, and Germany.[6] In early 1530 Antonio returned from various diplomatic missions abroad and was reunited with his monarch when the king was in Bologna laying plans for his coronation as Holy Roman Emperor by Pope Clement VII.[7]

I propose that the Mendozas' interests influenced Charles's own interests in the 1530s and encouraged him to entrust the mission of first viceroy in New Spain to a Mendoza. On April 17, 1535, a royal commission issued by Charles V in Barcelona named Antonio de Mendoza viceroy and governor of New Spain, president of the *Audiencia*, or royal court, and vice-patron of the Church. The royal commission stipulated that Mendoza as viceroy was "to represent the person of the King, administer equal justice to all his subjects and vassals, and to be active in everything relating to peace, quiet, prosperity, and extension of the Indies."[8]

In this paper I examine two visual portraits of Antonio de Mendoza as viceroy that show, between them, not only how he performed imperial rituals as viceroy, but also how he served Charles's interest in mapmaking and manuscript production, distinctive forms of humanist patronage that were also a means of reinforcing the ultimate authority of the Spanish Crown. One portrait of Mendoza established an official form and composition for portraits of the viceroys of New Spain in general. These official portraits were displayed in the Hall of Royal Accord in the Royal Palace in Mexico City, and—as Paula Mues Orts notes elsewhere in this volume—influenced other series of portraits of clerics, civic leaders, *cofradías*, and nuns installed as groups, or congregations, throughout New Spain. The second portrait of Mendoza represents a particular characteristic of Mendoza's rule. It is a small watercolor, the frontispiece of the manuscript *Relación de Michoacán*, which was created between 1538 and 1541, deposited in the Escorial in Spain sometime in the sixteenth century, and largely forgotten until

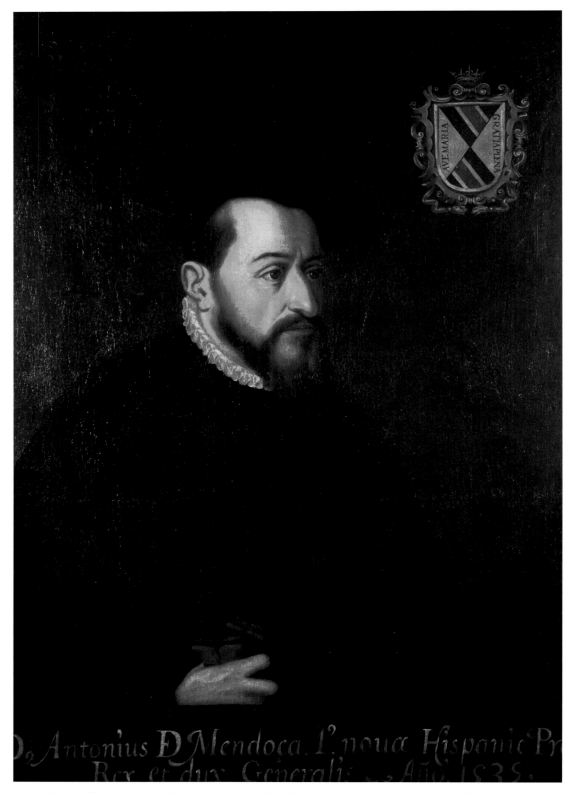

Fig. 1. *Portrait of Antonio de Mendoza*. Mexico, circa 1540. Oil on canvas, 37½ x 26⅓ in. (95.3 x 66.8 cm). Museo Nacional de Historia, Mexico City. CONACULTA, INAH, MEX. Reproduction authorized by the Instituto Nacional de Antropología e Historia.

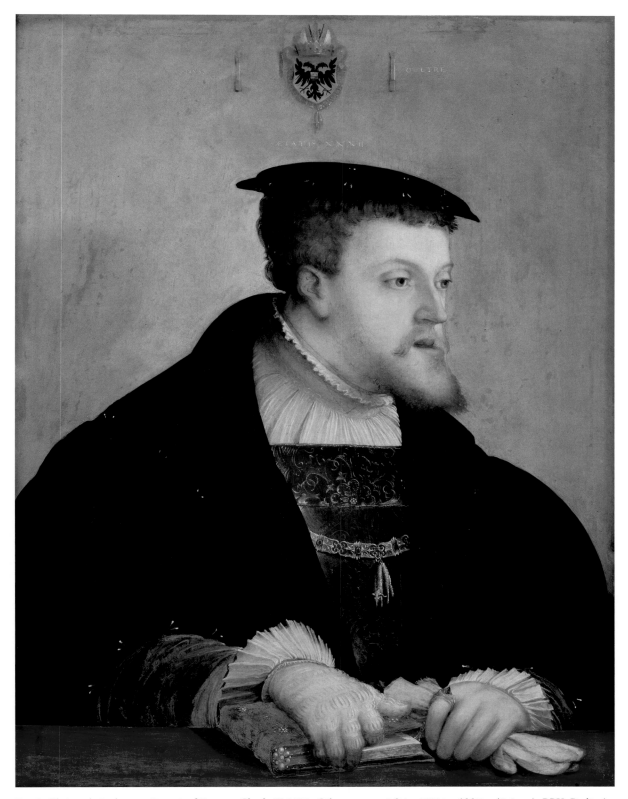

Fig. 2. Christoph Amberger, *Portrait of Emporer Charles V*, 1532. Oil on canvas, 26¼ x 19⅝ in. (66.7 x 49.8 cm). BPK, Berlin / Staatliche Museen zu Berlin, Gemäldegalerie / Jörg P. Anders / Art Resource, NY.

the nineteenth century.[9] Together, I propose, the two portraits illuminate the dual mandate of Mendoza's rule as the ultimate representative of the king and as a humanist ruler who sought to foster effective collaboration with the indigenous peoples of New Spain.

The official image of Mendoza as the newly appointed viceroy of New Spain (fig. 1) is a half-length portrait painted sometime during his term of office after he arrived in New Spain. In the portrait, Mendoza wears the black cloak and hat of his office, clutches gloves in one hand, and looks off to the right in a three-quarter view. The sitter's likeness is carefully rendered—the profile is distinctive, the white lace of his shirt sets off his dark hair and neatly trimmed beard, and a slight wrinkle at his brow shows he is neither a young man nor a man of many years. Appointed as viceroy at age 45, he has a knowing gaze and determined presence.

The form and composition of the official portrait are indicators of the office of viceroy in New Spain. The figure of the viceroy is situated against a dark, plain background with a ledge at the bottom. As in the portrait of Charles V (fig. 2), the ledge separates the sitter from the viewer to imply a hierarchy. Located on the ledge is an inscription that identifies the subject with his full name and official title: *Don Antonius de Mendoza, Primero Nova Hispanie ProRex et dux Gineralis Ano: 1535.* The viceroy's lineage and social status are further clarified by the Mendoza family coat of arms, placed in the upper right corner of the canvas. This early sixteenth-century European portrait format emphasizes the painting's function to document the sitter's sociopolitical position as well as his likeness.

With the appointment of Viceroy Mendoza, Charles V set up a system of representational government in New Spain. In this structure the viceroy officially represented the king in his absence. Visually, the official portrait emphasizes signs and insignia that anchor the sitter within the political hierarchy of sixteenth-century Spain. And the grooming and appearance of Mendoza propose a physical likeness to the King, who had a similar beard, strong chin, and long nose (figs. 1 and 2).[10] In the aristocratic-hierarchical world of sixteenth-century Spain, the relationship between the king

and his first viceroy in New Spain was manifest through representations of power in ritual, in material production, and in the production of knowledge.

This was an age of royal progresses, when the Holy Roman Emperor marked his universal domain in his dozens of journeys to visit, secure, and survey his territories. A marvelous scroll, fifteen meters long and containing forty hand-colored prints, spells out Charles's role as Defender of the Faith, a title conferred at his coronation by Pope Clement VII in Bologna in 1530 (fig. 3). Antonio had witnessed the coronation at the Church of St. Petronius and the celebratory procession that followed it. Again and again, in far-off kingdoms of the Habsburgs' universal monarchy his viceroys performed this duty for Charles in absentia. Progresses consolidated support for the regime, popularized its attitudes with the local government, and made concrete the abstraction of the Crown in the actual presence of the viceroy as the king's surrogate.[11] Government records note that on November 14, 1535, when Viceroy Mendoza arrived in Mexico City, festivities and great state ceremonies took place. "Trumpeters with gaily colored cloaks and the roll of kettle drums greeted his arrival as the city dignitaries, knights and commoners went out to meet him arrayed in fiesta attire."[12] Games in the plaza and a repast for the viceroy, his gentlemen, and the performers followed the solemn reading of his commissions by a public crier. The next day Mendoza entered into conference with the *cabildo* and other governing bodies.

In contrast to the verbal description of the ceremonies, which adheres to European traditions of state progresses, the *entrada* of Mendoza to Mexico City must have been a colorful blend of indigenous attire, dance, music, and cuisine with the Euro-Christian aspects of public, state-sponsored rituals. The first viceroy's *entrada* certainly combined symbolism and meaning from all parts of New Spain's society to underscore the complex field of power relations that was evolving in this diverse and unknown geography.

For a view of what Mendoza's 1535 *entrada* might have involved, a 1557 scene represented in the Tlatelolco Codex (a history of events in Mexico City from 1542 to 1560) can be thought

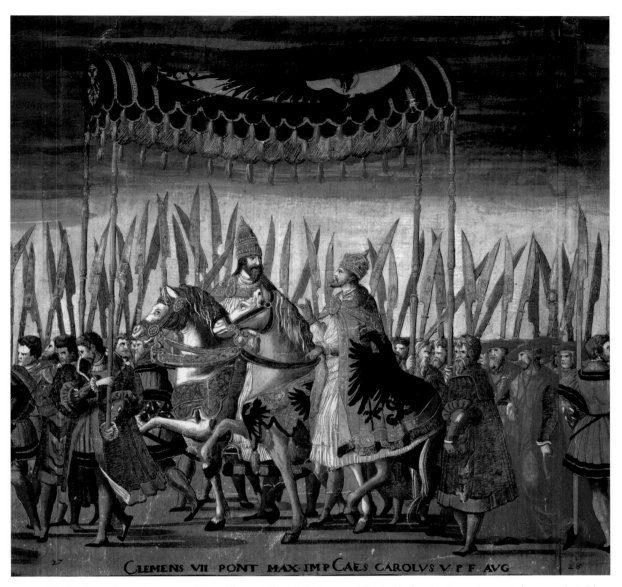

Fig. 3. Nikolas Hogenberg, *Procession of Pope Clement VII and the Emperor Charles V after the Coronation at Bologna on the 24th of February, 1530* (detail). Flanders, circa 1535–1539. Hand colored prints pasted on a canvas scroll with gold, 98½ feet long (250.2 cm). Getty Research Institute, Los Angeles. Digital image courtesy of the Getty's Open Content Program.

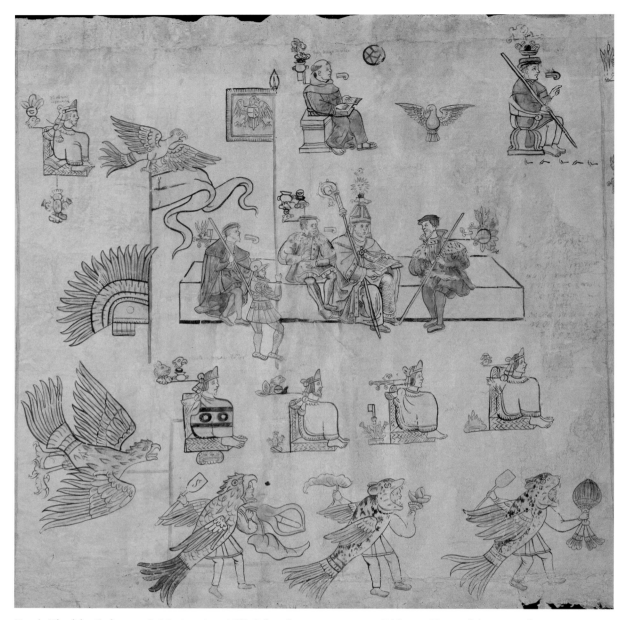

Fig. 4. *Tlatelolco Codex*, part 8. Mexico, circa 1560. Ink and pigment on paper. Biblioteca Nacional de Antropología e Historia, Mexico City. CONACULTA, INAH, MEX. Reproduction authorized by the Instituto Nacional de Antropología e Historia.

of as a diagram of the complex political entities that were taking shape during Mendoza's term of office (fig. 4). Here indigenous and European authorities have gathered in the central plaza of Mexico City to show allegiance to the new king of Spain, Philip II.[13] We see a central platform where four European-clothed figures are seated, and above and below them are horizontal tiers of figures with hieroglyphs identifying the high-ranking individuals. Seated in the central tier are the viceroy, the archbishop, the president of the *Audiencia* and one of its judges. The central figures and the platform they sit upon are rendered using European perspective and shading to indicate volume and space. In vivid contrast, below the platform are four seated lords, rendered in native tradition as compact seated forms in profile, representing four prominent cities of the Aztec Empire. Each native lord is accompanied by his name rendered hieroglyphically, and a toponym placed adjacent to the mat where he is seated identifies his polity. Stylistically, the codex offers visual evidence of the complex sociopolitical structure of early colonial New Spain. Indigenous painters who recorded the historical events showed the evolution of power among figures of authority from diverse social and political factions.

With the acquisition of new territory, Charles's curiosity increased, as did his desire to experience all events in his realm. To comprehend the diverse cultures and geographic areas of the empire, Charles supported the publication of treatises on astronomy, scientific and navigational instruments, and geography.[14] He prized images, texts, and maps drawn from direct experience and observation (fig. 5).[15] Documents based on accurate observation, and most particularly maps, were one form of visual culture by which Mendoza brought his humanist Renaissance vision to bear on New Spain, and these forms of information gathering played a crucial role in his establishment of a land grant system, serving as legal protection for the rights of the indigenous peoples.[16] Consequently, indigenous people produced hundreds of maps in the sixteenth century. The greatest number served legal purposes connected with land grants, boundary disputes, and eventually royal questionnaires.

Before considering the second visual portrait of Mendoza, I want to provide a portrait of the viceroy through his actions—actions in which the visual image served as the primary means to both communicate and document information. Mendoza established a *mercedes* (land grant) system to comply with the mandate of Charles V to reward ex-conquistadors and their heirs. The *encomienda* system awarded Spaniards parcels of land in which native inhabitants provided free labor to their new landlords in exchange for military

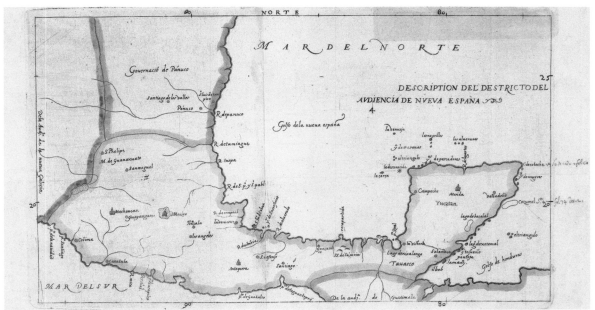

Fig. 5. Attributed to Royal Chronicler Antonio de Herrera, *Map of the Audiencia of New Spain*. Spain or New Spain, circa 1601. Ink and pigment on paper. Gutiérrez Special Collection, Getty Research Institute, Los Angeles (P840001).

protection; a tribute system also required the indigenous people to tithe to the Spanish lords.

Mendoza set a legal process for granting land by requiring written records of the lands under consideration.[17] The final step in Mendoza's process was the making of a map, or *pintura,* as visual proof that the land could be granted without harm to the indigenous community. The map functioned on a number of levels. As Barbara Mundy has observed, the map served to fix the land under consideration in space, to verify its dimensions and position, and to eliminate with a visual document the ambiguity inherent in the written decree.[18] The *pintura* also gave the indigenous community a voice in the legal process.

Mendoza took his role as protector of the indigenous population seriously; he often heard and, at times, adjudicated land disputes brought to him by the native population. He recognized the importance of pictorial documents as a way for indigenous peoples to communicate their claims in legal proceedings. A number of pictorial maps

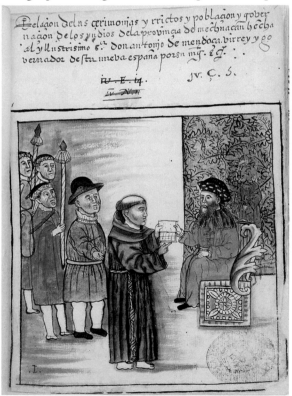

Fig. 6. Frontispiece, *Relación de Michoacán.* New Spain, circa 1538–41. Pigments on European paper, 8 x 5¾ in. (20.3 x 14.6 cm). Real Biblioteca de Monasterio de San Lorenzo de El Escorial, Spain. © Patrimonio Nacional.

dating before 1550 (the final year of Mendoza's rule) attest to the viceroy's belief that native pictographic records were authoritative; and *pinturas* continued to be included as a standard part of the *mercedes* process administered by all viceroys in sixteenth-century New Spain.[19] As images of New Spain, maps also allowed Mendoza to know more widely his subjects and the territories he governed.

Accounts of Mendoza's leadership show him as a benevolent and just ruler guided by political savvy that I suggest stemmed from his boyhood growing up on the grounds of the Alhambra in a multicultural community, his father as role model, and a humanist education.[20] But the situation in New Spain was constantly shifting in the early decades of the colonial period. And the goals of Mendoza's office were twofold: to reinforce the ultimate authority of the Spanish Crown through the office of viceroy, as well as to foster effective collaboration with the indigenous peoples by gaining knowledge of the land and the diversity of people.

Mendoza understood the importance of images as a form of communication between the Spanish and indigenous peoples. Almost immediately, from the point of contact in the 1520s, Spanish chroniclers noted European interest in the indigenous painted manuscripts. Franciscan friars were impressed with the pictorial documents and quickly understood that through images the two cultures could begin to exchange information. Simultaneously, the mendicant friars were using pictures to assist them in evangelization. Whether for administrative or conversion or other purposes, pictorial manuscript production helped bridge from indigenous to colonial rule in the period under Viceroy Mendoza's rule.

The second visual portrait of the viceroy is the frontispiece of the *Relación de Michoacán,* a manuscript he commissioned around 1538–1539 (fig. 6).[21] It shows Viceroy Mendoza receiving a book from a Franciscan friar. Mendoza is seated to the right on an ornamental chair or throne with a tapestry screen behind him. The friar who was charged with gathering and compiling information from native nobles in Michoacán is standing in the center of the image, with a cluster of four people standing to the left.

Viceroy Mendoza first visited Michoacán, one of the four bishoprics in New Spain, between

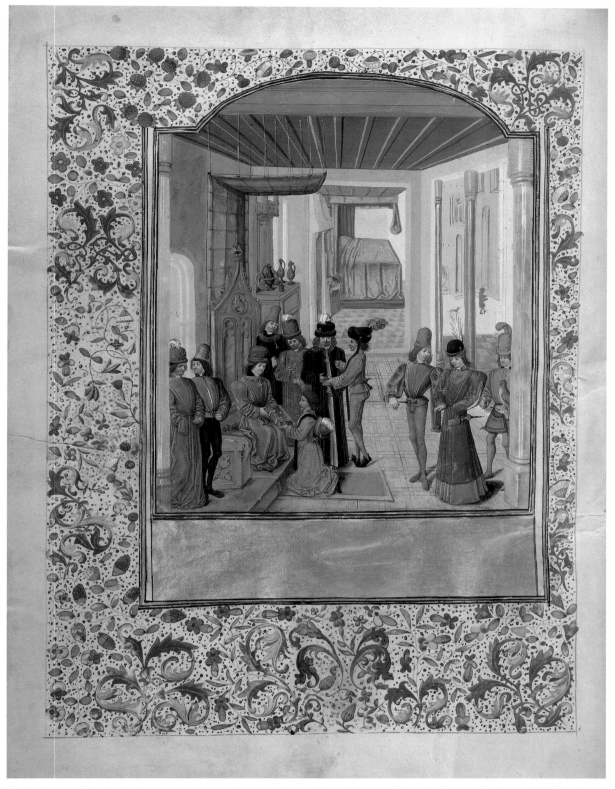

Fig. 7. Master of the Jardin de vertueuse consolation and assistant, *Vasco da Lucena Giving his Work to Charles the Bold*. Flanders and France, circa 1470–1475. Tempera colors, gold leaf, gold paint and ink on parchment. Ms. Ludwig XV 8, fol. 2v.  J. Paul Getty Museum. Digital image courtesy of the Getty's Open Content Program.

1538 and 1539. The fame of Michoacán was rising at this time, following the king's official recognition of the city and province by granting them a coat of arms in 1534.[22] The purpose of Mendoza's official visit was to learn firsthand about this outlying bishopric and to gain insight about the native population to include in his annual report to the king. While in Michoacán Mendoza commissioned Franciscan Friar Jerónimo de Alcalá to compile oral testimony and visual documentation about the "antiquities of the people, their customs, government, and land" so he could govern more effectively.[23] Mendoza's motivations were both political and personal: to gather information for administrative purposes, to provide political publicity for his rule, to promote diversity of indigenous cultures in New Spain, and to remedy the general lack of knowledge in Europe regarding the province and peoples of Michoacán.

Modeled on the European "presentation portrait," the frontispiece sheds light on the complex relationship among those involved with the making of the manuscript. As an example of the presentation portrait (fig. 7), in a fifteenth-century French illumination, Charles the Bold, duke of Burgundy, sits in front of a long red fabric that hangs from the ceiling by gold threads. The luxurious fabric delineates the duke's space and focuses attention on the action of presentation. Vasco da Lucena, author of the French translation of the *History of Alexander the Great*, kneels before the duke as he presents his masterpiece. Representing a similar presentation of a written and illuminated manuscript to a figure of authority, the image from New Spain visualizes the lines of authority specific to Michoacán between 1538 and 1541. In the *Relación* frontispiece, Don Pedro Cuiníarángari, governor of Michoacán, wears European clothes and stands in front of three noblemen (holding spears and wearing headbands) who served as native informants. Fray Jerónimo de Alcalá is positioned between the indigenous group and the Spanish authority, linking those who were responsible for creating the content of the book and the viceroy who sponsored the book's creation. Alcalá, who was fluent in Purépecha and served as translator, is shown as central to the project and in alliance with both the indigenous governor and the Spanish viceroy.

Revisions to the composition and partial erasures in the image underscore a complicated and shifting dynamic among the makers, giver, and recipient. At one time a second figure stood behind Mendoza. To conceal that figure the tapestry screen was painted, creating a zone occupied exclusively by the Spanish political authority, in the vein of the French presentation page for Charles the Bold. A second revision shifted the friar's position from seated to standing, according deference to the viceroy as the only seated figure in the scene. Mendoza's exalted position is thereby recorded visually as well as in the prologue by Alcalá, which highlights the Franciscan missionary enterprise in Michoacán but cedes political and moral authority to the viceroy.

In 1541 Mendoza made a second visit to Michoacán. He received the manuscript at this time. Between the commissioning of the manuscript and its presentation, Mendoza's authority had been challenged. Three situations necessitated the viceroy's second visit to the remote western region: (1) a reported disagreement between Spanish captains in the area, (2) a land dispute between a Spanish *encomendero* and the bishop of Michoacán, and (3) an Indian rebellion in Guadalajara.[24] A lingering controversy between the Spanish *encomendero* Juan Infante and Bishop Quiroga had been building since 1538. They were arguing over possession of twenty-five towns adjacent to Tzintzuntzan (the ancient indigenous capital), together with the associated rights to free labor and tithes.[25] This escalating situation involved the Spanish military and exacerbated complications between the bishop and the mendicant friars, who were attempting to protect the native inhabitants of the towns.[26] Mendoza ruled that the land was to be granted to the *encomendero* because Juan Infante had an "executive letter" from the Council of the Indies granting him possession.

Viewing the land dispute as one between two Spanish factions further complicated Mendoza's support of the indigenous population in the Michoacán bishopric. Meanwhile, the uprising of indigenous people in Guadalajara was escalating to a point that required Mendoza to go to the battlefield in October 1541, accompanied by Fray Jerónimo de Alcalá and Governor Cuiníarángari, to oversee the military efforts and ensure Spanish

victory. Five thousand indigenous people were recruited to fight on the Spanish side. Under the command of Governor Cuiníarángari, these native mercenaries helped to crush the uprising. While the Spanish could claim a victory, Mendoza acknowledged that this was a grave situation for all of New Spain. This multifaceted situation was a turning point in his tenure as viceroy.[27]

The book we see being given to Mendoza in the frontispiece of the *Relación de Michoacán* is likely a "presentation copy," one that provides the patron with an idea of what the finished manuscript will include (see fig. 6). Since the sixteenth century it has been in the library of the Escorial in Spain.[28] The manuscript is in fragmentary condition, missing an entire section of text, and filled with corrections and erasures. Essentially, its physical condition can be considered a metaphor for the political situation in early colonial New Spain, with its constantly shifting allegiances to opposing lines of authority. If the image from the Tlatelolco Codex diagramed the array of religious, political, historical, and present figures involved in governing New Spain in the 1550s (see fig. 4), the frontispiece of the *Relación*, with its erasures and edits, indicates the uncertainty and inherent instability of that structure between 1538 and 1541 (see fig. 6).

Mendoza's initial ambition for the manuscript was to promote the diversity of the indigenous people of New Spain. He intended to demonstrate the existence of ancient cultures, such as those of Michoacán, that were previously underappreciated by the Spanish but were as sophisticated as those encountered by Cortés in central Mexico. Mendoza mentioned the *Relación* in a letter to the Spanish chronicler of the Indies, Gonzalo Fernández de Oviedo y Valdés, on October 6, 1541: "once I finish collecting the material I will send it to you. . . . And what I have here is not so negligible that you cannot make a book of it."[29] However, after this mention of the *relaciones* gathered from the nobles of Michoacán, Mendoza never mentioned the project again. After he successfully stopped the uprising—considered one of the most serious challenges to Spanish rule during his viceroyship—Mendoza shifted his focus back to Mexico City to centralize and consolidate Spanish authority in the office of the viceroy.

Nevertheless, with this manuscript project Mendoza initiated a pattern of patronage and cultural policy that would mark his administration, placing emphasis on the production of knowledge through pictorial and textual means. It is noteworthy that Mendoza commissioned the *Relación de Michoacán* in 1538, just three years after arriving in New Spain. A second text-and-image manuscript, the *Codex Mendoza*, was begun in the early 1540s, and the *Suma y narración de los Incas* was commissioned in 1551, after he relocated to become viceroy in Peru, and just a year before his death. Mendoza followed the imperial call for systematic collection of information pertaining to geography, both human and physical. And with the production of pictorial manuscripts, Antonio de Mendoza served the Crown with both pen and sword, as his ancestors and father had done before him.

We have two different types of portraits of Mendoza, representing two essential aspects of the first viceroy's office—the administrative and the humanist. The official portrait presents a clear visual framework for the person inhabiting the office (see fig. 1). All of Mendoza's successors would have their portraits painted in this style to represent in visual terms the physical and sociopolitical embodiment of the office. The presentation portrait, however, shows a critical moment, a turning point in the first viceroy's tenure as a participant in the governance of New Spain (see fig. 6). Visual evidence shows the viceroy as one of a number of entities vying for the ultimate position of authority supported by the allegiance of Spanish clergy and the indigenous population of New Spain. It was the knowledge he gained through direct experience that guided him to shift his actions as viceroy to a central location of authority in Mexico City.

## Notes

[1] Helen Nader, *The Mendoza Family in the Spanish Renaissance, 1350 to 1550* (New Brunswick, NJ: Rutgers University Press, 1979), 38.

[2] Nader, *The Mendoza Family.* Chapter 1 provides a full discussion of the Mendozas' contribution to fourteenth- and fifteenth-century Spanish literature.

[3] Nader, *The Mendoza Family*, 115, 116, 188–193, discusses building projects sponsored by the Guzmán and Santillana branches of the Mendoza family; Tendilla is of the Santillana branch.

[4] Nader, *The Mendoza Family*, 144–146. Private households

in Spain were the centers of intellectual life and breeding grounds for humanist education. The intellectual life of the Mendoza household, and the education of the sons, reflects not only the social milieu they encountered day to day in Granada but also the interests of their father. It is beyond doubt that the children learned Arabic as part of their daily routine, speaking with household servants and conversing with members of the Muslim community in Granada.

5 Cammy Brothers, "The Renaissance Reception of the Alhambra: The Letters of Andrea Navagero and the Palace of Charles V," *Muqarnas* 11 (1994): 79–102. An imperial iconography was formulated as Charles's identity as emperor was constructed with a visual ensemble, including the imperial coat of arms with the motto *plus ultra* and the adoption of state architecture *a la romano*. Projects Charles undertook in Spain, and interventions in Hispano-Moresque architecture in Cordoba, Seville, and Granada, were clear statements of Christian power and Charles's presence in the southern kingdom.

6 Arthur Scott Aiton, *Antonio de Mendoza, First Viceroy of New Spain* (Durham: Duke University Press, 1927), 11. Luis and Antonio pledged their loyalty first to King Ferdinand upon the death of Queen Isabel (1504) and then to Charles upon the death of Ferdinand (1516). Throughout the succession disputes, Tendilla's sons maintained their allegiance to this succession of monarchs. Luis and Antonio were among the first Spanish nobles to recognize Charles as king designate of Spain. In 1516, Antonio and Francisco de Cobos, a friend of Tendilla, were sent to the court in Flanders to notify Charles of his grandfather's death. That year, as king of Spain, Charles ordered a fleet of forty ships to sail for Spain with Antonio and Francisco de Cobos in the royal entourage.

7 Henry Kamen, *Empire: How Spain Became a World Power, 1492–1763* (New York: Harper Collins, 2003), 64. Charles's purpose in Bologna was to make amends to the pope by showing his acceptance of his expected role as Defender of the Faith. Through the ceremonies and crowning, Charles's rule was solemnly ratified by the pope.

8 Aiton, *Antonio de Mendoza*, 35.

9 Officially labeled Escorial MS. C.IV.5, the *Relación de Michoacán* was deposited in the monastery palace sometime in the sixteenth century. It is listed in the first catalogue made of the Escorial library's holdings about 1600. From the early nineteenth century full and partial copies were made of the manuscript, now placed in the New York Public Library, Library of Congress, Archivo de la Real Academia de la Historia, Biblioteca Nacional de Madrid, Bibliothèque Nationale de Paris, and Milan Public Library.

10 Michael Schreffler, *The Art of Allegiance: Visual Culture and Imperial Power in Baroque New Spain* (University Park: Pennsylvania State University Press, 2007), 68–72.

11 The mute ritual enactments involved in these processions were a way to communicate originary myths and social values to an illiterate populace, especially one that was multicultural and for whom even the spoken word was therefore an ineffective form of communication and persuasion.

12 Aiton, *Antonio de Mendoza*, 16.

13 Barbara Mundy, "Indigenous Dances in Early Colonial Mexico," in *Festivals and Daily Life in the Arts of Colonial Latin America, 1492–1850*, ed. Donna Pierce (Denver, CO: Mayer Center for Pre-Columbian and Spanish Colonial Art at the Denver Art Museum, 2012), 20–23. This is the closest visual document, in terms of date and public ritual, I have found that allows us to imagine the *entrada* of Mendoza.

14 William Lawrence Eisler, *The Impact of the Emperor Charles V upon the Visual Arts* (Philadelphia: Pennsylvania State University, 1983), 131, 132.

15 Barbara E. Mundy, *The Mapping of New Spain: Indigenous Cartography and the Maps of the Relaciones Geográficas* (Chicago: University of Chicago Press, 1996), 16, 17.

16 Dana Leibsohn, "Primers for Memory," *Writing without Words: Alternative Literacies in Mesoamerica and the Andes*, ed. Elizabeth Boone and Walter G. Mignolo (Durham: Duke University Press, 1994), 161–187.

17 Mundy, *The Mapping of New Spain*, 181–185. The process established by Mendoza involved a decree (*acordado*) stating the beneficiary and identifying the land, its size, and its rough location. Once the *acordado* was reviewed by the viceroy, the decree was sent to the local official (*corregidor/alcalde mayor*) of the province where the land lay. The provincial official then carried out the next steps of the process (*deligencias*): inspecting the site to ensure that the grant didn't include native croplands, announcing publicly the pending grant, and calling for local witnesses to testify to the status of the lands under consideration and adjacent to the plot.

18 Ibid.

19 Mundy, *The Mapping of New Spain*, 184.

20 Cynthia L. Stone, *In Place of Gods and Kings: Authorship and Identity in the Relación de Michoacán* (Norman: University of Oklahoma Press, 2004), 243, n. 29. Stone notes policies toward the indigenous population in which Mendoza is both supportive and tolerant: creating the order of indigenous knights (*caballeros tecles*), and advocating continuation of local customs with regard to tribute collection, artisan guilds, and election of indigenous governors and caciques. She also points to examples of severe punishment that the viceroy directed and justified as preventing rebellion.

21 The full title of the manuscript is *Account of the ceremonies and rites and settlement and government of the Indians of the province of Michoacán made for the Illustrious Lord Don Antonio de Mendoza viceroy and governor of this New Spain on behalf of his Royal Catholic Imperial Majesty.*

22 Stone, *In Place of Gods and Kings*, 30.

23 Alcalá employed indigenous informants who were members of the local Purépecha-speaking nobility. Their oral commentary was recorded in the manuscript texts. Four native artists were engaged to create forty-four small paintings for the manuscript.

24 Stone, *In Place of Gods and Kings*, 31.

25 Bernardino Verástique, *Michoacan and Eden: Vasco de Quiroga and the Evangelization of Western Mexico* (Austin: University of Texas Press, 2000), 124–130.

26 Ibid.

27 Mendoza was the focus of a *residencia*, a judicial review of his tenure in office, as a result of the Mixtón War, from 1541 to 1548. The review concluded in Mendoza's favor.

28 Stone, *In Place of Gods and Kings*, 8. The original, fragmentary manuscript arrived in the Escorial sometime in the second half of the sixteenth century.

29 Stone, *In Place of Gods and Kings*, 17,18.

# "Copies or Resemblances of Nature"
## The Limitations of Portrait Painting in Colonial British America

### *Susan Rather*

In London to study law in 1751, Peter Manigault of Charleston, South Carolina, seized the opportunity to commission a portrait. He described the resulting work (known only through an old black-and-white photo) in a letter to his mother, in which he also revealed some of his considerations in selecting a painter. Although he did not name the portraitist, Manigault chose Allan Ramsay (1713–1784), a Scot of considerable prominence in mid-eighteenth-century Britain.

> And now a few Words concerning my Picture . . . Tis done by one of the best Hands in England, and is accounted by all Judges here, not only an Exceeding good Likeness, but a very good Piece of Painting: The Drapery is all taken from my own Clothes, & the very Flowers in the lace, upon the Hat, are taken from a Hat of my own . . . I was advised to have it drawn by one Keble . . . but upon seeing his Paintings, I found that though his Likenesses, (which is the easiest Part in doing a Picture,) were some of them very good, yet his Paint seemed to be laid on with a Trowel, and looked more like Plaistering than Painting.[1]

Manigault's criteria for evaluating portrait and portraitist were commonplace on both sides of the British Atlantic. His synecdochic characterization of Ramsay as a "hand" reflexively exposes the widely held perception of painters as manual workers. The repeated words "paint" and "painting" further draw attention to material and process, as do the terms in which Manigault denigrated William Keable, the now little-known portraitist he rejected. Plastering, like all artisan labor, had to be learned, but the skill set necessary to covering a wall paled beside the challenge of applying pigmented oil to canvas in ways that made the raw materials appear as something other than themselves.

Strikingly, Manigault considered "likeness," evidently meaning representation of a sitter's face, to be the "easiest part" of the process.

Eighteenth-century portraitists did not agree. With good reason, they identified their greatest challenge in coloring flesh, a point also made by continental artists and writers. Denis Diderot, the pioneering French art critic, thought "the rest is as nothing in comparison. Thousands of painters have died without acquiring a feeling for flesh, and there will be thousands more who'll die without acquiring it."[2] Perhaps only those well acquainted with painting technique could appreciate the difficulty of representing skin tones, while the evidence suggests that most British and American portrait clients had other priorities (figs. 1–2). Manigault's remarks affirm the greater importance of "drapery"—clothing and fabrics—and of other material goods that most forcefully communicated social position, a primary function of the eighteenth-century Anglo-American portrait.

The division of labor in later seventeenth- and eighteenth-century British portrait making had potential to diminish portraitists in the eyes of patrons who agreed with Manigault. "Face-painter," a term then common, aptly describes the work of busy portraitists like Sir Peter Lely, painter to the Stuart court during the 1660s and 1670s, or Allan Ramsay, the artist Manigault chose. They and others might paint only a sitter's head or even just the face, leaving the remainder of the picture to a specialist "drapery painter." The English artist William Hogarth, unusual in not using drapery painters, dismissively called them "painter taylors." Such contract workers, he charged, often furnished "nine parts in ten" of a picture.[3]

"Phiz-mongers" was engraver-antiquarian George Vertue's punning slap to portrait painters who "scarsely coud do any part but the face of a picture"—a remark from within the profession that has the effect of supporting Manigault's lay view that painting faces was easy, a matter of rote.[4] Collectively, the remarks of Hogarth, Vertue, and Manigault leave little room for genius in portrait painting, the only genre in which British painters on either side of the Atlantic readily found employment. The impossible ideal to which German

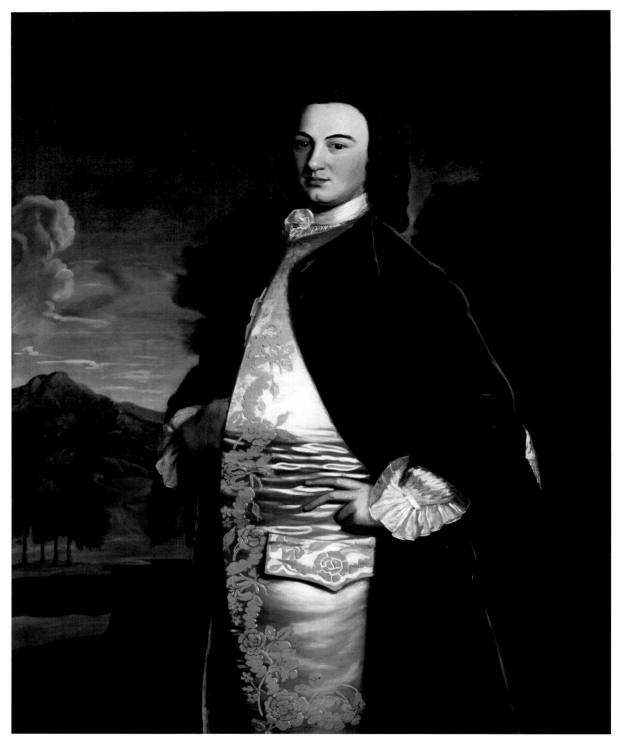

Fig. 1. Robert Feke, *James Bowdoin II*. Boston, 1748. Oil on canvas, 49⅞ x 40⁵⁄₁₆ in. (126.68 x 102.39 cm). Bowdoin College Museum of Art, Brunswick, Maine, Bequest of Mrs. Sarah Bowdoin Dearborn.

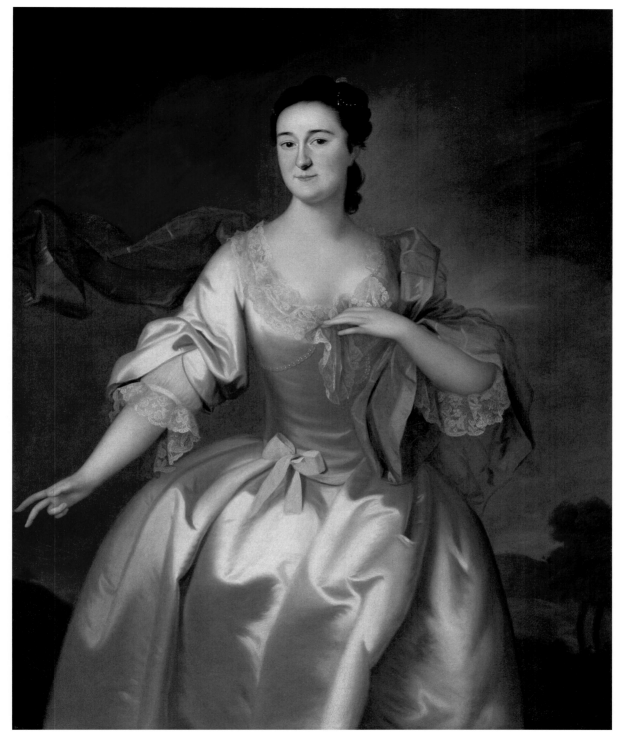

Fig. 2. Joseph Blackburn, *Mrs. James Pitts (Elizabeth Bowdoin)*. Boston, 1757. Oil on canvas, 50⅛ x 40 in. (127.3 x 101.6 cm). Detroit Institute of Arts, Founders Society Purchase, Gibbs-Williams Fund/Bridgeman Art Library.

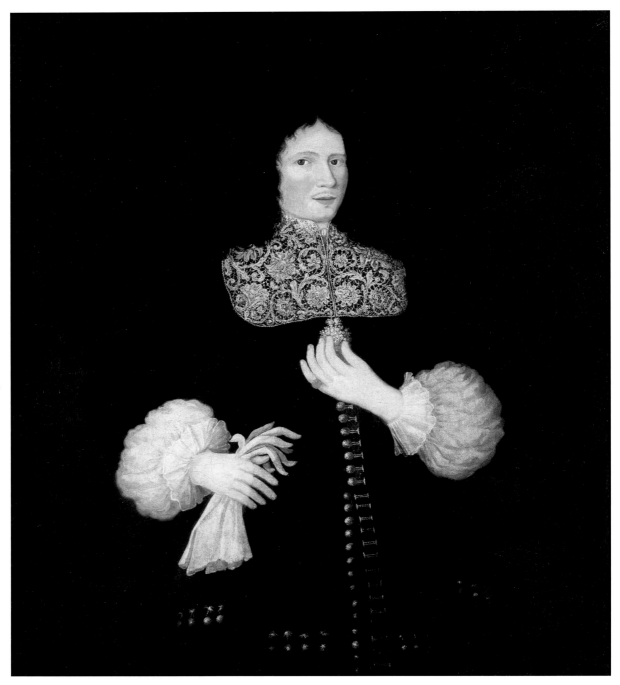

Fig. 3. Freake-Gibbs Painter, *John Freake*. Boston, circa 1670–1674.  Oil on canvas, 42½ x 36¾ in. (108 x 93 cm). Worcester Art Museum (MA), Gift of Mr. and Mrs. Albert W. Rice, 1963.135.

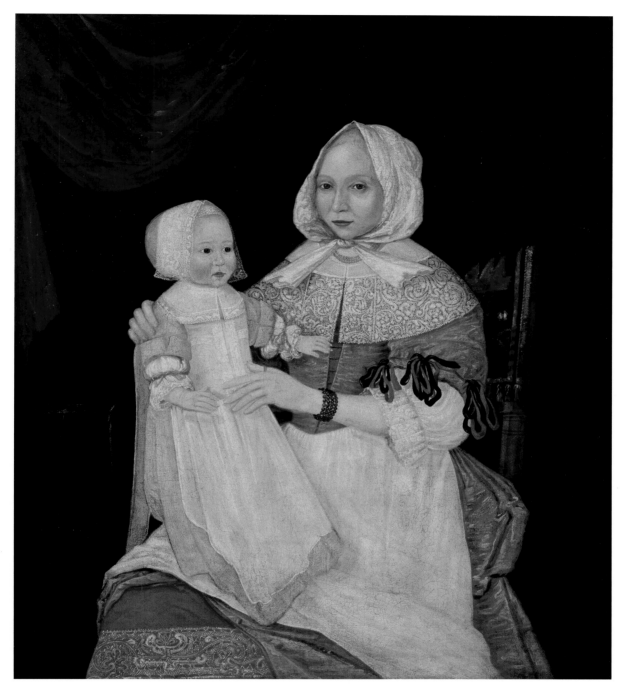

Fig. 4. Freake-Gibbs Painter, *Mrs. John Freake (Elizabeth Clarke) and Baby Mary*. Boston, circa 1670–1674. Oil on canvas, 42½ x 36¾ in. (108 x 93 cm). Worcester Art Museum (MA), Gift of Mr. and Mrs. Albert W. Rice, 1963.134.

dramatist, art critic, and philosopher Gotthold Lessing drew attention in a play of 1772 could not even in jest have been applied to an Anglophone painter at mid-eighteenth century: that he might, like Raphael, "have been the greatest artistic genius even if he had the misfortune to be born without hands."[5]

The equation of painters with handworkers, artisans, had long since been banished by European artists. Beginning in Italy during the Renaissance, they sought and attained recognition as practitioners of a liberal, intellectual art. This status, promoted by newly forming academies of art, came especially through engagement with history painting—collectively, subjects from the Bible, mythology, literature, history, and allegory. In the academic view, these required invention and imagination, whereas portraiture depended more on imitation. Select seventeenth-century artists benefitted from the rise in professional status, and some, including Diego Velázquez, acquired distinction as gentleman-courtiers.

In England, somewhat isolated from continental developments following the Reformation, the social position of native artists changed more slowly and unevenly. A sequence of continental painters employed at the English court—starting with Peter Paul Rubens and Anthony Van Dyck in the 1630s—gained the stature of knighthoods. But it would be more than another century before the Crown bestowed collective recognition on British artists in endorsing the Royal Academy of Arts in 1768, a laggard relative to such institutions in Italy, France, and Spain. In Anglophone North America—where the earliest paintings of colonial manufacture date to the 1660s—painters retained artisanal status deep into the eighteenth century. First impressions aside, they were not necessarily untutored (figs. 3 and 4). The unidentified Freake "limner" (an archaic word for portraitist used well into the eighteenth century) painted with skill in a neomedieval Elizabethan style that endured in provincial England, including the Boston area of New England, long after Charles I brought court painting into line with continental tastes.[6] Painters might learn through traditional apprenticeships in the trade known as "painting in general." That line of work encompassed not only picture making but also painting repair and a range of other more practical jobs that also used oil paint, such as the embellishment of signs, coaches, and houses. Boston-born John Greenwood (1727–1792) began as an apprentice to Thomas Johnston before turning to portraiture, in which he was self-taught. In Philadelphia, Matthew Pratt (1734–1805) served his apprenticeship to James Claypoole, "Limner & Painter in General," as did his exact contemporary in Cumbria, England, George Romney (1734–1802).[7] Though many painters neither sought nor even recognized a life beyond artisanry, both Pratt and Romney did, migrating to London during the 1760s for better professional opportunities and status (fleeting in the case of Pratt, a sign painter at the end of his career). They and others yearned to be considered as minds, not just hands.

The dominance of portraiture in Great Britain (constituted in 1707 by the union of Scotland and England) sorely vexed painters who were familiar with and gave any weight to European art theory, especially the French art theory that began to be translated into English by around 1700. In what are surely the best-known remarks by any colonial American painter, John Singleton Copley (fig. 5), in 1767, complained to an English correspondent about his native Boston:

> A taste of painting is too much Wanting . . . was it not for preserving the resemble[n]ce of perticular persons, painting would not be known in the plac[e]. The people generally regard it no more than any other usefull trade, as they sometimes term it, like that of a Carpenter tailor, or shew maker, not as one of the most noble Arts in the World.[8]

In naming tailors, carpenters, and shoemakers, Copley (1738–1815)—a high-status artisan more on par with a silversmith—exaggerated the occupational slight. Yet his charge had foundation. The lingering Anglophone equation of painters with artisans is evident in Samuel Johnson's contemporaneous English dictionary, which defined artisan as either "artist; professor of art" or "manufacturer; low tradesman."[9] Johnson introduced undated verse that identified the artisan-artist with portrait painting: "Best and happiest *artisan*/Best of painters, if you can,/With your many colour'd art,/Draw the mistress of my heart." Cheery as

the passage might sound, it exposes impediments to the elevation of portrait painting: portraitists needed to please their clients, and portraits by definition represent particular persons. Portraitists remained tethered to unimproved nature.

Early in the eighteenth century, Anthony Ashley Cooper, the 3rd Earl of Shaftesbury, adamantly laid out how portraiture harmed the painter: "the subjecting of his genius, narrowing of his thought, contraction of his idea, deadening of his fancy." Portraiture, the philosopher continued, adversely affected the artist by "tying him down to copying, translating, [and] servilely submitting him to the lords and ladies."[10] The London artist Jonathan Richardson disagreed. Also a connoisseur and writer, Richardson in 1715 published the first sustained defense of portraitists and argument on behalf of English artists, its discursive character evident from the title: *Essay on the Theory of Painting*. "The *invention* of the Painter," Richardson asserted, "is exercis'd in the Choice of the Air, the Attitude, the Action, Drapery, and Ornaments, with respect to the Character of the Person."[11] These remarks clearly refer to portraitists, whom he grants powers of "invention" normally associated with history. Yet as late as 1767, in his *Essay on Original Genius*, English writer William Duff restated the persistent idea that portraits were merely "COPIES or RESEMBLANCES of Nature."[12] The art treatises to which Copley had access in Boston either dismissed or barely mentioned portraiture. What Copley did not realize was that ambitious artists even in the London metropolis were still campaigning for the dignity of painting and of portrait practice in particular.

Copley's perspective has received disproportionate attention from Anglo-Americanists for two reasons. First, he is far better documented than many artists—with scores of letters and lots to say on painting—and, second, we still agree with the contemporaries who recognized him as the most talented artist to have worked in colonial British America. His portrayal of Margaret Kemble Gage, in Copley's own judgment "beyond Compare the best lady's portrait I ever Drew," demonstrates his high level of accomplishment (fig. 6).[13] Copley may have been a big fish in a small pond—no one was more ready to advance that idea than he—but the sought-after portraitist was less isolated than

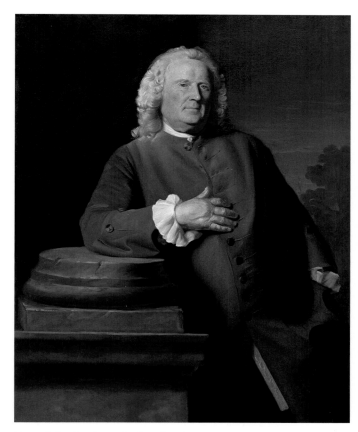

Fig. 5. John Singleton Copley, *Epes Sargent*. Boston, circa 1760. Oil on canvas, 49¹³⁄₁₆ x 40¹⁄₁₆ in. (126.6 x 101.7 cm). National Gallery of Art, Washington, Gift of the Avalon Foundation.

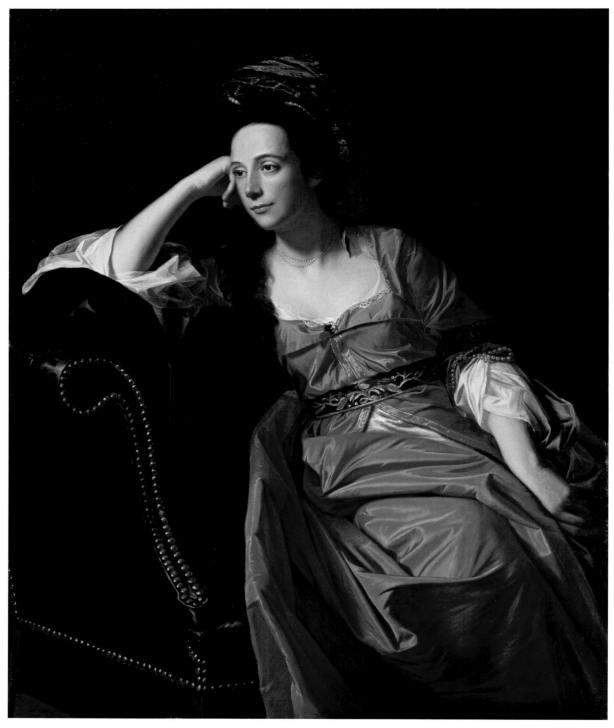

Fig. 6. John Singleton Copley, *Mrs. Thomas Gage (Margaret Kemble)*. New York, 1771. Oil on canvas, 50 x 40 in. (127 x 101.6 cm). San Diego, Timken Museum of Art, Putnam Foundation Collection.

he sometimes represented.[14] Looking beyond
Copley affords a more balanced perspective on
British-American portraiture and its makers.

Although no American city supported a large
population of artists, Philadelphia proved as fertile
an environment as any just after midcentury.
Eleven painters, almost all portraitists, can be
documented there between 1749 and 1769, by
which time the city rivaled Bristol for second larg-
est in the British Empire.[15] Some of those painters
hailed from the region, including one John Green,
who left no pictures before departing for Bermuda
in 1765 but who appears as an artist in a lightly
penciled sketch by the young Benjamin West
(1738–1820) (fig. 7). West went on to an illustri-
ous career in London, becoming historical painter
to George III in 1772 and second president of the
Royal Academy of Arts twenty years afterwards.

In 1758, around the same time he drew Green,
West made a miniature self-portrait, which he pre-
sented to a young woman with whom he had an
attachment (fig. 8).[16] In accord with its form and
purpose, the work makes no statement about West
as an artist, except insofar as it demonstrates his
skill in a socially valued type of picture making.
Among other painters in Philadelphia, a few were
temporary residents who cherry-picked promi-
nent clientele during painting trips up and down
the eastern seaboard. This group included John
Wollaston, a professionally trained English painter
who introduced contemporary London style to
Americans during the 1750s (fig. 9). Both Copley
and West emulated Wollaston early in their careers
(fig. 10).

Robert Feke also passed through Philadelphia,
but, unlike Wollaston, Feke seems to have been
a talented autodidact, to judge from a dozen
signed portraits and attributed others. If his life
remains somewhat of a mystery, Feke (c. 1707–
c. 1751) has the distinction of being one of the
earliest artists to attract description. In 1744,
the Scottish physician and travel-diarist Dr.
Alexander Hamilton met the artist in Newport,
Rhode Island, and recorded his impressions. Feke,
Hamilton said, was

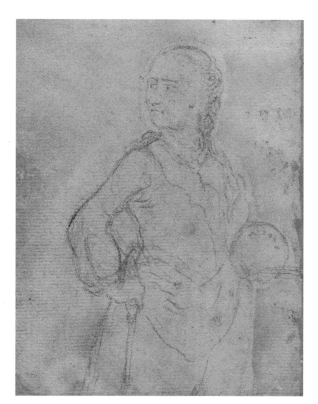

Fig. 7. Benjamin West, *Portrait of John Green* (drawing from
West's sketchbook). Philadelphia, circa 1758–1760. Pencil on
paper, 6½ x 3⅞ in. (16.5 x 9.8 cm). Benjamin West drawings
and sketchbooks circa 1790–1807, Historical Society of
Pennsylvania.

Fig. 8. Benjamin West, *Self-Portrait*, miniature. Philadelphia,
1758/1759. Watercolor on ivory, 2½ x 1¹³⁄₁₆ in. (6.4 x 4.6
cm). Yale University Art Gallery.

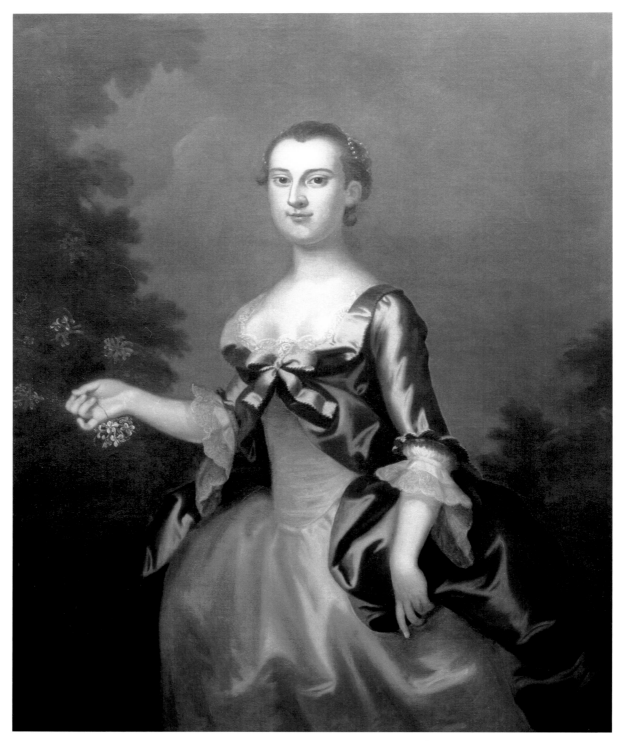

Fig. 9. John Wollaston, *Martha Dandridge Custis*. Virginia, 1757. Oil on canvas., 50 x 41 in. (127 x 104.14 cm).  Washington-Custis-Lee Collection, Washington and Lee University, Lexington, VA.

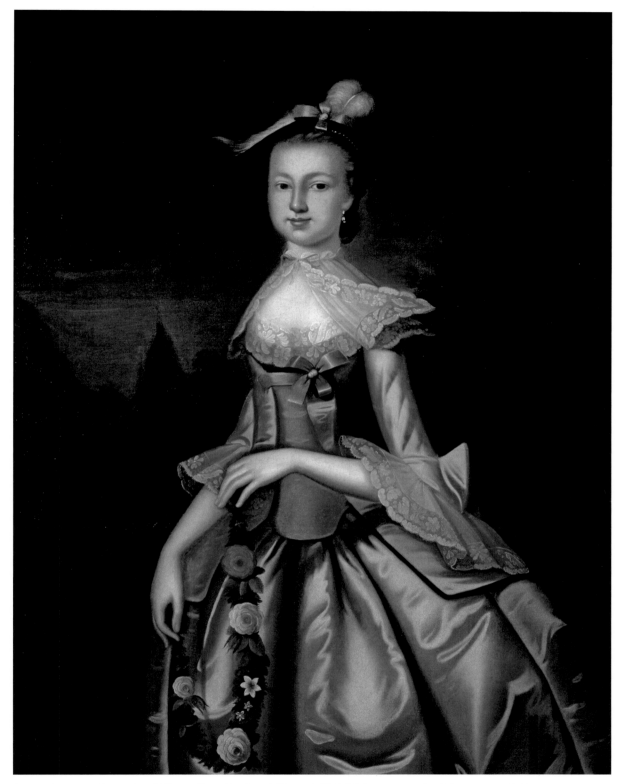

Fig. 10. Benjamin West, *Jane Galloway (later Mrs. Joseph Shippen)*. Philadelphia, circa 1757. Oil on canvas, 49¾ x 39¼ in. (126.4 x 99.7 cm).  Courtesy of the Philadelphia History Museum at the Atwater Kent, Historical Society of Pennsylvania Collection.

the most extraordinary genius ever I knew, for he does pictures tollerably well by the force of genius, having never had any teaching. I saw a large table [meaning picture] of the Judgement of Hercules, copied by him from a frontispiece of the Earl of Shaftesbury's, which I thought very well done. This man had exactly the phizz [the look or appearance] of a painter, having a long pale face, sharp nose, large eyes with which he looked upon you stedfastly, long curled black hair, a delicate white hand, and long fingers.[17]

Feke's self-portrait (fig. 11) seems to show exactly what Hamilton observed, as has often been remarked, but the doctor's comments bear greater scrutiny.

Hamilton recognized Feke as an untutored genius. The word genius in this context referred less to "extraordinary capacity for imaginative creation," a sense that arose in England at around that very time, than to "natural ability or capacity."[18] This meaning appeared as well in a 1740 obituary for the otherwise barely known Boston painter Nathaniel Emmons: "his excellent Works were the pure Effects of his own Genius, without

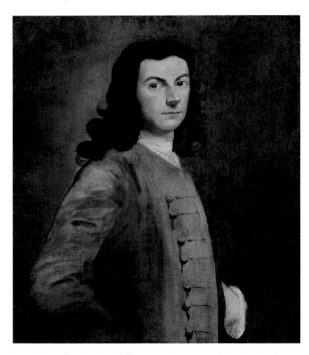

Fig. 11. Robert Feke, *Self-Portrait*. Newport (?), circa 1741–1745. Oil on canvas mounted on aluminum, 29¾ x 25⅞ in. (75.56 x 65.72 cm). Museum of Fine Arts Boston, M. and M. Karolik Fund, 1970.499.

receiving any Instructions from Others."[19] These references acknowledge provincial realities, given that the British colonies had no art schools and limited apprenticeship opportunities. Still, the identification of "genius" in Emmons's obituary foreshadows an enduring characterization of American artists (not least by themselves) as unconstrained by isolation or even aided by it.

In writing of his encounter with Feke, Dr. Hamilton made no mention of portraits, any artist's bread and butter and the only works by Feke to survive. What drew Hamilton's attention was the historical "table" or picture that Feke had copied from the engraving accompanying Lord Shaftesbury's "A Notion of the Historical Draught or Tablature of the Judgment of Hercules," published in the frequently reprinted 1713 edition of *Characteristicks of Men, Manners, Opinions, Times* (fig. 12). In the opening sentence, Shaftesbury explains his use of the word tablature to distinguish a work of cohesive meaning and design from "mere *Portraiture*." While he concedes that a successful portrait or any other "inferiour" type of painting must have "*Unity of Design*," he identified a much greater challenge in history painting, in which "not only *Men*, but *Manners*, and human Passions are represented."[20]

The most significant moment in the story of Hercules at the crossroads—an allegory of civic responsibility—comes when the hero turns away from the entreaties of Pleasure and toward the stern claims of Virtue. Painters, by long tradition, had been thought incapable of independent judgment, and Shaftesbury himself subscribed to that view. He dictated every aspect of the composition to the artist he chose to execute it, Neapolitan history painter Paolo de Matteis (1662–1728)—notwithstanding his opinion of de Matteis as Italy's best artist. (Shaftesbury was in Naples himself, but even if in England, he would not likely have selected a British painter.) Shaftesbury flattered de Matteis when he requested a copy, calling the original painting the product of "your Idea and your hand."[21] Shaftesbury's words, however insincere, indicate that he was not oblivious to the claims of artists, even when attempting to impose his own superior ideas. Still, to Shaftesbury, de Matteis and engraver Simon Gribelin remained little more than hands.

For Dr. Hamilton, Feke was both a mind— "extraordinary genius"—and a hand. In his description of Feke, Hamilton took note of the artist's "delicate white hand, and long fingers," as well as his steadfast gaze from notably large eyes. Such features made Feke look as Hamilton believed a painter should. Forty years before widespread revival of interest in physiognomy as a way of judging character through analysis of facial and bodily features, the observant physician thought he recognized the "phizz of a painter." Here we have an early glimpse of an identity for Anglophone artists, as distinct from other men.[22]

British-American painters would not quickly be liberated from artisanal status; that much is clear from Copley's complaint, which postdates Dr. Hamilton's remarks by more than twenty years. Colonial careers in many respects more representative than Copley's can be glimpsed in newspaper advertisements, such as the one placed by a mariner from Bristol who resurfaced as a painter in America (fig. 13):

William Williams, Painter,
At Rembrandt's Head, in Batteaux-street,
Undertakes painting in general, viz. History, portraiture, landskip, sign painting, lettering, gilding, and strewing smalt. N.B. He cleans, repairs, and varnishes, any old pictures of value, and teaches the art of drawing. Those ladies or gentlemen who may be pleased to employ him, may depend on care and dispatch.

Williams's New York advertisement and another from a Philadelphia newspaper in 1764 indicate that he, like many other colonial artists, followed the career of painting in general.[23] Lettering, gilding, and strewing smalt were all aspects of signboard manufacture, so Williams (1727–1791) targeted not only the "ladies and gentlemen" he mentioned but also artisans who relied on trade signs to guide customers to their shops.[24] Williams had worked at Hogarth's Head in Philadelphia earlier in the decade, so his adoption of Rembrandt's Head in New York hints at a shrewd regional marketing strategy for a city of Dutch heritage. Unlike Copley, who did not hang a sign, advertise, or earn a living by any means other than portraiture, Williams exemplified the artisanal practicality

Paulo de Matthæis Pinx:    THE    Sim: Gribelin sculps:

# Judgment of *Hercules*.

## INTRODUCTION.

(1.) BEFORE we enter on the Examination of our Historical Sketch, it may be proper to remark, that by the word *Tablature* (for which we have yet no name in *English*, besides the general one of *Picture*) we denote, according to the original word TABULA, a Work not only distinct from a mere *Portraiture*, but from all those wilder sorts of Painting which

Vol. 3.    [Z 3]    are

Fig. 12. Simon Gribelin after Paolo de Matteis, frontispiece to Shaftesbury, "The Judgment of Hercules," *Characteristicks of Men, Manners, Opinions, Times* (6th edition, [London], 1737), vol. 3. Photo: Harry Ransom Humanities Research Center, University of Texas, Austin.

WILLIAM WILLIAMS, Painter,
At REMBRANDT's Head, in Batteaux-street,
UNdertakes painting in general, viz. History, portraiture, landskip, sign painting, lettering, gilding, and strewing smalt. N. B. He cleans, repairs, and varnishes, any old pictures of value, and teaches the art of drawing. Those ladies or gentlemen who may be pleased to employ him, may depend on care and dispatch.

Fig. 13. Advertisement of "William Williams, Painter," *The New-York Gazette, and the Weekly Mercury*, 8 May 1769. Courtesy of the American Antiquarian Society.

and flexibility that helped more painters than not survive in a provincial market.[25]

The artist kept a record of his output, now known only through a second-hand, early-nineteenth-century summary. It indicates that he made 241 paintings during two decades in North America, including two years in the British island colony of Jamaica.[26] Few painters active in colonial British America have a greater number of recorded pictures than Williams, while few named eighteenth-century artists have so scant a surviving body of work. Yet even the limited evidence makes clear that Williams painted in a wider variety of genres than most colonial artists.

Williams appears to have been particularly enterprising while resident in New York. Seventeenth- and eighteenth-century inventories reveal that, relative to Anglo-Americans, persons of Dutch origin or descent in that colony had more diversified and, in a few cases, much more substantial collections of pictures, consistent with middle-class consumption of art in the Netherlands.[27] The Swedish naturalist Peter Kalm, visiting New York City in 1748, observed that the walls of houses there were "quite covered with all sorts of drawings and pictures in small frames."[28] At the Stuyvesant residence in 1768, Pierre Eugene Du Simitière saw a variety of pictures, including portraits and "a conversation piece in a landskip."[29] The partial transcription of Williams's paintings indicates that he produced landscapes, marine subjects, and history paintings while in New York.

Williams is also somewhat unusual in having signed his works, a practice of limited meaning at a time and in a place where modern notions of authorship did not yet fully apply. The only signed American painting by the later-famous Benjamin West speaks to that point. Unusually for a Briton on either side of the Atlantic, West—who claimed Williams as teacher—had received an early commission for a historical subject, *The Death of Socrates*, which he based loosely on an engraving. Then just eighteen and living in frontier Lancaster, Pennsylvania, West was not more than an artisan in the eyes of the man who commissioned the work, gunsmith William Henry. In an essay that placed this choice of subject in the context of colonial Pennsylvanian politics, historian Paul Scott Gordon perceptively noted that Henry followed a convention common in engraving, by having his own name, in the implied role of inventor, added to the canvas. West's name, coupled with the word "pinxit," signified his manufacture or handwork as opposed to invention.[30]

Characteristically for a mid-eighteenth-century Anglophone painter, Williams mostly made portraits. One of his most significant commissions was for a trio of portraits that he both signed and dated (figs. 14–16). The client was Scottish-born printer and bookseller David Hall, who in 1766 acquired Benjamin Franklin's share of the Philadelphia printing business in which they had long been partners. Hall, then in his early fifties, chose this time of new promise and independence to commission full-length, life-size portraits of his children—two sons who would inherit the business and a daughter approaching marriageable age.

Williams spared no effort in representing Deborah, William, and David Hall. Fourteen-year-old William regards the beholder with cool self-possession, left hand assertively on hip, right on two volumes set atop a marble-surfaced table. A folio leans against the table's decorative leg. Books were common props in portraits, and here the artist gave them an active role. Slight disarrangement of leather-bound volumes on the tall bookshelf behind William implies his removal of those closer to him, including the first volume of Tobias Smollett's *Complete History of England*, identifiable by lettering on the spine. Initially published in 1757, the full set included fifteen costly volumes, which David Hall and other Philadelphia booksellers advertised after acquiring sets from London. The collection of books in William Hall's portrait refers at once to his father's career and to the young man's learning and prospects. Williams suggests the power of books to reveal worlds in the right rear-ground of the composition, where a heavy rounded arch opens to sky, water, and a tall, slender lighthouse. By positioning young William Hall precisely at compositional midpoint between books and vista, the artist suggested the promising future that the father's success afforded his eldest son.

Six years later, as it happened, David Hall's untimely death thrust William and his younger brother David Jr. into the printing business. As represented by Williams in 1766, eleven-year-old

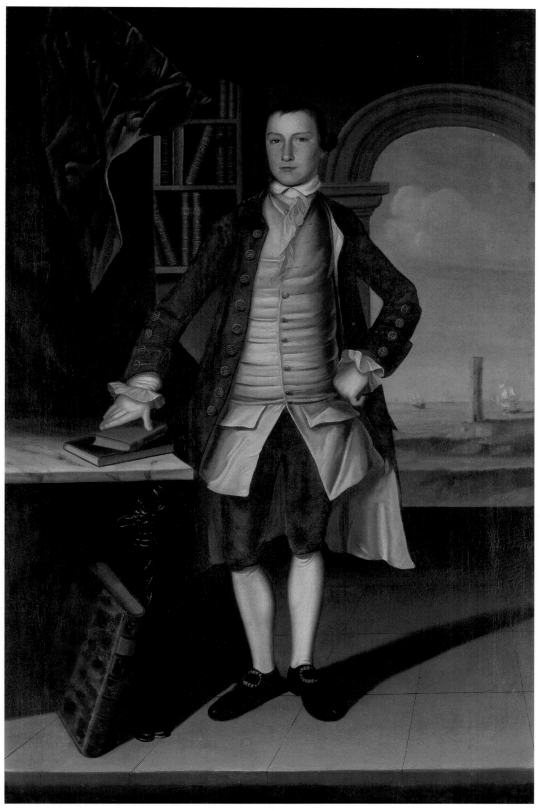

Fig. 14. William Williams, *William Hall*. Philadelphia, 1766. Oil on canvas, 71 x 46 in. (180.34 x 116.84 cm). Courtesy of the Winterthur Museum, gift of Henry Francis du Pont, 1959.1332.

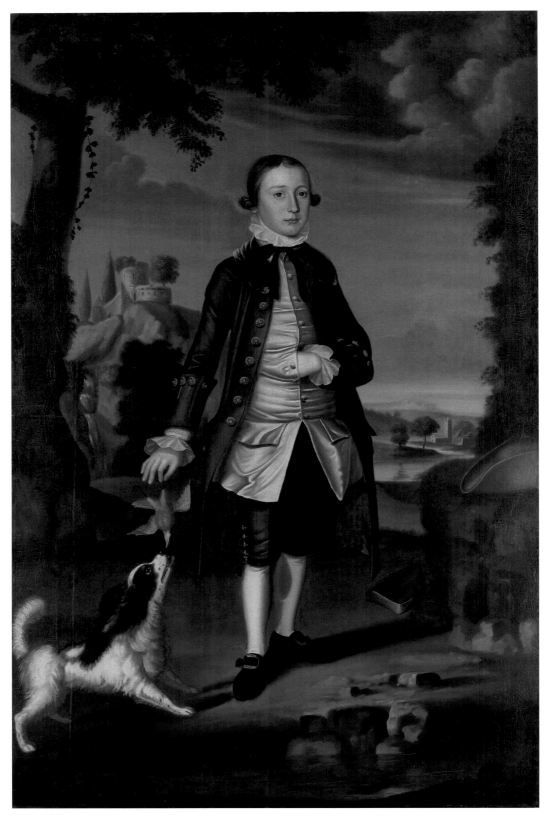

Fig. 15. William Williams, *David Hall*. Philadelphia, 1766. Oil on canvas, 70⅞ x 45⅞ in. (180 x 114.3 cm).
Courtesy of the Winterthur Museum, gift of Henry Francis du Pont, 1959.1333.

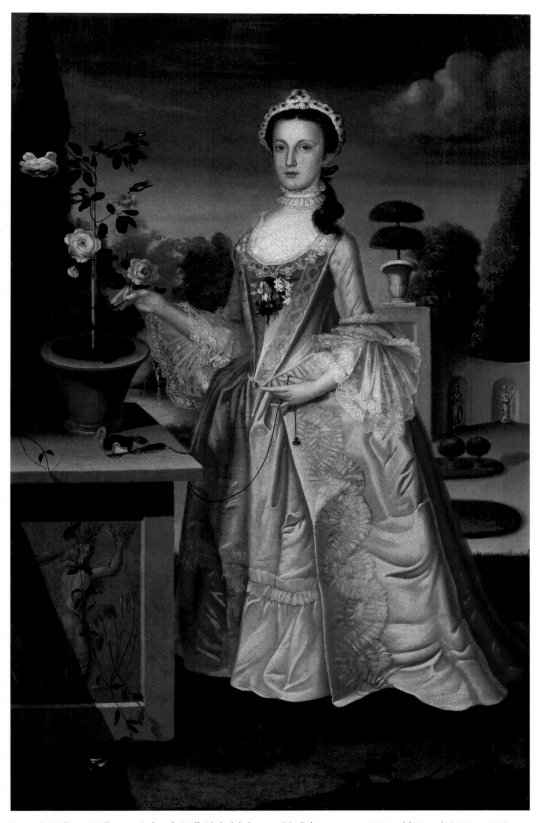

Fig. 16. William Williams, *Deborah Hall*. Philadelphia, 1766. Oil on canvas, 71⅜ x 46⅜ in. (181.3 x 117.8 cm). New York, Brooklyn Museum, Dick S. Ramsay Fund, 42.45. See also p. 216.

David Hall knew only the pleasures of youth. He has been shooting birds; one tiny prey dangles from the boy's pinched thumb and forefinger, at the maw of an excited spaniel, and the butt of his gun can be glimpsed to the right. A halo of landscape features surrounds David. A small stream or spring occupies the immediate foreground (a compositional device Williams used repeatedly), a twisted tree spreads its lacy canopy of foliage over the boy's head, and vine-covered masses culminate in puffy clouds to the left and right. The distant view presents an array of fanciful landscape and architectural motifs, including a rocky promontory with castle, a tumbling waterfall, a placid winding river, and a building with a tall square tower.

In contrast to the open settings in the boys' portraits, Williams situated fifteen-year-old Deborah Hall in front of a substantially enclosed garden, as refined as the young lady herself. Female sitters in British and American portraits often appear in invented attire specific to portraits. *Mrs. Hugh Hall* (no relation to the Hall children) appears in one such type in her portrait by John Smibert (1688–1751), who left a successful practice in London

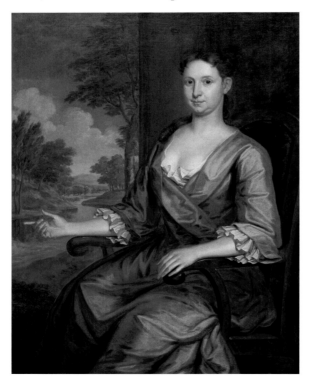

Fig. 17. John Smibert, *Portrait of Mrs. Hugh Hall*. Boston, 1733. Oil on canvas, 49 x 39 in. (124.5 x 7.6 cm). Denver Art Museum, 1984.819. For a full page image see p. 66.

to paint in British North America after 1729 (fig. 17). By contrast, Deborah Hall wears an expensive dress at the height of fashion: a lavish *robe à la française* with ruching on the gown and petticoat, cascading lace at the elbows, and lace trim and a floral bouquet on the bodice.

To Deborah's right, a stone plinth faced with a relief of Apollo and Daphne supports a potted rose plant in full flower—one bloom about to be plucked by the young girl—as well as a pet squirrel, its slack chain elegantly threaded through the girl's fingers. A serene body of water can be glimpsed beyond the plinth. To Deborah's left, a manicured garden of topiary and clipped islands of grass are enclosed within a high wall, one section curved and ornamented with niches and statuary. Beyond the wall, softly shaped trees suggest an extended park. To the northwest of Philadelphia, along the Schuylkill River, country estates featured carefully laid out gardens, such as that of the Penn family, where an English visitor in 1754 noted the effect of "agreeable variety" produced by the "neat little park," "spruce hedges cut into beautiful figures," "spacious walkway," and "groves." The visitor also took note of two other gardens that he pronounced "very elegant," one with "7 statues in fine Italian marble curiously wrot" and another with urns and statues of Apollo, Diana, Fame, and Mercury.[31] The garden that Williams painted in Deborah Hall's portrait, in other words, may not have sprung solely from his imagination, as is usually assumed. On the other hand, Williams filled the space with emblematic details that speak to the importance of patience and virtue in a young woman.[32]

The backgrounds for all three Hall portraits have often been said to evoke theatrical scenery, which the versatile Williams is known to have made in 1759. In a rare surviving document concerning his career, Williams petitioned Pennsylvania governor William Denny to allow a new theater to open, against objections from religious opponents, so he could be paid for work already completed. Williams claimed he had yet to receive the "£100 and upwards" it had cost him to make "a New set of Scenes," and his cosignatory, Alexander Alexander, was out £300 for construction of the building.[33] Although this ratio seems remarkable, early American theaters were

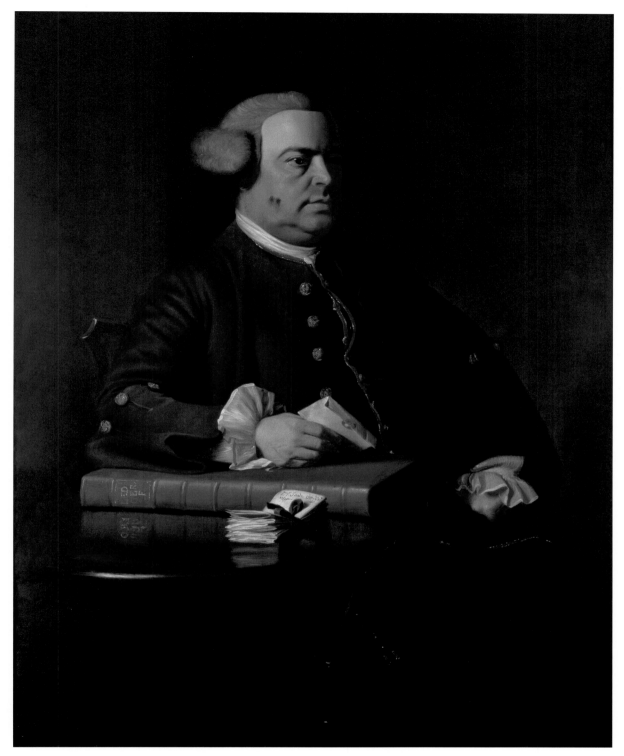

Fig. 18. John Singleton Copley, *Nathaniel Allen*. Boston, 1763. Oil on canvas, 50 x 40 in. (127 x 101.6 cm). Honolulu Museum of Art, Frank C. Atherton Memorial Fund, 1976, 4376.1.

quite basic structures, usually abandoned or sold when a season concluded. Philadelphia's Society Hill Theatre, for which Williams painted scenes, served a traveling English company in 1759 only. Scenery, by contrast, had greater value to a theater troupe, owing to its easy transportability, the practice of restaging the same plays in different cities, and the possibility of rehabilitating worn stock. Few productions featured specialized scene paintings, a costly and unnecessary expense at a time when scenery served to establish a generalized and generically appropriate locale for a play. Eighteenth-century audiences expected and appreciated artifice.

Williams's portraits indicate that contemporaneous viewers appreciated artifice in that type of work as well, notwithstanding the twentieth-century belief that a lack of artifice in Copley's portraits contributed significantly to his popularity. The particularized faces of Copley's sitters look startling in company with the more generic faces seen in most colonial portraits, including those by Williams (fig. 18). But the settings in which Copley placed those sitters and their poses were often transparently artificial. That has always been obvious in such grandiose portrayals as the full-length portraits of Mr. and Mrs. Jeremiah Lee, commissioned to hang in their impressive new mansion in Marblehead, Massachusetts (see Kornhauser, pp. 194–195, figs. 4–5). But it is equally evident in many seemingly more modest works, if the viewer will only look away from ostensibly forthright faces that seem to invite connection.

The Lee portraits belong to a relatively small group of paintings in which Copley placed his subjects at implied physical remove from the viewer; more typically, he fostered a sense of intimacy. Williams embraced distance. In the portrait of William Hall, he made no concession to the idea that the boy's world and the viewer's are coextensive. The artist scored the floor on which young William stands, a conventional way of creating illusory depth. But he articulated its forward edge, just above the frame, so the floor reads as a stage-like platform. The arrangement compels the viewer to recognize a similar effect in the portraits of David and Deborah Hall. Most of Williams's surviving easel paintings in any genre

show pronounced elements of fantasy or authentic settings that had a fantastical and theatrical appearance. He did invent, as did most portraitists; but few received credit for doing so.

Only when showy brushwork became a prominent measure of genius did American artists win their battle over craftsmen, because it freed them from adherence to certain manual standards that governed artisan labor. John Neal, one of the first American art critics, made the distinction in 1823, when he contrasted portraitist Charles Willson Peale, Copley's contemporary, with Gilbert Stuart, leader of the following generation. Both artists were then near the end of their lives but still painting. Neal described Stuart as "careless, bold and confident," invoking qualities associated with the man and his art: "He develops character like a magician. He uses little or no material; is authority, in whatever he does." Material in this case means paint, not fabric, although painting fabric could in the hands of Peale or Copley consume material, as Neal made clear. Peale, he wrote, "never seems weary of labour"; "His drapery is . . . too labored" and "he never lets [a portrait] go out of his hand, but as a piece of *workmanship*, which will always be worth the money that he has been paid for it."[34] Labor plus materials equals value. This artisanal equation would give way only slowly, and then incompletely, to other means for evaluating the work of fine artists in the new United States.

## Notes

[1] Peter Manigault to Ann Manigault, 15 Apr 1751, in "Peter Manigault's Letters," ed. Mabel L. Webber, *South Carolina Historical and Genealogical Magazine* 31 (Oct. 1930): 277–278. For extended consideration of the issues presented in this essay, see Susan Rather, *The American School: Artists and Status in the Late Colonial and Early National Era* (New Haven and London: Yale University Press for the Paul Mellon Centre for Studies in British Art, 2016).

[2] Denis Diderot, "My Feeble Ideas about Color," 1765, in *Diderot on Art*, trans. John Goodman, 2 vols. (New Haven: Yale University Press, 1995), 2:199. Earlier, in 1708, his compatriot Roger De Piles placed the ability to capture a sitter's coloring at the very heart of the portraitist's enterprise; *Principles of Painting* (London, 1743), 165 (first English translation of *Cours de Peinture par Principes*). Among English artists, see William Hogarth, *The Analysis of Beauty*, ed. Ronald Paulson (New Haven and London: Yale University Press for the Paul Mellon Centre for Studies in British Art, 1997), 87–93, 132–134 (the latter passage rejected from the original published version), and Sir Joshua Reynolds, *Discourses on Art*, ed. Robert R. Wark (New Haven and

London: Yale University Press for the Paul Mellon Centre for Studies in British Art, 1975), 152 (Discourse VIII, 1778).

[3] William Hogarth, from Michael Kitson, "Hogarth's Apology for Painters," *Walpole Society* 41 (1966–1968): 98, 100; see also 83.

[4] George Vertue, "Vertue Note Books," *Walpole Society* 22 (1933–1934): 123.

[5] Gotthold Ephraim Lessing, *Emilia Galotti* (1772), Act 1, Scene 4; as quoted in Lessing, *Emilia Galotti*, trans. Anna Johanna Gode von Aesch (Great Neck, New York: Barron's Educational Series, 1959), 7. The speaker, an artist, addresses the limitations of painting and the ultimate inability of the hand to do the bidding of the eyes (or mind).

[6] For information about the Freake Limner and other painters and paintings from a rich early American collection, see the outstanding website of the Worcester Art Museum: http://www.worcesterart.org/collection/Early_American/.

[7] "Pratt's Autobiographical Notes," as reprinted in William Sawitzky, *Matthew Pratt, 1734–1805: A Study of His Work* (New York: New-York Historical Society in cooperation with the Carnegie Corporation of New York, 1942), 15–16. These notes, believed to have been written in 1770, exist only in a transcription made by Charles Henry Hart in 1892, published in *Pennsylvania Magazine of History and Biography* 20 (1895): 460–466, and now in the Historical Society of Pennsylvania.

[8] Copley to [Benjamin West or Captain R. G. Bruce], [1767], in *The Letters and Papers of John Singleton Copley and Henry Pelham, 1739–1776* ([Boston]: Massachusetts Historical Society, 1914), 65–66. Pelham, Copley's half-brother, mentioned French theorists [C. A. Du] "Fresnoy and [Roger] Depile" in a letter to Copley, 22 Oct. 1771 (ibid., 160–161), doing so in the manner of an ongoing dialogue. Which of their writings Pelham had in mind remains unknown. Du Fresnoy's *The Art of Painting* had been translated from Latin into French by de Piles (who added his own remarks) and then into English by John Dryden (1695), an edition later revised by court portraitist Charles Jervas (1716). However, the distinct mention of De Piles may indicate Copley's awareness of that author's *Principles of Painting* (1708), translated into English in 1743. In his earliest mention of a text on art, 12 Nov. 1766, Copley queried West about a point in [Francesco] Algarotti, presumably *An Essay on Painting* (London, 1764); ibid., *Copley–Pelham Letters*, 51–52.

[9] Samuel Johnson, *A Dictionary of the English Language*, 3rd ed., 2 vols. (London, 1765), s.vv. "artisan," "craftsman," "liberal," "mechanick." "Artist" and "manufacturer" appear as synonyms in Daniel Defoe, *The Complete English Tradesman* (London, 1745; repr. New York: Burt Franklin, 1970), 2. Alfred F. Young finds the terms "artisan" and "craftsman" less frequent than "tradesman" during the colonial period, while "mechanic" was a term of derision and not the term of pride it became during the 1790s; "How Radical Was the American Revolution," in *Beyond the American Revolution: Explorations in the History of Radicalism*, ed. Alfred F. Young (DeKalb, IL: Northern Illinois University Press, 1993), 330–331. See also Thomas J. Schlereth, "Artisans and Craftsmen: A Historical Perspective," in *The Craftsman in Early America*, ed. Ian M. G. Quimby (New York and London: W. W. Norton for The Henry Francis du Pont Winterthur Museum, 1984), 34–61.

[10] Anthony Ashley Cooper, 3rd Earl of Shaftesbury, *Second Characters or the Language of Forms*, ed. Benjamin Rand (Cambridge, UK: University Press, 1914), 135–136; this work, composed around 1712, remained unpublished until the twentieth-century edition. But see also Shaftesbury, *Characteristicks of Men, Manners, Opinions, Times*, 3 vols. (London, 1732), 1:144–145.

[11] Jonathan Richardson, *An Essay on the Theory of Painting* (London, 1715), 19–38 (quotation at 76). Mark A. Cheetham addressed nationalistic purpose in Richardson's writing on art—which he sees as suffused with the example of John Locke—in *Artwriting, Nation, and Cosmopolitanism in Britain: The 'Englishness' of English Art Theory since the Eighteenth Century* (Farnham, UK, and Burlington, VT: Ashgate, 2012), 19–22.

[12] For example, Daniel Webb, *An Inquiry into the Beauties of Painting* (London, 1765), 4–5, 35–36.

[13] *Copley-Pelham Letters*, 174 (6 Nov. 1771).

[14] Regarding Copley's stake in his own provinciality, see Emily Ballew Neff, "Copley's 'Native' Realism and His English 'Improvement,'" in Neff et al., *John Singleton Copley in England* (Houston, TX: Museum of Fine Arts, Houston, 1995), 12–22.

[15] Gary B. Nash, "Up from the Bottom in Franklin's Philadelphia," *Past and Present* 77, no. 1 (1977): 62, table 1 and note.

[16] Helmut Von Erffa and Allen Staley, *The Paintings of Benjamin West* (New Haven and London: Yale University Press, 1986), 450 (cat. 524); also Robin Jaffee Frank, *Love and Loss: American Portrait and Mourning Miniatures* (New Haven: Yale University Press, 2000), 37–46.

[17] Carl Bridenbaugh, ed., *Gentleman's Progress: The Itinerarium of Dr. Alexander Hamilton, 1744* (Chapel Hill: University of North Carolina Press, 1948), 102.

[18] "genius, n. and adj." Oxford English Dictionary Online. www.oed.com.

[19] *Boston News-Letter*, 22–29 May 1740. Strikingly, the writer acknowledged the transformative power of genius: "some of his Imitations . . . are so exquisite, that tho' we know they are only Paints, yet they deceive the sharpest Shight [sic]."

[20] Anthony Ashley Cooper, 3rd Earl of Shaftesbury, *Characteristicks of Men, Manners, Opinions, Times*, 2d ed., 3 vols. (London, 1713), 346–391 (quotations at 347, 349).

[21] Shaftesbury characterized de Matteis in a letter to Sir John Cropley, 16 Feb. 1712; *The Life, Unpublished Letters, and Philosophical Regimen of Anthony, Earl of Shaftesbury*, ed. Benjamin Rand (London: S. Sonnenschein; New York: Macmillan, 1900), 468–469. Livio Pestilli devoted a chapter to negotiations between Shaftesbury and de Matteis and to versions of *The Judgment of Hercules* in *Paolo de Matteis: Neopolitan Painting and Cultural History in Baroque Europe* (Farnham, UK, and Burlington, VT: Ashgate, 2013), 115–144 (quotation at 128–129; Pestilli's translation).

[22] The relatively few women artists could not avoid distinction, but of a wholly negative character, since they (like artisans) were presumed to lack the ability to abstract from experience requisite to fine artists. For that reason, portraiture, which necessarily addressed particularities, ranked as one of the more acceptable genres for women—though a charged occupation if the subject were male, as Angela Rosenthal

laid out in "She's Got the Look! Eighteenth-Century Female Portrait Painters and the Psychology of a Potential 'Dangerous Employment,'" in *Portraiture: Facing the Subject*, ed. Joanna Woodall (Manchester and New York: Manchester University Press, 1997), 147–166.

[23] *New-York Gazette, and the Weekly Mercury*, 8 May 1769; *Pennsylvania Journal and Weekly Advertiser*, 13 January 1763.

[24] Smalt was blue powdered glass derived from cobalt, used to create glittery surfaces that made signs more eye catching. On the technique of painting signs, see Sandra L. Webber, "'Faithfully and Promptly Executed': A Conservator's View of Sign Painting," in *Lions & Eagles & Bulls: Early American Tavern & Inn Signs*, ed. Susan P. Schoelwer (Hartford, CT: Connecticut Historical Society, 2001), 66–79.

[25] Even in London, diversification could help keep a career afloat. Arthur Pond presents a well-documented metropolitan model of artistic enterprise and adaptability, as detailed by Louise Lippincott, *Selling Art in Georgian London: The Rise of Arthur Pond* (New Haven and London: Yale University Press for the Paul Mellon Centre for Studies in British Art, 1983).

[26] Williams's list appeared at the end of a now-lost manuscript that he bequeathed to Thomas Eagles of Bristol, the native city to which Williams returned later in life. That record now survives only in the severely condensed version that Eagles appended to a letter of 1810 from Benjamin West, a pupil of Williams's while a child; West to Thomas Eagles, 10 Oct. 1810, as transcribed by T. Eagles and reprinted in David H. Dickason, "Benjamin West on William Williams: A Previously Unpublished Letter," *Winterthur Portfolio* 6 (1970): 127–133. As this endnote suggests, the history of Williams is complicated and thoroughly entangled with West's, my focus in "Benjamin West's Professional Endgame and the Historical Conundrum of William Williams," *William and Mary Quarterly*, 3rd ser., 59 (October 2002): 821–864.

[27] For the importance of Dutch artistic traditions in eighteenth-century British North America, see Ruth Piwonka and Roderic H. Blackburn, *A Remnant in the Wilderness: New York Dutch Scripture History Paintings of the Early Eighteenth Century* (New York: Bard College Center for the Albany Institute of History and Art, 1980) and Louisa Wood Ruby, "Dutch Art and the Hudson Valley Patroon Painters," in *Going Dutch: The Dutch Presence in America, 1609–2009*, ed. Joyce D. Goodfriend, Benjamin Schmidt, and Annette Stott (Leiden and Boston: Brill, 2008), 27–57. Esther Singleton cites inventories that included pictures presumably made in the Netherlands, e.g., a seapiece, a "small winter," a "sea strand," "ye city of Amsterdam"; *Social New York under the Georges, 1714–1776* (New York: D. Appleton, 1902), 90, also 87 for a 1771 sale of art that included pictures by several named seventeenth-century Dutch painters.

[28] Peter Kalm, *Travels into North America*, trans. John Reinhold Forster, 3 vols. (London, 1771), 1:250.

[29] Pierre Eugène du Simitière Collection, Library Company of Philadelphia (Papers Relating to New England and New York, 1412.Q).

[30] Scott Paul Gordon, "Martial Art: Benjamin West's The Death of Socrates, Colonial Politics, and the Puzzles of Patronage," *William and Mary Quarterly*, 3rd ser., 65 (Jan. 2008): 65–100 (97–98 regarding the unusual signature and its implications).

[31] "Ezra Stiles in Philadelphia," *Pennsylvania Magazine of History and Biography* 16 (1892): 375; "Extracts from the Diary of Hannah Callender," *Pennsylvania Magazine of History and Biography* 12 (1888): 454–455. See, more broadly, my source for these citations: Elizabeth McLean, "Town and Country Gardens in Eighteenth-Century Philadelphia," *Eighteenth Century Life*, n.s., 8 (January 1983): 136–147, part of a useful special issue on "British and American Gardens," edited by Robert R. Maccubbin and Peter Martin.

[32] For interpretation of select details in Williams's *Deborah Hall*, see Roland E. Fleischer, "Emblems and Colonial American Painting," *American Art Journal* 20, no. 3 (1988): 3–9.

[33] Petition of June 2, 1759, Society Collection, Historical Society of Pennsylvania, Philadelphia. The theater opened on June 25, 1759, so Williams presumably received payment.

[34] Neal's alter ego in John Neal, *Randolph, A Novel*, 2 vols. (n.p., 1823), 2:67.

# Selfhood and Surroundings in Early American Portraiture
## An Ecocritical Approach

### Karl Kusserow

Robert Rauschenberg's *Earth Day* (fig. 1) is not an eighteenth-century portrait, or even a nineteenth-century one. It is in its way a portrait, though—both of the essential symbol of America and of the place itself. Rauschenberg designed this poster for the first Earth Day, on April 22, 1970, which many consider the beginning of the modern American environmental movement. It was the artist's first mass-produced image disseminating an environmental message, and it is not a pretty one. The America it portrays is a place of crisis, of ecological degradation and duress. Photographs collaged from newspapers and magazines picture strip mining, deforestation, junkpiles, and polluted waters, all surrounding the superimposed darkened form of a bald eagle, which faces the image of a gorilla as if to underscore the endangered status of each. Rauschenberg's poster both commemorated the Earth Day event and, through its large unsigned edition, brought issues of pollution and conservation to a still wider audience.[1]

American art has long engaged environmental themes, from Thomas Cole's veiled antipastorals of the Jacksonian era through Alexandre Hogue's *Erosion* series a century later, but only since the time of Rauschenberg's "portrait" has it sustained an overt, pervasive critique. Most art, American or otherwise, addresses ecology and environmental history latently, or obliquely. Recently, however, art historians have begun to consider historic American art in terms of its environmental implications—much as a generation of scholars before them productively reassessed visual culture along gender and other previously unexamined lines of inquiry. This ecocritical approach opens up important realms of interpretive possibility, allowing us to more fully investigate the crucial—and often unexplored—significance of our evolving human relationship not just to one another, but to everything else.[2]

The primary subject of this essay is Henry Benbridge's large group portrait *The Hartley Family,* of about 1787 (fig. 2). Well known and widely exhibited, it is one of the major

productions of eighteenth-century American art, further distinguished for having descended directly in the family of its subjects until its donation to the Princeton University Art Museum in 1986, two centuries after it was painted. It is usually described in terms of its elaborately costumed sitters and their relationship to one another; this essay focuses instead on its apparently generic, relatively nondescript landscape setting, the environment in which Benbridge's portrayal unfolds. I consider that environment in two ways: first as it relates to those in a number of other American portraits both before and after it; then, by contrast, as it

Fig. 1. Robert Rauschenberg (American, 1925–2008), *Earth Day*, 1970. Color lithograph with collage on white wove paper, 51¹⁵⁄₁₆ x 37⅜ in. (131.9 x 94.9 cm). Gift of the Friends of the Princeton University Art Museum, Princeton University Art Museum, x1971-21. Art © Robert Rauschenberg Foundation and Gemini G.E.L./Licensed by VAGA, New York, NY. Published by Gemini G.E.L. Photo Bruce M. White.

Fig. 2. Henry Benbridge (American, 1743–1812), *The Hartley Family*. Charleston, circa 1787. Oil on canvas, 76⅜ x 59⁷⁄₁₆ in. (194 x 151 cm). Gift of Maitland A. Edey, Class of 1932, Princeton University Art Museum, y1986-84.

moved with the portrait through time, circulating among various distinguished owners—all descendants of those depicted in it—in their own distinct environments, until ultimately arriving at Princeton.

Henry Benbridge was born in Philadelphia in 1743—five years after Benjamin West, his distant relative; two years after Charles Willson Peale.[3] In 1765 Benbridge undertook four years' artistic training in Rome, enrolling in the academy of Pompeo Batoni, an Italian artist whose stock in trade was ingratiating portraits of British gentlemen on the Grand Tour. Benbridge returned to America by way of London, eventually settling in Charleston, South Carolina, where between 1772 and at least 1790 he was that wealthy, style-conscious city's leading artist. Fewer than fifty works from Benbridge's Charleston career survive. *The Hartley Family* is perhaps the most accomplished among them, typifying the artist's conservative neoclassical aesthetic and attesting to his stature as the most sophisticated portraitist then at work in the South. The portrait shows four female generations of the same prominent family—none of whom, curiously, owing to marriage and remarriage, was actually named Hartley when the painting was done. We know little of the commission, one remarkable for the time in its depiction of a group of related women shown without reference to the realm of husbands, nuclear family, or other artifacts of patriarchy. A letter from Benbridge to his sister of April 28, 1787, notes, "I have begun a large picture of four whole lengths the size of life, [which] with some other work will take up . . . the summer to finish."[4] This has always been assumed to refer to *The Hartley Family*, though who and what prompted such a substantial commission remains unclear. We have learned much, however, about the subjects of the painting, and much as well about its provenance during the 199 years between its completion and its arrival in Princeton. The portrait depicts, at left, Margaret Miles Hartley Williams, born the daughter of Thomas and Mary Miles in 1722; Margaret inherited Hyde Park, a plantation in Colleton County south of Charleston, from which, it is believed, much of the family's considerable wealth derived. Her daughter, Sarah Hartley Crosthwaite Somersall, born in 1745, is the figure to Margaret's left; her

centrality to the composition suggests it may have been she who commissioned it. To her left, in turn, is her daughter, Mary Somersall, twelve years old at the time of the painting. The youngest child, in the foreground, is Margaret Miles's great-granddaughter, descended along another line and named Margaret Phelp Campbell.

It is a commanding image, remarkable for its scale and ambition, for the stateliness of its subjects, and for the fact that they are all women, bound by matrilineal ties. The painting is notable as well for the natural setting in which its subjects have been placed. Examining *The Hartley Family* and its landscape background within a continuum of similar natural backgrounds in American portraits—mostly also from the South—of the eighteenth and early nineteenth centuries allows us to compare and contrast the ways in which each constructs the external world and the sitters' relation to it, and to ponder what that may mean. While American artists relied heavily on European sources in devising their compositions—on prints made after painted portraits, on occasional exposure to the paintings themselves, and more diffusely on mutual immersion in a transatlantic visual aesthetic—they exerted their own agency in the particular sources they chose to adopt, and in how they modified and developed those sources. Many European portraits were set indoors and contain no landscape elements at all. That American artists gravitated instead to them suggests they were influenced not only by foreign artistic precedent but also by local conditions and attitudes about the surrounding world. These attitudes existed on both sides of the Atlantic, in ways both discrete and complementary, but their American expression particularly reflects their production at the margins of the cultivated world.[5]

Reflecting received aesthetic standards while conveying—and bolstered by—the special environmental conditions of their time and place, landscape representation in eighteenth-century American portraiture may be divided into three phases. In the first, corresponding roughly to the first third of the century, and exemplified by Justus Engelhardt Kuhn's *Henry Darnall* and *Eleanor Darnall III* of about 1710 (figs. 3–4), the natural world is depicted fantastically in elaborate, park-like settings, imaginary gardens, and baroque

Fig. 3. Justus Engelhardt Kuhn (born Germany, died 1717), *Henry Darnall III*. Maryland, circa 1710. Oil on canvas, 54 x 44⅛ in. (137.2 x 112.1 cm). Courtesy of Maryland Historical Society, 1912.1.3.

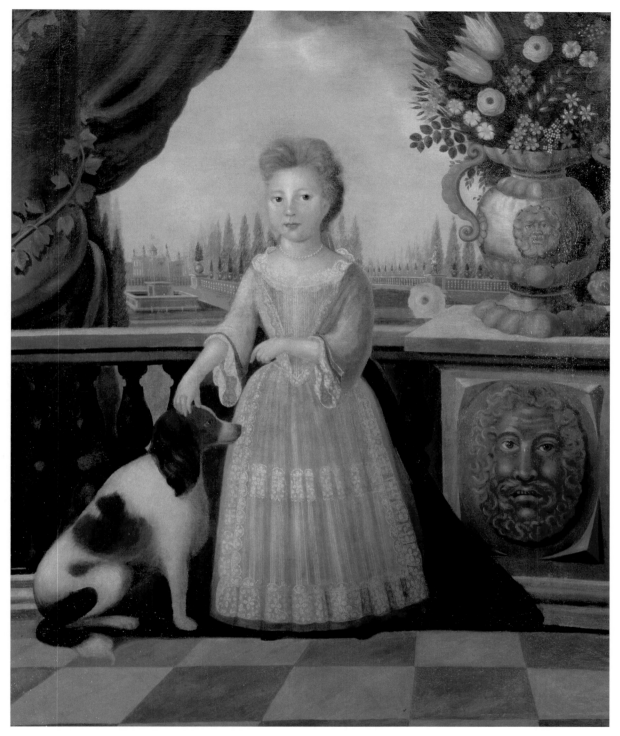

Fig. 4. Justus Engelhardt Kuhn, *Eleanor Darnall*. Maryland, circa 1710. Oil on canvas, 54¼ x 44 in. (137.8 x 111.8 cm). Courtesy of Maryland Historical Society, 1912.1.5.

architectural trappings. Although the Darnalls owned some 35,000 acres west of Maryland's Chesapeake Bay and completed a large brick mansion, "The Woodyard," in the years immediately preceding Kuhn's portraits—which may have been meant to hang there—Eleanor and Henry's likenesses are set before landscape backdrops like nothing present there at the time (nor, indeed, like each other).[6] Rather, in conjuring the sort of controlled baroque space that actually existed abroad, and that these early émigré artists knew from prints, or glimpsed in paintings, or had even seen firsthand, such representations of American "nature" offered a sort of wish-fulfillment vision, portending the productive, even aestheticized, domestication of a landscape considered unappealing and threatening in its wild, uncultivated state.[7] Similar strategies to bring nature under conceptual control through artful regularization and rationalization characterize early American landscape representation in other contexts, such as Pierre Fourdrinier's 1734 engraved view of Savannah, Georgia (fig. 5). Here visual logic and artifice also prevail over observed reality as the settlement, merely a year old, is rendered with a systematized linearity that extends even to the trees of the encroaching forest and the wholly prospective layout of the unimproved lots. It is not such a distance from here to the similar willful symmetries in the backgrounds of Kuhn's Darnall children; in each case, a desire to mentally organize and visually shape an environment widely held to be both useless and overwhelming allows it instead to be considered manageable and fruitfully habitable.[8]

Around the second third of the eighteenth century, such overtly fictive landscape inventions gave way to persuasively realistic settings. These imaginably actual landscapes, though they retain an air of creative design due to their generic appearance, embody a distinct shift in conceptions of American nature, from one in which a disorderly wilderness is metaphorically tamed through wholesale invention to one in which a more plausible naturalized setting can be appreciated on its own terms. This shift was informed by changes abroad, where a proto-Romantic appreciation of unregulated nature—or at least the semblance of it—developed in the writings of Edmund Burke, Immanuel Kant, and later William Gilpin, and

was materially expressed in landscape painting and design as well as in period portraiture. In America, as settlement and cultivation advanced, and the perceived threat of wilderness receded, the emerging notion of a productive human symbiosis with nature perfectly suited local conditions, and is pictorially embodied in the Denver Art Museum's *Mrs. Hugh Hall*, painted by John Smibert in 1733 (fig. 6).[9] Occupying a new, liminal space both of and apart from her placid natural surroundings—in contrast to the balustrades separating the Darnall children from their concocted environs—Mrs. Hall points a finger to associate herself with the adjacent natural world. This device, commonly encountered in religious images in which the finger is pointed upward to connote divine assistance, here suggests nature's beneficence in constructing the world of the sitter. To be sure, Mrs. Hall was not literally linked to the sort of nature represented here—she lived in Boston, and her husband was a merchant with strong family ties to Barbados, not the temperate vales Smibert has conjured for his wife's portrait.[10] Rather, her representation responded more generally to changing attitudes here and abroad about nature, and to the specific conditions of her American context.

Closer to Charleston and the Hartleys, similar trends prevailed toward both plausible generic landscape settings and the increased integration of sitters with them. In 1750, for example, John Hesselius, active mainly in Virginia and Maryland, completed his portrait of *Ann and Sarah Gordon* (fig. 7), showing the sisters enveloped in nature and compositionally coherent with it, with their russet and ochre dresses picking up roseate tints in the sky and earth-toned background. In Charleston itself, seven years later, Jeremiah Theus, a Swiss-born Rococo artist at work from 1740 until eclipsed by Benbridge's neoclassicism, painted an especially grand portrait of leading citizen *Elizabeth Manigault* (fig. 8), positioning her in the same sort of mediating position between nature and culture as Smibert's *Mrs. Hall*. Manigault's hand gesture linking her to the generalized landscape recalls that portrait as well, and the artist's strategy of binding the sitter tonally to the landscape through an affiliation of her pearlescent dress with the adjacent silvery sky is like Hesselius's in his portrait of the Gordon sisters.[11]

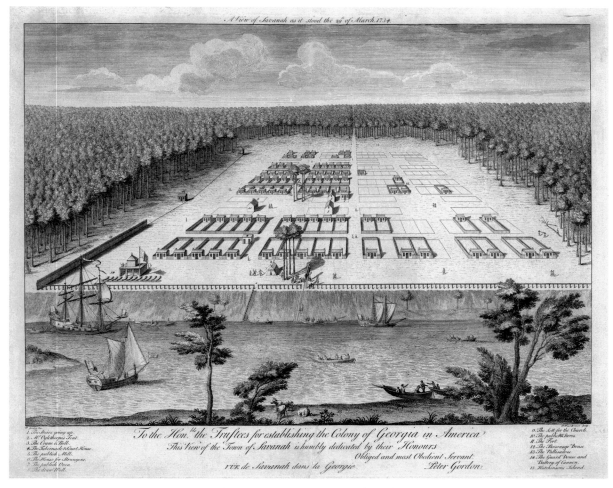

Fig. 5. Pierre Fourdrinier (engraver), *A view of Savanah as it stood the 29th of March, 1734.* London, circa 1735. Engraving, 15⅜ x 20 in. (39.1 x 50.8 cm). Library of Congress Prints and Photographs Division, LC-DIG-pga-01273.

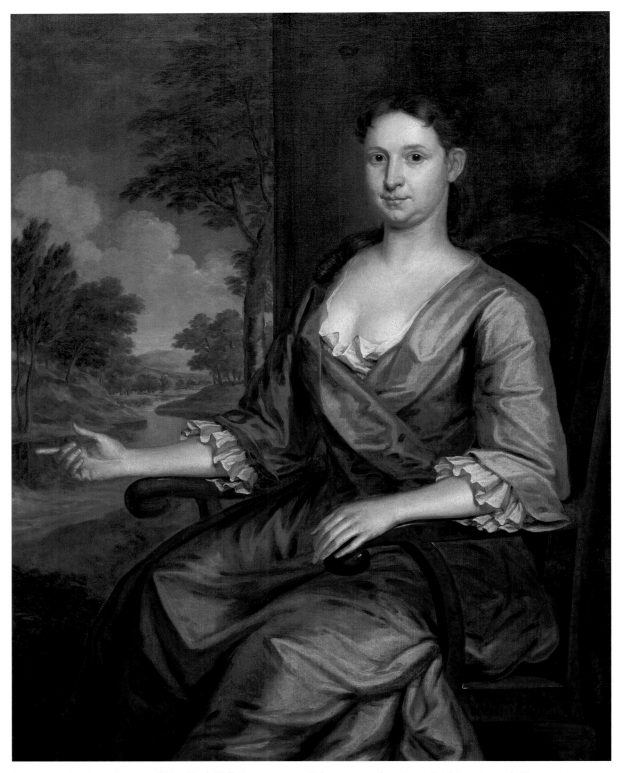

Fig. 6. John Smibert, *Portrait of Mrs. Hugh Hall*. Boston, 1733. Oil on canvas, 49 x 39 in. (124.5 x 99.1 cm). Denver Art Museum, Funds from 1983 Collectors' Choice Benefit, Acquisition Challenge Grant, Mabel Y. Hughes Charitable Trust, Volunteer Endowment, Mr. and Mrs. Paul Atchison, Mr. and Mrs. Bruce Benson, Mr. and Mrs. William C. Foxley, Mr. and Mrs. Charles Haines Jr., Mr. and Mrs. William R. James, Mr. and Mrs. Frederick R. Mayer, Mr and Mrs. Robert Petteys, Mr. and Mrs. Walter S. Rosenberry III, Mr. and Mrs. Keith Singer, and anonymous donors; 1984.819.

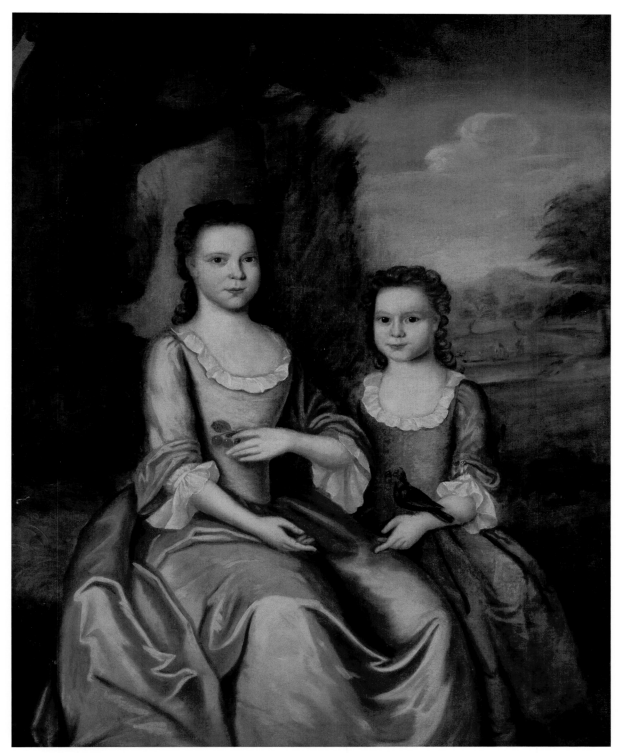

Fig. 7. Attributed to John Hesselius, *Ann and Sarah Gordon*. Virginia, circa 1750. Oil on canvas, 48¼ x 38½ in. (122.6 x 97.8 cm). Virginia Historical Society (1984.47).

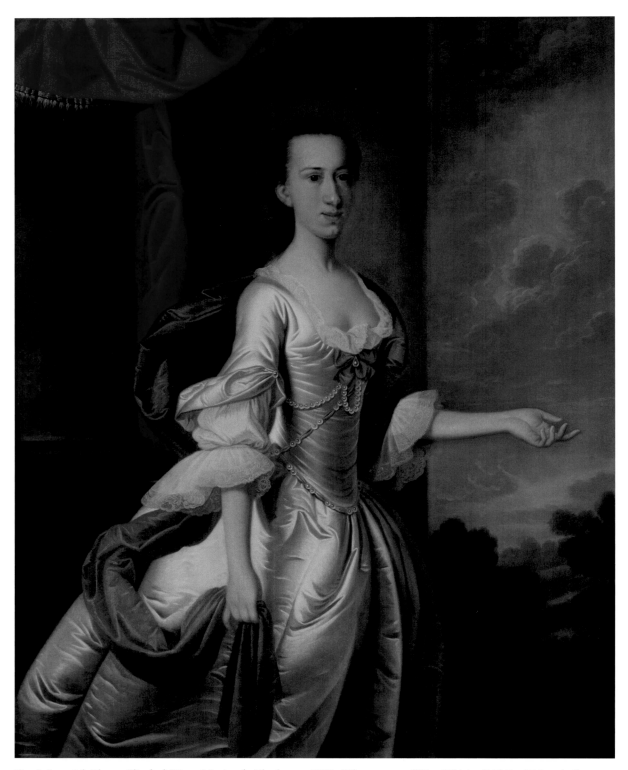

Fig. 8. Jeremiah Theus, *Elizabeth Wragg Manigault*. Charleston, 1757. Oil on canvas, 49½ x 38½ in. (125.7 x 97.8 cm). Courtesy of The Charleston Museum, 1952.121.1.

As for Benbridge, his surviving works include numerous portraits similarly placing sitters in close proximity to a generic natural background. One is *Benjamin Simons Heyward* of around 1786 (fig. 9). The young sitter's especially tactile connection to the natural setting evinces nascent Romantic ties between childhood and nature, but that setting is surely invented, as Heyward must have lived on his father's plantation on James Island near Charleston, where not a hill—let alone the mountains rising in the distance—is to be found. Thus, on the eve of his major undertaking with *The Hartley Family,* Benbridge, like other American portraitists, expressed in his work an affinity for the realistic if generalized presentation of a natural realm free of the earlier fictions of human dominion.[12]

Such representation was to change again at the end of the eighteenth century, as ongoing cultivation increasingly enabled artists to depict a nature that was actually domesticated, and as the effect of these improvements enhanced affiliation with not just the natural world as a general construct, but particular environments within it.[13] Sometime before 1776 John Durand painted *Thomas Atkinson* (fig. 10) standing in front of Mansfield, the family seat he was likely intended to inherit. The detail with which Durand has rendered the landscape background leaves no doubt that he meant to evoke a particular place—as much a portrait as the sitter's own. And here the productive and agentive, as opposed to merely decorative, interrelationship of the two—person and place—is underscored by the basket of apples Thomas holds.

Reviewing images of three young boys in their home environments across the eighteenth century—*Henry Darnall* (fig. 3), *Benjamin Simons Heyward* (fig. 9), and *Thomas Atkinson* (fig. 10)—we see a progression from an initial vision of conceptual order imposed on a wholly imaginary natural world, from which the sitter is emphatically separated; to a subsequent landscape at once plausibly realistic and yet demonstrably generic, which heralds a more symbiotic association of the human and the natural; to a more particularized representation of real people in real places. While this evolution was somewhat uneven among regions and artists—the Benbridge portrait in the group above, for example, actually precedes the

Fig. 9. Henry Benbridge, *Benjamin Simons Heyward*. Charleston, 1786. Oil on canvas, 48 x 35 in. (121.9 x 88.9 cm). Courtesy of The Charleston Museum, 1988.60.1

Fig. 10. Attributed to John Durand (American, 1746–after 1782), *Portrait of Thomas Atkinson*. Virginia, circa 1770–1776. Oil on canvas, 28½ x 23¼ in. (72.4 x 59.1 cm). Private collection, photograph courtesy of the Museum of Early Southern Decorative Arts (MESDA), MESDA Object Database file S-5776.

Fig. 11. Ralph Earl (American, 1751–1801), *Huldah Bradley.*
Connecticut, 1794. Oil on canvas, 44⅛ x 32⅛ in. (112.1 x 81.6 cm).
Museum of Fine Arts, Boston, Ellen Kelleran Gardner Fund, 40.3.

Durand one by a few years—and while the influence of European artistic precedent and the actual domestication of American nature contributed significantly, fundamentally it betokens essential changes in mind regarding the crucial relationship of Americans to their environment.

The pride of place in this newly particular American portraiture is not always overt, as with young *Thomas Atkinson.* Consider Ralph Earl's portrait of *Huldah Bradley* of 1794 (fig. 11). Earl depicted his New England subjects—like Southerners, often tied to the land through agriculture—as surrounded by their native environments. Although *Huldah Bradley* may appear to be set before the sort of nondescript landscape background encountered at midcentury, the artist was actually evoking a specific place, Greenfield Hill, the Bradley residence on Connecticut's Long Island Sound—the representation of which becomes clearer when the portrait is shown (as was intended) with its mate, an image of Huldah's sister, *Lucy Bradley* (fig. 12).[14]

A similarly subtle referentiality might be posited for *The Hartley Family*, whose impressive setting has always been considered generic—and thus, in the periodization of this argument, behind the times. The most recent scholarship on Benbridge accurately describes his portrait backgrounds as mainly "artificial and inventive."[15] But given what is known about the context of this major work, and the more general evolution traced here, we might reconsider the assertion that "his settings evoke the ancient classical world" and that "These elements are especially noticeable in the large portrait of the Hartley family of Charleston."[16] The Hartley sitters' considerable wealth derived from the inheritance of a plantation by the older woman, Margaret— a factor that may have influenced daughter Sarah's marriage in 1765 at just fourteen, in an elaborate elopement staged at gunpoint, to the significantly older William Crosthwaite. The *South-Carolina Gazette and Country Journal* described the young bride as "an agreeable young Lady, with a handsome Fortune," who "was legally intitled unto a Considerable Substance in Lands."[17] Clearly, their wealth was a decisive factor in these peoples' lives, and it makes sense, in our new paradigm, that its source would be invoked in the painting produced to

memorialize them. Certainly Sarah is pictorially linked to her setting through the compositional echo of her squarish shoulders and ovoid head in the similarly shaped and colored pedestal and vase rising behind her.[18] And her mother is tonally bound to the shadowy woods behind her, even as, more subtly, the wooden spindles of the bench on which she rests join her to them. The trees—darkened over time like the rest of the painting—seem on close inspection not just any trees, but rather bald cypresses, *Taxodium distichum* (fig. 13), the symbol of the southern swamps and precisely what would have been found at the family's plantation. The small glimpse of water just off the right edge of the painting further links it to the rice-growing plantation Lowcountry.

In support of what may seem this overdetermined reading of *The Hartley Family*'s setting, we might turn briefly to another painting also at Princeton, American folk artist Erastus Salisbury Field's c. 1838 portrait of *Josiah B. Woods* (fig. 14). Like *The Hartley Family*, it descended in the family of the sitter, and hence much can similarly be gleaned about its historical circumstances. It, too, was at first assumed to depict a nonspecific setting, as folk art portraits continued to do well into the nineteenth century. Certain generic elements of the painting support this reading: the distinctive patterned carpet is identical to the one in Field's contemporary portrayal of an unrelated family from another town, the Moore family (fig. 15), and Josiah's pose, implements, and costume relate clearly to those of the youngest Moore, at far left of that painting. Moreover, another Field portrait, *Louisa Gallond Cook* (1838; Art Institute of Chicago), and its apparent mate, *Mr. Cook* (c. 1838; National Gallery of Art), similarly share compositional features with the Woods portrait, namely the swagged red curtain, the parapet and Tuscan column, and aspects of the river scene—suggesting that none of them evokes any place in particular.[19] However, we know that the Woods family, leading citizens of Enfield, Massachusetts, resided in the mid-nineteenth century—and Josiah's portrait for many years hung—in a mansion whose distinctive columns Field may have sought to evoke (fig. 16). And their home overlooked the Swift River, whose current powered the family's mills, and whose several branches came

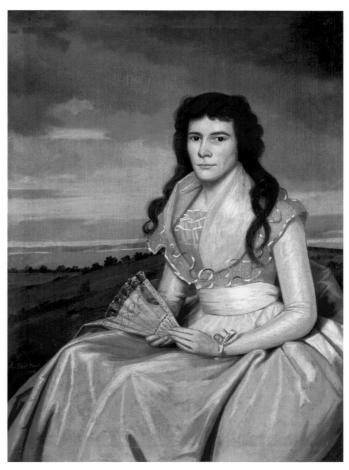

Fig. 12. Ralph Earl, *Lucy Bradley*. Connecticut, 1794. Oil on canvas, 44⅛ x 31⁵⁄₁₆ in. (112.1 x 79.5 cm). Detroit Institute of Arts, Founders Society purchase and Dexter M. Ferry Jr. Fund / Bridgeman Images.

Fig. 13. Bald Cypress Tree (*Taxodium distichum*), Congaree National Park, South Carolina. NPS Photo/jt-fineart.

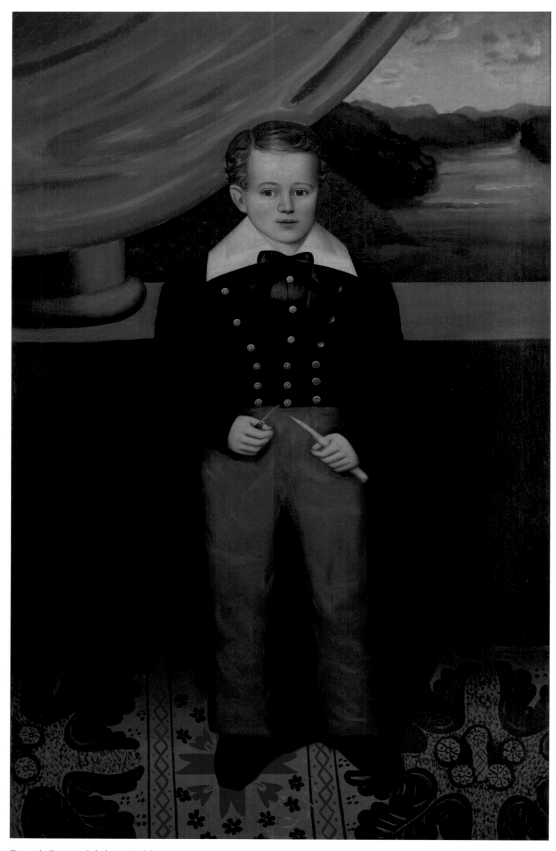

Fig. 14. Erastus Salisbury Field (American, 1805–1900), *Josiah B. Woods Jr.* Massachusetts, circa 1838. Oil on linen, 51 × 32¼ in. (129.5 x 81.9 cm). Gift of Christine Woods Kitto, Princeton University Art Museum, 2014-89.

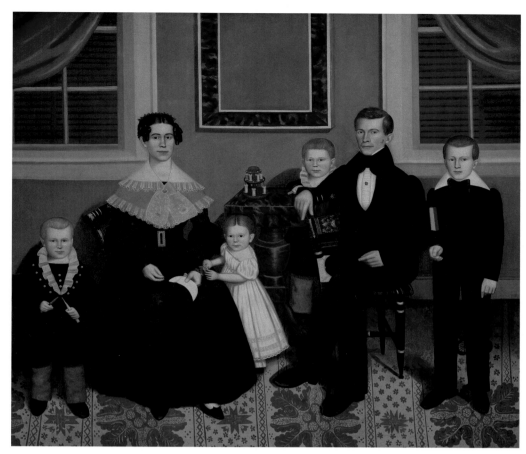

Fig. 15. Erastus Salisbury Field, *Joseph Moore and His Family*. Massachusetts, circa 1839. Oil on canvas, 82⅜ x 93⅜ in. (209.2 x 237.2 cm). Museum of Fine Arts, Boston, Gift of Maxim Karolik for the M. and M. Karolik Collection of American Paintings, 1815–1865, 58.25.

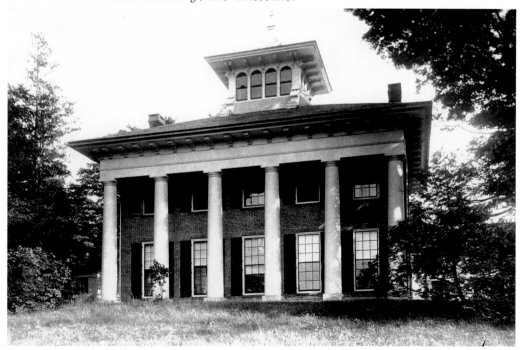

Fig. 16. "Woods Mansion north facade," from Janet Merrill Leidel, *Quabbin and the Family That Summered There* (unpublished manuscript, collection of Christine Kitto, Princeton, N.J., n.d.), n.p.

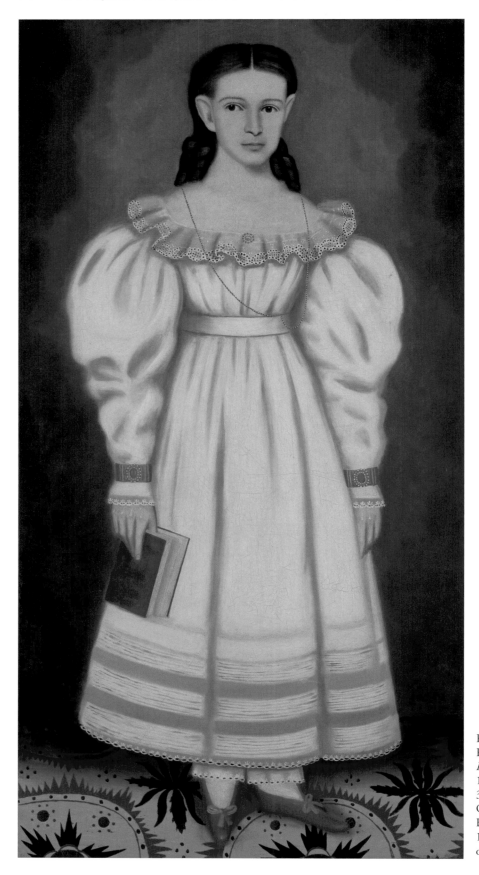

Fig. 17. Erastus Salisbury Field, *Girl of the Bang-Phelps Family.* Massachusetts, circa 1848. Oil on canvas, 58¾ x 30¼ in. (149.2 x 76.8 cm). Gift of Edgar William and Bernice Chrysler Garbisch, 1963, Metropolitan Museum of Art, 63.201.4.

together within view of the house much as in the background of the painting. One cannot know for certain how it all looked, since the entire town was swallowed up a hundred years later in the creation of the Quabbin Reservoir to satisfy Boston's growing thirst. But modern photographs of the area's topography seem not much different from the vista Field portrays. We cannot always be sure that a portrait, created when conditions were conducive to the representation of specific landscape environments, depicts only a particular person, when it may represent a particular place as well.[20]

Now consider the sort of painting Field was consistently creating a decade after the portrait of Josiah Woods, a typical example of which is *Girl of the Bang-Phelps Family*, of about 1848 (fig. 17). Though it clearly relates stylistically to the Woods portrait and others like it, this later painting—like virtually every other portrait the artist created from midcentury on—is set indoors, entirely without reference to the external world. In this way it exemplifies a major transformation in American portraiture during the middle years of the nineteenth century—its move, uneven but unmistakable, from exterior to interior, from outside to in. This shift relates to a variety of profound social, economic, and cultural transformations occurring at the same time: from rural to urban, from agricultural to industrial, from small-scale mercantilism to finance capitalism, from a cult of public character to one of private personality, from Enlightenment ideals of transparency and externality to Romantic ones of interiority and mood. As the primary means of visually expressing selfhood, portraiture tracks these transformations, like period cultural products more generally. One need only think of the distance from Washington Irving and James Fenimore Cooper at the beginning of the century, through Nathaniel Hawthorne and Herman Melville in the middle, to Henry James and Edith Wharton at century's end to sense the parallel move in literature from narratives rooted in the external environment to those concerned fundamentally with inner being.[21]

In the context of these changes, and their relation to the ties among selfhood, portraiture, and the external world, we can return to *The Hartley Family*. However, now, rather than comparing it to portraits of different time periods, with their similar and differing evocations of the natural world, we will follow it through time, as that world changed, and as the painting shuttled up and down the Eastern Seaboard in the different domestic contexts of its owners—the portait's sitters and their descendants.

*The Hartley Family* was located for nearly half a century at 45 East Bay Street, in a grand Charleston "single house," a local building type characterized by extensive multi-story "piazzas" or open-air porches perpendicular to the street (fig. 18). James Hartley purchased the plot overlooking Charleston Harbor in 1757. He was a planter, so his wealth, like that of his wife Margaret, the old woman in the painting, derived directly from close connection to Southern land—palpably present in the home where the painting first hung, and depicted, as I suggested above, in the image itself. Margaret's daughter Sarah, the painting's central figure, inherited the property and lived there with her second husband, William Somersall,

Fig. 18. Interior of 45 East Bay Street, Charleston. Courtesy of Debbie Peretsman.

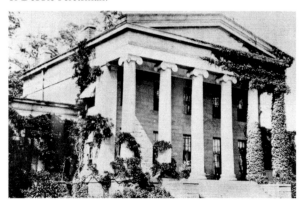

Fig. 19. *Danskammer*. Photograph from Wesley and Barbara H. Gottlock, *Lost Towns of the Hudson Valley* (Charleston, S.C.: History Press, 2009), 75.

Fig. 20. D. Maitland Armstrong, *Chimney Corner*. New York, 1878. Oil on canvas, 21½ x 16½ in. (54.6 x 41.9 cm). Photograph by David Bohl. Courtesy of The Preservation Society of Newport County.

also a planter and a merchant as well, as did their daughter Mary, the young girl in white at the right of the painting, eventually with her husband, Col. John Ward, yet again a planter and also a lawyer. Thus each generation that lived with the painting on East Bay Street had a fundamental dependence on the surrounding natural world, even as, with the latter two generations, change asserted itself in the household through the increasingly removed realms of commerce and the law.[22]

Mary and John Ward's daughter, named Sarah after her grandmother, married a northerner, Edward Armstrong, and in 1834 they built a mansion, Danskammer (fig. 19), in New York before selling the Charleston one two years later and installing *The Hartley Family* in their new home. Darkly imposing with its gray granite exterior and black walnut interior, and located on a small peninsula jutting into the Hudson River—a spectacular site from which the house curiously shut itself out—Danskammer offered less congenial surroundings for the Hartley painting, which must have seemed oddly out of sync with the place's more inward orientation.[23]

In 1836, Mary's son David Maitland Armstrong was born. Raised at Danskammer, he went on to a remarkable career as, among other things, an accomplished artist. In 1878, Maitland, as he was known, painted a portrait of his son Edward, who like his father grew up at Danskammer, and is pictured in front of its hearth (fig. 20). Maitland's family portrait of the great-great-great-grandson of Margaret Miles Hartley offers a fascinating comparison with *The Hartley Family*. Now the family seat is depicted from the inside, not the outside, and nature's generative energies have been replaced by those of the fireplace, symbol of domesticity. The transformation from outside nature to inside culture is underscored by the worldly curios surrounding the hearth, and by the exchange of the live pet at the lower left of *The Hartley Family* for the toy one in Maitland's composition.[24]

Maitland Armstrong's own biography and the fate of Danskammer offer another telling gloss on the changing relations of individuals to their sustaining environments. As the nineteenth century wore on, the house was increasingly surrounded by industry, by manufacturers transforming the abundant local clay into bricks for wide distribution.

This extractive and depletive industrial process, so different from the husbandry of the plantation, was enabled by an equally disparate system of investment capital and corporate ownership that maximized profit but diluted ties to a particular place and to nature generally. Armstrong himself lamented the change afoot around Danskammer in his autobiography:

> [B]efore the brick-yards came, scarring the landscape and even gnawing away our lawns and gardens, the situation was beautiful. . . . We had a delightful bathing beach . . . now of course swallowed up by west shore railroad."[25]

But even this aesthete was complicit in the degradation and contributed very directly to the "gnawing away" of his "lawns and gardens" as the operator of the Arrow Brick Co., located right on Danskammer Point where the house stood until he took it down—and later run by Edward, the little boy in the painting. A c. 1905 photograph of the Arrow brickyard, where twenty million bricks were produced annually, indicates what had become of the Armstrongs' idyll (fig. 21). The land that Maitland's father had assembled to run as a gentleman's farm at the beginning of the nineteenth century, and the house where *The Hartley Family* hung for forty years, were by century's end transformed into a factory site with a relationship to "nature"—and a scale of operations—that would have bewildered the sitters in painting.

Meanwhile, *The Hartley Family* moved down the Hudson with Maitland to New York, and

Fig. 21. Arrow Brick Works (circa 1905). Photograph by William Thompson. From Wesley and Barbara H. Gottlock, *Lost Towns of the Hudson Valley* (Charleston, S.C.: History Press, 2009), 57.

Fig. 22. Robert Meservey, "Hall looking toward front door" (circa 1947), Kingscote, Newport, Rhode Island. Courtesy of The Preservation Society of Newport County.

Fig. 23. Installation view of Margaret Armstrong's parlor with circa 1930 copy of *The Hartley Family*, in North Library, Kingscote. Courtesy of The Preservation Society of Newport County.

around 1878 was installed in his townhouse at 58 West 10th Street, where it remained for another few decades. Maitland was a fixture of the New York art world and, with his friend John La Farge, was an important stained glass innovator, the two of them responsible for the invention of opalescent glass, a more than usually opaque type. Maitland had the house he bought enlarged by another friend, the architect Stanford White, who included in the plans a large window that Maitland filled with over four hundred panes of clear and colored glass. Stained glass, especially the opalescent variety, shuts light and nature out, turning the interior back in on itself. Indeed, at the Philadelphia Centennial Exposition held a few years before the renovation of Maitland's new residence, its use was specifically promoted in order to screen out "neglected or dingy areas" and other "objectionable sights." Thus, as installed on 10th Street in bustling New York, in the home of an artist whose métier was the very definition of interiority, *The Hartley Family* moved a further step away from the environmental sensibility in which it originated.[26]

This by now well-traveled painting had one last stop on its journey to Princeton. In 1917, the widow of Edward Armstrong, the boy in Maitland's painting, brought *The Hartley Family* up to her family's Newport "cottage." "Kingscote" was the first of Newport's grand cottages, and unusual among them for its Gothic Revival design.[27] Historically, the Gothic was expressly concerned with the creation of interior space, of a shell to enclose an ethereal, self-contained realm separate from the world outside. Centuries later, the Gothic Revival partook of much of this impulse toward shadowy enclosure, as the entrance foyer to Kingscote suggests (fig. 22). For over fifty years, *The Hartley Family* was installed in Kingscote's overstuffed parlor, a totem of the family's distinguished past but also a symbol of how far it had traveled in the intervening years—physically and metaphorically.

Finally, around 1930, as if in anticipation of the great heirloom's eventual departure from their midst, Margaret Armstrong, another descendant, painted a copy of it. While perhaps not the most distinguished artistic effort, it suggests the portrait's centrality to the family identity, however anachronistic it may have come to seem. Most

appropriately, the painting was hung high in a room displaying not just other portraits but, even more predominantly, images of landscapes (fig. 23). One can only imagine how pleased these painted Hartleys must have been to find themselves again amid sympathetic surroundings. In the century and a half since their inclusion in Benbridge's grand depiction of nature and culture in the eighteenth-century southern Lowcountry, they had become vestiges of an earlier world, estranged from the modern industrial age they endured to occupy, even as their continued presence on the parlor wall marked the distance—locationally, aesthetically, environmentally—between those worlds.

## Notes

Thanks to Miri Kim and Jeffrey Richmond-Moll for advice and assistance in the preparation of this essay.

[1] On Rauschenberg's environmental art, see Robert S. Mattison, *Last Turn—Your Turn: Robert Rauschenberg and the Environmental Crisis* (New York: Jacobson Howard Gallery, 2008).

[2] For examples of ecocritical approaches to American art, see Alan C. Braddock and Christoph Irmscher, eds., *A Keener Perception: Ecocritical Studies in American Art History* (Tuscaloosa: University of Alabama Press, 2009); also see Braddock, "From Nature to Ecology: The Emergence of Ecocritical Art History," in *A Companion to American Art*, ed. John Davis, Jennifer A. Greenhill, and Jason D. LaFountain (Chichester, UK: Wiley, 2015), 447–467. A concise overview of literary ecocriticism, where ecocriticism originated, and what informs its application to visual culture, is Greg Garrard, *Ecocriticism* (New York: Routledge, 2012); also see Garrard, ed., *The Oxford Handbook of Ecocriticism* (New York: Oxford University Press, 2014).

[3] On Benbridge, see Robert G. Stewart and James Boswell, "The Portraits of Henry Benbridge," *American Art Journal* 2, no. 2 (1970): 58–71; Stewart, *Henry Benbridge (1743–1812): American Portrait Painter* (Washington: Smithsonian Institution Press, 1971); Angela D. Mack, ed., *Henry Benbridge (1743–1812): Charleston Portrait Painter* (Charleston: Gibbes Museum of Art, 2000); and Carolyn J. Weekley, *Painters and Paintings in the Early American South* (Williamsburg, VA: Colonial Williamsburg Foundation, 2013), 375–388.

[4] Quoted in Stewart, *Henry Benbridge*, 40.

[5] Clients as well as artists often had print collections that could be consulted for sources. Several scholars have identified European mezzotints that served, in one degree or another, as the basis for American portraits, beginning with Waldron Belknap Jr. in the 1950s; see John Marshall Phillips, Barbara N. Parker, and Kathryn C. Buhler, eds., *The Waldron Phoenix Belknap, Jr. Collection of Portraits and Silver, with a Note on the Discoveries of Waldron Phoenix Belknap, Jr. Concerning*

*the Influence of the English Mezzotint on Colonial Painting* (Cambridge: Harvard University Press, 1955). The point here is not to deny the significance of European sources for early American portraits, but to suggest that multiple factors played a role in the production and meaning of landscape representation in them, and that, when artists borrowed from European precedent, they did so in ways that resonated with their own particular circumstances, including environmental ones. Benbridge was especially adept at amalgamating sources to his own ends: "Benbridge's portraiture after returning to America was diverse and demonstrates his adaptation of the lessons learned in Europe adjusted to forms that suited the varying tastes of his American patrons. . . . Direct copies . . . are rare because most of Benbridge's portraits are the result of his assimilation of many sources" (Maurie D. McInnis, "'Our Ingenious Countryman Mr. Benbridge,'" in Mack, *Henry Benbridge*, 11).

[6] On the Darnalls and Kuhn, see Kathleen Orr Pomerenk, "Faith in Art: Justus Engelhardt Kuhn's Portrait of Eleanor Darnall," master's thesis, Georgetown University, 2009.

[7] On the early American construction of wilderness as a foreboding "waste," the word's nearest synonym, and the concept's historical transformation, see Roderick Nash, *Wilderness and the American Mind*, 3rd ed. (New Haven: Yale University Press, 1982); William Cronon, *Changes in the Land: Indians, Colonists, and the Ecology of New England*, 2nd ed. (New York: Hill and Wang, 2003); and Cronon, "The Trouble with Wilderness or, Getting Back to the Wrong Nature," in Cronon, ed., *Uncommon Ground: Rethinking the Human Place in Nature* (New York: W.W. Norton, 1995), 69–90.

[8] The representation of American wilderness was in keeping with "the human tendency to systematize the patchwork [of diverse natural communities] and impose a more regular pattern on it. People sought to give their landscapes a new purposefulness, often by simplifying its seemingly chaotic tangle" (Cronon, *Changes in the Land*, 33). Such strategies have a history extending back to the seventeenth century; see Timothy Sweet, "Filling the Field: The Roanoke Images of John White and Theodor de Bry," in Braddock and Irmscher, *Keener Perception*, 23–42.

[9] The transformation of environmental beliefs underlying the move from a nature portrayed as contained and controlled to one more freely and realistically rendered is rooted in changing attitudes toward wilderness; see Cronon, "Trouble with Wilderness," and Nash, *Wilderness*, which notes, "By the mid-eighteenth century wilderness was associated with the beauty and godliness that had previously been defined by their absence" (46). Exemplifying this development, in the decade preceding Benbridge's portrait of the Hartleys, artist-naturalist William Bartram, while camping beside Florida's Lake George, admitted to being "seduced by these sublime enchanting scenes of primitive nature" (quoted in Nash, *Wilderness*, 54). Such attitudes were to culminate the following century in the work of Thomas Cole and others.

[10] On the iconographic significance of the upward-pointing finger in an American context, see David Steinberg, "Charles Willson Peale: The Portraitist as Divine," in Lillian B. Miller and David C. Ward, eds., *New Perspectives on Charles Willson Peale: A 250th Anniversary Celebration* (Pittsburgh: University

of Pittsburgh Press, 1991), 131–143. Hugh Hall was a commission merchant, slaver, and distiller—and the subject in 1758 of what is believed to be John Singleton Copley's first pastel (now at the Metropolitan Museum of Art, acc. no. 1996.279).

[11] Theus's portrait was apparently produced as a mate to one of Elizabeth's new husband, Peter Manigault, completed in 1751–1752 in London by Allan Ramsay (now lost but known from an old photograph). Interestingly, though the American portrait seems clearly linked to the English one, and though both contain landscape backgrounds, the sitters in each relate differently, even antithetically, to them, with Peter facing away—literally turning a shoulder to—the natural world, and Elizabeth gesturing toward it. See Weekley, *Painters and Paintings*, 199–201; and Richard H. Saunders and Ellen G. Miles, *American Colonial Portraits: 1700–1776* (Washington: Smithsonian Institution Press, 1987), cat. 53.

[12] Already in 1762 Jean-Jacques Rousseau's influential *Emile, or On Education* posited childhood as a separate stage in human development characterized by closeness to nature. The Heyward portrait is discussed in Roberta Sokolitz, "Nature and Setting in the Art of Henry Benbridge," in Mack, *Henry Benbridge*, 35.

[13] Portraits of the American South, Weekley notes, often "show expansive landscape settings, some with elaborate vistas and architectural settings that evoke the importance of owning large tracts or farms called 'plantations.' For most wealthy or upper-middling southerners, landscape elements in general and broad vistas in particular symbolized and affirmed the most important material aspect of their everyday world: land, the source of much of their wealth and power" (Weekley, *Painters and Paintings*, 3).

[14] Earl scholar Elizabeth Mankin Kornhauser notes, "[I]n 1794, Earl painted portraits of the Bradley sisters, focusing his attention on a view of the beaches of Long Island that could be seen from the Bradley farm in Greenfield Hill. When hung together, the portraits form one continuous panorama" (Kornhauser, *Ralph Earl: The Face of the Young Republic* [New Haven: Yale University Press, 1991], 56).

[15] Sokolitz, "Nature and Setting," 32. Even so, some have found the backgrounds to occasionally be at least broadly referential. In 1960 David Sellin stated that Benbridge's *Portrait of the Enoch Edwards Family* (1779; Philadelphia Museum of Art) featured a glimpse of Pennsylvania landscape in the background, just as his portrait of General Pascal Paoli (1768–1769; Fine Arts Museums of San Francisco), which toured Europe and brought the artist his earliest fame, contained a distinctly Corsican scene. See Sellin, "A Benbridge Conversation Piece," *PMA Bulletin* 55, no. 263–264 (1959–1960): 6.

[16] Weekley, *Painters and Paintings*, 379.

[17] "Marriage Notices," *South-Carolina Gazette and Country Journal*, December 31, 1765; "legally intitled" quoted in Cara Anzilotti, *In the Affairs of this World: Women, Patriarchy, and Power in Colonial South Carolina* (New York: Praeger, 2002), 69.

[18] Underscoring this linkage, Stefanie Walker notes, "Isolated vases rendered almost as 'found objects' in landscape settings must be understood as representing ideas about the fundamental relationship of humanity and nature"

(Walker, "Symbol to Satire: The Vase as Icon," in Heather Jane McCormick and Hans Ottomeyer, eds., *Vasemania: Neoclassical Form and Ornament in Europe* [New Haven: Yale University Press, 2004], 158).

[19] For the Cook portraits, see Mary Black, *Erastus Salisbury Field: 1805–1900* (Springfield, MA: Museum of Fine Art, 1984), cat. nos. 63–64.

[20] Information about the Woods portrait, donated to the Princeton University Art Museum in 2014, is from the object's curatorial file (acc. no. 2014-89).

[21] Hence even as nature was being symbolically romanticized and sanctified in the landscape paintings of the Hudson River School, its gradual disappearance from portraiture betokened the actual growing separation of Americans and their identities from it.

[22] Information on the biographies of *The Hartley Family*'s successive owners and the details of their domestic surroundings results from research conducted in the preparation of this essay; see the object's curatorial file (acc. no. y1986-84).

[23] On Danskammer and its subsequent history, see "A Brief History of Roseton and Danskammer Point, NY, from the Perspective of the Great Hudson River Brick Industry," accessed January 2015, http://brickcollecting.com/roseton.htm.

[24] In *The Hartley Family*, the small dog at Margaret Hartley's feet refers to her fidelity: "In portraiture, at the feet of a woman or in her lap, [a dog] alludes to her marital fidelity or, if a widow, to her faithfulness to her husband's memory" (James Hall, *Dictionary of Subjects and Symbols in Art* [Boulder, Colorado: Westview Press, 1979], s.v. "Dog").

[25] David Maitland Armstrong, *Day Before Yesterday: Reminiscences of a Varied Life*, ed. Margaret Armstrong (New York: Charles Scribner's Sons, 1920), 4–5.

[26] See Robert O. Jones, *D. Maitland Armstrong: American Stained Glass Master* (Tallahassee, FL: Sentry Press, 1999); and Tom Miller, "The D. Maitland Armstrong House—No. 58 W. 10th Street," *Daytonian in Manhattan* blog, March 19, 2013, accessed January 2015, http://daytoninmanhattan.blogspot.com/2013/03/the-d-maitland-armstrong-house-no-58-e.html. Donald G. Mitchell, chairman of the Exposition's judges of industrial and architectural designs, and stained-glass artist Charles Booth quoted in Alice Cooney Frelinghuysen, "A New Renaissance: Stained Glass in the Aesthetic Period," in *In Pursuit of Beauty: Americans and the Aesthetic Movement* (New York: Metropolitan Museum of Art, 1986), 184.

[27] On Kingscote and the Gothic Revival in Newport's domestic architecture, see James L. Yarnall, *Newport Through Its Architecture: A History of Styles from Postmedieval to Postmodern* (Lebanon, NH: UPNE, 2005), 39–44.

# Corporate Portraiture in New Spain
## Social Bodies, the Individual, and Their Spaces of Display

*Paula Mues Orts*

In this essay I discuss a particular sort of eighteenth-century New Spanish[1] portrait that depicts the subject according to a prototype that is reiterated in different paintings forming a series or collection, specifically painted for a certain architectural space and constituting a portrait gallery belonging to corporations or institutions (fig. 1). I do not address individual portraits or those depicting a private, family, or intimate image, even though some of these bear formal resemblances to portraits from corporate galleries, since their intention was connected to the memory and display of lineage and family virtues (see Middleton, p. 114, fig. 11).

The portraits that most interest me employed a compositional structure or visual protocol related to ranking individuals and the institutions to which they belonged. Various visual or textual elements (inscriptions accompanying the portraits) denote the individuals' belonging to a particular institution or social circle; I have therefore called them "corporate portraits," a term derived from the concept of "social body," so common in the eighteenth century.[2] Of course, I'm not relating viceregal portraits to the "corporate portraits" of the present, especially photographs, since evidently intention and emotive quality vary enormously between them, although it is significant that the idea of unity and belonging is still extant.

Although some portrait galleries of this sort were set up earlier, it was not until the eighteenth century that they proliferated. In some cases all of the portraits were made by the same artist, and in others they were sponsored by the corporations over a long period of time, employing multiple artists. In any case, they were intended to be shown as part of a series in a particular place. It wasn't unusual to adapt sixteenth- and seventeenth-century portraits to eighteenth-century mores so that they could be exhibited in new places, such as the series of archbishops in the Metropolitan Cathedral of Mexico.[3] In the eighteenth century, pervaded with change and reform, several different orders of society chose these portraits as a form of self-depiction. Understanding their inner workings also deepens the explanation of this complex moment of history.

My argument here is that these spaces played a major role in the urban milieu as a meeting point for individuals and institutions alike, since they were open to members or visitors at key moments in the history of the sponsoring bodies (fig. 2). Although in recent times there has been progress in researching these portraits, it's still unusual for interpreters to take into consideration their urban context and architectural setting, perhaps because many of these places have been destroyed or their purpose modified, while the portraits have been scattered. Nevertheless, it's possible to observe the serious implications of hanging pictures celebrating individuals and groups in a particular place. Each member supplied a special element to the whole by adding his[4] own individual virtues to the corporation's. "Dressing up" with pictures the walls of the halls where public or private corporate events took place had a clear symbolism in regard to historicity, identity, and legality, as I demonstrate below.

Given the importance of these galleries and their proliferation during the eighteenth century not only in Mexico City, but also in Puebla, Querétaro, and Oaxaca, among other places, this essay explores the complex issues surrounding the paintings. On the one hand, I present a wide-ranging panorama of the artistic, social, and symbolic aspects of the creation of portrait galleries in the eighteenth century. On the other hand, I examine some particular cases in order to study this topic from different standpoints.

The first works devoted in Mexico to New Spanish portraiture stressed the genre's value as a memorial of historical figures, and made some basic assumptions about the differences between individual portraits, which show less homogeneity and are more intimately placed, and those belonging to groups (fig. 3). However, because of their intent and orientation, these portraits were not appreciated as works of art. They simply were not considered as representations with a purpose

Fig. 1. View of the portrait gallery, temple of La Profesa, Mexico City. Photo: María Ruíz Cervera. Reproduction authorized by the Instituto Nacional de Antropología e Historia.

Fig. 2. View of the Salón General (General Function Hall), Antiguo Colegio de San Ildefonso, Mexico City. Photo: Ernesto Peñaloza. Photo courtesy Universidad Nacional Autónoma de México.

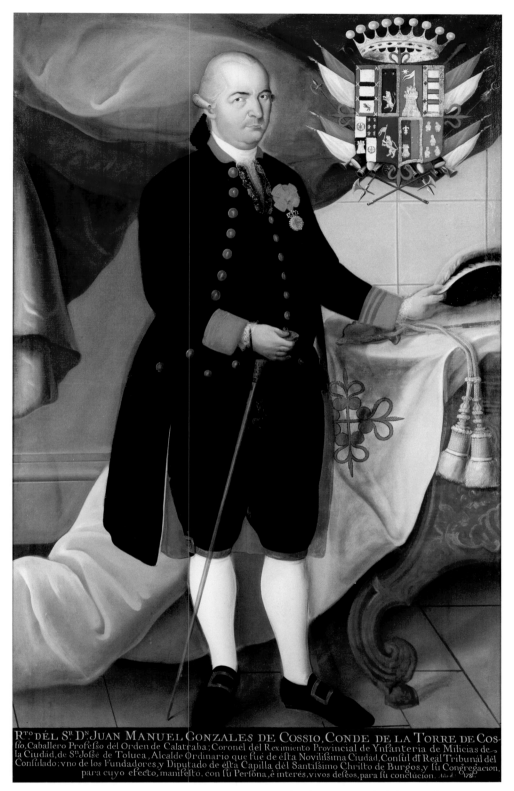

Fig. 3. José Joaquín Esquivel, *Portrait of Juan Manuel González de Cossío, Conde de la Torre de Cossío*. Mexico, 1781. Oil on canvas, 74¾ x 45⅓ in. (190 x 115 cm). Museo Nacional de Historia, Mexico City. Formerly in the portrait gallery of the Cofradía del Cristo de Burgos. Reproduction authorized by the Instituto Nacional de Antropología e Historia.

beyond the mere recollection of the sitter's likeness and individual deeds.[5]

Even if its artistic qualities have since attained some recognition, New Spanish portraiture has been regularly criticized as non-naturalistic and not very original in composition and manufacture. It is considered as a spawn of Spanish portraiture, and as closely related to its Flemish counterpart. Moreover, the model of aristocratic or official portraiture became a formula that was repeated uncritically in different venues.[6] According to traditional art historical assessment canons, it has been considered a lesser art, not deserving of close scrutiny.[7] However, the formula's success and the meaning that contemporaries gave to it indicate that assorted values, expectations, and social relations were created around corporate portraits, and they deserve close examination.

Official portraiture is regarded as the most repetitive and customary sort of all. Various studies do not distinguish between individual portraits that copied the official portraiture formula, quite widespread, and those intended to be "corporate portraits." This confusion can be traced in part

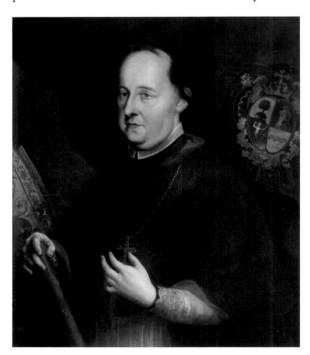

Fig. 4. José de Ibarra, *Portrait of Juan Antonio de Vizarrón y Eguiarreta*. Mexico, 1734. Oil on canvas, 36⅝ x 28 in. (93 x 71 cm). Museo Nacional de Historia, Mexico City. Photo: Paula Mues Orts. Reproduction authorized by the Instituto Nacional de Antropología e Historia.

to the loss of the portraits' original context and the dispersion of many portrait galleries. Some of these individual portraits were used to supplement a tomb, such as the famous full-length portrait of the viceroy the Duke of Linares, presently in Mexico's National Museum of Art, underscoring the connection between the sitter and the religious corporation that owned the burial place and thus further blurring the distinction between individual and corporate portraits.

Various scholars have alerted us to the importance of the portrait series—for instance, Luis Ávila Blancas, Tomás Pérez Vejo, Clara Inés Ramírez, and Armando Pavón, as well as Mónica Hidalgo and Michael Brown[8]—although they have not attended sufficiently to the spaces, importance, symbolism, and development across the eighteenth century of the genre as a whole. Instead, writers have stressed the viceroys' portraits painted for the Royal Palace and the Mexico City Town Hall, both originating in the sixteenth century (fig. 4).[9] Among others, Inmaculada Rodríguez, Michael Schreffler, and Rebeca Kraselsky have considered two interesting aspects of them: seriality and the symbolic space they occupy. These two series were very important for the development of New Spanish portraiture. Their history and evolution (including changes and permanence of formats and other elements in order to generate a sense of stability) relate directly to issues raised by the study of corporate portraits, and I refer to them below.[10]

First, let us reflect on the portrait itself, particularly in light of Spanish painting theory, in order to question some of the presumptions about the genre as a whole that affect the study of corporate portraits. It is customary to think that every portrait seeks to capture an individual's features in a framework more permanent than memory. Therefore, the copy of the person and the naturalism of his or her representation are elements to be considered when discussing portraits. However, there is not always an evident relationship between the model, the painter, and the portrait. The finished product is linked to local and historical ideas on naturalism, identity, personality, and dignity, and to the era's technological possibilities and the artist's capabilities.

Antonio Palomino (1655–1726) defined portraiture in 1715: "PORTRAIT, see Image," and "IMAGE, exact likeness of any corporeal thing."[11] But Palomino did not restrict the meaning to "corporeal" things, since he also used the term "portrait" to refer to images of God, the Virgin Mary, and the saints, while defining the act of portraying as "copying and forming an exact image of a particular subject."[12]

Along the same lines, the *Diccionario de Autoridades* defined TO PORTRAY in these terms in 1737: "To form the image of a subject, which serves as its model to achieve exact likeness, either in painting, sculpture, or engraving"; the second sense specifies, "it is the same as imitating a thing, attaining a similarity."[13] Thus, a portrait was "a painting or effigie depicting someone or something," and an effigy was "An image, picture, bulk and outline, similar to someone." The same dictionary defined PORTRAYER as "He who portrays," and clarified this sense by using the Latin words *pictor imitator*.[14] This definition is interesting for two reasons: first, the specialist genre painter was important enough to receive a dictionary definition, and second, that definition is related, as should be expected, to the imitation painter.

A crucial forerunner of Palomino was the Sevillian painter and writer Francisco Pacheco (1564–1644). Pacheco declared that God was the first painter (a common topic in artistic literature of the era), which turned Him into the first portrayer, since in this sense "to portray" was "to take from the natural," representing anything and not just the features of individuals. The painter "portrayed" or imitated Divine creation, assimilating with the creator, and more so if he was virtuous in imitating the human being, God's paramount creation. Other artists could learn to copy nature, but portraying was a grace granted by God to imitate or "steal" life out of a human being. These writers saw the portrait as a task dignified in part by their models, and in part by the action of Divine *imitatio* itself. Thus, Titian (1490–1576) and Diego Velázquez (1599–1660), Francisco Pacheco's son-in-law, painted portraits with such vivacity (especially if these were meant for the king) that they were regarded as the foremost representatives of intellectual creation.[15]

When speaking specifically about individual portraits, Palomino, like other eighteenth-century writers, put forward a series of precepts encompassing the copying of both the natural and the subject's circumstances in accordance with the model's category:

It would be joyful . . . to find a painter whose subject was happy with the resemblance, not seeking flattery, since true portraits, those most perfect, are the most like: there are cases in which the poor painter is visibly troubled, because if he pleases the patron he loses credit with the critics who know the difference; and if he attends to what is like he will displease the patron; and as the painter is ill paid, he is at odds about how to escape each of these pitfalls.[16]

He states later on that in the case of painting princely subjects (of no particular lineage),

We painters are not in such a lowly state that we are not capable of making a gift, even to kings themselves. And so it always is, that in regard to the face some features that do not favor the subject, such as some wrinkle, some flabby skin, or bad color, can be toned down without failing to fulfill the outlines . . . it has to be thus executed, for due to the injury of age or other accident, though it is not presently as such, it once was so.[17]

That is, the painter accepted that sometimes the portrait could not merely copy from the flesh; rather, it was necessary to depict the subject's social category and represent him in accordance with his social condition or idea of himself. In this dichotomy between naturalism and idealism, the New Spanish portrait leans strongly toward the latter.[18] In order to achieve the ideal portrayal, the painter used an official painting arrangement that highlighted the individual through attributes that conferred upon him a social personality, a hierarchical position, or a group or corporate identity. The repetition of both the elements and the structure in paintings from the same series had a function associated with the identity of the sponsoring communities; hence eighteenth-century portraits for the university and for colleges, for instance,

generally showed a library in the background.

In his study on Rembrandt, Harry Berger has suggested that a portrait is always a "fiction" in which the sitter and the painter choose a manner of representation according to their intent to underscore those traits best suited to the former's interest. Along with size, one of the most important among these choices is the sitter's pose. Even in those portraits where Rembrandt sought to offer a sensation of naturalness and spontaneity, the sitter's identity was in fact constructed and even alienated. Through the use of poses as a codified form of social communication, portraiture acquires a rich cultural and symbolic dimension.[19] This sort of analysis is still lacking in studies on New Spanish portraiture, but some of the categories proposed by Berger could help us understand official portraits coming from corporate galleries, where the sitter's pose is usually related to his place and duties within the corporation, and the reasons that made him worthy of pictorial representation.

An example of this kind of portrait is the full-length image of *Don Fernando Nava Arnanz*, probably painted after his appointment as *racionero* or prebendary of the cathedral chapter of Valladolid (present day Morelia) in Michoacán, and currently in the Denver Art Museum (fig. 5). Attributes from official portraiture and ones connecting him to this ecclesiastical corporation can be seen throughout the work. The rich curtain in the background, embroidered with his family's crest, confers dignity upon the sitter. Next to him is a table with a pen, seal, and inkwell, all identifying him as a Church official; the clock alludes to the temporary nature of his services to the cathedral, perhaps as a *juez hacedor* or administrator, while the library at the back of the scene points to his training and expertise in canon law. Nava is looking toward the spectator, advancing one step to the front. The long white sleeves of his priestly robes direct us to his hands: one of them is holding a book, with its pages separated by one of his fingers; in the other he holds a biretta, significantly pointing at the same time to the ground. This gesture's actual meaning is unknown to us, but it must have carried a special message for viewers in those days.

Another aspect of the portrait generally related in manifold ways to painting theory is the question of size, not always taken into account. Some treatises referred specifically to this topic, others only implicitly by mentioning practical or symbolic aspects of it. However, choosing the size of the paintings and their arrangement in space is as important for their perception as the position of the sitter or the shape and size of the easel. Painters were wholly aware of the effect of size on the outcome of their intentions or those of their patrons.

One of the major painting theoreticians in the post-Tridentine Catholic world, cited by several Spanish treatises, was Cardinal Gabriele Paleotti (1522–1597). In his *Discorso intorno alle immagini sacre e profane* he reflected upon the repercussions of the concepts of similitude, image, and equality in relation to the size of the works:[20]

> One thing is an image, another equality, another similarity, . . . where there is an image there is similarity, but not equality; where there is equality there is similarity but not image, where there is similarity there is neither image nor equality.[21]

If the object was a sense of *equality* between the image and its model, the representation had to be the same size as the original (or at least be of natural proportions, taking its spatial location into account). Otherwise, the work could only be *similar* or metaphorical.[22] Therefore, when the purpose was to copy or make an image an *aequalitas,* namely, to liken it to a living model, the painting had to be life size, and generally in full body in order not to segment the model. If the painter was not interested in producing that effect, he could change the scale or cut the model, forming an "imago" or image that couldn't replace the original.

Originally, the full-body format was reserved exclusively for kings, highlighting the resemblance between the model and his depiction, for it was used to replace the absent monarch. A New Spanish eighteenth-century example is that of the royal oath ceremony or *jura*, which was performed in front of the king's portrait and not just before the royal banner. The model of the full-body kingly portrait was imitated by nobles and by corporations, although there were also half-length portraits similar to those in the viceroy series.

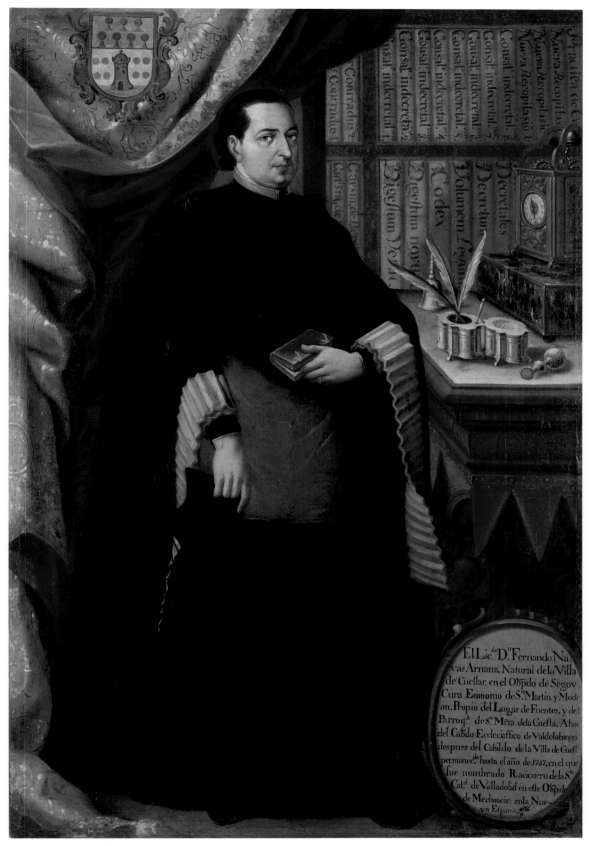

Fig. 5. José de Páez, *Portrait of Fernando Navas Arnanz*. Mexico, circa 1758. Oil on canvas, 67½ x 46 in. (171.5 x 116.8 cm). Denver Art Museum, Gift of the Collection of Frederick and Jan Mayer; 2013.356.

I want to make only two points about the portraits of the king's representatives (the viceroys), hung in spaces where two of the colony's main social bodies gathered—the *Audiencia* (the viceregal high court) and the City Council—since they have received more attention than any other series of portraits (see fig. 4 and Kunny in this volume). First, I believe the half-length format must have set viceregal portraits apart from the full-length ones for kings. Even though the viceroy was the king's alter ego, two circumstances limited his authority. To begin with, the king bestowed part of his power (*potestas*) on the viceroy but never his majesty (*maiestas*), which was God given and nontransferable. In addition, the viceroy's power was temporally limited, in contrast to the king's.[23] In this sense, it is very significant that the viceroy's portraits for both galleries were usually commissioned at the beginning of his term in office.

Another important half-length portrait gallery created in the eighteenth century was that of the metropolitan archbishops exhibited in the chapterhouse or *sala capitular*, where the cathedral chapter or body of prebendaries gathered to govern the cathedral clergy and the archdiocese (fig. 6). As part of a refurbishing of the chapterhouse undertaken in that century, this series replaced full-length portraits, begun in the sixteenth century, with new half-length paintings. Therefore, those archbishops not portrayed in the full-length series were not included in the half-length series either, with the exception of Juan de Palafox, painted in 1768 by Andrés de Islas for the latter series.[24]

The date of the half-length series is not known, but a careful analysis shows that most of these portraits were modified by adding architectural arches and cartouches in every picture until that of Francisco de Lorenzana. Only two works are signed: Manuel Rubio y Salinas's portrait by Miguel Cabrera and Palafox's by Islas, added (without the arch) in 1768, the year of Miguel Cabrera's death. This information, as well as the

Fig. 6. View of the Sala Capitular (Chapter hall), Catedral Metropolitana, Mexico City. Reproduction authorized by the Instituto Nacional de Antropología e Historia.

fact that the full-length series goes only as far as Archbishop Núñez de Haro y Peralta (1772–1800),[25] has led Rogelio Ruiz Gomar to conclude that many of the half-length portraits, in addition to the standardizing of the earlier works, might have been done under Cabrera's direction from the mid-eighteenth century until Islas's appearance in 1768.

Especially interesting is the portrait of Philippines-born Manuel José de Endaya y Aro, who was named to replace José Lanciego but died in Oviedo in 1729, before reaching New Spain (fig. 7). His sudden demise kept him from being presented to the Holy See by the King of Spain, but this lack of completion of the appointment may have gone unnoticed in New Spain, as a portrait of him was requested for the gallery.[26] Painting the portrait of an unknown dead person might have been a problem for the artist (although it wasn't unusual in New Spanish painting), for he finally reused an existing picture of Manuel Rubio

y Salinas (fig. 8), which is still recognizable by comparison with Rubio's portrait from the same gallery. The artist proceeded by painting over some facial features, adding a moustache and goatee, and Endaya's biography in the cartouche.[27] This case is an example of the way in which, in the creation of New Spanish corporate portrait galleries, a sense of belonging, unity, and stability was favored over the individuality of the members of the social body. This quite powerful social body was aware that the historical and collective depiction of its symbolic head gave a solid, stable, unbroken character to its activity.

Another interesting case is the gallery of the Guadalupe Congregation in Querétaro (fig. 9). The congregation was founded in 1669 owing to the devotion of Father Lucas Guerrero y Rodea, but its temple was finished in 1680 during a long power struggle between the secular clergy of the congregation and the Franciscan friars over the administration of Querétaro's parish church, which

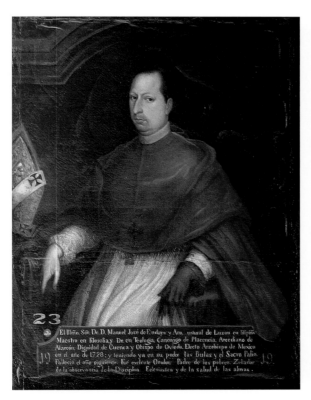

Fig. 7. *Portrait of Manuel José Endaya y Aro*. Mexico, 18th century. Oil on canvas, 65 x 50⅜ in. (165 x 128 cm). Sala Capitular, Catedral Metropolitana, Mexico City. Photo: Magdalena Castañeda Hernández. Reproduction authorized by the Instituto Nacional de Antropología e Historia.

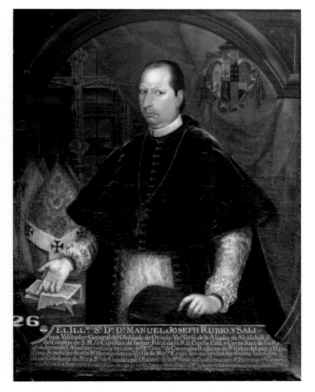

Fig. 8. Miguel Cabrera, *Portrait of Manuel Rubio y Salinas*. Mexico, 1758. Oil on canvas, 64⅝ x 50⅜ in. (164 x 128 cm). Sala Capitular, Catedral Metropolitana, Mexico City. Photo: Magdalena Castañeda Hernández. Reproduction authorized by the Instituto Nacional de Antropología e Historia.

had remained under Franciscan control since the foundation of the city. The congregation was able to gain ground because of its bonds to several prominent Mexicans, its own religious endeavor, and the founding of several brotherhoods in the temple. In 1759 the dispute was settled in favor of the secular clergy, and the church of the congregation served temporarily as the city's parish church.

For the congregation's assembly chamber, a portrait gallery was commissioned to diverse artists to gather the images of congregation members, benefactors, and others deemed important to the management and glorification of the cult. The gallery sought to proclaim the power of its members (that included high-ranking officers), their prominence, and their history as a congregation. In the context of the dispute, they argued the legality of its establishment and its aspirations. Most portraits are full length, following the official model. The painting program was so important to the patrons that they commissioned first-class artists who had previously painted the same sitters to repeat their portraits for the congregation's chamber. This selective artistic sponsorship, connecting artists to particular clients and creating a network between congregation members and artists, requires further

Fig. 9. View of the Sala de Juntas (Assembly Chamber) of the Congregation of Guadalupe, temple of Guadalupe, Querétaro, Mexico. Photo: Paula Mues Orts. Reproduction authorized by the Instituto Nacional de Antropología e Historia.

study. This commissioning procedure may have been unusual, but it probably ensured excellent works that, unfortunately, are nowadays ill preserved and awaiting funds for restoration.

The chamber presently exhibiting the portraits seems to be their original setting, and although the portraits have lost their frames and are hung too high, they still appear close to the viewers. In 1803 Father José María Zelaa e Hidalgo commented on these same pictures: "In the beautiful chapterhouse our illustrious congregation has in the dwelling alongside the church, there are four and twenty portraits of some of its founders, several benefactors, and many renowned people who have honored and distinguished it, bestowing splendor and luster on it; which are preserved here to perpetuate thus their noble appreciation and distinguished glory."[28]

My last example involves the motives for creating two portraits of Antonio López Portillo (1730–1780), the implications of their position in the galleries where they originally hung, and the appreciation of their viewers. When López Portillo, a 23-year-old creole *colegial* or resident student of the Jesuit College of San Ildefonso in Mexico City, completed his three-day examinations in the *aula magna* of the Royal University of Mexico in 1754, the whole city was astonished by his immense wisdom as he successfully defended the doctrines of authors from four different faculties: theology, canon law, civil law, and arts. According to bibliographer José Mariano Beristáin y Souza, after the conclusion of the young man's examination,

the University, joyful, satisfied, and even thankful, brought together that same night its Academic Senate, and decreed to *reward* its student by bestowing upon him . . . the four tassels of Master of Arts and Doctor in theology, canon law, and civil law, *and commissioning his portrait to be shown at the Function Room in order to encourage the young students and as a perpetual monument* to Portillo's knowledge, whose merits, accompanied by a sworn testimony by the examining doctors, were thus recommended to the king.[29]

Clearly, placing an effigy of the recent graduate in the university's *aula magna* was meant as a prize. The portrait acknowledged that López Portillo was distinguished by a singular talent, but also that the community welcomed him as one of the very best in the university's academic body. Future students would admire him as a "monument," forever young and surrounded by other men worthy of note. The picture would be displayed in the university's paramount chamber: the *aula magna*, where examinations and major proceedings were held. In that chamber the university's activity was symbolically performed: on the one hand, examiners represented the institution's impermanent wisdom, and on the other hand, the portraits stood in for the timeless wisdom that sustained it—even when the men depicted were dead, they still constituted part of the corporation's scientific knowledge. The young man's identity and virtues were thus added to those of the corporation.

Juan Luis Maneiro (1744–1802), biographer of the Jesuits expelled from New Spain by Charles III in 1767, also recorded López Portillo's legendary examination and the Jesuits' decision to follow the university's example by commissioning a second portrait of him (fig. 10), this one for the General Function Room of the College of San Ildefonso, where it is still preserved.[30] San Ildefonso was established in 1618 by the Jesuits as a residential college for the sons of creole elites from all of New Spain, whose families paid tuition to lodge them in the city while they obtained their degrees at the Jesuit College of San Pedro y San Pablo and the Royal University of Mexico. The Jesuits instilled a strong spirit of fraternity and encouraged common religious practices among the college's members. In their turn, many former *colegiales*, after pursuing successful careers as royal or Church officials, became benefactors of San Ildefonso. In gratitude to these renowned former members and sponsors, the Jesuits had their effigies painted for the walls of the college's General Function Room (fig. 11). Students' examinations and private and public college proceedings were held there.

According to Maneiro, López Portillo's portrait for San Ildefonso was intended to inspire the students to follow his example. Besides the common elements taken from official portraits, his effigy shows him wearing the four hoods of

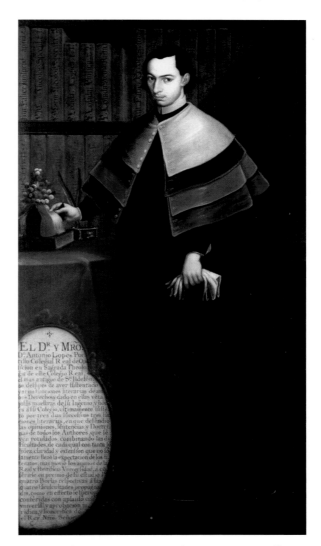

Fig. 10. Unknown artist, *Portrait of Antonio López Portillo y Galindo*. Mexico, 1754. Oil on canvas, 78 x 44⅛ in. (198 x 112 cm). General Function Hall, Antiguo Colegio de San Ildefonso, Mexico City.

the university's faculties and near a cap with four doctoral tassels referring to his exam. In the background is a library with the books whose authors he defended. López Portillo's modest demeanor highlights the values recognized by the social body that paid for the work, producing a correspondence between the literary description of his character and its pictorial form. This was undoubtedly the unknown painter's achievement, though word and image were ordinarily companions in corporate portraits, which included cartouches with a written description of the sitter's virtues or deeds. Texture and brilliance are obtained through strokes of light directly applied with the brush over some areas of the canvas, such as the sitter's hoods. Softened shadows applied to the face create the illusion of volume, while the inclusion of a high-placed source of light is the only suggestion of the passing of time.

Another portrait of López Portillo, signed by Mariano Vázquez in 1783, is preserved today at the Museo Nacional del Virreinato (fig. 12). It is unclear whether this is the one originally painted for the Royal University's *aula magna*, with some additions and modifications by Vázquez, or whether it is an entirely later work based on the 1754 original. López Portillo is shown as a more mature man, already a canon of the cathedral of Valencia in Spain, to which he was exiled in 1769 after being fired from his position as a prebendary in the Mexico City cathedral, charged with writing a series of pamphlets criticizing Archbishop Francisco Antonio de Lorenzana's anti-Jesuit pastoral letters. The date of the painting may be related to the model's death in 1780, and can be understood as a creole response to the metropolitan policy of reducing the number of creoles in the cathedral chapters and the royal *Audiencias*.[31] In this painting López Portillo is shown in a similar pose to that of the San Ildefonso portrait. However, some different qualities are evident in the treatment of light, volume, brush stroke, and texture. Vázquez includes a curtain in the back and toughens the sitter's facial features in order to suggest an older

Fig. 11. General Plan of the Antiguo Colegio de San Ildefonso, Mexico City. Number 7 corresponds to the General Function Hall. Taken from José Rojas Garcidueñas, *El antiguo Colegio de San Ildefonso* (México: UNAM, 1985).

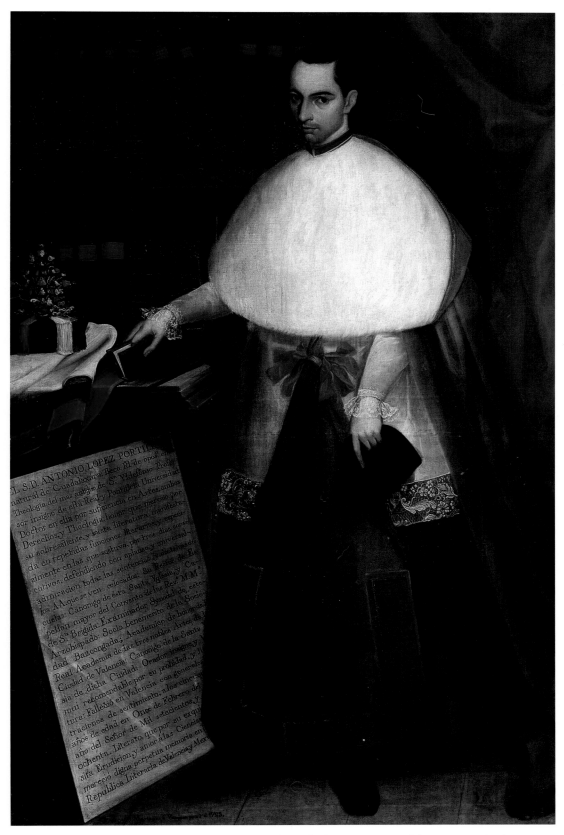

Fig. 12. Mariano Vázquez, *Portrait of Antonio López Portillo y Galindo*. Mexico, 1783. Oil on canvas, 74 x 49⅝ in. (188 x 126 cm). Museo Nacional del Virreinato, Tepotzotlán, Mexico. Reproduction authorized by the Instituto Nacional de Antropología e Historia.

age. The four hoods rest on the table by his side, as a memory of the great deed of his youth.[32]

López Portillo's portraits, and their sponsorship, reflect the way paintings were capable of presenting an articulate rhetoric charged with political overtones associated with the exhibition spaces. Maneiro's publication of López Portillo's biography along with his book on famous exiled Jesuits (even though López Portillo himself didn't belong to this order), and his mention of López Portillo's portrait at San Ildefonso, reveal a strong political purpose. Maneiro alluded to an empty space left behind after the savant was banished along with the Jesuit priests from San Ildefonso. At the same time, Maneiro also suggested that Portillo remained present through his portrait: these paintings ensured the permanence of individuals and their values (as long as the canvases were not censored or destroyed).

I have identified a number of eighteenth-century corporate portrait galleries in Mexico City, each of them used in special acts by its community. The exact locations are represented here by numbers superimposed on the plan of Mexico City drawn by architect Pedro de Arrieta and his colleagues in 1737 (figs. 13a and 13b). The first are the galleries of the viceroys in the Royal Palace and the *Ayuntamiento*. Then follow those of the archbishops at the cathedral; the renowned graduates of the university, the College of Santos, and the College of San Ildefonso; illustrious Augustinian friars portrayed for the imitation of young novices, in the College of San Pablo; the founders and distinguished members of the San Felipe Neri Oratory (shown in both its pre- and post-1767 locations); the intellectual heroes of the Franciscan order, whose portraits were kept in the convent of San Francisco; the elite of the city's secular clergy, in charge of the San Pedro Congregation and its hospital; the rich members of the board of the Cofradía del Santo Cristo de Burgos, from its assembly hall next to the convent of San Francisco; the benefactors and patrons of the Colegio de Vizcaínas; and the superiors of the order of San Camilo, or *padres agonizantes*. As we can see, the city devoted remarkable spaces to this identity display that brought inner and outer spectators together.

Fig. 13a. Pedro de Arrieta, Miguel Custodio Durán, Miguel José de Rivera, José Eduardo de Herrera, Manuel Álvarez and Francisco Valdés, *Plan of Mexico City*. Mexico, 1737. Oil on canvas. Museo Nacional de Historia, Mexico City. Archivo de IIE-UNAM. Reproduction authorized by the Instituto Nacional de Antropología e Historia.

Fig. 13b. Corporate portrait galleries in 18th-century Mexico City, indicated over a detail of Figure 13a.
1. Gallery of viceroys, Royal Palace.
2. Gallery of viceroys, City Hall.
3. Gallery of archbishops, Metropolitan Cathedral.
4. Royal University.
5. College of Santos.
6. College of San Ildefonso.
7. College of San Pablo.
8. San Felipe Neri Oratory (pre-1767).
9. San Felipe Neri Oratory (post-1767).
10. Convent of San Francisco.
11. San Pedro Congregation and Hospital.
12. Confraternity of Santo Cristo de Burgos.
13. College of Vizcaínas.
14. Convent of San Camilo.

Eighteenth-century New Spain was a society changing with the new social, political, and economic circumstances brought about by its own development and by Bourbon reforms. Yet amid those changes, one of its essential features, as a polity structured by the social bodies it comprised, remained vigorous for the rest of the colonial period and even after independence. These bodies, whether in the course of creation (like the Guadalupe Congregation of Querétaro), transformation (the viceroys), or even crisis (the Jesuit order), linked individuals to the world. Corporate portraits depicted institutional historicity, bestowing a sense of solidity and timelessness, and of social distinction. By showing symbols of power, they also represented the legitimacy of the corporations within the social, juridical, and political order. Individuals gained relevance as they belonged to a community or several communities, and since social corporations embodied their associates' collective values, this identity had a sturdy group component. Portrait galleries may have grown in number and importance because individuals could belong to several different corporations at the same time and deserve a painted memorial in all of them, as we have seen. In these spaces manifold social relations were so entwined that they altered the life of individuals.

The apparent simplicity of New Spanish portraits painted for eighteenth-century corporate galleries should be questioned in light of the many considerations and concerns behind their production: the artist's choice of a peculiar compositional format (including the picture's size and the sitter's pose) adequate to its communicative intent; the codification of the sitter's accompanying attributes; the correlation of text and image, used to explain the relationship between the sitter and the portrait's commissioning corporation; and finally, the effect of the joint appreciation of portraits and the architectural spaces for which they were destined. From the perspective of art history, the study of corporate portraits drives us to reflect on questions raised by the status of images, the search for naturalism, and the display of collective and individual identities, and also alerts us to rethink our methodological tools to go beyond identifying styles and delve into the problems of period reception. In other words, what is at stake here is the dichotomy between two forms of art history: one that conceives art as something configured by its interpreter and centered on its irreducible aspect; and another one determined to explain its subject through the context surrounding it.

**Notes**

I am grateful to Víctor Cuchí Espada for his help with Spanish-English translation, and to Huguette Palomino, Fernanda Fernández, and Iván Escamilla for their careful revision of the text.

[1] I am aware that the denomination "New Spanish" is not widely accepted, but I consider it useful since it specifies a phenomenon particularly related to a region and a period, such as the portraits I examine here.

[2] The first Spanish academic dictionary (published between 1726 and 1739) defines "corps," in its sixth sense, as follows: "CORPS. It is the sum of individuals comprising a People, Republic, or Community. . . . Sometimes it means the community and entirety of a Republic, in its formal sense" ["CUERPO. Se llama también el agregado de personas que componen un Pueblo, República, o Comunidad. . . . Significa, algúnas veces el común y el todo de una República en lo formal della (*sic*)"]. *Diccionario de la lengua castellana, en la que se explica el verdadero sentido de las voces, su naturaleza y calidad, con las phrases o modos de hablar, los proberbios o refranes, y otras convenientes al uso de la lengua, dedicado al Rey Nuestro Señor Don Phelipe V (que Dios guarde). A cuyas reales expensas se hace esta obra. Compuesto por la Real Academia Española* (Madrid: Imprenta de la Real Academia Española, 1729), http://web.frl.es/DA.html. Consulted 1 January 2015.

[3] There are two series of portraits of archbishops in the cathedral. The first, portraying them in full length, was begun in the late sixteenth century, but in the eighteenth century it was standardized in size by adding or cutting fabric, and by adding text in the lower section with the date of the sitter's death. The other was painted in the eighteenth century, with sitters in half length; it is discussed below.

[4] There is no reference to female corporate galleries yet.

[5] For instance, Jesús Romero Flores, *Iconografía colonial* (México: INAH, 1940); Josefina Muriel de la Torre and Manuel Romero de Terreros, *Retratos de monjas* (México: Jus, 1952).

[6] See *El retrato civil en la Nueva España*, exhibition catalog, October 1991 to January 1992 (México: Museo de San Carlos, 1991); Elisa Vargas Lugo, "Una aproximación al estudio del retrato en la pintura novohispana" and "El retrato de donantes y el autorretrato en la pintura novohispana," in *Estudios de pintura colonial hispanoamericana* (México: UNAM / Centro coordinador y difusor de Estudios Latinoamericanos, 1992), 29–46 and 47–54.

[7] For a critical review of the idea of the canon in art history, see Keith Moxey, *The Practice of Theory* (Ithaca, NY: Cornell University Press, 1994).

[8] Luis Ávila Blancas, *Iconografía* (Puebla: Impresos López, 1955); Tomás Pérez Vejo and Marta Yolanda Quezada, Coords., *De novohispanos a mexicanos: retratos e identidad colectiva en una sociedad de transición* (México: INAH, 2009)

(especially the chapter on the portrait hall of the Cofradía del Cristo de Burgos); Mónica Hidalgo Pego, "En busca de una imagen propia. La colección de retratos de colegiales de San Ildefonso de México," in Enrique González, Mónica Hidalgo Pego, and Adriana Álvarez Sánchez, Coords., *Del aula a la ciudad. Estudios sobre la universidad y la sociedad en el México virreinal* (México: UNAM / IISUE, 2009), 289–312; Michael A. Brown, "La imagen de un Imperio: el arte del retrato en España y los virreinatos de Nueva España y Perú," in Juana Gutiérrez Haces, Coord., *Pintura de los reinos. Identidades compartidas, Territorios del mundo hispánico, siglos XVI–XVIII* (México: Grupo Financiero Banamex, 2009), 4:1446–1503.

[9] Romero Flores, *Iconografía*; Bárbara Meyer, María Esther Ciancas, Manuel Ramos, and Clara García Ayluardo, *El otro yo del rey: virreyes de la Nueva España, 1535–1821* (México: CONACULTA / INAH / Editorial Porrúa, 1996); Inmaculada Rodríguez Moya, *La mirada del virrey. Iconografía del poder en la Nueva España* (Castellón: Universitat Jaume I, 2005); Michael Schreffler, *The Art of Allegiance: Visual Culture and Imperial Power in Baroque New Spain* (University Park, PA: Pennsylvania State University Press, 2007); Rebeca Kraselsky, *Galerías de retratos y cuerpo político. La representación de los virreyes novohispanos. Siglos XVI y XVII* (master's thesis in art history, UNAM, 2013).

[10] Other noteworthy contributions on New Spanish portraiture are included in various exhibition catalogs where portrait galleries have been correctly, if briefly, considered as spaces relevant for the understanding of the genre and its formal characteristics. See *El retrato novohispano en el siglo XVIII*, exhibition catalog, October 1999 to February 2000 (Puebla: Museo Poblano de Arte Virreinal / Secretaría de Cultura del Estado de Puebla, 1999); Elisa Vargaslugo, Pedro Ángeles, Pablo Escalante, et al., *Imágenes de los naturales en el arte de la Nueva España, siglos XVI al XVIII*, exhibition catalog (México: Fomento Cultural Banamex / UNAM / IIE / DGAPA, 2005); Rebeca Kraselsky, "Apuntes sobre el retrato novohispano, sus fórmulas y lecturas," in *Imágenes del mexicano*, exhibition catalog (México: BOZAR EXPO / MUNAL, 2009), 373–385.

[11] "RETRATO, Véase Imagen," and "IMAGEN, Semejanza puntual de alguna cosa corpórea." Antonio Palomino, *Museo pictórico y escala óptica*, Prologue by Juan A. Ceán y Bermúdez (1715–1724; reprint Madrid: Aguilar, 1988), I, Index of terms, 1:665, 667.

[12] "RETRATAR: copiar o formar la puntual imagen de un sujeto." Palomino, *Museo*, 1:667, and Chapter 1. Palomino's ideas were rooted in the Thomistic conception, which served as the basis of every reflection on the subject within the Catholic cultural context. For Thomas Aquinas, representation "contained" a similarity with the "thing," and so the image was related to its prototype through similarity. The theologian defended the worship of religious images, considering them intermediaries between the prototype and the model, which they represented and toward which they conducted the worshipper's veneration. See Felipe Pereda, *Las imágenes de la discordia. Política y poética de la imagen en la España del 400* (Madrid: Marcial Pons, 2007).

[13] "Formar la imagen de algún sujeto, que sirve de original para sacarla enteramente parecida, o en la pintura, o en la escultura o grabándola." Second sense: "Vale asimismo [por] imitar alguna cosa, hacerla semejante." *Diccionario de Autoridades*, http://buscon.rae.es/ntlle/SrvltGUIMenuNtlle?cmd=Lema&sec=1.0.0.0.0, consulted 1 January 2015.

[14] "RETRATO . . . pintura o efigie que presenta a alguna persona o cosa"; "Efigie . . . Imagen, figura, bulto y hechura, semejante de alguno" [1732]. And for the "portrayer" definition: "RETRATADOR: El que retrata." *Diccionario de Autoridades*, http://buscon.rae.es/ntlle/SrvltGUIMenuNtlle?cmd=Lema&sec=1.0.0.0.0, consulted 1 January 2015.

[15] Susann Waldmann, *El artista y su retrato en la España del siglo XVII. Una aportación al estudio de la pintura retratista española* (Madrid: Alianza Forma, 2007), 155; Javier Portús Pérez, "Varia fortuna del retrato en España," in *El retrato español. Del Greco a Picasso*, catalog of the exhibition from 20 October 2004 to 6 February 2005 (Madrid: Museo Nacional del Prado), 16–67.

[16] "Dicha será . . . encontrar el pintor con sujeto, que se contente con lo parecido, sin buscar lo lisonjeado; siendo cierto que en los retratos, lo más perfecto, es lo parecido: hay casos en que el pobre pintor se ve en una muy notable tribulación; porque si da gusto a el dueño, pierde el crédito con los desapasionados que conocen lo desemejante; y si atiende a lo parecido, queda disgustado el dueño, y mal pagado el pintor, sin saber como escapar de alguno de estos dos escollos." Palomino, *Museo*, 2:199.

[17] "los pintores no estamos en tan ínfimo estado que no seamos capaces de hacer alguna merced, aun a los mismos Reyes. Y así siempre, que en el rostro se pudieran moderar algunas cosas, que no favorecen al sujeto, como alguna arruguilla, alguna flaqueza, o mal color, sin faltar a los contornos . . . se debe así ejecutar; pues aunque entonces por injuria de la edad, o de otro accidente, no esté puntualmente así, algún tiempo lo estaría." Palomino, *Museo*, 2:200.

[18] Rogelio Ruiz Gomar has stated that "painters in New Spain focused on following accepted guidelines for the official and the court portrait in the Old World, without introducing major changes." Later on he describes the generality of New Spanish portraits such as those discussed here: "The disposition of the individuals portrayed was almost always the same: standing and three quarters, although there are many that portray their models from the waist up. In turn, there are few examples in which the model is seated, fully frontal or in profile . . . the gaze is seldom eloquent; it is mostly severe or more still, distant, and inexpressive." The author continues, "the model is carefully dressed with the attire suitable to him, and surrounded by everything that characterizes him. In addition, there are four elements which, apart from social condition, sex, and provenance, are repeated systematically: drapery, a small furnished table, the coat of arms, and an inscription with his name and history. The table, alongside the figure, might be covered with a tablecloth, and over it there are several objects that underscore the individual's personality and social position." Rogelio Ruiz Gomar, "La pintura de retrato en la Nueva España," in *El retrato novohispano*, 9.

[19] Harry Berger, *Fictions of the Pose: Rembrandt against the Italian Renaissance* (Stanford, CA: Stanford University Press, 2001).

[20] My argument is based on Stoichita's text referring to *Las Meninas*. Víctor Stoichita, "*Imago regis*: teoría del arte y retrato real en *Las Meninas* de Velázquez," in Fernando

Marías, ed., *Otras Meninas* (España: Editorial Siruela, 1995), 183.

[21] "Aliud est imago, aliud aequalitas, aliud similitudo: ubi imago, ibi continuum similitudo, non continuum aequalitas, ubi aequalitas, continuum similitudo, non continuum imago; ubi similitudo non continuum imago, non continuum aequalitas," Cardinal Paleotti cited Aristotle and Saint Thomas. Gabriele Paleotti, *Discorso intorno alle immagini sacre e profane* (1582) (Milan: Librería Editrice Vaticana / Cad & Wellness, 2002), 17.

[22] Paleotti, *Discorso*.

[23] Power is the capability to command. According to political theory set forth since the sixteenth century, the king had absolute power, but could delegate ordinary power to whomever he chose. Authority was the acknowledgment of that power, either by men or by God, as was sustained in the Spanish monarchy. In the case of the viceroy, power came from the king, of whose power he partook. The king reserved to himself the right to revoke the viceroy's power, as well as his authority. Majesty could not be transferred, and was grounded in divine election. See Iván Escamilla, "La corte de los virreyes," in Antonio Rubial García, Coord., *Historia de la vida cotidiana en México. La ciudad barroca* (México: Fondo de Cultura Económica, El Colegio de México, 2005), 371–406; and Kraselsky, *Galerías de retratos*. During the eighteenth century, viceroys became even more aware of the limitations of their power, as the procedures for appointing and supervising them became stricter under the house of Bourbon. Some authors have argued the opposite view, that the viceroy was an alter ego of the king with unlimited power through all of the viceregal period. See Víctor Minguez, *Los reyes distantes. Imágenes del poder en el México virreinal* (Castelló: Universitat Jaume I, 1995); Rodríguez Moya, *La mirada del virrey*.

[24] There are two texts about the archbishops' galleries essential to their interpretation: Esther Acevedo, "Sala capitular," in *Catedral de México. Patrimonio artístico y cultural* (México: SEDUE / Fomento Cultural Banamex, 1986), 58–79; Rogelio Ruiz Gomar, "Los arzobispos de México y sus retratos," in *Sociedad de Historia Eclesiástica Mexicana. Memoria 1995–1996* (México: Textos dispersos ediciones, 1997), 115–129.

[25] Ruiz Gomar, "Los arzobispos," 119.

[26] Ruiz Gomar, "Los arzobispos," 124.

[27] Ruiz Gomar, "Los arzobispos," 122, 124–125.

[28] "En la hermosa Sala Capitular o de Juntas que tiene nuestra Ilustre Congregación, en la vivienda contigua a su iglesia, están colocados como veinte y cuatro retratos de algunos de sus fundadores, de varios bienhechores y de muchas personas condecoradas que la han honrado y distinguido, constituyéndola en tan gran lustre y esplendor; los que conserva allí para perpetuar de esta manera su noble agradecimiento y su distinguida gloria." José María Zelaa e Hidalgo, *Glorias de Querétaro en la fundación y progresos de la muy ilustre y venerable congregación eclesiástica de presbíteros seculares de María Santísima de Guadalupe de México . . .* (Querétaro: Imprenta Guadalupana, 1926), chapter 12, 168. (Reprint of the original edition, "Lustre de esta venerable congregación, y número de individuos que ha tenido y tiene en el día," México: Mariano de Zúñiga y Ontiveros, 1803).

[29] Emphasis mine. López Portillo's examination took place on 28 May, 6 June, and 11 June 1754. "Y la universidad alborozada, satisfecha, y aun agradecida, convocó aquella misma noche su claustro pleno, y decretó *premiar* a su alumno concediéndole . . . las cuatro borlas de maestro en artes, y doctor en teología, cánones y leyes, *y mandando colocar su retrato en el general grande para estímulo de la juventud y monumento perpetuo* de la literatura de Portillo, cuyo mérito, precedido de un juramento de los doctores que lo habían examinado, recomendó al rey dicha academia." José Mariano de Beristáin y Souza, *Biblioteca hispanoamericana septentrional o catálogo y noticias de los literatos, que nacidos o educados, o florecientes en la América Septentrional española, han dado a luz algún escrito, o lo han dejado preparado para la prensa* (México: Ediciones Fuente Cultural, 1947), 4:157.

[30] Juan Luis Maneiro, *Sobre la vida de tres mexicanos ilustres (siglo XVIII)*, trans. Julio Pimentel Álvarez, Serie didáctica 15 (México: UNAM / Instituto de Investigaciones Filológicas, 1990), 37–39. Maneiro wrote López Portillo's biography as a supplement to his book *De vitis aliquot mexicanorum aliorumque qui sive virtute, sive litteris Mexici in primis floruerunt* [On the lives of some Mexicans and others who formerly flourished in Mexico, either by their virtues or their knowledge] (Bologna, 1791).

[31] See Dorothy Tanck de Estrada, "El rector desterrado. El surgimiento y la caída de Antonio López Portillo, 1730–1780," in Enrique González and Leticia Pérez Puente, Coords., *Permanencia y cambio I. Universidades hispánicas 1551–2001* (México: UNAM / CESU / Facultad de Derecho, 2005), 181–196.

[32] It would be quite interesting to subject this portrait to technical studies (such as X-rays) in order to ascertain whether it was painted over.

# Reading Dress in New Spanish Portraiture
## Clothing the Mexican Elite, circa 1695–1805

*James Middleton*

## Why Portraiture?
## Why the Eighteenth Century?

The story of the clothing seen in New Spanish portraits is not the whole story of dress in New Spain. Dress historians rely heavily on portraits, but for colonial Mexico, the narrative they illustrate belongs only to that small group of people who were "sufficiently important" to have their likenesses recorded. The *criollo* elite (people of pure Spanish blood born in the New World) wore predominantly Spanish and European-style clothing, and held themselves aloof from the stylistic syncretism spawned by those *mestizo* people (of mixed blood) whose images can be seen in *casta* paintings, among whom the most interesting and individual New World styles were generated. It is a mistake, however, to presume that—because the upper classes wore European-style clothing—their dress lacks interest compared to that of lower-status people: transformed by the *genius loci* of Mexico, the European dress of elite New Spaniards was creolized, becoming as distinctly American as the European architecture, painting, and sculpture they patronized.

Even for those "sufficiently important" to have been painted, portraiture becomes useful as a tool for understanding dress only after about 1700. Before the eighteenth century, unlike the rest of Europe, where bourgeois or civil portraiture had long been practiced, the Hispanic world observed rather stringent rules-of-appropriateness governing who might, and who might not, be the subject of a portrait. Under these rules, formulated by late Renaissance theorists, to be the subject of a portrait was a privilege limited to *personages*: the king, his family, important nobles, and notable officials both ecclesiastical and secular.[1]

But certainly not a tradesman, however wealthy! For most of the sixteenth and seventeenth centuries, it would have been the height of presumption for a wealthy Spanish or New Spanish merchant to commission a portrait. This began to change with the relaxation of mores that came with the change, in 1700, from the Habsburg to the Bourbon dynasty. Wealthy colonial merchants now became personages in their own right, even being awarded (or purchasing outright) titles of nobility.[2] The Italian traveler Francesco Gemelli Careri noted in 1696 that "There are in Mexico an abundance of Knights [of Santiago] and other Orders, who sell Cloth, and Silk, and Chocolate and other things of less value, saying this in no way lessens their gentility, they having a Warrant of the Emperor Charles V for so doing."[3] This upstart elite recast their ancestors' fortresslike sixteenth- and seventeenth-century townhouses as eighteenth-century *palacios*, and commenced having portraits painted of themselves, their sons, wives, and daughters to fill their newly patrician walls.

At the time of the Bourbon accession, as Spain and its empire opened as never before to cosmopolitan influences, European fashion—especially women's fashion—was entering a period of unprecedented change. In England the men's suit assumed the three-piece form that it retains to this day, while in France, the establishment of a guild of female *couturières* who made clothes specifically for women and children introduced new styles and shapes for women's clothing that were eagerly imitated in the Americas.[4]

The relatively few extant portraits that predate the eighteenth century[5] show that New Spanish elite dress in that era had been entirely Spanish: local variation was unknown and indigenous influence unthinkable. After 1700, although upper-class dress remained impervious to native influence, the absorption of international influences was coupled with a number of localisms that together demonstrate the inventiveness of Mexican tailors and their patrons. This cosmopolitan spirit would be recorded in the exponential growth of nonofficial portraiture after about 1700. Along with the concurrent growth of the *casta* genre, this helps us to draw a fuller picture of what eighteenth-century people wore than we are able to draw for the previous two centuries.

Because the Frederick and Jan Mayer Collection at the Denver Art Museum possesses a nearly

Fig. 1. Luis Juárez, *Birth of the Virgin*. Mexico, 1615–1625. Oil on copper, 39¼ x 32¼ in. (99.7 x 81.9 cm). Denver Art Museum, Gift of Frederick and Jan Mayer, 2011.425.

encyclopedic range of portraits, covering most of the sartorial developments from the early eighteenth century through the early nineteenth, we can tell the story of eighteenth-century Mexican clothing primarily through images from this important collection.

## Reading Dress

The most basic aspect of "reading" historic dress, one that precedes any understanding of styles, motifs, and trimmings, is understanding structure: comprehending the physical object behind the painted image. Any piece of clothing consists basically of a number of separate flat planes engineered to fit a curved surface (the body). Different eras have found different solutions to this common problem. Understanding the way the clothes of a particular time function can be of particular benefit in our field, where firm dates have proven elusive for so many pictures and objects. Understanding structure helps us to see the difference between superficially similar garments that are separated by decades or between a real period garment and a later version, and even to detect fraud.

The first step in reading unfamiliar dress is understanding underwear. Although outer garments changed radically during the viceregal era, underwear remained essentially the same. Before the advent of dry-cleaning (the Dry Clean Coalition dates to 1840s Paris[6]), it was essential that a washable and absorbent layer be worn between skin and outer clothing. This was the shirt (*camisa*), the early modern West's most basic garment, a T-shaped tunic of linen or cotton[7] that was made in slightly different versions. Men wore a long-sleeved, thigh-length garment with button closures. The women's model was longer, with a low, wide neck, drawstring closures, and shorter sleeves. In Spanish, the word *camisa* serves for both the men's and women's version, though in today's English, the French *chemise* is generally used for the women's garment. The early modern chemise was also the source of the blouse traditionally associated with indigenous women, as can be seen on the Indian servant figure at the lower left of the circa 1625 painting by Luis Juárez of the *Birth of the Virgin* (fig. 1). In this scene set in the biblical era, figures anachronistically wear clothing

of the early modern period. The Indian woman's chemise is embroidered in black (silk?) at the neck; a plainer though finer, long-sleeved version of the garment can be seen on the figure standing above her, presumably a Spanish woman.

The shirt/chemise was often lavishly trimmed, and some part of it was generally visible, calling attention to the clean habits of the wearer, or their lack (references in literature to the condition of people's "linen" refer to this practice). The ruffles visible at the neck and arms of the eighteenth-century women's portraits seen in this study are the decorative edging of the chemise, not trimming attached to the bodice.

Men wore washable linen or cotton underdrawers. These changed very little from the medieval era until the invention of elastic: an extant pair of men's drawers in the collection of the Metropolitan Museum is dated "1800–1940."[8] Surprisingly, women—unless they were actresses or whores, beyond the pale of respectability—wore no underdrawers.[9] The nineteenth-century introduction of underdrawers was strongly resisted by proper ladies![10]

Both sexes also wore stockings, for which there was no gender differentiation. These were often decorated with embroidery at the ankles, called "clocking," and were gartered just above the knee.

Women also wore garments that changed the apparent shape of the body. The inverted-cone shape of the standard European bodice can be seen in its simplest form on the standing left figure of Luis Juárez's *Birth of the Virgin* (fig. 1). Like men's undershorts, the basic form of women's bodices changed very little between 1550 and 1800. This shape was achieved by means of a corset, or "stays" (fig. 2). Worn on the torso over the chemise, the corset was made of two or more layers of fabric, with flexible whalebone or reeds inserted into channels quilted between the layers. This garment was closed with lacing (like shoe lacing) at the front, the back, or both. The tightness or looseness of the lacing controlled the corset's fit.

On the lower body, women used a variety of structures to distend their skirts. The *vertugade*, or farthingale, was used from the 1520s to the 1640s. "Farthingale" is an Elizabethan English corruption of the Spanish word *vertugade*. The French called it a *vertugadin*. The sixteenth- and

seventeenth-century *vertugade* was a cone-shaped underskirt with graduated hoops of whalebone or of the saplings (*verdugos*) that gave the garment its name. Spain in fact launched the fashion for hoops during the sixteenth century, when, at the height of its imperial power, it briefly led Western fashion.[11]

The conical *vertugade* was sometimes amplified with stuffed pads at the hip (fig. 2). Barely noticeable at first, these increased in size through the middle years of the seventeenth century, when these pads (which resembled airplane neck pillows and were called "bum-rolls" in English) gave their form to the *guardainfante* hoop (called a drum or cartwheel farthingale in English) made famous by Velázquez's "Infanta" paintings.

After about 1680, the cone-shaped skirt silhouette (now called a *sacristán*), achieved with either hoops or heavily starched petticoats, returned. In New Spain this shape (generally retaining a

Fig. 2. Complete set of mid-eighteenth century women's undergarments including a chemise, corset, hip pads, and hoop skirt (*vertugade*). Drawing by the author.

modest hip-pad) remained the preferred fashion until about 1800, although a small number of elite women wore the dome-shaped panniers, or side-hoops (*tontillos* in Spanish), that became fashionable in the eighteenth century and are discussed below. The pannier gave width to the wearer's skirt, but relatively little depth (seen from above, the skirt would look like a shallow oval). It might be a true hoop skirt, a cage-like openwork structure, or a pair of basketlike side pieces (*pannier* means "basket" in French) held at the hip by a waistband. But while they loom artifically large in the portrait record, panniers—and the international-style gowns that were worn with them—were never truly popular in the New World: it is probable that most New Spaniards beyond central Mexico City never saw a gown with this shape.

### Mexico City in the Early Eighteenth Century

Mexico City was an important entrepôt for luxury products, like the Asian silk and American chocolate noted in the quotation above, making their way to Europe. This led to the development of a plutocratic aristocracy, which, as Gemelli Careri noted, did not consider its gentility diminished by trading in such goods. The creation of this new class was the pivotal factor in the exponential growth, after about 1700, of nonofficial, "civil" portraiture.

Cristóbal de Villalpando's canvas of Mexico City's *Plaza Mayor*, painted about 1695[12] (fig. 3), shows the diversity of sartorial choices available to New Spaniards living in what was surely the world's most diverse urban landscape, with more different types of people wearing more different kinds of clothes than could have been seen anywhere else on earth.[13] Elite men and women in purely European garb, middle- and artisan-class people in more local styles, indigenous people—both wealthy and poor—all wear distinctive and identifiable clothes.

### Early Eighteenth-Century Men

One of the notable features of Villalpando's canvas is his depiction of two styles of dress for upper-class men: the recently introduced Anglo-French men's suit (probably of fine wool with applied metallic lace) seen at the far left of the detail co-exists with the old-fashioned black wool (or silk)

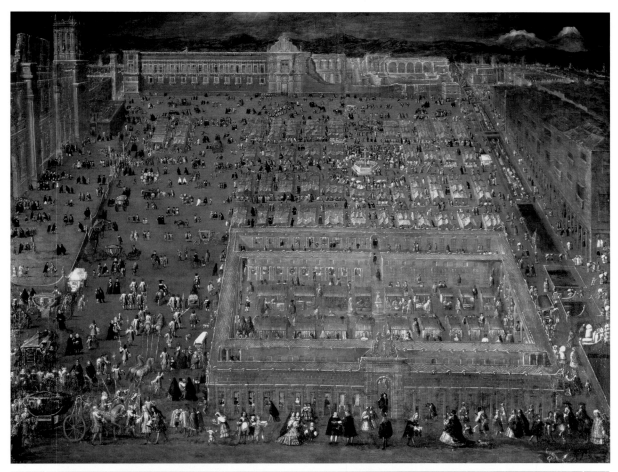

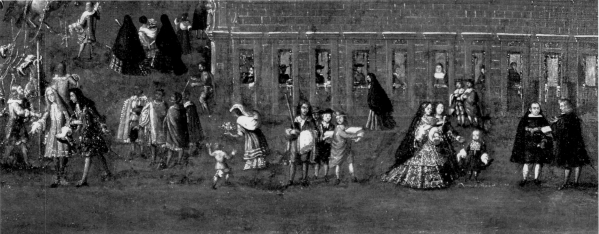

Fig. 3. Cristóbal de Villalpando, *The Main Plaza of Mexico City* (top, overall and bottom, detail). Mexico, circa 1695–1700. Oil on canvas, 70⅞ x 78¾ in. (180 x 200 cm). Private collection, Corsham Court, Bath, UK.

Fig. 4. Nicolás Rodríguez Juárez, *Portrait of Francisco Fernández de la Cueva, Duke of Alburquerque.* Mexico, circa 1708. Oil on canvas, 36⅝ x 27⅝ in. (93 x 70.2 cm). Museo Nacional de Historia, Mexico City, Mexico. Reproduction authorized by the Instituto Nacional de Antropología e Historia.

and linen *golilla* ensemble of the two men on the far right. The *golilla* ensemble takes its name from the rigidly starched linen collar (fig. 4) that had been ordained by Philip IV in a 1623 edict prohibiting neck ruffs, which he considered foreign (i.e., French) and wasteful:[14]

> Item: We command that all and sundry persons, of whatever state, quality, or condition they may be, shall and must wear *valona* collars plain, and without invention, laces, cutwork, drawnwork, or any other trimming, neither dressed with gum, blue powders, nor any other color, nor with iron, although we permit the use of starch.[15]

Before the twentieth century, gentlemen's dress collars were separate from shirts and served as a further guard against filth. Technically speaking, the *golilla* was the wire and cardboard support for a detachable heavily starched *valona* (Walloon) collar, but the support has given its name to both the collar and the deeply conservative ensemble with which it was worn.

The *golilla* had the dual advantage of using far less cloth than a ruff and being fantastically uncomfortable as well, presenting the wearer's head as if on a platter. The Duke of Alburquerque (served 1702–1710) was the last viceroy to wear the *golilla* (fig. 4)—perhaps a political signal, since Alburquerque was known to favor the house of Austria over the house of Bourbon in the contest for the Spanish succession, and had been sent to Mexico to keep him out of mischief.[16] In addition to the *golilla*, the duke's ensemble includes a black silk damask jerkin with pendant sleeves embroidered in red silk with the cross of Santiago, fitted inner sleeves, and lace cuffs. Officially, the *golilla* was never completely eclipsed. It continued to be worn by certain officials, such as judges of the *Audiencia*, as well as by conservative gentlemen, and particularly by scholars.

A flood of French influences is said to have overwhelmed the Hispanic world after the accession, in 1700, of the Bourbon dynasty.[17] This is an overstatement. The new influences were more international than French, and had begun well before the change of dynasty.[18] Carlos II disliked the *golilla* and adopted the Anglo-French men's

suit—the direct ancestor of today's three-piece suit—after about 1675, as can be seen in Claudio Coello's famous canvas of *La Sagrada Forma* (c. 1685–1690), depicting Carlos II adoring the Sacrament, painted for the Escorial Palace outside Madrid.

The three-piece, Anglo-French men's suit was a hallmark of early modernity. Among the most important social developments of the later seventeenth century, it inaugurated the trend toward simplifying both male and female dress that continues to this day.[19] At the time of the Stuart restoration (1660), following a decade of Puritan simplicity, English gentlemen were reluctant to return to the elaborate dress worn in other European courts. (A contemporary French men's court ensemble might incorporate as much as two hundred yards of ribbon![20]) English gentlemen, and their tailors, evolved a simple style consisting of a jacket, waistcoat (vest), and breeches that is easily recognizable as the origin of today's three-piece suit. After initial resistance, the mode was taken up in France. Approved for court wear by Louis XIV in about 1670,[21] it was quickly adopted in the rest of the European sphere, the New World not excepted. Indeed, the assumption by Spanish colonial gentlemen of an imported modern style may be the beginning of the brand of international modernity that would overwhelm locally generated Spanish-American culture in the nineteenth century, as the newly independent republics of the Americas strove to take their place among the nation-states of the modern world.

The Anglo-French suit's pre-Bourbon appearance in the New World can be seen in Nicolás Rodríguez Juárez's 1695 portrait of the young Manuel Fernández de Santa Cruz (fig. 5). Don Manuel's jacket in the modified Anglo-French style, identical to those worn by Carlos II and the Spanish gentlemen in *La Sagrada Forma*, has extremely short sleeves that show a large expanse of his (immaculate) linen shirt. His lace *valona* collar resembles a later eighteenth-century cravat (*corbata*), but is in fact an unstarched collar of the same type as the *golilla*.

By the second decade of the eighteenth century, a more fitted version of the men's jacket appeared, like that worn by Alburquerque's successor, the Duke of Linares, painted about 1710 by Juan

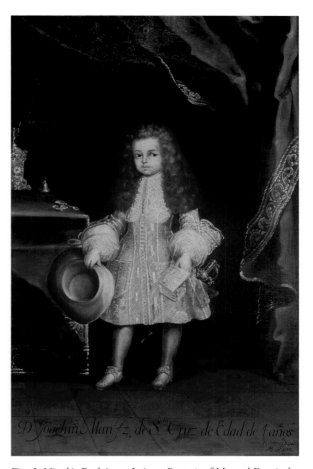

Fig. 5. Nicolás Rodríguez Juárez, *Portrait of Manuel Fernández de Santa Cruz*. Mexico, 1695. Oil on canvas, 63 x 42½ in. (160 x 108 cm). Museo Nacional de Arte, Mexico City, Mexico. © D.R. Museo Nacional de Arte / Instituto Nacional de Bellas Artes y Literatura, 2016

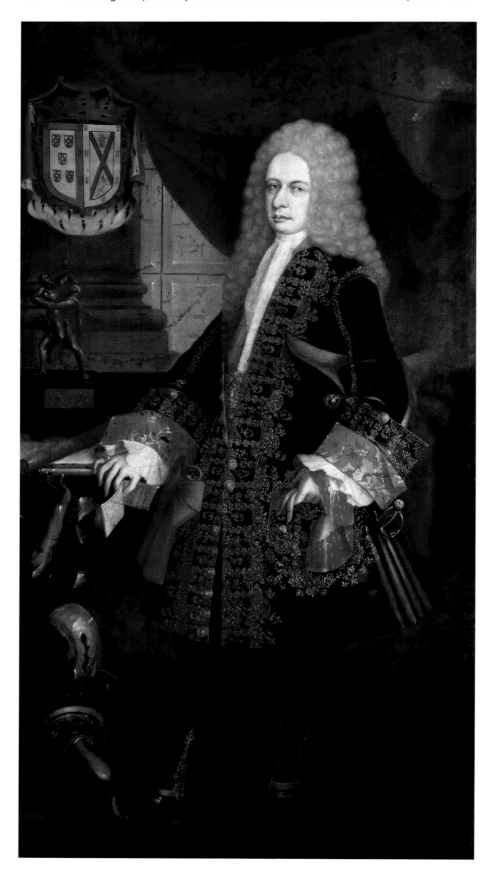

Fig. 6. Juan Rodríguez Juárez, *Portrait of Viceroy Alencastre Noroña y Silva, Duke of Linares*. Mexico, circa 1717. Oil on canvas, 87 x 51 in. (221 x 129.5 cm). Museo Franz Mayer Collection, Mexico City, Mexico.

Rodríguez Juárez, and seen here in the less well-known version of the painting from the Museo Franz Mayer (fig. 6). Linares's heavily embroidered, deep blue velvet jacket is identical in every detail to jackets worn in Europe: the sleeve has begun to lengthen, and the drooping *valona* collar has been replaced by a simple white neckcloth or cravat—the ancestor of today's necktie. The long sleeves of his (Asian?) brocade waistcoat roll over his jacket cuffs, and his silk stockings are embroidered with "clocks" at the ankle. The red ribbon hanging from his pocket is attached to the gold key that marks him as an honorific gentleman of the king's bedchamber.

Linares's ensemble has often been cited as a prime example of French influence in the New World.[22] Indeed, His Excellency probably thought he was dressing in the French style, since Madrid received the new international styles from Paris and called them "French"—then, as now, often shorthand for "in the latest and most fashionable style." That we still call these international styles "French" may be the ultimate triumph of Louis XIV's publicity machine, which, from the 1670s, aggressively branded French luxury products as the finest available.[23]

French goods had long been associated—as indeed they still are—with a kind of vaguely naughty luxury. This impression was only enhanced when Philip IV sourly noted his preference for textiles "made within these realms" (which, confusingly, included textiles from the Habsburg-ruled Spanish Netherlands and from the Spanish-controlled territories of Milan and Naples). Indeed, a snobbish notion of "Frenchness" is hard-wired into Spanish luxury consumption in ways that can be frustrating to the researcher: much of current dress scholarship in Spain and Spanish America is content to give the French name for the (demonstrably Spanish) item of dress under discussion, in a misguided effort to demonstrate that Hispanic elites of the past were as fashionable as anybody else.

This has been going on for so long that it has given some early (baseless) assertions of "Frenchness" the authority of a primary source: the Lima clergy saw the devastating 1746 earthquake as God's judgment on "French fashions,"[24] and the Mexican insurrectionist Ignacio Allende decried the "Frenchified and corrupt" ways of

elites.[25] Historians have too often accepted such contemporary judgments uncritically, but what did the Lima clergy—or a provincial New Spanish soldier—actually know about French culture?

There are, however, elements of indubitably French origin in Viceroy Linares's ensemble, although it is an open question whether these indicate actual French influence. His full-bottomed wig is the most visible of these. The powdered wig was among the longest-lived of French-inspired styles. It had been adopted as a gesture of deference to their elders by younger French courtiers during the declining years of Louis XIV,[26] and it was worn in New Spain until the end of the wars of independence. Men's formal wigs and women's formal hairstyles are some of our most useful tools for dating viceregal portraits. Hairstyles changed more regularly than clothing styles, and they were less varied, there being only a small number of fashionable styles in any given number of years. His Excellency's powdered, full-bottomed peruke in the full Louis XIV mode securely dates this painting to the era between about 1695 and 1720. Happily, the viceroy's known dates of service (1711–1716) further narrow the time period.

He carries his hat—which he cannot wear because it will ruin his coiffure, but without which he is not fully dressed—as a *chapeau-bras*, or "arm hat."[27] Later in the eighteenth century, such hats will be made specifically for the purpose of being carried, never to be worn. Finally, he wears the red heels that assure us that he is of the highest nobility. These were ordained for the high French nobility by Louis XIV in the 1670s and became a coveted status object. Although French in origin, red heels quickly became a fashionable perk of the highborn all over Europe and were even worn by Louis's archenemy, William of Orange.[28]

Although the Anglo-French suit would be embellished during the coming century in ways that obscured its apparent simplicity, its cut and construction remained simple, and would become simpler still. Indeed, its basic components of jacket, waistcoat, trousers, shirt, and tie have survived for more than three hundred years with no sign of fading from view.[29]

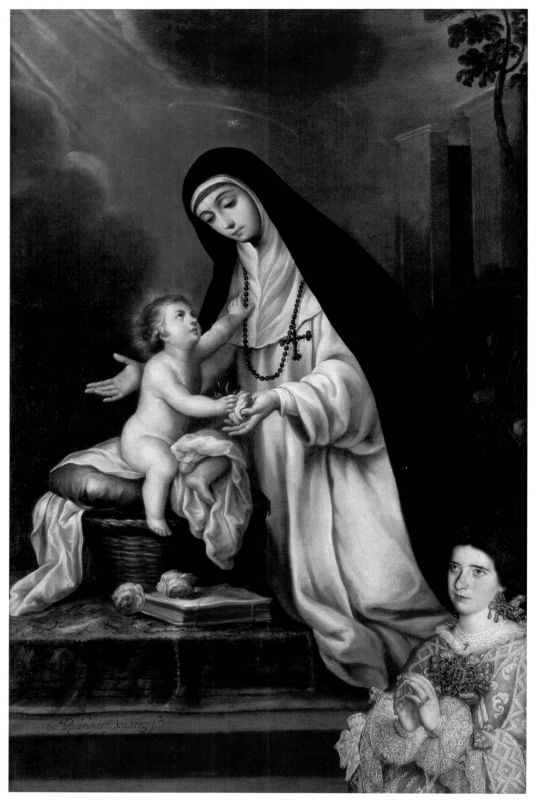

Fig. 7. Juan Rodríguez Juárez, *Saint Rose of Lima with Christ Child and Donor* (above, overall and opposite, detail). Mexico, circa 1710–1720. Oil on canvas, 66 x 42 in. (167.6 x 106.7 cm). Denver Art Museum, Gift of the Collection of Frederick and Jan Mayer, 2014.216.

### Women, 1700–1750

While women have traditionally been censured as "slaves to fashion,"[30] in New Spain, and in Spanish America in general, it was men who slavishly followed European modes in their quest to be seen as modern European gentlemen. Female dress was strongly influenced by international modes, but after 1700, colonial women rarely wore unedited versions of European styles. Rather than copying their peninsular cousins, New Spanish women began to develop styles that were quite different from peninsular modes.

A case in point is the donor figure in a painting by Juan Rodríguez Juárez depicting *Saint Rose of Lima with Donor*, c. 1710–1720 (fig. 7). The subject wears a loosely fitted tunic of silk damask, probably Asian, with applied silk braid and embroidery, over a linen chemise lavishly trimmed with imported lace, both probably Flemish, with contrasting brocade-woven silk ribbons and spectacular jewels. The dress we see in portraits can be maddeningly vague. The damask worn by the lady is painted in almost microscopic detail, but we can't see enough of the costume itself to make out how it works. The lady's tunic differs markedly from the contemporary peninsular style that can be seen on the two ladies in the center right foreground of Villalpando's painting of the Plaza Mayor (see fig. 3), who wear the conical skirt silhouette (called a *sacristán* hoop) that would remain New Spain's most favored style through the end of the eighteenth century. The dress worn by Juarez's donor figure seems quite similar, however, to informal clothes seen in *casta* paintings, in which some female figures wear a loose tunic such as the red one seen in figure 8, which seems about equally related to the indigenous *huipil* (fig. 9) and seventeenth-century Netherlandish women's jackets, like those in the domestic scenes of Vermeer and de Hooch (fig. 10).[31]

### Early to Mid-Eighteenth-Century Women: Construction *a la Española* and the *Casaquín* Bodice

The informality of the garment worn by the lady in figure 7 makes it an unusual choice for a portrait garment, and makes the painting the more valuable as a record of the informal dress of an extremely formal era. The conventional option

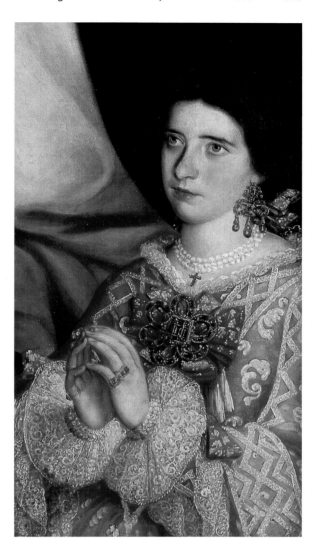

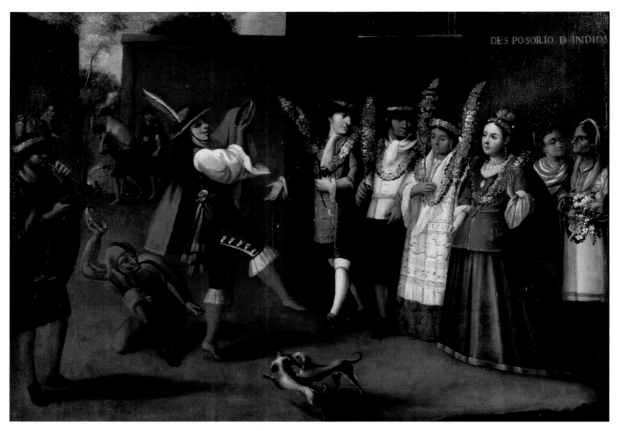

Fig. 8. Juan Rodríguez Juárez (attributed), *Indian Wedding*. Mexico, circa 1710–1725. Oil on canvas, 40 x 57 in. (101.6 x 144.8 cm). Museo de América, Madrid, Spain.

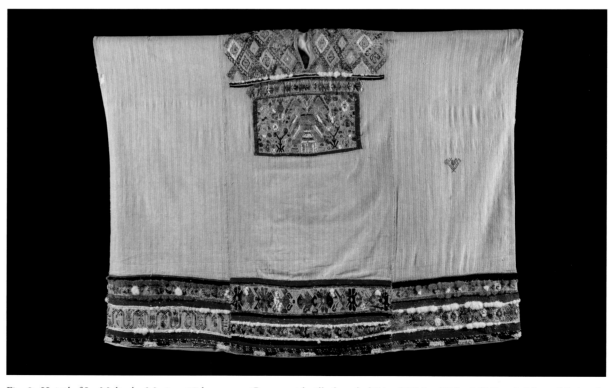

Fig. 9. *Huipil of La Malinche*. Mexico, 18th century. Cotton with silk thread, 47¼ x 55¼ in. (120 x 140.3 cm). Museo Nacional de Antropología, Mexico. Reproduction authorized by the Instituto Nacional de Antropología e Historia.

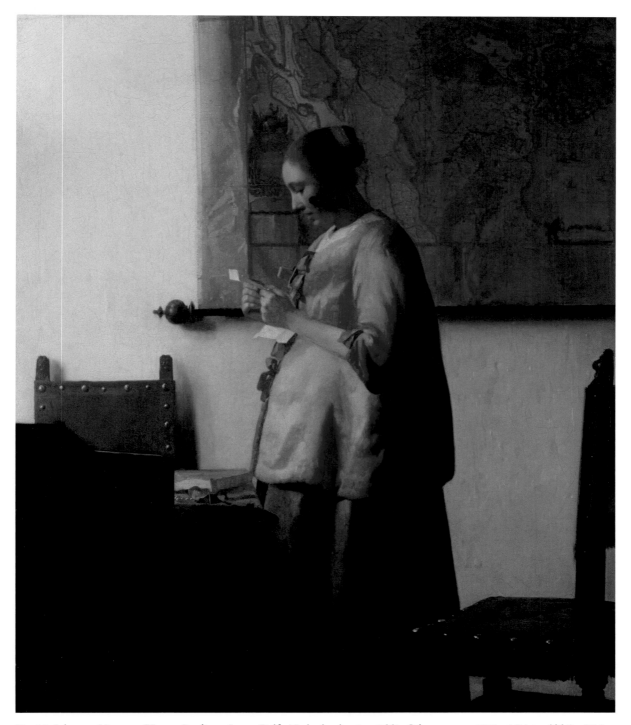

Fig. 10. Johannes Vermeer, *Woman Reading a Letter*. Delft, Netherlands, circa 1663. Oil on canvas, 18⅓ x 15⅓ in. (46.5 x 38.9 cm). Rijksmuseum, Amsterdam.

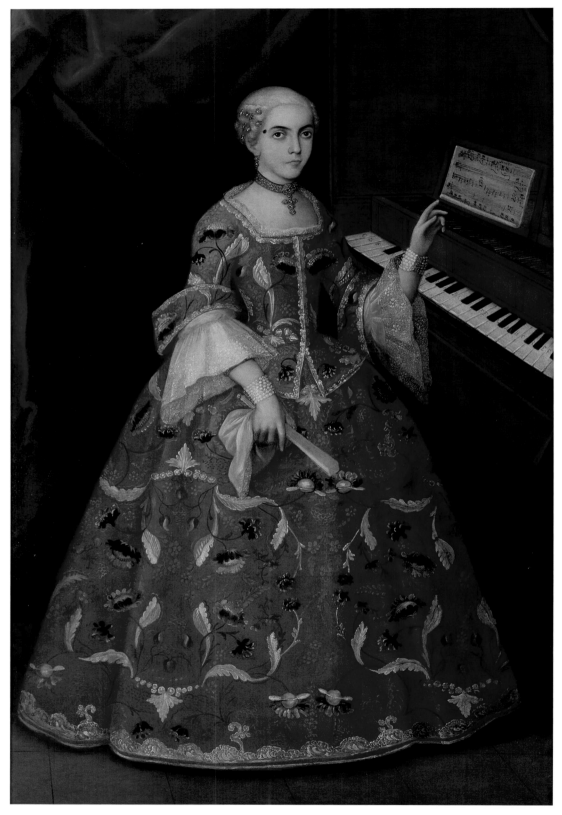

Fig. 11. *Young Woman with a Harpsichord*. Mexico, 1735–1750. Oil on canvas, 61⅝ x 40⅜ in. (156.5 x 102.6 cm). Denver Art Museum, Gift of the Collection of Frederick and Jan Mayer; 2014.209.

for portrait wear was a formal gown, like that in the anonymous *Young Woman with a Harpsichord*, painted about 1735–1750 (fig. 11). This portrait sums up the most important New Spanish women's style trends of the first half of the eighteenth century. The canvas may represent a young girl destined for a convent, dressed "*en gala* for the final farewell to the outside world"[32] that preceded her formal vows. Her harpsichord indicates that she was musically skilled, and young ladies with exceptional musical ability were sought after by convents, many of which offered a very high standard of music-making. Indeed, the convent offered New Spanish women their only opportunities to live the life of a professional musician.[33]

Superficially, her dress resembles an international-style open robe of the mid-eighteenth century, like that worn by the women in a 1742 English group portrait by Thomas Hudson (fig. 12). This remarkably versatile style of gown, which flourished, in its varied permutations, from the 1670s through the 1780s, reunited bodice and skirt into a single garment worn open over an underskirt. It was called a "*mante*," "*manto*," or "*manteau*"

in France and a "mantua" in England. In Spain it went by a variety of names, among which "*bata abierta*" translates literally as "open robe."[34] The first open robes were actual Asian robes that had been imported to England during the reign of Charles II. These and copies of them were worn as informal "undress" by privileged women, and are especially to be seen in English portraits, where their use became conventionalized as portrait costume (fig. 13).[35] These loose robes, pinned and stitched to fit the wearer's corseted shape, were quickly co-opted by French women. Since Louis XIV loathed them they became wildly fashionable, and—although English in origin—they would dominate the eighteenth century as "French" fashion.

Open robes, characterized by their one-piece, shoulder-to-ankles construction, were a product of a revolution in women's dressmaking that occurred in France and England in the last years of the seventeenth century: the 1675 establishment in Paris of a dressmakers' guild made up of women, in opposition to the all-male tailors' guild,[36] was quickly followed by the professionalization of

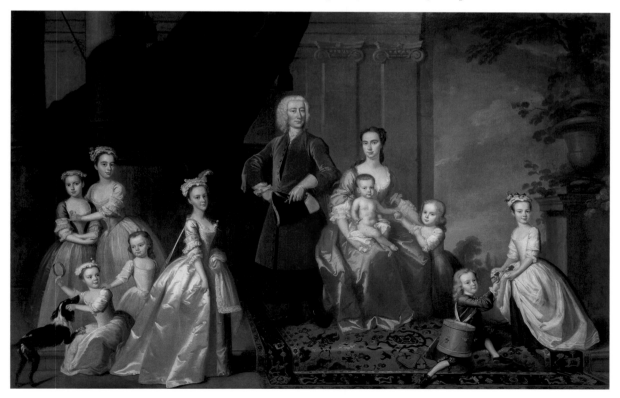

Fig. 12. Thomas Hudson, *The Radcliffe Family*. United Kingdom, circa 1742. Oil on canvas, 104¼ x 162⅛ in. (264.8 x 411.8 cm). Berger Collection at the Denver Art Museum, TL-17968.

Fig. 13. Michael Dahl, *Portrait of a Lady*. United Kingdom, late 17th century. Oil on canvas, 95 x 58 in. (241.3 x 147.3 cm). Berger Collection at the Denver Art Museum, TL-18006.

English needlewomen.[37] This event, of seismic importance in the history of women's entry into the workforce, put the professional manufacture of elite women's clothing into women's hands. In the Hispanic world, however, elite women's dress (at least that part of it made by professionals) remained the responsibility of male tailors, as the chronicler Juan de Viera makes anecdotally clear in a 1778 passage about the wives of certain tradesmen in Mexico, who "present themselves in clothing that is in no way distinguishable from the dress of the greatest ladies. It is a marvel to see them in the churches and their promenades dressed in such a manner that often one cannot tell which is the wife of a count, *and which is that of a tailor"* (emphasis mine).[38] The tailors would not lose control of women's fashions in New Spain until the arrival of French *modistes* in the years following independence.[39] In the Hispanic world, the period of transition from seventeenth- to eighteenth-century women's styles occupied the entire first half of the eighteenth century. During the transition, Hispanic tailors adapted elements of the new style, forged by the women's innovative approach to dressmaking, to the seventeenth-century construction techniques that they knew. The new-style, one-piece construction (not seen in the Spanish New World until about 1760, and never truly popular) came to be called *a la francesa*, while the older-style two-piece construction (always more prevalent) was known as *a la española*.[40]

The gown worn by the young woman with a harpsichord, while adopting the low-cut, square neckline, elbow-length sleeves, and general shape of the new style, retains the two-piece construction *"a la española"* of the seventeenth century. It may seem odd to refer to a two-piece garment in the singular as a "gown," but the ensemble was construed as a unit, no matter how many pieces it comprised, in the same way that "a suit" today is considered a single, multi-part garment. She wears New Spain's most popular eighteenth-century bodice style, the *casaquín*. This was characterized by its peplum (the wide strip of fabric at the waist, a remnant of the *guardainfante* gowns) and by its turned-back *bota* (boot) cuffs, thought to resemble the turned-down top of a boot.

Another portrait from the Denver collection, that of Doña Micaela Esquibel (c. 1750) (fig. 14),

the mother of the foundress of an elite convent,[41] shows the same style of bodice in a closer view. Doña Micaela wears precisely the same bodice as the *Young Woman*, even to the textile and the distribution of the trim. The bodice was probably closed at the center front with hook-and-eye closures, which date at least to the fifteenth century.[42]

The relatively plain skirt of the woman with the harpsichord is embellished with applied silver lace at the hem to match the silver braid of her bodice. Judging from the width at the hip, it is worn over either a pannier or perhaps a stuffed hip-pad. The gown's fabric is probably an Asian silk and metallic brocade. It is really impossible to judge an eighteenth-century fabric's origin by motif: Asian and European weavers expertly copied each other's work. The extraordinary width of the pattern, however (two widths of which suffice for the skirt's front), suggests a wider loom than was used by European weavers at the time.[43] Brocade, a fabric tapestry-woven in different colors, is often mistaken for embroidery, but the presence of a regular pattern usually gives it away: embroidery tends not to repeat.

Under her gown, she wears a (linen) chemise trimmed with lace, almost certainly of Flemish origin. Flanders, the source of the world's highest quality linen, had been ruled by various members of the Habsburg family since the late fifteenth century. The province enjoyed favored trade status with the Spanish Empire even after the Bourbon accession, and its products were widely available in the New World, arriving both from Europe and, having traveled the long way around the globe, via the Manila trade: the Marquess of Cruillas (viceroy of Mexico, 1760–1766) informed Carlos III in 1765 that the Manila trade imported Flemish laces "and many other kinds of European goods into New Spain."[44] The slight puff of white fabric seen just under her cuff and above her sleeve ruffles suggests that they are indeed attached to a full chemise, and not the separate pieces (called *engageantes* in French and *vuelos* in Spanish) that were also sometimes worn.

In accessories, besides her fine handkerchief, or *paño*—surely also of imported linen—she carries a closed fan and wears diamond earrings, a choker with a diamond cross pendant, matched pearl bracelets, and—nearly invisible under her sleeve

Fig. 14. Anonymous, *Portrait of Doña Micaela Esquibel*. Mexico, circa 1750. Oil on canvas, 31¾ x 16½ in. (80.6 x 41.9 cm). Denver Art Museum, Gift of Robert J. Stroessner, 1991.1166.

Fig. 15. *Garden Party on the Terrace of a Country Home.* Mexico, circa 1725. Oil paint and gold on canvas, 87 x 219 in. (221 x 556.3 cm). Denver Art Museum, Gift of Frederick and Jan Mayer, 2009.759.

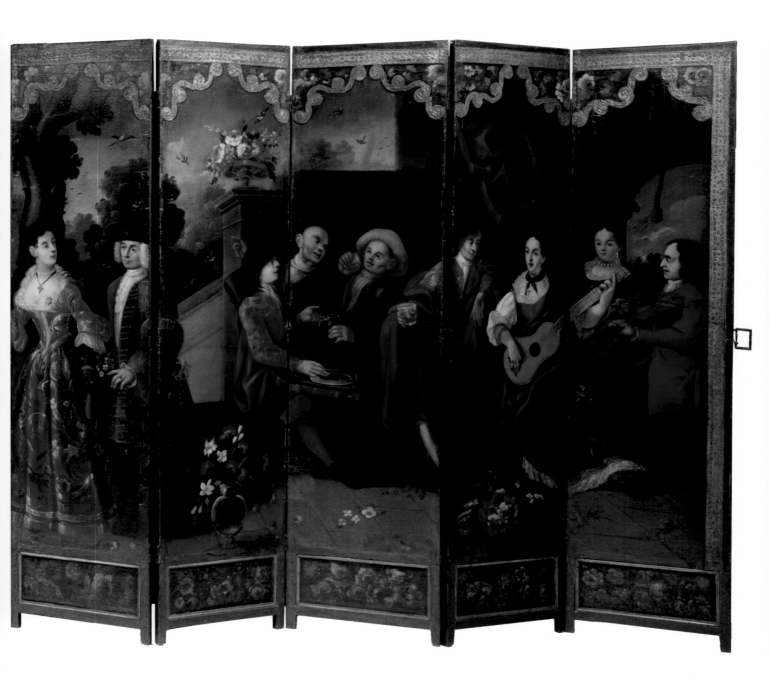

ruffle—a heavy gold cuff bracelet pushed up on the forearm.

Her close-dressed, powdered hair—embellished with wire-sprung jeweled *tembladores* (hair ornaments) that would have trembled with every movement of her head—may well be a wig, although in the eighteenth century, full wigs were worn only by women with "problem hair."[45] Her hair style is quite similar to that seen in other portraits of young girls enjoying their last secular fling before entering a convent.[46] Indeed, with its close side-curls, her hair more resembles a man's wig of the era than a lady's hair style (see figs. 15 and 18 for comparison). It seems possible that girls in her position may have already had their hair cut for the convent and may have worn the only kind of wig that would have been widely available—that is, a man's wig dressed in a feminizing style.

Finally, she wears a *chiqueador*, or beauty patch, at her temple. These were made of silk, velvet, or even tortoise shell, and were often quite large. Beauty patches were an international fad of the seventeenth and eighteenth centuries. In Europe, they were worn all over the face (with a complex code of meaning attached to their positions[47]), but in the Hispanic world they were worn primarily at the temple.[48]

A *chiqueador* of about the same size can be seen on the principal female figure in a *biombo* (folding screen) painting (fig. 15) that dates from about the same time as both the Thomas Hudson painting and the *Young Woman with a Harpsichord*, and gives a good picture of the style scene for upper-class New Spaniards in the years around 1740. The women's dresses, superficially similar to the English gowns in the group by Hudson, continue to show two-piece construction *a la española*, but the men's clothes are entirely European in both presentation and construction, except perhaps for greater exaggeration of the cuff than would have been seen in London.

## Conspicuous Consumption in the City of Palaces, 1750–1800

In the second half of the eighteenth century, Mexico City was one of the biggest cities in the world. With a population estimated between 150,000 and 200,000, it was approximately the same size as Madrid and Venice.[49]

Eighteenth-century advances in mining technology increased silver production,[50] which, joined with the continued vigor of the Manila trade, funded a building boom in which much of central Mexico City assumed the appearance it still presents, commemorated by the encomium "the city of palaces."[51]

In the viceregal capital's increasingly cosmopolitan atmosphere, styles that might have been provincial aberrations in a smaller place became, thanks to the dual alchemy of wealth and population, expressions of urban high fashion. Juan Antonio Prado's 1767 panorama of Mexico City's Zócalo (fig. 16) records all of the clothing types seen in Villalpando's 1695 view of the same square seen from the other side (see fig. 3), with the added element of two different skirt silhouettes for women: the old-fashioned cone-shaped *vertugade*, now known as a *sacristán*, and the new dome-shaped pannier, or *tontillo*, coexisted in New Spain as they did nowhere else.

## Mid-Eighteenth-Century Men: The Contrasting Cuff Style

One striking expression of big-city style in New Spain was a fashion in men's clothing for the use of vividly contrasting textiles in the same ensemble, seen in Miguel Cabrera's circa 1752 portrait, from the Brooklyn Museum, of Don Juan Xavier Joachín Gutiérrez Altamirano Velasco, Count of Santiago de Calimaya (fig. 17). The count was the most titled person in the New World, and the *cartela* at the count's feet fulsomely retails the entire list.

Don Juan Xavier's suit is almost certainly made of the Chinese brocade that was the mainstay of the Manila trade.[52] Among his many titles was the purely honorific one of governor-in-perpetuity (*Adelante Perpetual*) of the Philippines, which had been subdued by his ancestor Miguel López de Legaspi in 1565. But he probably had no inherited commitment to promote the products of Asian trade; the easier explanation is that everybody who could afford to wear Asian silk did so.

Indeed, nearly everyone *could* afford it. Much Asian silk was quite cheap: its cost in eighteenth-century Lima was *one-ninth* that of comparable European silk,[53] so—according to an alternative view—it is possible that the nobility, who were by

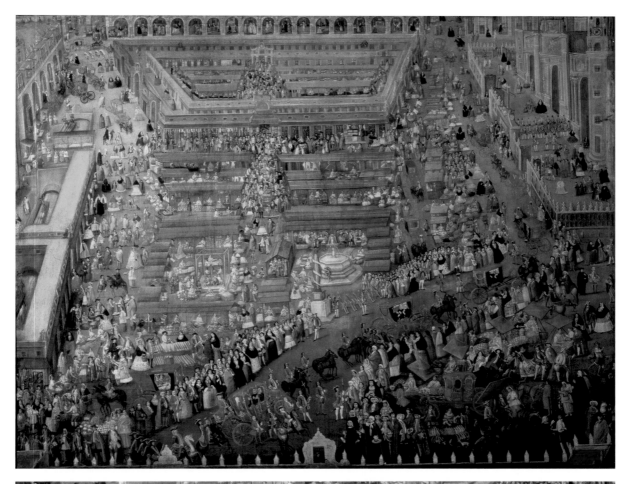

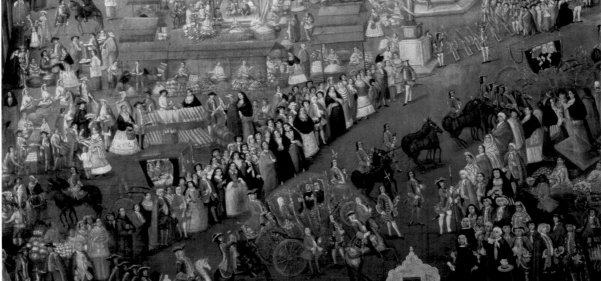

Fig. 16. Juan Antonio Prado, *La Plaza Mayor de la Ciudad de México* (top, overall and bottom, detail). Mexico, 1767. Oil on canvas, approximately 78¾ x 118⅛ in. (200 x 300 cm). Museo Nacional de Historia, Mexico City. Reproduction authorized by the Instituto Nacional de Antropología e Historia.

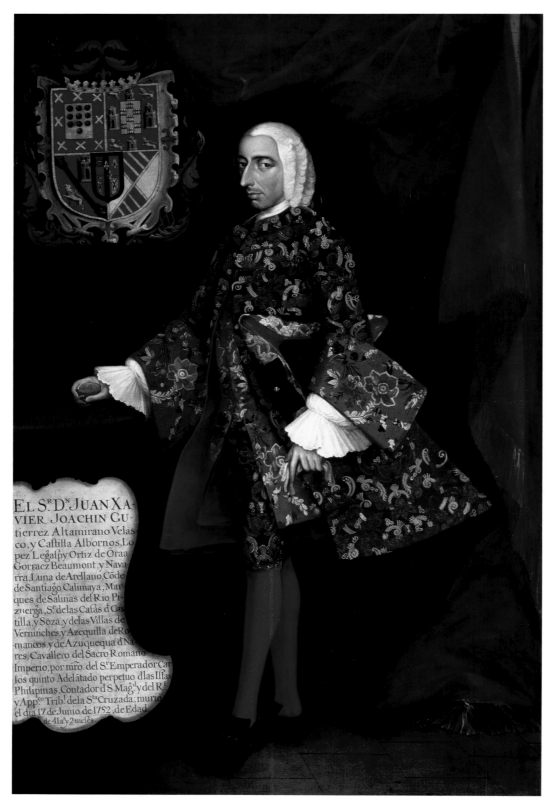

Fig. 17. Miguel Cabrera, *Don Juan Xavier Joachín Gutiérrez Altamirano Velasco, Count of Santiago de Calimaya*. Mexico, circa 1752. Oil on canvas, 81½ x 53½ in. (207 x 135.9 cm). Brooklyn Museum, Museum Collection Fund and Dick S. Ramsay Fund, 52.166.1

both custom and inclination conspicuous consumers,[54] may have made a point of buying expensive European textiles, and of being seen to do so. It seems probable, however, that the cheaper Asian silks were plain-woven, and that textiles as grand as those worn by the count must always have been quite dear.

The exaggerated cuff of the 1730s and 1740s (seen in fig. 17) had often been the focus of special decoration. It was also common in New Spain as in Europe for a gentleman's cuffs to match his waistcoat, a holdover from the earlier period when waistcoat sleeves were long and could be rolled over the cuff of the jacket, as in Juan Rodríguez Juarez's portrait of Viceroy Linares (see fig. 6). When the waistcoat was patterned, however, the body of the suit was generally plain. The use of contrasting patterns was not unknown in Europe, but it remained an occasional practice there, limited to the young and the flashy. In New Spain, however, it seems to have blossomed into a true fad—a further expression of the delight in exuberant ornament seen in New Spain's eighteenth-century church architecture, which many today find visually confusing. Its popularity may also have been due to the Manila trade, which dealt in ready-made Asian garments made from contrasting textiles, and in porcelain made for the export market, which deliberately emphasized pattern-on-pattern designs that Western consumers would have seen as appealingly exotic.[55] Juan de Viera, whom we last encountered describing the ostentatious dress of New Spanish women, noted in the same paragraph the splendid dress of Acapulco merchants: "Every tradesman goes forth on feast days with as much propriety and ostentation as if he were a fleet-merchant, covered with more braid than a cavalry officer."[56]

The contrasting cuff mode was not unique to New Spain, and I believe that it is *original* to New Spain only in the sense that Mexico was one of the places where the practice generated spontaneously. (It seems likely that in any place where vividly patterned cloth was available, someone must have got the idea of making pattern-on-pattern garments.) It was rare in Spain and Italy, where one might have thought that the Latin aesthetic ethos might be more hospitable, but does appear with some regularity in Scandinavian and Russian portraits,

and in English portraits as well—particularly in the work of Thomas Hudson, whose group portrait of the Radcliffe family is such a good example of midcentury dress (see fig. 12). It is almost never seen in French portraiture, and it seems likely that the practice would have been thought vulgar in France.

While it is impossible to open a book that deals with eighteenth-century New Spanish portraiture and *not* see contrasting cuffs in numerous examples, one may search volume after volume of European portraits and never see it. This leads me to conclude that in Mexico the practice gathered the momentum it needed to become a true style: the nascence of a chance not taken to strike more boldly into sartorial exuberance, perhaps a tentative reaction to the tyranny of the European male modes that New Spanish men wore, as I have noted, without any local variation. As we have seen, viceregal women transformed the European styles they wore by the introduction of numerous stylistic localisms and preferences, and would continue to do so until the end of the century. Men, however, seem to have been constrained not to rock the sartorial boat, and the contasting cuff mode remains a tantalizing example of what might have been.

Despite the New World exuberance of its materials, there is nothing else about the count's suit that betrays its Mexican origins. The ensemble is completely European and quite up to date in cut, consistent with styles worn in contemporary France and England. The count's jacket dates the painting to the 1740s or 1750s, the *terminus ante quem* being 1752, the date of the count's death. (The portrait may well be posthumous, and the small sundial he carries may be a *memento mori*.) The sleeve is shorter and the cuff is reduced from its peak size in the 1730s, which we saw in both the Mexican *biombo* painting (see fig. 15) and the English group portrait by Thomas Hudson (see fig. 12). The jacket's side-front has begun to be cut away to reveal more of the waistcoat. The count's jacket can be buttoned only at the breast. By the next generation, no gentleman would be able to button his jacket even if he cared to.

The suit's ostentatious textiles are nicely balanced by other elements that are plainer than they might otherwise be: the cuffs of his (linen) shirt

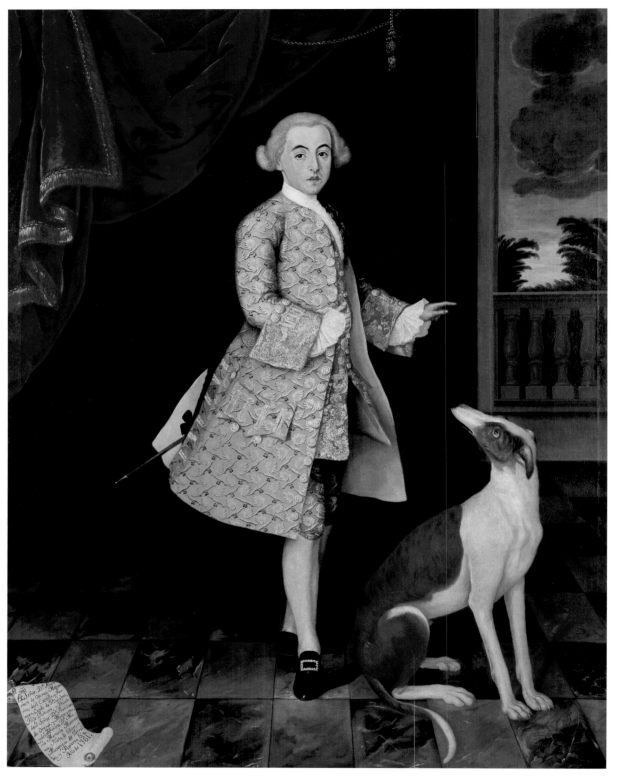

Fig. 18. *Portrait of Francisco de Orense y Moctezuma, Count of Villalobos.* Mexico, 1761. Oil on canvas, 74 x 59 in. (188 x 150 cm). Denver Art Museum, Gift of the Collection of Frederick and Jan Mayer, 2011.427.

are of plain cloth rather than lace (though pressed into minute pleats), and the style of his close-dressed bob wig seems a bit conservative, though not too much so for the most titled person in the Americas (and especially not if he were dead). In comparison with the wig worn by the father in Hudson's 1742 *Radcliffe Family*, however, the count's wig is notably shorter and more tightly curled. Plain red (silk) stockings, rather severe shoes, a lavishly trimmed tricorne *chapeau-bras*, and a ceremonial sword complete his ensemble.

The Mayer collection's anonymous 1761 portrait of Francisco de Orense y Moctezuma, count of Villalobos (fig. 18), depicts a Spanish descendant of the indigenous ruler Moctezuma II Xocoyotzín (the famous "Montezuma," whose descendants in the female line were honored with Spanish titles), who visited his Mexican estates in 1761[57] and had his portrait painted while there. His pattern-on-pattern suit suggests that he may have done this in full tourist mode, intentionally presenting himself dressed in extravagant Mexican style.

The suit shows a particularly elegant combination of textiles, much subler than that seen in Cabrera's earlier portrait, with its silver-gray brocade body and subtly contrasting gold brocade cuffs and waistcoat. These textiles *appear* more European than Asian, though it is impossible to be certain. The cut of the jacket and waistcoat reflect the approximately ten years' stylistic development that had occurred in men's dress since Cabrera painted Don Juan Javier: the jacket front is fully open, its sleeves longer and its skirts slightly less stiff. The waistcoat is shorter, and formal dress no longer requires a *chapeau-bras*, though a sword is still necessary. His powdered wig has side rolls in the *ailes de pigeon* (pigeon wings) style, with its tail (or possibly his own hair) bound in a queue with black silk.

### Mid-Eighteenth-Century Women: The Open Robe and Construction *a la Francesa*

The style that appears most frequently in portraits that was probably seen least in real life was the international-style mantua, or open robe, discussed above. Few New Spanish women wore unedited versions of European styles; but as those who did were more likely to have their portraits

painted than those who did not, the style appears frequently in portraiture. In reality, though known in the Spanish New World, open robes were never truly popular. Although they appear frequently in portraits, they are rarely seen in the casta paintings and *biombos* that recorded what people really wore. That some of these gowns are extant in Mexican collections actually underscores the probability that they were seldom worn; it is a maxim in dress studies that garments which survive in good condition were little used.

The open robe was pushed, pulled, and trimmed into many different shapes but its basis remained a front-opening, shoulder-to-ankles overdress. Its main types were the *robe à la française*, with a loose back (fig. 19); the *robe à l'anglaise*, with a fitted back (fig. 20); and the *robe à la polonaise*, with looped-up skirts (fig. 21), which might be cut either *à la française* (called a *bata* in New Spain) or *à l'anglaise* (a *vaquero*).

The unidentified lady in pink[58] seen in figure 19 (who may be the daughter-in-law of the gentleman in figure 17) dates to about 1760. She wears one

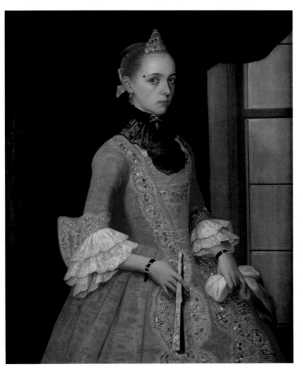

Fig. 19. *Lady of the Sánchez Navarro Family* (possibly María Bárbara de Ovando y Rivadeneyra, Countess of Santiago de Calimaya). Mexico, circa 1760. Oil on canvas, 37¾ x 31½ in. (96 x 80 cm). Private collection, Mexico. Photo Jeff Wells, Denver Art Museum.

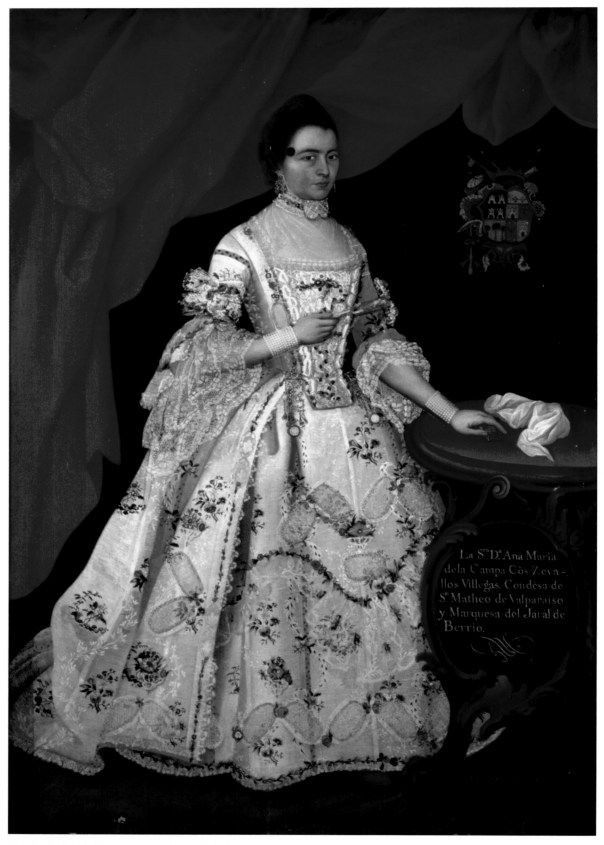

La S.ᵐ Dᵃ Ana Maria
dela Campa Còs Zeva-
llos Villegas, Condèsa de
S.ⁿ Matheo de Valparaiso
y Marquesa del Jaràl de
Berrio.

Fig. 20. Andrés de Islas, *Doña Ana María de la Campa y Cos*. Mexico, 1776. Oil on canvas,  76 x 52¾ in. (193 x 134 cm).
Banamex Collection, Mexico City. Photo courtesy Instituto Nacional de Antropología e Historia.

of the earliest examples of one-piece *a la francesa* construction found in New Spanish painting.[59] This can be seen by the unbroken line of silver braid running from the shoulder to the skirt front. The silver-trimmed, salmon-pink silk moiré gown is apparently a loose-backed *robe à la française* (*bata*). If it were *à l'anglaise* (*vaquero*), with a fitted back, one would be able to see a triangular patch of background between her arm and her bodice, as in figures 20 and 21. It is in fact a closed rather than an open robe, since the side-front edges of her skirt meet at the center front, rather than being left open to display an underskirt.[60] An effective adaptation of the international style, it displays a satisfying collection of localisms that demonstrate New Spanish sartorial independence, especially when compared with figure 20, which represents a thoroughly conventional gown in the international style.

The pink gown retains the boot cuffs and conical, *sacristán* hoop of the earlier eighteenth century, though applied to the new style of construction—reversing the practice in which new-style details were superficially added to gowns constructed in the old style. The front closure of the bodice, with silver cords wound like boot-lacing between silver buttons, is quite distinctive, as are the black lace collar/jabot closed with a diamond bow, and the diminutive crenellation of tiny artificial flowers she wears like a tiara.[61]

The hair ornament is peculiar indeed, and—though the resemblance is surely accidental—looks rather like the conventionalized indigenous crowns worn by the allegorical figures of "Mexico" in various emblematic works of the same era.[62] The collar/jabot seems to be an ingenious local combination of two mid-eighteenth-century European ideas: the lace choker (a favorite device of the Marquise de Pompadour), and the fichu, a linen or lace tucker that filled the neckline of a décolleté gown. In Europe these were worn universally as afternoon wear, to protect the bosom from the sun's harsh rays, and were worn formally by older women. They were particularly popular in New Spain, and were worn with all but the most formal gowns (figs. 20 and 21).[63]

The lady in pink (fig. 19) is also an excellent illustration of fashions in posture. In addition to the clothing styles worn in a given era, there are also socially approved styles of self-presentation. One of the most striking things about the lady in pink is her pronounced hips-forward stance. Looking at Hispanic women's portraits of the sixteenth and seventeenth centuries, we can see that aristocratic women tended to lean back from the pelvis, creating a vertical line at the center front of the bodice that minimized the apparent size of the bosom. This can be seen as well in the *Young Woman with a Harpsichord* (see fig. 11). The line of braid at the center front of her bodice is perpendicular to the floor, while the line of her back (seen between her proper right arm and her torso) is canted at a severe angle.

By contrast, as can be seen in English paintings (see figs. 12 and 13), European women wearing the new-style international gowns emphasized the bosom simply by standing differently, with a more relaxed and less symmetrical stance, practicing the graceful forward bend that is so essential to "looking right" in an eighteenth-century gown.[64] The women in the informally *galant* New Spanish *biombo* (see fig. 15) have apparently mastered this new, chic, and sexy manner of self-presentation.

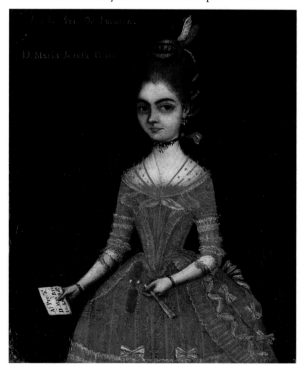

Fig. 21. Ignacio Barreda, *Portrait of María Josefa Brito*. Mexico, circa 1790. Oil on canvas, 5⅞ x 4½ in. (14.9 x 11.4 cm). Denver Art Museum, Gift of the Collection of Frederick and Jan Mayer, 2013.378.

Though it is probable that the artist is using posture as a way of demonstrating the advanced modernity of the scene, it also suggests that the observation of posture was freighted with class markers: *women* knew about the new mode in posture, but *ladies* may have been careful about being seen to practice it. Indeed, *casta* paintings also show distinct differences in posture from class to class. There would be no change in women's posture in formal portraiture until the end of the century, and more than their clothing, it is the Mexican ladies' outmoded manner of comporting themselves that would likely have marked them as provincial in the drawing rooms of Europe.

If the lady in pink charms with exotic localism, Doña Ana María de la Campa Cos (the Countess of San Matheo de Valparaíso and Marquesa of Jaral de Berrio), painted in 1776 by Andrés de Islas (fig. 20), impresses with well-assimilated internationalism, in a confidently essayed *robe à l'anglaise* (*vaquero*) of (probably European) floral and metallic brocade with matching underskirt worn over panniers, which might have been made anywhere in the European sphere. She even stands in a tentatively bosom-forward posture. Whether or not they did so very often, Mexico City's tailors were clearly equal to the task of making an international-style gown in the latest style.

The marquesa's localisms are to be seen in her accessories rather than her gown: she wears an astonishingly large *chiqueador*, a diaphanous fichu that would have been out of place in so formal a portrait in Europe, and—most importantly—a matched pair of watches at her waist. This was one of the Hispanic world's oddest fads, apparently not limited to New Spain, although it is seen in numerous later eighteenth-century New Spanish portraits. It was not only a women's style: Juan de Viera noted in 1778 that the common people go forth on feast days "with two watches like the most eminent man."[65] They are seen in abundance, however, on women's portraits, perhaps because men's watches were less ostentatiously displayed. Some people are said to have worn as many as seven![66]

In 1786, ten years after Ana María de la Campa Cos was painted, Doña María Josefa Brito (fig. 21) was married in her home city of Mérida, Yucatán. It was probably on that occasion that she was painted in a crimson *robe à l'anglaise* (*vaquero*), its silk damask skirts with applied decoration drawn up *à la polonaise* over pannier (*tontillo*) hoops. She also wears a fichu of sheer fabric and an elaborate watch fob. Her hair is dressed in the towering French "pouf" style that arrived in New Spain in about 1780, briefly flourished, and quickly subsided. Here again, the lady's hairstyle is a valuable secondary tool for dating, since the picture itself is undated and the hairstyle fits with the subject's 1786 marriage. The arrival in New Spain of these over-the-top late eighteenth-century hairstyles would herald the final flowering of home-grown Mexican style.

## Court Costume and Military Chic

The subject of the famous portrait by Miguel Cabrera of María de la Luz Padilla y Gómez de Cervantes (fig. 22) from the Brooklyn Museum appears to be wearing an open robe, but she is actually wearing a court gown, the era's most formal type of dress. Court costume had first developed in Spain at the time of Philip IV's 1623 edict concerning ruffs, when gentlemen's formal dress was transformed, by the adoption of the *golilla* collar, into a *de facto* uniform. Louis XIV (Philip's son-in-law) disliked the new informal women's fashions introduced from England in the 1670s. His response was to attempt to arrest this trend by decreeing that women should appear at court in conservative gowns based on those of the 1660s, consisting of three discrete pieces: a heavily boned bodice, a skirt, and a separate train, known collectively as the *grand habit de cour.*

Louis's decree did nothing to stem the tide of fashion, though he did succeed in creating a court mode that was somewhat distinct from high fashion and developed in a kind of semi-isolation until the French Revolution brought it to an end.[67] This court uniform was adopted in varying versions by all the courts of Europe. Like construction *a la española*, the *grand habit* fossilized the elements of mid-seventeenth-century dress into an extremely conservative practice. The French *grand habit* was the most rigidly regulated of court costumes, insisting, for example, on a sleeveless bodice in the style of the 1660s that revealed a prescribed arrangement of lace flounces on the chemise. This was worn without variation in

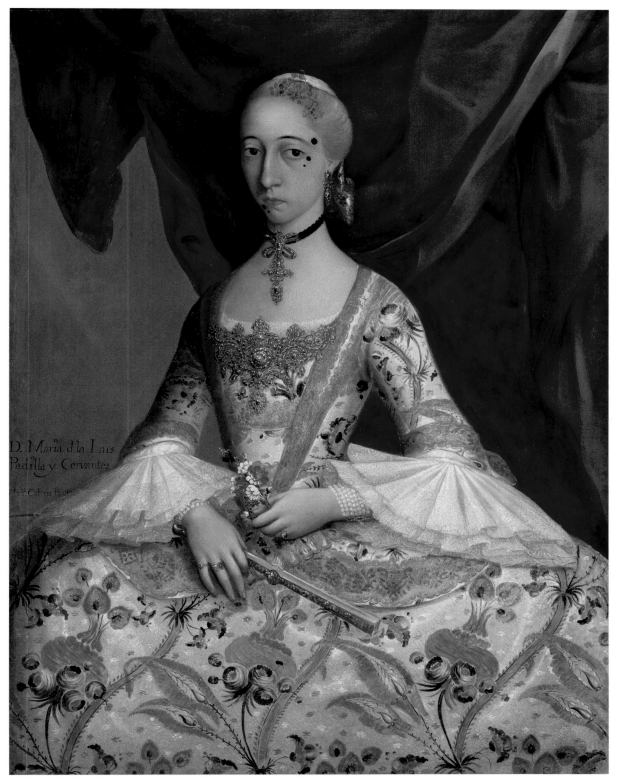

Fig. 22. Miguel Cabrera, *Doña María de la Luz Padilla y Gómez de Cervantes.* Mexico, circa 1752. Oil on canvas, 43 x 33 in. (109.2 x 83.8 cm). Brooklyn Museum, Museum Collection Fund and Dick S. Ramsay Fund, 52.166.4.

Fig. 23. Andrés López, *Viceroy Matías de Gálvez as Vice-protector of the Academy of San Carlos*. Mexico, circa 1790. Oil on canvas, 89 x 61 in. (226.1 x 154.9 cm). Museo Nacional del Virreinato, Tepotzotlán, Mexico. Reproduction authorized by the Instituto Nacional de Antropología e Historia.

Vienna, St. Petersburg, and some smaller German and Italian courts.[68] The English court wore a slightly less formal version called a court mantua,[69] with sleeves that matched the bodice and the all-important court train incorporated into the body of the gown, as in an open robe. Spanish practice hovered between the two poles, incorporating the sleeves of English practice, but retaining the three-piece French construction.

We can tell that María de la Luz is *not* wearing a one-piece open robe by the tabs at the lower edge of her bodice, which show that bodice, skirt, and train are all separate pieces of floral silk and metallic brocade, possibly English-made, with gold braid worn over pannier (*tontillo*) hoops. Perhaps the most striking thing about her gown is that she is not sitting down—the extraordinary width of her skirt is due to her pannier. The general shape of the court gown was allowed to mirror the fashionable shape as long as the gown itself was composed of the requisite number of approved components.

Although two late eighteenth-century gowns in the collection of the Museo Nacional de Historia (Chapultepec Castle) have recently been identified by the author as court dresses, we don't yet know enough about New World court protocol to be able to say whether the garb worn here was required for attendance at the viceregal palace or whether the sitter (or her family, who would have controlled her choices in such a matter) was engaging in a *nouveau-riche* display of arrogated privilege by wearing such conspicuously grand clothing. The lady, a daughter of the Marqués of Santa Fe de Guardiola, was married in 1752 (to her uncle), and this—judging by her hairstyle—seems a reasonable date for the picture. Such an event as the marriage of the daughter of a marqués was likely formal enough to require such a gown.[70]

Men's court dress in the New World is easier to assess. Men had an official role to play in ceremonial life, and were obliged to wear official dress. In the 1740s, American viceroys had begun to wear the blue-and-crimson quasi-military uniform of Spanish court officials. This was based on the French *justaucorps à brevet*, ordained by Louis XIV in the mid-1670s and named for the *brevet* or warrant that allowed fifty privileged French courtiers to wear it.[71]

At first, the viceroys of New Spain—and their tailors—interpreted this uniform with a good deal of variation, and official portraits painted between about 1740 and 1770 show numerous changes rung on the theme of the blue jacket with crimson waiscoat. By the 1770s, however, the ensemble had ossified into a true uniform, usually made of fine wool with standardized gold-embroidered trim, as seen in the circa 1790 painting by Andrés López of Viceroy Matías de Gálvez (fig. 23). Lesser officials, like Don Esteban de la Carrera y Prado, the royal treasurer of the port of Acapulco, as seen in a 1782 portrait by Ramón de Torres (fig. 24), wore the uniform ornamented with silver rather than gold.

Another portrait in the collection of the Denver Art Museum serves as a useful introduction to the most important New Spanish men's trend of the late eighteenth century: military chic (fig. 25).[72] After about 1760, the contrasting cuff mode died and New Spanish men went uniform-crazy. As the Bourbon reforms systematically removed American-born New Spaniards from positions of authority,[73] service in militia units became the only way for them to serve the Crown in an official

Fig. 24. Ramón de Torres, *Don Esteban de la Carrera y Prado*. Mexico, 1782. Oil on canvas, 38 x 32 in. (96.5 x 81.3 cm). Denver Art Museum, Collection of Frederick and Jan Mayer, 17.2014.

Fig. 25. *Portrait of Captain F. Casana*. Mexico, circa 1782. Oil paint on canvas, gilt wood frame, 28¾ x 18½ in. (73 x 47 cm). Denver Art Museum, Gift of Frederick and Jan Mayer, 2013.327.

capacity. Upper-class men began to wear uniforms for formal occasions, giving them a corporate uniform that both balanced and to a degree challenged that worn by the viceroy himself, although, as in Spain, military uniforms were not permitted at court functions. This cosmetic militarization of the *criollo* class has been seen as an important step in the progress toward independence.[74]

In the mid-eighteenth century, military uniform was less than a century old. In the past, field soldiers had tended to dress alike because the clothing available to them was similar, as in Velázquez's *Surrender at Breda*. English foot soldiers began to wear the famous red coat in 1686, but it was in no way different from a civilian jacket except that it was just like the next one,[75] and officers' clothing especially tended to be indistinguishable from fashionable dress.

The anonymous painting of the young Joachim Sánchez Pareja Narváez y la Torre (fig. 26) in the uniform of the Dragónes del Regimento de México (Dragoon Regiment of Mexico)[76] shows how military dress began to pull away from civil dress: the cut of his jacket is indistinguishable from a fashionable men's jacket of the period, but the abundant silver braid disposed in a specific pattern is new, as is the utilitarian collar.

The Brooklyn Museum's 1793 portrait by Mariano Guerrero of Juan Lorenzo Gutiérrez de Altamirano, the 8th Count of Santiago de Calimaya (fig. 27) and the son of the gentleman seen in figure 17, shows him in the dress of the Regimento de la Infantería de la Corona de la Nueva España (Infantry Regiment of the Crown in New Spain). The turned-back facing of the coat is a specifically military gesture, and together with the standing collar shows the next stage of development away from civil dress. By the early nineteenth century this combination of folded-back facing and high collar would be the distinguishing characteristic of military uniforms in the West. Like the Duke of Linares (see fig. 6), the count carries the honorific red-ribboned key that identifies him as a gentleman of the king's bedchamber.

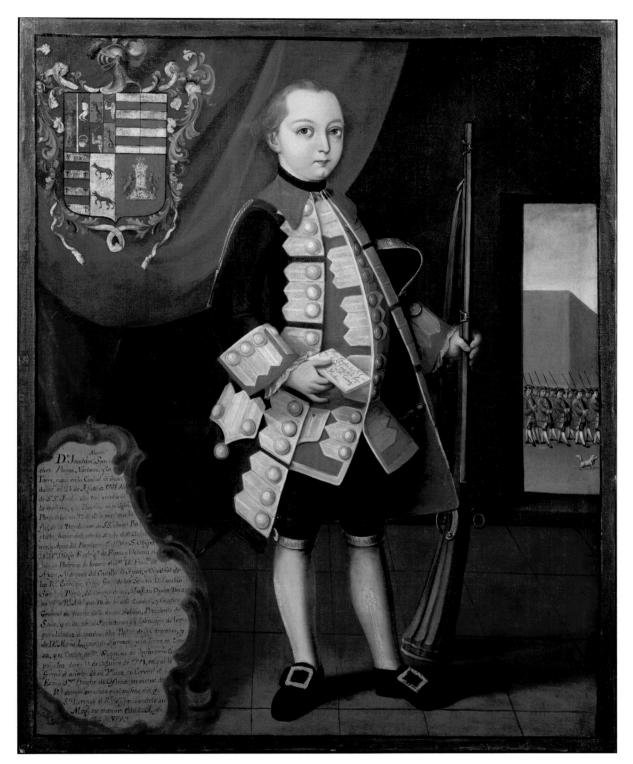

Fig. 26. *Portrait of Joachim Sánchez Pareja Narváez y la Torre as an Army Cadet.* Mexico, 1773. Oil on canvas, 47¾ x 40½ in. (121.3 x 102.9 cm). Denver Art Museum, Collection of Frederick and Jan Mayer, 52.2000.

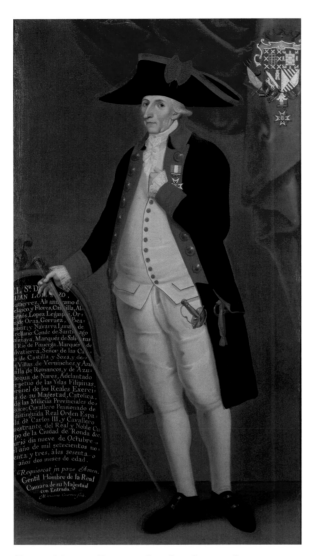

Fig. 27. Mariano Guerrero, *Don Juan Lorenzo Gutiérrez Altamirano de Velasco y Flores, Count of Santiago de Calimaya.* Mexico, circa 1790. Oil on canvas, 73½ x 38½ in. (186.7 x 97.8 cm). Brooklyn Museum, Museum Collection Fund and Dick S. Ramsay Fund, 52.166.2.

## Men's Civil Dress in the Second Half of the Eighteenth Century

Men's dress, however, was by no means completely militarized, and on a day-to-day basis most gentlemen wore civilian dress in the form of varied permutations of the Anglo-French three-piece suit first introduced in the 1690s. I noted above that men are fashion's true slaves, and—with the exception of the midcentury's contrasting cuff mode—New Spanish men's dress of the later eighteenth century was emphatically European in style, entirely lacking in local variation, and quite up-to-date. There is no apparent time-lag between the clothing seen in European and New Spanish men's portraits of this era—a reminder that it took from three to five months to get from Madrid to Mexico City, not twenty years.

It must have been vitally important to New Spanish merchants to be seen to be wearing the latest versions of European men's clothes, although the effect of their sartorial modernity is blunted for us by the strongly local pictorial style of New Spanish portraitists. In José Mariano Farfan de los Godos's 1776 portrait of Don Fernando González de Collantes Zevallos (fig. 28), for example, the merchant gentleman's conservative embroidered gray wool and red fabric European suit contrasts strikingly with the exuberant Rococo console that holds his paper and inkwell, and displays his biographical information on a cartouche incorporated in its gilded base—a piece of furniture that never existed in three dimensions.

Don Fernando's portrait is part of the Denver Art Museum's remarkable series of men's portraits, which together tell a cohesive story of the development of New Spanish men's style from the 1750s through the 1790s. Almost as in an animation, we can see the progressive cutting away of the side-front of the jacket, the tightening of the sleeves, and the gradual shortening of the waistcoat, from just above the knees in 1750 to waist-length in 1800.

In Juan Manuel de Avila's *Double Portrait of a Carmelite Monk and a Nobleman* (fig. 29), painted about 1750, the gentleman wears a suit of crimson mohair or silk velvet with a brocade waistcoat of silk, possibly Asian. The jacket is identical in cut to that seen in Cabrera's 1752 portrait of the 7th Count of Santiago de Calimaya (see fig. 17),

with its shortish sleeves and nearly knee-length waistcoat.

Next in the sequence is the young count of Villalobos (see fig. 18), securely dated to 1761, whom we saw earlier as an illustration of the contrasting-cuff mode. His jacket sleeves are longer and his waistcoat a handsbreadth shorter than those worn by the man in crimson, and the skirt of his jacket is less full. Also, where the red jacket is buttoned at the chest, the young count's jacket is open, a sign of the widening of the jacket's front opening and progressive cutting away of the skirts. This is the origin of the term "cutaway jacket," and the deep vent at the back is the origin of the split tail of the (no longer quite) modern tailcoat.

Fifteen years later Fernando González de Collantes Zevallos wears a jacket that could not possibly be buttoned all the way, although—as befits a conservative older man—the sides of his jacket-front meet over his bosom (fig. 28). His waistcoat is significantly shorter than earlier models.

Ignacio Estrada's 1788 portrait of another merchant, Juan Sastre y Subirats (fig. 30), is superficially quite similar to that of Don Fernando. But Señor Sastre y Subirats is wearing a different type of jacket: a frock coat, identifiable by its collar, a feature which the earlier formal jacket lacks, but which (with the lapels that were also sometimes seen on the frock coat) would go on to become one of the defining characteristics of the modern men's jacket.

The frock coat (called *frac* in Spanish as in French) was an informal garment that developed in mid-eighteenth-century England for country wear. The frock was also known in French as a *redingote*—a corruption of "riding coat"—and was taken up in France as part of a general vogue for English goods that was, paradoxically, at its height during those periods when France and England were at war (such as the era of the American War of Independence).[77] We see another note of informality in Don Juan's shirt collar, which is clearly attached to his shirt and folded over his neckcloth; this is an eighteenth-century aristocratic adoption of a workingman's functional shirt.[78]

As in the portrait of Don Fernando, the inherent *Mexicanidad* of Sr. Sastre y Subirats's portrait seems at odds with his ultramodern costume. We

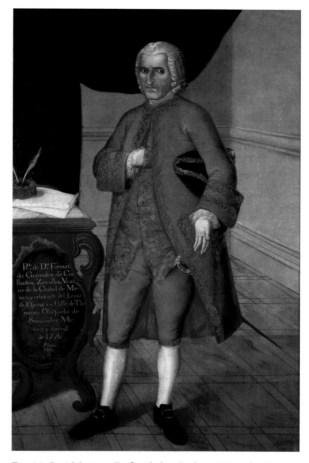

Fig. 28. José Mariano Farfán de los Godos y Miranda, *Portrait of Don Fernando González de Collantes Zevallos.* Mexico, 1776. Oil on canvas, 75½ x 48½ in. (191.8 x 123.2 cm). Denver Art Museum, Gift of the Collection of Frederick and Jan Mayer, 2013.355.

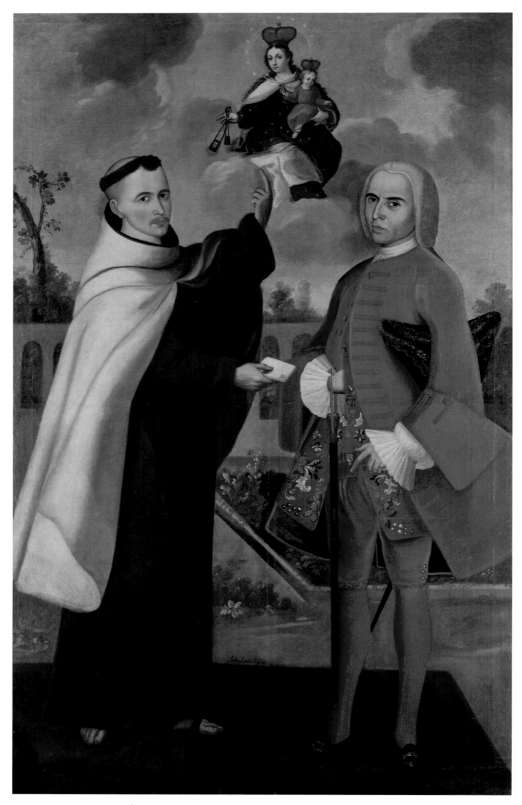

Fig. 29. Juan Manuel de Ávila, *Double Portrait of a Carmelite Monk and a Nobleman with the Virgin of Carmen*. Mexico, circa 1750. Oil on canvas, 80 x 50 in. (203.2 x 127 cm). Denver Art Museum, Collection of Frederick and Jan Mayer, 2013.358.

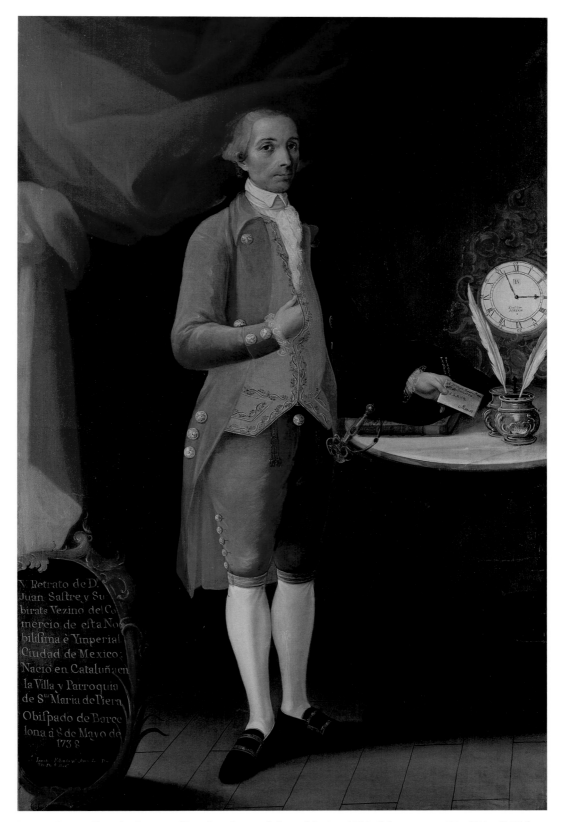

Fig. 30. Ignacio Estrada, *Portrait of Don Juan Sastre y Subirats*. Mexico, 1788. Oil on canvas, 77 x 50 in. (195.6 x 127 cm). Denver Art Museum, Collection of Frederick and Jan Mayer, TL-17167. For a detail image see p. 2.

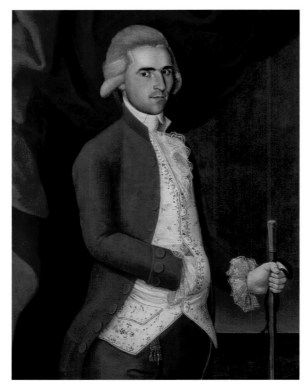

Fig. 31. José Joaquin Esquivel, *Portrait of a Gentleman*. Mexico, late 1700s. Oil on canvas. 34½ x 27⅓ in. (87.6 x 69.3 cm). Denver Art Museum, Collection of Frederick and Jan Mayer, 15.2014.

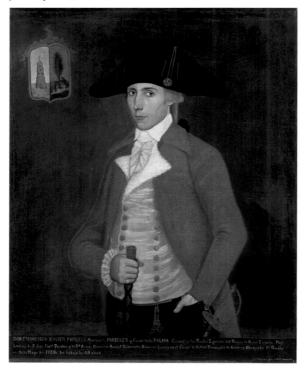

Fig. 32. Francisco Aguirre, *Portrait of Francisco Javier Paredes*. Mexico, circa 1800. Oil on canvas, 40½ x 31¼ in. (102.9 x 79.4 cm). Denver Art Museum, Collection of Frederick and Jan Mayer, 14.2014.

don't know how New Spaniards viewed the history of the *frac*—whether they knew it was an English style or simply accepted it as the latest thing. What seems significant is that it *was* the latest thing, and that the style seems to have arrived in Mexico City at about the same time as it appeared in places like Vienna and Naples.

In addition to his collar, we can see that Don Juan's jacket front is still further cut away; it would now have been impossible to button any part of it. The sleeves are significantly tighter, and the cuff significantly reduced. His waistcoat is shorter still, and its remaining skirt is also being cut away, showing an inverted V at the waist.

The anonymous gentleman seen in the circa 1790 portrait by José Joaquin Esquivel (fig. 31) wears a formal jacket with a standing collar, narrow sleeves, and a severely cut away front opening, again impossible to button. He wears essentially the same waistcoat as Sr. Sastre y Subirats, though made of all-over embroidered silk of a type that was pre-embroidered in China and sold as unassembled pattern-pieces in the West.[79]

The portrait of Francisco Javier Paredes painted in 1800 by Francisco Aguirre (fig. 32) shows a version of the *frac* quite similar to that worn by Sr. Sastre y Subirats, but with a further development placing the waistcoat's hem at the wearer's waist (where it has stayed until the present day), and with the exaggerated lapels that would eventually attach to the jacket itself to form the modern jacket's typical front. The cuff is now practically nonexistent, and must have seemed embarassingly old-fashioned to those who remembered the extravagant examples of the midcentury.

The 1795 portrait, by Juan de Sáenz, of Fernando de Musitú Zalvide (fig. 33) stands somewhat outside the sequence of the previous six and may be a unique representation of *majo* style in New Spanish portraiture. The Madrid demimonde of *majos* and *majas*, famously recorded by Francisco Goya, was the ultimate in eighteenth-century Spanish cool, and Don Fernando wears a different type of jacket from those we have seen: a short, informal jacket often seen in *biombo* and *casta* paintings as the "Sunday best" of middle- and artisan-class people, like that seen in a *casta* painting circa 1785 by Francisco Clapera (fig. 34).

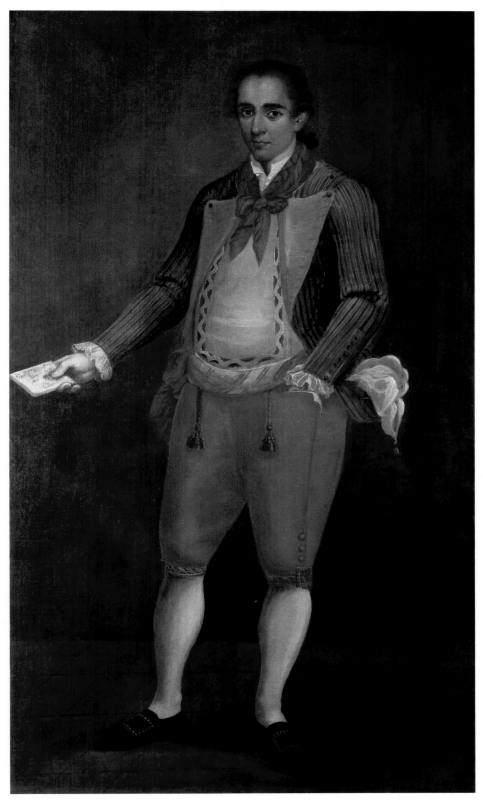

Fig. 33. Juan de Sáenz, *Portrait of Francisco Musitú Zalvide*. Mexico, circa 1795. Oil on canvas, 64¾ x 36 in. (164.5 x 91.4 cm). Denver Art Museum, in memory of Frederick R. Mayer with funds provided by Harley and Lorraine Higbie, Carl and Marilynn Thoma, and Alianza de las Artes Americanas, 2008.27.

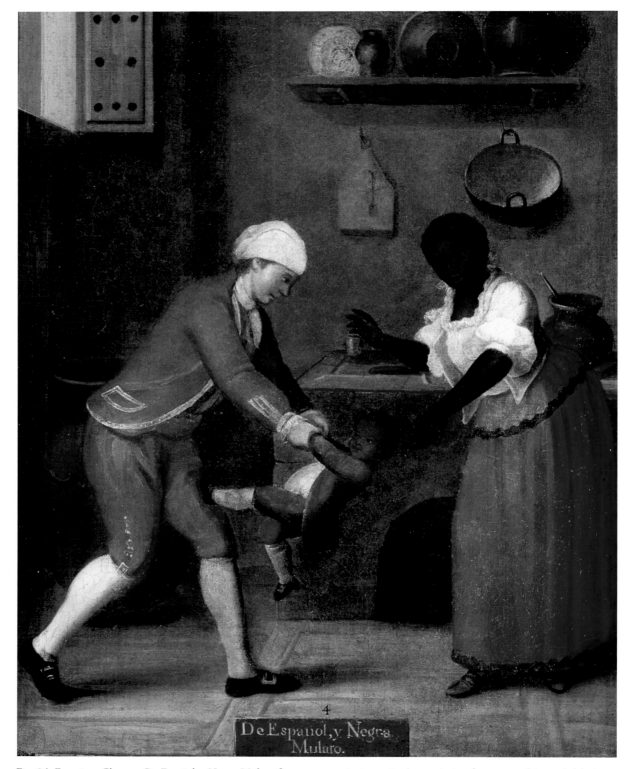

Fig. 34. Francisco Clapera, *De Español, y Negra, Mulato*, from a casta painting series (one painting from a set of sixteen). Mexico, circa 1785. Oil on canvas, 20 x 15½ in. (50.8 x 39.4 cm). Denver Art Museum, Gift of the Collection of Frederick and Jan Mayer, 2014.428.

### Fin de Siglo Women

As New Spanish men's styles grew ever more difficult to distinguish from European modes, women's styles became increasingly individuated. By the end of the century, the women's tailors of Mexico had synthesized international style, producing garments that were both unmistakably of their era and strikingly local. New Spain's flirtation with the open robe had been brief, and two-piece construction *a la española* remained the dominant technique. This can be seen in the anonymous 1780 portrait of María Dolores del Río y Alday (fig. 35) of Pátzcuaro (in today's state of Michoacán), who, according to the information given on her *cartela*, "died in the city of her birth at the age of 12 years." Her bizarre posture can be explained as a late and provincial example of the "hips forward" stance, which here seems a caricature of outmoded refinement.

She wears a crimson *casaquín* bodice with New Spain's preferred cone-shaped *sacristán* hoop under a skirt of indeterminate fabric. Both skirt and bodice seeming to be ornamented with applied strips of lace, narrow on the bodice and quite wide at the hem of the skirt. The front of her *casaquín* bodice mimics the closure of an open robe, with the series of bows called an *échelle* (ladder) in French. Her dress is quite unusual in that she wears no sleeve ruffles (although it is inconceivable that she wore no chemise). This allows us to see with clarity the pushed-up cuff bracelets that are half-hidden under the sleeve ruffles in figures 11, 15, and 20.

If a provincial girl from Pátzcuaro was able to manage a degree of chic, the sophistication of Mexico City women should not surprise us. Doña Ramona Musitú e Icazbalceta (fig. 36), the elder sister of the gentleman in figure 33, painted two years earlier by the same artist, walks with her two daughters in a formal park. She is dressed not as a Madrid *maja* but in Mexico City's version of the prevailing international style, with an elaborately embroidered, ivory-colored, long-sleeved *robe à l'anglaise* (*vaquero*) with a sheer fichu. Her daughters are dressed in simpler gowns of the same style. Comparison with English fashions of the same decade shows that while the Mexican model is thoroughly and confidently of its era, it retains the strongly local cone-shaped skirt, and its look is generally smoother and more tailored than the softer English version.

Her elaborate, powdered coiffure in the "hedgehog" style (which succeeded the tall and narrow pouf seen in figure 21, and of which we can see the men's version in figure 31), topped with a hat bedecked with feathers, flowers, lace, and ribbons, seems quintessentially late eighteenth century. The sudden appearance in the portrait record after about 1780 of such elaborate styles suggests the arrival in New Spain of a cadre of the professional hairdressers who were the only people capable of constructing the era's ornate hairstyles. It's interesting to note that the hairstylists seem to have arrived at exactly the same time as the cadre of academically trained artists sent from Spain in 1781 to establish Mexico City's Academy of San Carlos.

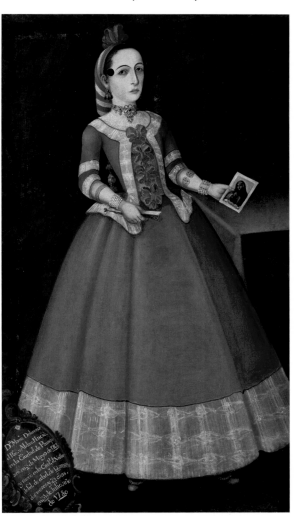

Fig. 35. *Portrait of Doña María Dolores del Río y Alday.* Mexico, 1780. Oil on canvas, 66¼ x 38¾ in. (168.3 x 98.4 cm). Denver Art Museum, Gift of the Collection of Frederick and Jan Mayer, 2013.332.

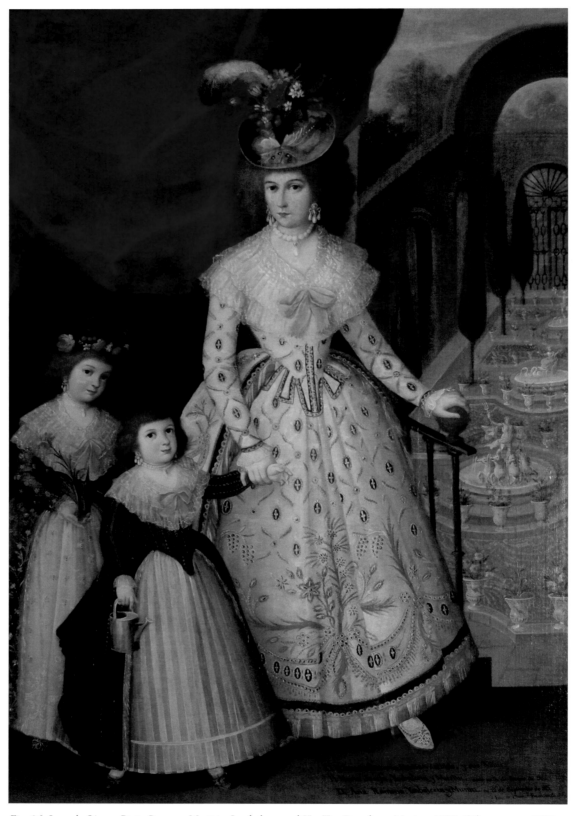

Fig. 36. Juan de Sáenz, *Doña Ramona Musitú e Icazbalceta and Her Two Daughters*. Mexico, 1793. Oil on canvas, 78¾ x 53½ in. (200 x 136 cm). Fundación Cultural Daniel Liebsohn A.C., Mexico.

### Epilogue

These hair stylists and academicians can be seen as the advance guard of the emigrant artists, architects, merchants, cooks, pastry-chefs, and dressmakers who flocked to the new republics of Spanish America in the nineteenth century. The 1790s would be the last hurrah of New Spanish sartorial independence. As the European Neoclassicism that had been introduced in the 1780s by royal fiat with the establishment of the Academy of San Carlos took hold, elite patrons eagerly abandoned the localisms that had made New Spanish painting, sculpture, and architecture distinctly American, in favor of academically "correct" models.

It was perhaps inevitable that, as New Spain strove to become independent Mexico, home-grown cultural expressions would be discarded as embarrassing and provincial. Taking its place among the modern nations, nineteenth-century Mexico imported French architecture, English technology, and Italian opera. The entirely international character of the Neoclassical clothing seen in the group portrait of the family of Viceroy Iturrigaray (served 1803–1808) confirms that this Europeanization was also reflected in dress (fig. 37). The clothing of powerful men had been thoroughly European for a century. For elite women, the new international-style, high-waisted gowns now ceased to be formal or portrait clothing and became everyday dress, such as the one seen here, made probably of cotton muslin and over-embroidered in gold. By the early years of the independent republic, upper-class dress was firmly in the hands of French modistes and English tailors, where it would remain until at least the 1970s.

Thanks to the exponential proliferation of images brought forth by photography, nineteenth-century Mexican dress became legible in ways that New Spaniards could not have imagined. When, in the twentieth century, elite Mexican women began again to wear locally influenced clothing, New Spain had become a very different place.

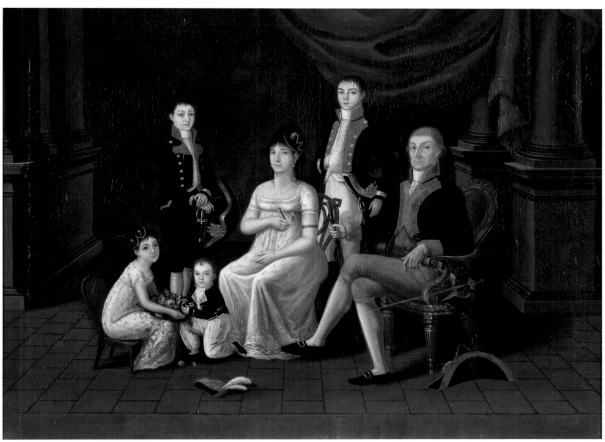

Fig. 37. José María Uriarte (attributed), *Viceroy Iturrigaray and Family*. Mexico, 1805. Oil on canvas, 23 x 29⅛ in. (58.4 x 74 cm). Museo Nacional de Historia, Mexico City, Mexico. Reproduction authorized by the Instituto Nacional de Antropología e Historia.

## Notes

[1] Especially learned or particularly saintly figures also might also qualify. For portrait theory, see Michael Brown, "Images of an Empire: Portraiture in Spain, New Spain and the Viceroyalty of Peru," in *Painting of the Kingdoms: Shared Identities: Territories of the Spanish Monarchy, 16th–18th Centuries*, ed. Juana Gutiérrez Haces (Mexico: Fondo Cultural Banamex, 2009); Laura. R. Bass, *The Drama of the Portrait: Theater and Visual Culture in Early Modern Spain* (University Park, PA: Penn State University Press, 2008); James M. Cordova, *The Art of Professing in Bourbon Mexico* (Austin: University of Texas Press, 2014).

[2] As the sixteenth-century aristocracy of *conquistadores* and *encomenderos* who had dominated the conquest era began to lose their place to newly rich merchants, the children of those merchants began to be seen by the old aristocracy as acceptable marriage partners. "The displacement of the first settler group led in the late sixteenth century to a literature bewailing the disinheritance of the conquest families, which contributed to an increasing awareness of creole identity" (Louisa Schell Hobermann, *Mexico's Merchant Elite, 1590–1660: Silver, State, and Society* [Durham: Duke University Press, 1991], 9). In due course those merchants began to acquire noble titles for themselves, titles that, although not precisely bought and sold, were made available to the very wealthy with the understanding that some pecuniary consideration would be involved. Peter Bakewell (*A History of Latin America to 1825*, 3rd ed. [Oxford: Blackwell, 2010], 377) states that the "marquisates and countships were not sold, but awarded for notable service." However, Julio de Atienza (*Títulos nobiliarios Hispanoamericanos* [Madrid: Aguilar, 1947], 19) notes several instances of specific payments in the vicinity of 30,000 pesos, the approximate equivalent of $15,000,000 (U.S.) today.

[3] Francesco Gemelli Careri, *Giro dal Mondo* (Naples, 1699); English edition: *A Voyage Round the World* (London, 1704), 527.

[4] See Clare Haru Crowston, *Fabricating Women: The Seamstresses of Old Regime France, 1675–1791* (Durham, NC: Duke University Press, 2001).

[5] There are three known independent portraits of women painted before 1700, plus a handful of additional female donor portraits incorporated into larger religious compositions. The earliest of the independent portraits, the *Dama Desconocida* attributed to Balthasar de Echave Orio, Museo Nacional de Arte, Mexico City, was almost certainly cut down from a votive image. (Previously anonymous, the sitter in this painting has been identified by Michael Brown in his essay in this volume.) There are numerous portraits of men from the early period, though nearly all are of an official character. The dress in all of these images is resolutely Spanish.

[6] http://www.drycleancoalition.org/download/drycleaning-historical_developments.pdf.

[7] Linen was preferred, but cotton undergarments may have been more common in the cotton-growing territories of New Spain.

[8] *Men's drawers*, Spanish, linen, c. 1800–1940. Gift of Polaire Weissman. Accession number: C.I.40.199.1940.

[9] C. Willett Cunnington and Phyllis Cunnington, *A History of Underclothes* (New York: Dover, 1992), 52, 68.

[10] Cunnington and Cunnington, *A History of Underclothes*, 110, note that "For us, there is a certain irony in the fact that at first, the wearing of drawers by women was considered extremely immodest."

[11] For the history of the international Spanish mode, see Brian Reade, *The Dominance of Spain* (London: Harrap, 1951); José Luis Calomer and Amalia Descalzo, *Spanish Fashion at the Courts of Early Modern Europe* (Madrid: Centro de Estudios Europa Hispánica, 2014).

[12] Paula Mues Orts and Iván Escamilla, "Espacio real, espacio pictórico y poder: la vista de la plaza mayor de México de Cristóbal de Villalpando," in *La imagen política, México*, ed. Cuauhtemoc Medina (Mexico City: UNAM/IIE, XXV Coloquio Internacional de Historia del Arte, 2006), 177–204.

[13] "No había en todo el orbe una ciudad que alojara una sociedad tan pluriétnica, manifestó. A la capital de la Nueva España acudían españoles procedentes de la península Ibérica, italianos, flamencos, alemanes, esclavos venidos de las colonias portuguesas en África: Guinea, el Congo, Mozambique; gente de Asia: chinos, filipinos, hindúes, vietnamitas, camboyanos, muchos de ellos habían llegado también como esclavos y habían comprado su libertad": Antonio Rubial García, "Ciudad de México: La más cosmopolita de la época colonial," *Diario avanzada* (14 de octubre de 2014) http://www.diarioavanzada.com.mx./index.php/historia/9135-ciudad-de-mexico-la-mas-cosmopolita-de-la-epoca-colonial.

[14] The subsequent text of the edict makes clear that Philip wished to encourage the use of textiles "made within these realms" (*como sean de las labradas dentro destos reynos*). Abelardo Carillo y Gariél, *El traje en la Nueva España* (México: INAH, 1959), 117.

[15] Philip IV, *Pragmatica*, 11 February 1623, quoted in Carillo y Gariél, *El traje*, 117.

[16] Christoph Rosenmüller, *Patrons, Partisans and Palace Intrigues: The Court Society of Colonial Mexico* (Calgary: University of Calgary Press, 2008), 101–125.

[17] The documentation for this "well-documented phenomenon" (Viqueira Albán) is an unsourced quotation from José Miranda's *Humboldt y Mexico* given in Juan Pedro Viqueira Albán, *Propriety and Permissiveness in Bourbon Mexico* (Wilmington, DE: Scholarly Resources, 1999), xviii. José Miranda, *Humboldt y Mexico* (México: Universidad Nacional Autónoma de México, 1962), 25: "saraos y otras fiestas mundanas al estilo francés." See also Enrique Krause and Hank Heifetz, *Mexico, a Biography of Power* (New York: Harper Perennial, 1997), 4.

[18] James Middleton, "Reexamining French Style in Bourbon Latin America" (IV Simposio de la Historia de Arte, Bogotá, Universidad de los Andes, 22–24 de agosto de 2014).

[19] For an excellent overview of the ongoing simplification of Western dress from the late seventeenth century to the present day, see Anne Hollander, *Sex and Suits* (New York: Knopf, distributed by Random House, 1994).

[20] Aileen Ribeiro, *Fashion and Fiction* (New Haven, CT: Yale University Press, 2005), 225.

[21] Diana De Marly, *Louis XIV and Versailles* (London: Batsford, 1988), 42: "by 1678 the French had given up trying to resist . . . Louis XIV lost this round."

[22] For example by James Oles in *Art and Architecture in Mexico* (London: Thames and Hudson, 2013), 109.

[23] De Marly, *Louis XIV and Versailles*, 27–50.

24 Scarlett O'Phelan Godoy, "La moda francesa y el terremoto de Lima de 1746," *Bulletin de l'Institut Français d'Études Andines* 36, no. 1 (2007): 19–38. In fact, nowhere in her article does O'Phelan Godoy directly link the Lima clergy with any specifically anti-French statements. The clergy disapproved of the luxury of women's clothes, not their putative French origin; the author is unwittingly reinforcing the flawed idea that "luxury = French."

25 Krause and Heifetz, *Mexico, a Biography of Power*, 98.

26 De Marly, *Louis XIV and Versailles*, 117.

27 *Chapeau-bras*: "a dress hat made to be carried under the arm." Valerie Cumming, C. W. Cunnington, and P. E. Cunnington, *The Dictionary of Fashion History* (Oxford/New York: Berg, 2010), 43.

28 Philip Mansel, *Dressed to Rule* (New Haven, CT: Yale University Press, 2005), 15; De Marly, *Louis XIV and Versailles*, 26.

29 Hollander, *Sex and Suits*, 181–199.

30 The term seems to have originated in early eighteenth-century France; Crowston, *Fabricating Women*, 51.

31 Ilona Katzew, *Casta Painting* (New Haven, CT: Yale University Press, 2004), 71.

32 Mme. Calderón de la Barca, *Life in Mexico, during a Residence of Two Years in That Country* (London, 1843), 158, 192.

33 Musicologists and performers have established that the nun-musicians of colonial Mexico lived much more stable lives than their male counterparts, and were probably the most skilled musicians in the New World. For example, see Thomas Gage, *A new survey of the West-India's, or, the English American, his travail by sea and land: containing a journal of three thousand and three hundred miles within the main land of America* (London: Printed by E. Cotes and sold by John Sweeting . . . , 1655), 59; also http://www.newberry.org/newberry-consort-celestial-sirens.

34 Unlike the rest of Europe, where these new-style gowns went by French names, Spain and the Spanish dominions used a multiplicity of different terms that are only beginning to be decoded.

35 Aileen Ribeiro, in *The Art of Dress: Fashion in England and France, 1750 to 1820* (New Haven, CT: Yale University Press, 1995), extensively discusses conventionalized portrait dress, especially in her fourth chapter, "Remembrance of Things Past, Image and Reality in Fancy Dress in England," 181 et seq.

36 Crowston, *Fabricating Women*, 41.

37 English professional needlewomen seem not to have gathered into a guild, although they successfully resisted the efforts of male sewing guilds in 1668 and 1702 to repress female employment, and women were admitted to the York merchant tailors' guild in 1704. By the 1760s, public opinion began to be "overtly hostile" to men in what were increasingly seen as "feminine" professions. Nicola Jane Phillips, *Women in Business, 1700–1850* (Rochester, NY: Boydell Press, 2006), 176–177.

38 Juan de Viera, "Breve compendiossa narración de la ciudad de México, corte y cabeza de la América septentrional," *La ciudad de México en el siglo xviii (1690–1780): tres crónicas* (México: Consejo Nacional para la Cultura y las Artes, 1990), 256–257, second part; quoted in Abby Sue Fisher, "*Mestizaje* and the *Cuadros de Casta*: Visual Representations of Race, Status and Dress in Eighteenth Century Mexico" (PhD diss.,

University of Minnesota, 1992), 69: "De la misma manera se presentan sus mugeres que no se distinguen en el traje de las más señoras. Y es una maravilla verlas en los templos y en los paseos de modo que muchas veces no se puede conocer qual es la muger de un conde, ni qual la de un sastre."

39 Calderón de la Barca, *Life in Mexico*, 31, 90, 111, 297, 325, 436, 444.

40 Mansel, *Dressed to Rule*, 15; De Marly, *Louis XIV and Versailles*, 26.

41 That of the Hermanas Capuchinas de Santa María de Guadalupe, founded in 1782 in the Villa de Guadalupe, just outside Mexico City.

42 The hook and eye closure, documented from at least the mid-sixteenth century, can be seen prominently in Pieter Breughel's *The Old Shepherd*, ca. 1550, Vienna, Kunsthistorisches Museum.

43 Kristen Stewart, in a catalogue entry for the exhibition *Interwoven Globe*, gives twenty-eight inches as a maximum European loom width. Amelia Peck, et al., *Interwoven Globe: The Worldwide Textile Trade, 1500–1800* (New York: Metropolitan Museum of Art; New Haven: distributed by Yale University Press, 2013), 196.

44 William Lytle Schurz, *The Manila Galleon* (New York: Dutton, 1939), 25–32.

45 Hollander, *Sex and Suits*, 64.

46 Virginia Armella de Aspe, Teresa Castello Yturbide, and Ignacio Borja Martínez, *La historia de México a través de la indumentaria* (México: Inversora Bursátil, 1988), 144.

47 See Aileen Ribeiro, *Dress in Eighteenth-Century Europe* (New Haven, CT: Yale University Press, 2002), 152–153; Edward Maeder, *An Elegant Art: Fashion and Fantasy in the Eighteenth Century* (Los Angeles: Los Angeles County Museum of Art; New York: H. N. Abrams, 1983), 231.

48 *Chiqueadores* are erroneously believed to have been packed with aromatic herbs against headache. This explanation is common among high-status Mexicans today (from one of whom I first heard it), but this seems to be an after-the-fact justification concocted by people who had inherited such portraits and were at a loss to otherwise explain such an odd detail.

49 Mexico City may well have been larger than Madrid, and was certainly the world's second largest—if not largest—Spanish-speaking city. Doris Ladd (*The Mexican Nobility at Independence, 1780–1826* [Austin: Institute of Latin American Studies, University of Texas, 1976], 40) gives a population of 213,000 for 1794, placing it in the second tier of European cities with Venice, Rome, Amsterdam, and Vienna. Only Paris, London, Naples, Constantinople, and Beijing were significantly larger (see Colin McEvedy, *Penguin Atlas of Modern History*, [Harmondsworth, UK: Penguin, 1972], 60), with populations of several hundred thousand to a million.

50 Bakewell, *A History of Latin America to 1825*, 353–354; James Early, *The Colonial Architecture of Mexico* (Dallas, TX: Southern Methodist University Press, 2001), 133; also D. A. Brading, *Miners and Merchants in Bourbon Mexico, 1763–1810* (Cambridge, UK: Cambridge University Press, 1971), 353–354.

51 These words, traditionally ascribed to Alexander von Humboldt, actually come from Charles Latrobe's *The Rambler*

*in Mexico* (London, 1836), 84.

52 William Lytle Schurz, *The Manila Galleon,* 32.

53 Woodrow Borah, *Silk Raising in Colonial Mexico* (Berkeley: University of California Press, 1954), 121.

54 Ladd, *The Mexican Nobility at Independence*, 53–71.

55 See Amelia Peck, et al., *Interwoven Globe.* Pattern-on-pattern design, generally considered garish or "too busy" in the West, is one of the features that most differentiate "traditional" Asian design from design in the European tradition.

56 Viera, *La ciudad de México*, 256–257: "Qualquier oficial sale en los dias de fiestas con tanta decencia y ostentación como fue un flotista, vestido de más galones que si fuera un veinte y cuatro, con dos reloxes como el hombre más decente." It seems extraordinary to me that the clashing textiles are not the first thing we notice when we look at Cabrera's portrait: I had known the picture for nearly thirty years before noticing this, and it seems indicative of Cabrera's skill as a painter that we see the subject almost without noticing his extravagant clothing.

57 As Michael Brown persuasively argued in "Portraiture in New Spain, 1600–1800: Painters, Patrons and Politics in Viceregal Mexico" (PhD diss., New York, New York University Institute of Fine Arts, 2011).

58 Traditionally identified as "A Lady of the Sánchez Navarro Family."

59 The Brooklyn Museum has a portrait of a child wearing an open robe, attributed to Nicolás Enríquez and believed to depict María de la Luz Padilla y de Cervantes as a toddler. It is indeed inscribed with her name and is circumstantially dated to 1735 on the basis of the putative subject's age. I believe that the portrait actually represents María de la Luz's daughter, María Manuela Josefa de Loreto Rita Modesta Gómez de Cervantes y Padilla (http://www.geni. com/people/Mar%C3%ADa-de-la-Luz-Josefa-de-Padilla-y-G%C3%B3mez-de-Cervantes/6000000006782672700), born June 14, 1754, who seems to have died quite young, and that the portrait was wrongly inscribed, perhaps quite early in its history. As the radiographs on the Brooklyn Museum's website demonstrate, the portrait has been subject to enough interventions to raise red flags about its reliability as a document. Although the dress itself seems not to have been tampered with, the 1735 date predates the open robe's first appearance in a New Spanish portrait by about twenty-five years. Indeed, the open robe was uncommon in peninsular Spain until about 1750. It is not impossible that the Brooklyn portrait attributed to Enríquez is just what it says it is, and that it indeed represents an early appearance of the international style in New Spain, but more work needs to be done before we commit to this position.

60 See Maeder, *An Elegant Art*, 168, 169.

61 Both the distinctive front closure of the gown and the black jabot are seen in a slightly later votive portrait of María Bárbara de Ovando y Rivadeneyra, Countess of Santiago de Calimaya, attributed to Miguel Cabrera (reproduced as figure 27 in Luisa Elena Alcalá and Jonathan Brown, *Painting in Latin America, 1550–1820* [New Haven, CT: Yale University Press, 2014]), which I believe to be based on this painting, although the textile of the gown is different in Cabrera's canvas.

62 An engraving of 1754–1758 by Johann Sebastian and Johann Baptist Klauber, *The Allegory of the Protection of the Virgin of Guadalupe over New Spain*, clearly shows the "Mexican" diadem on the lower right-hand figure.

63 The same black lace collar/jabot is worn by a figure in a circa 1770 folding screen at Mexico's Museo Nacional de Historia representing a garden party at a country house (*Biombo del Sarao*, Chapultepec).

64 It is possible that changes in corsetry abetted this change in posture, though few Hispanic corsets survive from the Old or New Worlds dating before the great posture shift of the midcentury.

65 Viera, *La ciudad de México*, 256–257. See note 56 for full quote in Spanish.

66 Chloe Sayer, *Costumes of Mexico* (Austin: University of Texas Press, 1985), 95.

67 See Mansel, *Dressed to Rule.* Although the French Revolution intervened, court dress was resumed with a vengeance under Napoleon's empire, and the monarchs of the Bourbon Restoration did not attempt to change Napoleon's dicta. The most extreme divergence of court dress from high fashion was seen in the final years of the court of George III of England, during which women were obliged to wear hoops with their high-waisted empire style gowns.

68 Mansel, *Dressed to Rule*, 2–3.

69 Ribeiro, *Dress in Eighteenth-Century Europe*, 188, 189.

70 Stylistically, it might have been painted as late as the 1770s, but the artist died in 1768. The subject died in 1776.

71 De Marly, *Louis XIV and Versailles*, 61–63.

72 Since his name is on the envelope, the portrait previously was believed to depict Bernardo de Gálvez, son of Matías, who served as governor of Spanish Louisiana, headquartered at New Orleans, and led a successful campaign culminating in the 1781 siege of Pensacola, costing Britain its foothold in the Gulf of Mexico. He replaced his father briefly as viceroy of Mexico in 1785–86. However, recent research has concluded that the painting is dedicated to Gálvez by the sitter Captain F. Casana, who served in the Aragon Regiment and fought with Gálvez in the early 1780s. See José Manuel Guerrero Acosta, "Los soldados de Gálvez: europeos y americanos en México y durante la revolución americana (1770–1783)," in *Bernardo de Gálvez: la presencia de España en México y Estados Unidos* (Madrid: Ministerio de Defensa, 2015), 207.

73 On the inefficacy of the Bourbon reforms in the Americas see Bakewell, *A History of Latin America to1825*, 364–369; Brading, *Miners and Merchants*, 33.

74 Ladd, *The Mexican Nobility at Independence*, 114.

75 Chris McNab, *Military Uniforms Visual Encyclopedia* (London: Amber Books, 2011), 9.

76 http://miniaturasmilitaresalfonscanovas.blogspot. com/2011/10/el-virreinato-de-nueva-espana-fuente.html.

77 See Aileen Ribeiro, *Dressing Eighteenth-Century Europe*, 207–243.

78 Diana De Marly, *Fashion for Men* (London: Batsford, 1985), 78.

79 Elena Phipps, "The Iberian Globe," in Amelia Peck, et al., *Interwoven Globe*; also Museo Nacional de Historia, *El Galeón de Acapulco* (México: INAH, 1998), 43.

## Regional Tastes in a Transatlantic Market
### Joseph Blackburn in New England and Bermuda

*Jennifer Van Horn*

In 1755 the English-born artist Joseph Blackburn (fl. 1752–1778) began painting portraits in Boston, including a spectacular depiction of *Isaac Winslow and His Family* from that year (fig. 1).[1] The story of Blackburn's arrival in the city is well known today, not because of Blackburn—who remains relatively unknown—but rather because of the impact his Boston sojourn had upon the young painter John Singleton Copley. Copley, then only seventeen, quickly and adeptly began to master his older competitor's style, beginning with his portrait of Ann Tyng, which closely resembles Blackburn's depiction of Mary Sylvester (figs. 2 and 3).[2] Both paintings show the young women in pastoral landscapes playing the part of a shepherdess, a metropolitan portrait guise popular for young unmarried sitters since it connoted both innocence and erotic appeal.[3]

This cat-and-mouse game persisted over the next several years as Copley replicated Blackburn's Rococo palette, shimmering surfaces, and mezzotint-inspired poses, eventually making them his own. As a number of scholars have noted, we see great similarities in several Blackburn/Copley pairings, for example Blackburn's *Portrait of a Woman* (c. 1760) and Copley's *Mrs. George Watson (Elizabeth Oliver)* (1765), as well as Blackburn's portrait of Joseph Dwight (1756) and Copley's similarly posed painting of Jonathan Belcher (1756).[4] This pattern persisted until, as the story goes, Blackburn—fearful of Copley's burgeoning prowess—fled Boston for Portsmouth, New Hampshire. Eventually he left the North American colonies altogether to return to England, presumably with his tail between his legs.[5] Though I am presenting that viewpoint a bit tongue-in-cheek,

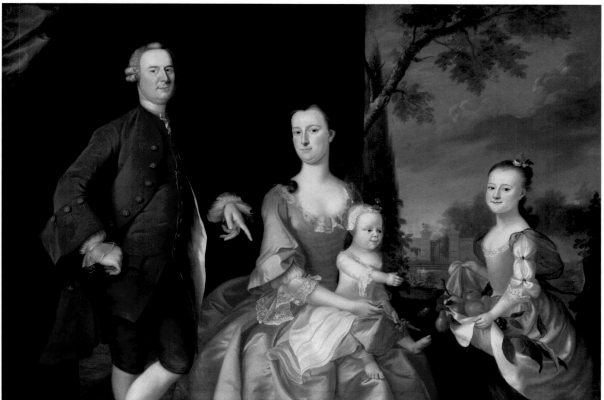

Fig. 1. Joseph Blackburn, *Isaac Winslow and His Family*. Boston, Massachusetts, 1755. Oil on canvas, 54½ x 79¼ in. (138.43 x 201.29 cm). Museum of Fine Arts, Boston, A. Shuman Collection—Abraham Shuman Fund, 42.684.

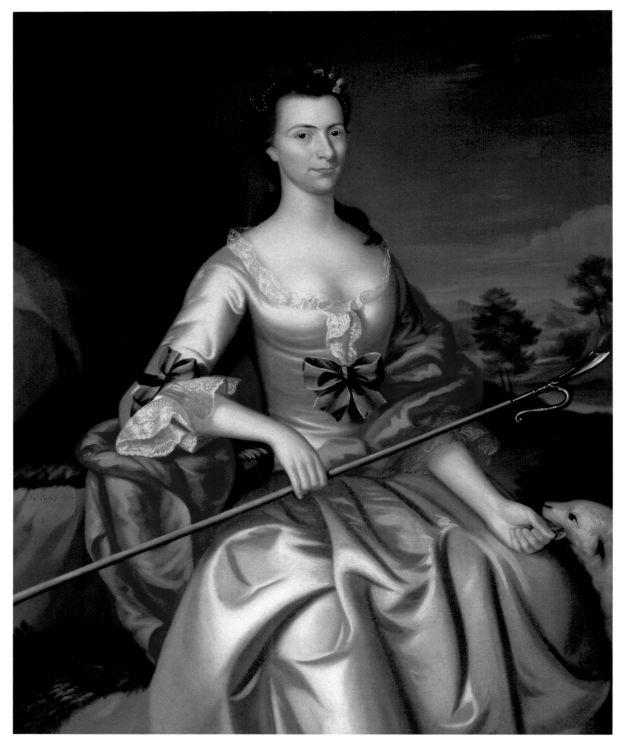

Fig. 2. John Singleton Copley, *Ann Tyng (Mrs. Thomas Smelt)*. Boston, Massachusetts, 1756. Oil on canvas, 50⅛ x 40⅛ in. (127.32 x 102.55 cm). Museum of Fine Arts, Boston, Juliana Cheney Edwards Collection, 39.646.

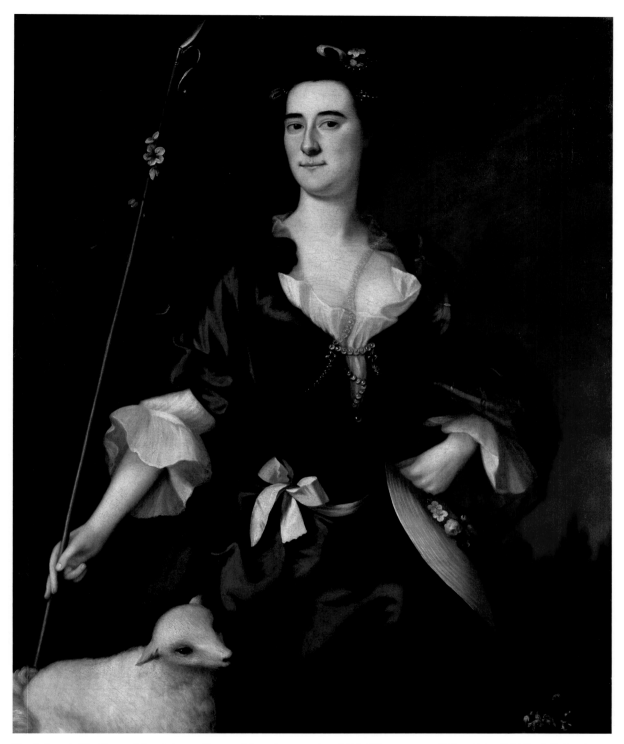

Fig. 3. Joseph Blackburn, *Mary Sylvester*. Boston, Massachusetts, circa 1754. Oil on canvas, 49⅞ x 40 in. (126.7 x 101.6 cm). Metropolitan Museum of Art, Gift of Sylvester Dering, 1916, 16.68.2. www.metmuseum.org

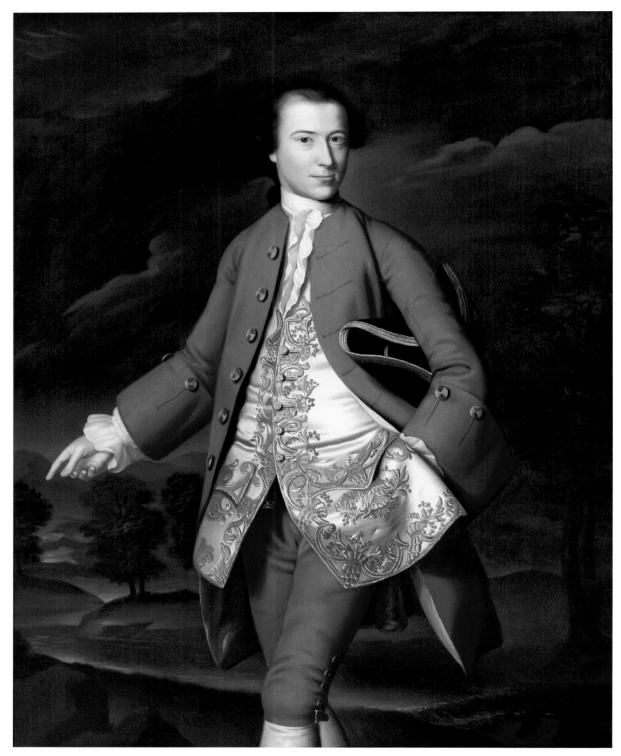

Fig. 4. John Singleton Copley, *Portrait of Theodore Atkinson, Jr.* (1737–1769). Boston, Massachusetts, 1757–1758. Oil on canvas, 50 x 40 in. (127 x 101.6 cm). Museum of Art, Rhode Island School of Design, Providence, Jesse Metcalf Fund, 18.264.

there is something to be said for the argument that Copley's skill encouraged Blackburn to move on to new markets. As an example, we could consider Copley's stupendous painting of Theodore Atkinson Jr. (1757–1758), in which he arguably surpassed the technical virtuosity of the older English artist (fig. 4).[6]

This essay revisits Blackburn's time in Boston and asks readers to focus *not* on John Singleton Copley, but instead on the older English artist Copley mimicked. What brought the England-trained Blackburn to Boston—or even more broadly, to the *terra inconnu* of the American colonies? How did Blackburn, an artist unknown to his North American clientele, go about finding patrons? How did he do it so successfully? Finally, let us consider the style of portraiture Blackburn offered. Art historians have documented Blackburn's effect on Copley, but what impact might Blackburn's North American travels have had on his own choices in depicting sitters?

We should begin with the forces that drew Blackburn to Boston and establish how his stay in this city fit into his broader travels. Blackburn is first documented in Bermuda in 1752, and between then and his death in 1778 he painted approximately 150 portraits of sitters in diverse locations around the Atlantic rim. Blackburn's brief stay in Ireland in 1767, for example, yielded a charming depiction of a young Dublin girl brandishing a lottery ticket (fig. 5).[7] While the portraitist's origins are obscure, art historians have speculated that Blackburn trained with a London painter and specialized in drapery, owing to his facility at representing fabrics and elements of costume. Indeed, one of the few eighteenth-century observers to comment on Blackburn's paintings noted this skill. In a letter to her brother-in-law, Bostonian Mary Cary Russell wondered "what business he [Blackburn] has to make such extreme fine lace and satin, besides taking so exact a likeness." Blackburn's ability to capture textures is especially visible in his portrait of the Winslow family (see fig. 1). The painterly treatment of the lace on the baby's cap, the semitransparent sheen of the young girl's cape, and the impasto of the jewels that embellish her imaginary costume are compelling displays of virtuosity (fig. 6). London's growing number of portrait painters at midcentury

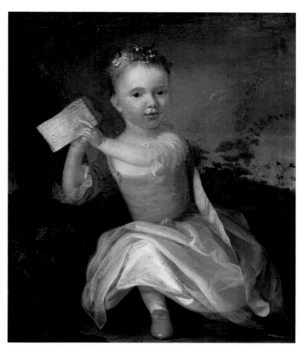

Fig. 5. Joseph Blackburn, *Portrait of a Young Girl Holding a Dublin Lottery Ticket*. Dublin, Ireland, 1767. Oil on canvas, 30⅞ x 24⅞ in. (76 x 63 cm). National Gallery of Ireland, 4456. Photo © National Gallery of Ireland.

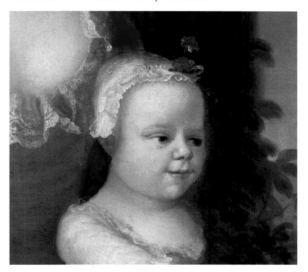

Fig. 6. Detail of Figure 1.

Fig. 7. Joseph Blackburn, *Hugh Jones*. Monmouthshire, United Kingdom, 1777. Oil on canvas, 50½ x 40⅛ in. (128.3 x 101.9 cm). Worcester Art Museum, museum purchase, 1962.21.

meant that drapery painters, who were employed by major artists to complete a sitter's clothing and the details of a landscape, became increasingly common; Blackburn might have studied with, and worked for, any number of these limners. None of his paintings from his early English career have yet been identified.[8]

Likely trained in the artistic capital, Joseph Blackburn ended his life as a provincial British portraitist, working in the southwest of England and Wales. This is evidenced by a sequence of portraits he completed in the region, culminating with his final known painting, a portrait of Hugh Jones, an agent for the Morgan family at their estate of Tredegar in Monmouthshire, then in England (fig. 7).[9] It was in the middle of his career, between 1752 and 1764, that Blackburn spent twelve years traveling in North America and the Caribbean. The artist's itinerary led him first to St. George, Bermuda, and then to Newport, Rhode Island, before he set out for Boston and finally Portsmouth, New Hampshire, his last North American port of call before his return to London. Blackburn may also have spent time painting in Jamaica, but this has not yet been substantiated by any known portraits that the artist painted on the island.[10]

Blackburn's will, recently discovered at the National Archives in Kew, England, reveals that he profited financially from his transatlantic venture; the artist's North American sojourn enabled him to become a landholder in Worcester, England. Unfortunately the total value of his estate is not listed in his will. He appears to have been quite successful, however, as at his death the artist bequeathed each of his daughters two hundred pounds in addition to his real estate and the value of his personal goods. Though he is listed as a "gentleman," Blackburn continued to paint until his death. His profession, as well as the fact that his daughter Henrietta married William Hill, a brewer in Worcester, indicates that he remained in the middling sort.[11]

Of course Joseph Blackburn was not the only British portraitist to travel to multiple sites in North America and the Caribbean in the middle decades of the eighteenth century. His fellow British-born artists John Wollaston, Christopher Steele, and Cosmo Alexander shared similar travels

and between them painted more than 700 depictions of North American sitters scattered across more than a dozen sites in the British Atlantic. Such "Straggling Adventurers of the Brush"— as one early nineteenth-century Dublin observer called them—were not mere itinerants who moved along local networks. Rather, these artists shaped their careers around the new patrons and possibilities for circum-Atlantic travel created by the formation of a British Atlantic commercial empire.[12]

To be sure, several North American–born artists likewise crossed the Atlantic, including Benjamin West and Charles Willson Peale, who came to London for artistic instruction. John Singleton Copley also traveled from Boston to London (via Italy), in effect reversing his older competitor's journey, and very successfully set up shop in London after the American Revolution. But while many portraitists saw travel as a means of enhancing their livelihood, Joseph Blackburn and his fellow transatlantic sojourners differed from other artists in the length of their North American painting tours as well as the geographic breadth of their travels. Blackburn—as well as Wollaston, Steele, and Alexander—left already established careers to move along extensive circuits that encompassed a number of Atlantic port cities in North America and the Caribbean. Moreover, upon their return to the United Kingdom each of these painters continued to pursue patrons in British transatlantic ports, including Dublin, Edinburgh, and Southampton.[13]

Although many of Blackburn's paintings, as well as those of other artists in this group, have been identified and documented, these painters remain understudied. On the whole, artists whose careers crisscrossed the Atlantic have not fit easily into nationally based categories, and since a nationalist trajectory has dominated British and American art history for much of the last century, these painters have been underestimated. The best example of this may be the jingoistic conclusions drawn by Theodore Bolton and Harry Binsse in 1931. They lamented that some of Joseph Blackburn's and John Wollaston's works had "been [erroneously] attributed to Copley," which they deemed "an unfortunate thing for Copley's reputation" since his works were "of a maturity and excellence far exceeding the productions of any British face-painter." They prophesied that once "more . . . of these 'Copleys' [were] . . . recognized as [the work of] Blackburn . . . or Wollaston," it would be "a clearing of the ground most necessary to the true appreciation of Copley's own worth." While Bolton and Binsse's patriotic fervor led them to vilify Blackburn, they were certainly correct that several of these artists' works had been misattributed. The greatest reattribution came not in discovering a "poor" Copley to be a Blackburn, but rather in uncovering that one of the most lauded of Blackburn's American paintings was in fact an early Copley. Until the 1940s Copley's portrait of Theodore Atkinson Jr. (see fig. 4) had been erroneously attributed to Blackburn, who painted pendant portraits of Atkinson's parents. Because *Theodore Atkinson Jr.* had been deemed the finest work of Blackburn's oeuvre, its reattribution to Copley was taken as further proof of native-born American artists' superior talent.[14]

Earlier, at the turn of the twentieth century, many had understood Blackburn and his peers to be American because their sitters were. Indeed, Blackburn's portrait of Portsmouth merchant Colonel Jonathan Warner (incidentally the first portrait that the Museum of Fine Arts, Boston, ever purchased, in 1883 at the cost of $300) was even included in the American Painting Gallery at the famous World's Columbian Exposition in Chicago of 1893 (fig. 8). It shows a reserved Warner, his hand gracefully ensconced in his waistcoat, dressed in a tan broadcloth suit with shimmering silver buttons. The merchant's coolly appraising gaze is echoed by the painting's gray color range, its frosty hues punctuated only by the sitter's black bag wig and the black hat he grasps in his right hand. In the twentieth century, as American art historians sought to promote the beauty of any paintings produced in America, Blackburn came to prominence. Since then the geographic span of his career has allowed him, and other artists who worked around the Atlantic rim, to fall between the cracks; they belong to everyone and no one. For example, the National Gallery of Ireland labels Blackburn "British," while the Museum of Fine Arts, Boston, includes him in its American Wing but qualifies, "(born in England), active in North America."[15]

Fig. 8. Joseph Blackburn, *Colonel Jonathan Warner*. Portsmouth, New Hampshire, 1761. Oil on canvas, 50 x 40¼ in. (127 x 102.23 cm). Museum of Fine Arts, Boston, General funds, 83.29.

When these transatlantic artists have been studied, it is often for their connection to native-born American artists: Blackburn for his influence on Copley; Wollaston for his impact on Benjamin West; Alexander for his brief tutelage of Gilbert Stuart. (Cosmo Alexander took on Stuart as an apprentice in Newport, and brought Stuart with him on a southern painting tour before taking him to Edinburgh, where Alexander died.[16]) As scholars' gaze has broadened to encompass the Atlantic world as a unit of analysis, however, these artists begin to gain new importance. Like "merchant adventurers," the name loosely applied to English merchants involved in the export trade, these "Adventurers of the Brush" attempted to open new markets for portraiture by selecting destinations where their products would have appeal and by winning patrons from the emerging transatlantic mercantile class. Indeed, Joseph Blackburn can be recognized as formulating a portrait style and career path that specifically fulfilled the needs of North American merchants.[17]

The remainder of this essay offers a case study of how Joseph Blackburn "adventured" his paintings by focusing on the artist's work in two locales: Bermuda and New England. Blackburn painted approximately 20 portraits on the island and 110 in New England (80 in Boston, 6 in Rhode Island, and 20 in New Hampshire). While Bermuda and New England are geographically distant, close trading relationships between their merchants, begun in the seventeenth century, thickened and grew more lucrative in the middle decades of the eighteenth century. These mercantile connections were vital for Blackburn's success in both locales. The artist likely traveled to Bermuda (his first North American port of call) at the suggestion of (and perhaps also with the financial backing of) Francis Jones, of whom he painted his first known North American portrait (fig. 9). A wealthy merchant, as well as president of the Governor's Council and vice-admiral of the colony, Jones is shown with a ship—likely carrying his goods— visible in the window behind him. The artist and his patron may have met in England in 1752, while the Bermudian was in the metropole on legislative business. Upon Blackburn's arrival on the island, he painted five known portraits of the Jones family, including a pair of stunning

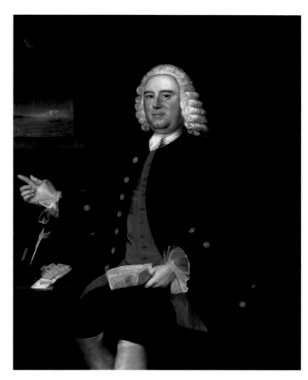

Fig. 9. Joseph Blackburn, *Portrait of Francis Jones, President, Commander-in-Chief, and Vice Admiral of Bermuda*. Bermuda, 1752. Oil on canvas, 50 x 40 in. (127 x 101.6 cm). The Cummer Museum of Art & Gardens, Jacksonville, FL. Purchased with funds from the Cummer Council, AP.1984.2.1.

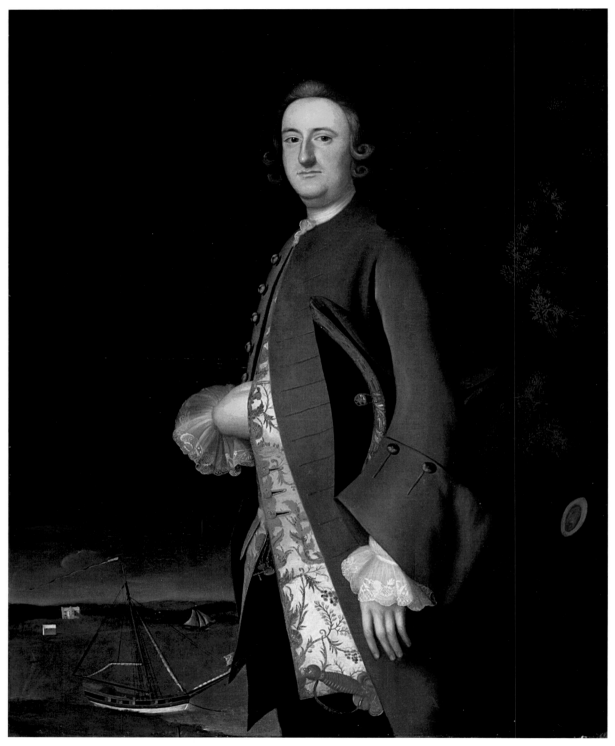

Fig. 10. Joseph Blackburn, *Portrait of Captain John Pigott*. Bermuda, circa 1752. Oil on canvas, 50 x 40 in. (127 x 101.6 cm). Los Angeles County Museum of Art, purchased with funds provided by the American Art Council in honor of the museum's twenty-fifth anniversary, M.90.210.1.

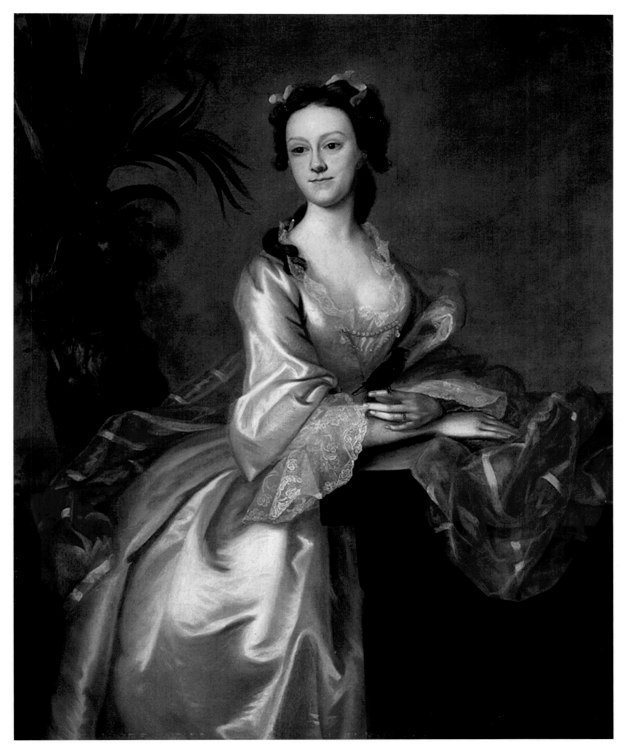

Fig. 11. Joseph Blackburn, *Portrait of Mrs. John Pigott*. Bermuda, circa 1752. Oil on canvas, 50 x 40 in. (127 x 101.6 cm). Los Angeles County Museum of Art, purchased with funds provided by the American Art Council in honor of the museum's twenty-fifth anniversary, M.90.210.2 .

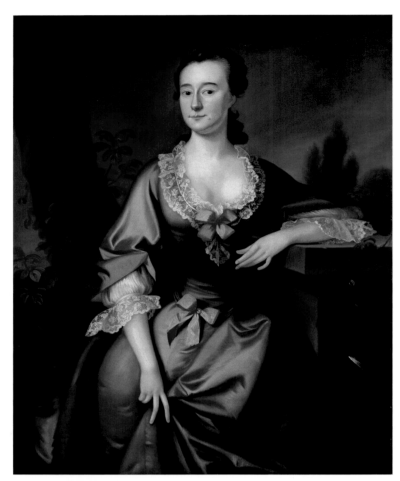

Fig. 12. Joseph Blackburn, *Mrs. David Chesebrough*. Newport, Rhode Island, 1754. Oil on canvas, 49⅞ x 40⅛ in. (126.7 x 101.9 cm). Metropolitan Museum of Art, gift of Sylvester Dering, 1916, 16.68.3. www.metmuseum.org.

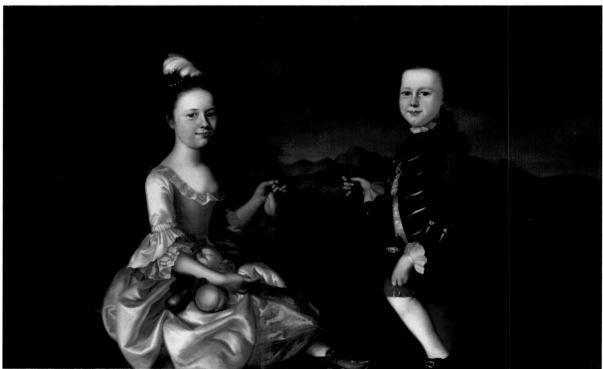

Fig. 13. Joseph Blackburn, *Portrait of Elizabeth Bowdoin and James Bowdoin III*. New England, circa 1760. Oil on canvas, 36⅞ x 58¹/₁₆ in. (93.7 cm. x 147.4 cm). Bowdoin College Museum of Art, bequest of Mrs. Sarah Bowdoin Dearborn, 1826.11.

three-quarter-length portraits of Captain John Pigott and his wife Fannie Jones Pigott (Francis Jones's daughter) (figs. 10 and 11).[18]

The Bermuda merchant delivered Blackburn more than an immediate circle of patrons, however. It was almost certainly Jones, or one of his successful merchant friends, who suggested the portraitist's next port of call: Newport, Rhode Island, a New England port whose residents enjoyed especially close trading ties to Bermuda. By 1754, Blackburn had completed his first known New England painting, a portrait of Margaret Sylvester Chesebrough, wife of David Chesebrough, a Newport merchant with Bermuda connections (fig. 12). As Blackburn arrived in Boston from Newport, then, he entered the port not as an unknown commodity, but rather as a well-known artist, moving and trading along his merchant patrons' existing networks.[19]

Once introduced to New Englanders, Blackburn made inroads quickly in the region's interconnected mercantile community. For example, his portrait of the Isaac Winslow family, one of his first known works in Boston, shows the scion of a wealthy and powerful merchant family (see fig. 1). Winslow had worked for the well-known merchant and Maine land developer James Bowdoin before beginning to trade on his own account and partner with his brother in a shipbuilding venture. After Blackburn's success in painting the Winslow family, the artist would go on to complete a delightful double portrait of Bowdoin's two young children (1760) (fig. 13). Blackburn found similar success in painting the family of Bostonian Charles Apthorp, described upon his death as "the greatest and most noble merchant on this continent." In particular, the artist's portrait of the merchant's daughter Susan Apthorp (1757) is a spectacular example of his Boston work in which Blackburn's ability to realistically depict costume—here an iridescent gray/purple silk dress that seems to shift colors depending upon the viewer's position—complements the sitter's whimsically flirtatious charm (fig. 14).[20]

Upon arriving in Portsmouth, New Hampshire, Blackburn found additional patrons among the city's transatlantic merchants. His most notable supporters in the city were the Warner family, of whom he painted six portraits, all

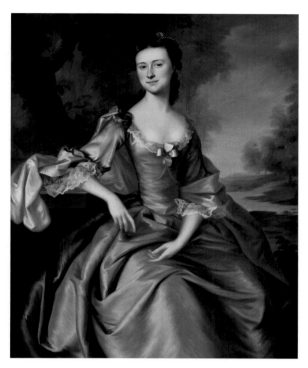

Fig. 14. Joseph Blackburn, *Susan Apthorp (Mrs. Thomas Bulfinch)*. Boston, Massachusetts, 1757. Oil on canvas, 50 x 40 in. (127 x 101.6 cm). Museum of Fine Arts, Boston, gift of Mr. and Mrs. John Templeman Coolidge, 45.517.

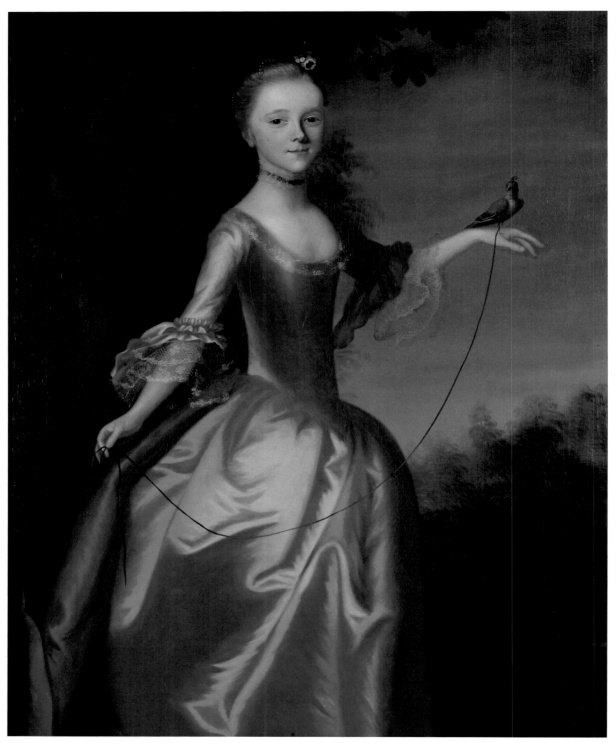

Fig. 15. Joseph Blackburn, *Mary (Polly) Warner*. Portsmouth, New Hampshire, 1761. Oil on canvas, 50 x 40 in. (127 x 101.6 cm). From the collection of the Warner House Association, Portsmouth, NH.

three-quarter-lengths that measure a large 50 by 40 inches. Five of these paintings, incredibly, still hang in the Warner House in Portsmouth, New Hampshire, including Blackburn's portrayal of the charming young Polly Warner (1761) (fig. 15). A fashionable brick mansion constructed with the tremendous fortunes its owners garnered through exchange, the Warner House is positioned high on a hill above Portsmouth's once busy harbor (fig. 16); the house's then avant-garde architectural style and the portraits that dominate its walls remain an ode to transatlantic mercantile wealth and power at midcentury.[21]

It is worth asking why Joseph Blackburn's works held such appeal for North America's transatlantic merchants.[22] Part of the key to the artist's success with this group lies, of course, in his English origins. His works were "in the newest fashion," as so many advertisements touted the latest styles imported from London by merchants including the Warners. Fashionability, however, does not provide the complete answer. In fact, Blackburn's portraits were not really at the height of London taste, certainly by the time he left New England in the 1760s. Blackburn was neither a Gainsborough nor a Reynolds, both of whom gained prominence in the late 1750s; he did not universalize figures, draw parallels to antiquity, nor exhibit the loose facture that made some of these English artists' canvases seem to dissolve into light and color. What Blackburn offered sitters instead was a well-honed formula of representation loosely derived from the poses and formats popularized by Thomas Hudson, a London painter at the height of his popularity in the 1740s who moved increasingly out of fashion over the course of Blackburn's career.[23]

If London's art scene was not the primary force that dictated transatlantic merchants' desire for these paintings, then where else might we look? I argue that we should expand our view to encompass other changes taking place in the production and marketing of goods in New England in the same years when Blackburn visited the region. Art historian Margaretta Lovell's important study of the cabinetmakers in Newport, Rhode Island, and the furniture they produced provides a model of other artisans who were simultaneously adjusting their craft to take advantage of

the new opportunities Atlantic trade presented. Like Blackburn and other transatlantic portrait painters, Newport's cabinetmakers realized that great profits could come from opening up distant markets. They became, in effect, "merchant-cabinetmakers," exporting large numbers of furniture pieces to consumers in the Caribbean and the southern colonies as well as other venues in New England. A chest of drawers produced by the famous Newport cabinetmaker John Townsend in 1765 exemplifies the kinds of goods that the city's craftsmen sent to consumers in distant locales (fig. 17). Carved of mahogany, Townsend's chest of drawers exhibits what furniture scholars have identified as the most common form of decoration for Newport furniture: a linear sequence of abstracted and deeply carved shells that adorn the tops of three alternating concave and convex bands.[24]

When studied in tandem, the newly arrived portrait painters and Newport's cabinetmakers appear to have shared strategies for attracting consumers at a distance. The labels cabinetmakers placed on many of the pieces they exported enabled new consumers in far locales to come back to them for more. John Townsend, for example, pasted a label bearing his name, location, and the date he manufactured the piece on the inside of the top drawer of his chest of drawers (fig. 18). British artists working in the colonies similarly marked their works. Though only two survived into the twentieth century, portrait painter John Wollaston pasted labels on the backs of his canvases in New York City, where he painted between 1749 and 1752. By using paper labels

Fig. 16. The Warner House. Portsmouth, New Hampshire, circa 1716. Photograph by the author.

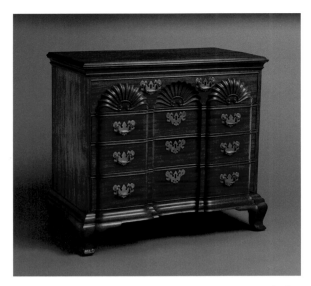

Fig. 17. John Townsend, Chest of Drawers. Newport, Rhode Island, 1765. Mahogany, tulip poplar, pine, chestnut, 34½ x 37½ x 20¾ in. (87.6 x 95.3 x 52.7 cm). Metropolitan Museum of Art, Rogers Fund, 1927, 27.57.1. www.metmuseum.org

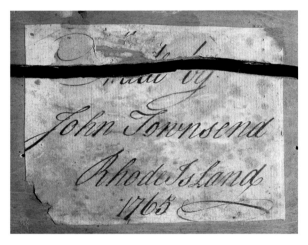

Fig. 18. Label from Figure 17.

Wollaston connected himself to the cabinetmakers' tradition, and—though written in Latin—his labels bore similar information, listing the artist's name as well as the date and location where the painting was completed. The paintings' lengthier inscriptions bore even more details about the artist and his patron. For instance, one label reads (in translation), "This is the True Image of William Smith Junior at the Age of Twenty-Three Painted by John Wollaston of London in New York AD 1751." Joseph Blackburn did not label his paintings but signed his canvases prominently and with remarkable consistency. "I. Blackburn Pinx" or "I. Blackburn Pinxit," the Latin for "Joseph Blackburn painted this," appears on a great many of his known works. Often the artist signed in clever places designed to reward the viewer's sustained attention, as with his portrait of Mary Sylvester, where his signature rests on the lower portion of the shaft of the shepherdess's crook (see fig. 3). Though she married Boston merchant Thomas Dering, Mary Sylvester also had Newport connections; the couple elected to wed in the city in 1765. Blackburn's signed wooden staff then may have directly recalled local cabinetmakers' labeled works.[25]

In looking to perfect their styles for easy export and transportability, portraitists and Newport cabinetmakers also shared aesthetic strategies. Margaretta Lovell traces the visual qualities that made Newport furniture ideal for distant ports, claiming that as craftsmen enlivened the forms' architectonic outlines with rich curves and then embellished surfaces with vibrant mahogany and striking but understated shell ornament, they successfully wedded the new Rococo style with the earlier Baroque idiom. Newport's cabinetmakers figured out how to brand themselves as distinctive in a transatlantic market (those omnipresent shells), yet to generate a style with broad-based appeal beyond their region. As he circulated through Atlantic ports, Blackburn formulated a similar export-oriented mode of portraiture perfected through repetition that appealed to mercantile consumers in multiple locations across the Atlantic. As Newport's cabinetmakers did in furniture, Blackburn integrated a Rococo palette over the strong structure of a Baroque portrait style. The artist's approach had clear metropolitan

precedents, and thanks to their knowledge of British mezzotints consumers likely recognized its metropolitan flair, but Blackburn did not directly emulate London's newest paintings. Instead, like other British painters who found ready patrons in North America, he formulated a hybrid commercial product with appeal beyond the London art scene that could be easily disseminated and altered to fit sitters in new destinations.[26]

Like Newport's relatively simple furniture with its shell decoration, the commonality of Blackburn's Hudson-informed style helped the artist break into new markets. Blackburn's predictability of approach is visible across many of his portraits, including those of Bostonians Susan Apthorp and Sarah Cunningham (see fig. 14 and fig. 19). These paintings bear striking parallels; both feature a woman seated in an English landscape with one bent arm resting on a stone plinth while silk drapery cascades over the stone. The young and unmarried Susan Apthorp is more coquettish, with a remarkably narrow waist and pearls threaded through her hair. The older, married Mrs. Nathaniel Cunningham is more staid, though she and Apthorp wear remarkably similar (and likely imagined) gowns. Both costumes feature a central ribbon bow from which a string of pearls loops around the sitters' torsos. While Cunningham's hair is unadorned, her sleeves are held up by two red jewels that contribute to her portrait's luxury. Though Blackburn included minor variations, both sitters' poses rely upon a simplified Hudson type that was immediately graspable for transatlantic elites.

Beyond their shared formal qualities, Blackburn's works exhibit a common market orientation. His portraits thematically and iconographically point to the culture of movement and connection in which his transatlantic merchant sitters worked. This is evident through his two major topoi: the letter and the bird. Many of Blackburn's portraits of merchants, such as that of Bermudian Francis Jones, highlight the sitters' writing, sending, and reading of letters, the tool of information exchange that enabled these men to convey prices and advice across large distances and to broker successful cargoes (see fig. 9). Jones holds an opened letter with a pile of correspondence resting on the table before him. Beyond

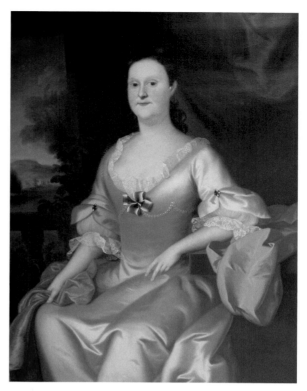

Fig. 19. Joseph Blackburn, *Mrs. Nathaniel Cunningham*. Boston, Massachusetts, circa 1755–1758. Oil on canvas, 50 x 39½ in. (127 x 100.33 cm). Colby College Museum of Art, gift of Mr. and Mrs. Ellerton M. Jetté, 1961.018.

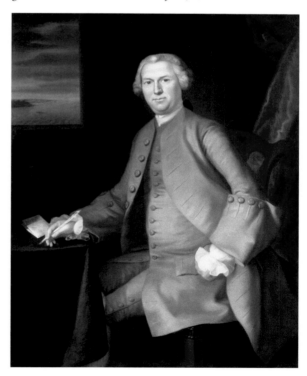

Fig. 20. Joseph Blackburn, *Samuel Cutts*. Portsmouth, New Hampshire, circa 1762–1763. Oil on canvas, 50¼ x 40⅜ in. (127.6 x 102.6 cm). Metropolitan Museum of Art, bequest of Clarence Dillon, 1979, 1979.196.1. www.metmuseum.org

that sits his writing set, complete with quill and red sealing wax, so that he could respond to his newly opened missives. Letters appear in both the artist's Bermuda and New England paintings, as we see in Blackburn's portrait of Portsmouth, New Hampshire, merchant Samuel Cutts, which closely resembles his depiction of Francis Jones (fig. 20).[27] Cutts, with quill in hand, appears to be penning a letter as one of his ships, visible through the window behind him, departs port, recalling the similar view in the painting of Jones.

While Blackburn's portraits of men frequently contain letters, his paintings of women from both locales often feature birds. The most enthralling example is his depiction of eleven-year-old Polly Warner (see fig. 15). Like the letter (and the artist himself), the bird crossed vast distances and relied upon the freedom of open exchange for survival. In Polly Warner's painting her delicately uplifted left wrist, upon which the bird sits, is balanced below by the alternating stretch of her right arm. The string that she grasps loosely in both hands spans her body, providing a sense of space bridged effortlessly through movement. Hers may be an exotic Chinese bird; certainly it is not a North American or European species. If so it echoed the Chinese export porcelain and other luxuries that her father imported to eager Portsmouth consumers and used within his own house. The bird might have been part of an exotic cargo, its life, like that of the Warners and Blackburn's own, conditioned by trade.[28]

Letters and birds function in Blackburn's paintings as transatlantic delegates for the sitters and the artist. Though the paintings remained fixed in merchants' opulent homes, they reminded viewers of the movement at the heart of both the merchants' craft and the traveling portraitists' trade. Connection and successful transference of items are also themes in Blackburn's group portraits. While many artists employed the compositional trick of binding together figural groups by using poses and colors to lead the eye from one figure to another, Blackburn takes this fluidity of transfer to new heights. In his portraits chains of figures appear to move goods along their lengths—for instance, the fruit for which the young baby grasps in *Isaac Winslow and His Family* and the child's rattle that the mother extends out to her daughter

(see fig. 1). Blackburn's pairing suggests two commodities moving in opposite directions along a mercantile network. In Elizabeth and James Bowdoin's double portrait the children's similarly juxtaposed outstretched hands seem to anticipate the exchange of fruit for bird (see fig. 13). Such scenes of transference would have been satisfying to transatlantic merchants who sought completed networks and successful transmissions of information, goods, and money in their own ventures.[29]

Perhaps Blackburn's market-oriented style is best understandable when we examine how the portraitist altered his paintings to suit patrons in different locales. To win a new clientele, artists, like merchants, needed to tailor their products to satisfy local elites. Although, as we have seen, Joseph Blackburn's Bermuda depictions share poses and compositional elements with his New England portraits, they also diverge in significant ways. Blackburn's depictions of Captain John Pigott and Fannie Jones Pigott contain several items endemic to Bermuda (see figs. 10 and 11). Pigott, collector of customs, is pictured near the St. George harbor. Sitting at port and sailing away in the distance respectively are two Bermuda sloops, vessels of a type produced on the island and exported to eager buyers around the Atlantic rim who desired its speed. To the sitter's left the artist included a distinctive Bermuda cedar tree, its red wood the secret of the Bermuda sloop's success, as it was insect- and water-resistant as well as lightweight. Many Bermudian elites invested in sloop building, and Pigott may well have been among them. John Pigott's portrait also features a Bermuda house on the far shore. A vernacular style of architecture restricted to the island, the Bermuda house, with its pale stuccoed walls, continues to shape residents' and tourists' perceptions of Bermuda's uniqueness.[30]

The artist's portraits of Bermudian women feature local flora and fauna. This is most noticeable in his painting of Fannie Jones Pigott, which includes a Bermuda bluebird, perched on the sitter's outstretched finger, and a palmetto at the back left (see fig. 11). Unlike Polly Warner's icon of trade, Pigott's bluebird was a physical marker of her locale, and indeed the Bermuda bluebird, long thought to be indigenous to the island, retains an important role in contemporary Bermudians'

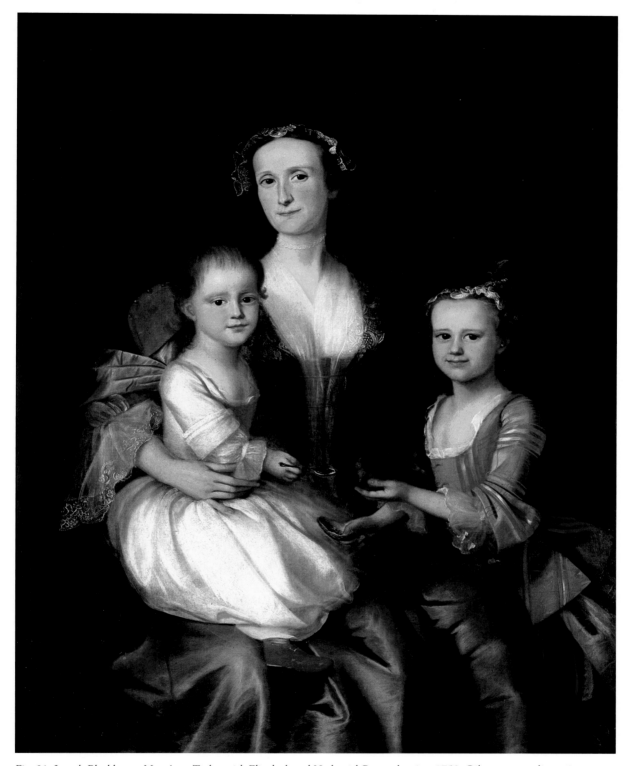

Fig. 21. Joseph Blackburn, *Mrs. Anne Tucker with Elizabeth and Nathaniel*. Bermuda, circa 1752. Oil on canvas, dimensions unknown. Bermuda Historical Trust, Hamilton, Bermuda.

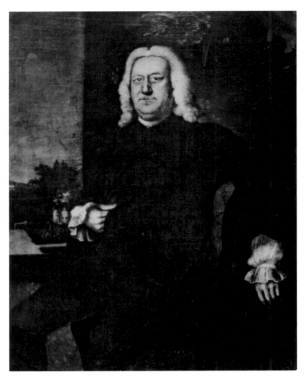

Fig. 22. Joseph Blackburn, *Charles Apthorp*. Boston, Massachusetts, 1758. Oil on canvas, 50 x 40 in. (127 x 101.6 cm). Private collection, current whereabouts unknown. Image courtesy of the Frick Art Reference Library.

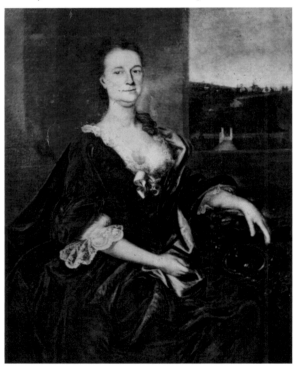

Fig. 23. Joseph Blackburn, *Mrs. Charles Apthorp (Grizzel Eastwick)*. Boston, Massachusetts, 1758. Oil on canvas, 49 x 39 in. (127 x 101.6 cm). Private collection, current whereabouts unknown. Image courtesy of the Frick Art Reference Library.

cultural identity. In Blackburn's rendering of *Mrs. Anne Tucker with Elizabeth and Nathaniel*, painted around 1752, the artist included similar local markers (fig. 21). Daughter Elizabeth cups a bird gently in her outstretched hand while her younger brother, Nathaniel, extends a silver spoon to feed the creature. While the bird is not as immediately recognizable as Pigott's Bermuda bluebird, it resembles a female cardinal (a North American species common on the island). If it is a cardinal, it could represent a pet bird tamed for its song, a common eighteenth-century activity for children. Elizabeth grasps an oyster shell in her other hand, perhaps a vessel the children have used to hold the bird's food. Oysters, though not exclusive to Bermuda, were common on the island, and the earliest settlers collected them in the hopes that they contained pearls.[31]

New Englanders seem to have been less intent upon proclaiming local difference. Most of Blackburn's New England patrons elected to wear fictitious costumes in their portraits and to be seated in generic landscapes that reimagined the North American sitters in an English country house park setting, as in Blackburn's portrait of Susan Apthorp (see fig. 14). A few exceptions to this formula are noteworthy: just as Bermudians incorporated material referents that marked their circumstances, so too did some New Englanders specify distinct architectural surroundings (see Kusserow essay in this volume). For instance, as Ellen Miles discovered in her recent exhibit *Capitol Portraits*, Bostonian Andrew Oliver Jr.'s painting contains a dovecote, or pigeon house, that was likely a real landscape feature of Oliver's garden. Pendant portraits of Charles and Grizzel Apthorp, parents of Susan Apthorp, include complete New England town scenes (figs. 22 and 23). Unfortunately these paintings are now unlocated and known only through black-and-white photographs in the Frick Art Reference Library. The panorama of a village spread out before a church steeple that rises in the background of Grizzel Apthorp's portrait recalls those that Ralph Earl would later paint of the Connecticut gentry (see Kornhauser in this volume). The artist's inclusions of these street scenes may speak to the importance of townships and community structure, so central to Puritan culture in New England.

Whereas Bermudians seem to have celebrated their exoticness (with fine clothing and a metropolitan-inspired format that assured viewers of their refinement), some New Englanders commemorated their communal accomplishments.[32]

So to return to the questions with which this essay began, we can now distinguish what Joseph Blackburn was doing in Boston from what John Singleton Copley was after. Though Copley borrowed Blackburn's tools, he ultimately offered his American consumers a different variation of the local and the metropolitan than Blackburn crafted. Copley gave his patrons a minute and exact treatment that could be accommodated to meet the demands of viewers in different transatlantic venues. However, as art historian Jennifer Roberts has shown, Copley's colonial American style did not lend itself easily to such circum-Atlantic movement. Roberts demonstrates that Copley had to work hard to bridge the distance between himself, painting in Boston, and his London viewers in his work *A Boy with a Squirrel*, shown at the Society of Artists exhibition in 1765. Describing the "fundamental intransitivity of his oil portraits of merchants," Roberts notes, "He had to *work* to make his paintings move." While Copley met the needs of many mercantile patrons, then, his early New England style was inherently static.[33] Perhaps we can understand Copley's reinvention of his approach during his London career to be his jettisoning of a style he understood to be local, as well as an admission that the Royal Academy was in full swing. By contrast, Blackburn's portraits were panregional; though adaptable to local needs, they ultimately formed through his circum-Atlantic travels.

Joseph Blackburn's portraits in Bermuda and New England offer one way to begin to counter the traditional view that artistic style was exported solely from the metropole outward to the British provinces and colonies. By emphasizing art's mercantile foundations and intercolonial movement, Blackburn's oeuvre instead encourages us to recapture how transatlantic portraitists ultimately worked alongside commerce and the rule of law to bind together the expanding empire. Blackburn's portraits met regional tastes, but they were formed in a transatlantic market.

## Notes

The author wishes to thank the conference organizers, Donna Pierce and Emily Ballew Neff, for including her in the fascinating symposium out of which this volume arose. She would also like to give special thanks to Ellen Miles, curator emerita of the National Portrait Gallery, who generously shared the results of her own years of research on Joseph Blackburn.

[1] For Joseph Blackburn see especially Ellen Miles, "Blackburn, Joseph," *Oxford Dictionary of National Biography* (Oxford University Press, 2004), 5:930; Richard Saunders, "Blackburn, Joseph," *American National Biography Online* (Oxford University Press, 2000), http://www.anb.org/articles/17/17-00075.html, retrieved 16 July 2007; Richard H. Saunders and Ellen G. Miles, *American Colonial Portraits: 1700–1776* (Washington, DC: Smithsonian Institution Press for the National Portrait Gallery, 1987), 192–195; Lawrence Park, *Joseph Blackburn: A Colonial Portrait Painter with a Descriptive List of his Works* (Worcester, MA: American Antiquarian Society, 1923); John Hill Morgan and Henry Wilder Foote, "An Extension of Lawrence Park's Descriptive List of the Works of Joseph Blackburn," *Proceedings of the American Antiquarian Society* 46 (April 1936): 15–81; C.H. Collins Baker, "Notes on Joseph Blackburn and Nathaniel Dance," *Huntington Library Quarterly* 9 (November 1945): 33–47; William B. Stevens, Jr., "Joseph Blackburn and his Newport Sitters, 1754–1756," *Newport History* 40 (Summer 1967): 95–107; Elizabeth Ackroyd, "Joseph Blackburn, Limner in Portsmouth," *Historical New Hampshire* 30 (Winter 1975), 231–243; Andrew Oliver, "The Elusive Mr. Blackburn," *Colonial Society of Massachusetts* 59 (1982): 379–392.

[2] Jules David Prown narrates the competition between Blackburn and Copley in Boston and argues for Copley's growing skill; see Jules David Prown, *John Singleton Copley in America, 1738–1774*, 2 vols. (Cambridge: Harvard University Press for the National Gallery of Art, 1966), 1:22–26. Prown also argues for the similarities between Blackburn's and Copley's works in the years between 1755 and 1757; see 1:22–23.

[3] For a comparison of these paintings see Carrie Rebora Barratt, et al., *John Singleton Copley in America* (New York: Harry N. Abrams for the Metropolitan Museum of Art, 1996), 176–178. For a discussion of "Van Dyck" costumes in portraiture see especially Aileen Ribeiro, *The Dress Worn at Masquerades in England, 1730 to 1790, and Its Relation to Fancy Dress in Portraiture* (New York: Garland Publishing, 1984). For the shepherdess at the masquerade see Terry Castle, *Masquerade and Civilization: The Carnivalesque in Eighteenth-Century English Culture and Fiction* (Stanford, CA: Stanford University Press, 1986), 77.

[4] For Copley's borrowing from Blackburn see Rebora Barratt, *Copley in America*, 206. See also Prown, *Copley*, 1:23. Prown notes that for the portraits of Joseph Dwight and Jonathan Belcher, Blackburn and Copley may have consulted a common mezzotint source.

[5] For Blackburn's decision to leave Boston see Rebora Barratt, *Copley in America*, 180. Prown argues that by 1758 "the tide had turned" and Blackburn started to incorporate some of

Copley's innovations; see *Copley*, 1:25.

[6] For Theodore Atkinson Jr.'s portrait see especially Rebora Barratt, *Copley in America*, 178–179. Prown also notes the beauty of this work; see *Copley*, 1:25.

[7] For Blackburn's work in Ireland, including this portrait, see Adrian Le Harivel and Michael Wynne, *National Gallery of Ireland Acquisitions 1982–83* (Dublin: The Gallery, 1984), 12–13.

[8] Mary Cary Russell to Chambers Russell, Boston, probably 1757, location currently unknown. Quoted in Park, *Blackburn*, 6. Richard Saunders speculates that Blackburn was trained in London and worked at a large studio where he may have specialized in drapery "because of his considerable deftness at painting lace and other details of dress." See Saunders and Miles, *American Colonial Portraits*, 193. For more about drapery painters see *Manners and Morals: Hogarth and British Painting 1700–1760,* ed. Elizabeth Einberg (London: Tate Gallery Publications, 1988), 67. Earlier, Lawrence Park speculated that Blackburn was trained by London painter Thomas Hudson given similarities in their works, but there has been no documentation of this hypothesis. See Park, *Blackburn*, 8.

[9] For this painting as well as Blackburn's work after his American travels see "Joseph Blackburn, *Hugh Jones*, 1777," in "Early American Paintings in the Worcester Art Museum," ed. David R. Brigham, http://www.worcesterart.org/Collection/Early_American/, retrieved 21 June 2014.

[10] For the possibility that Blackburn traveled to Bermuda in 1764 along with the governor see Frank W. Bayley, *Five Colonial Artists of New England: Joseph Badger, Joseph Blackburn, John Singleton Copley, Robert Feke, John Smibert* (Boston: privately printed, 1929), 54.

[11] "Will of Joseph Blackburn, proved September 7, 1787," National Archive (Kew, England), PROB 11/1156, fol. 354 r, v. My thanks to Ellen Miles for transcribing this document.

[12] William Carey, *Some Memoirs of the Patronage and Progress of the Fine Arts in England and Ireland* (London, 1826), 179. Quoted in Anne Crookshank, *Ireland's Painters: 1600–1940* (New Haven: Yale University Press for the Paul Mellon Centre for Studies in British Art, 2002), 161. For the presence of English and American artists in Ireland including Blackburn see Crookshank, *Ireland's Painters*, 161–180. For more about these artists and their careers see Jennifer Van Horn, "'Straggling Adventurers of the Brush': Transatlantic Artists and the Making of the British Empire," article in progress. My thinking has been shaped by recent studies of imperial careerists by historians and cultural geographers. See especially *Colonial Lives across the British Empire: Imperial Careering in the Long Nineteenth Century*, ed. David Lambert and Alan Lester (New York: Cambridge University Press, 2006). For models of transatlanticism see Alan Lester, "Imperial Circuits and Networks: Geographies of the British Empire," *History Compass* 4, no. 1 (2006): 1–18; S. Daniels and C. Nash, "Life Paths: Geography and Biography," *Journal of Historical Geography* 30 (2004): 449–458; Elleke Boehmer, "Global and Textual Webs in an Age of Transnational Capitalism; or, What Isn't New about Empire," *Postcolonial Studies* 7, no. 1 (2004): 11–26.

[13] For John Wollaston see especially Carolyn J. Weekley, *Painters and Paintings in the Early American South* (New Haven: Yale University Press for the Colonial Williamsburg Foundation, 2013), 226–247; Wayne Craven, "John Wollaston: His Career in England and New York City," *American Art Journal* 7, no. 2 (November 1975): 19–31; Jennifer Van Horn, "The Mask of Civility: Portraits of Colonial Women and the Transatlantic Masquerade," *American Art* 23, no. 3 (Fall 2009): 8–35. For Christopher Steele's career see especially Mary E. Burkett, *Christopher Steele 1733–1767 of Acres Walls Egremont: George Romney's Teacher* (London: Skiddaw Press, 2003), reprinted from the *Walpole Society's Transactions* 1996 (vol. 53); and Miles and Saunders, *American Colonial Portraits*, 32, 34, 195–198. For Cosmo Alexander see James Holloway, *Patrons and Painters: Art in Scotland 1650–1760* (Edinburgh: Scottish National Portrait Gallery 1989), 100–103; Pam McLellan Geddy, "Cosmo Alexander's Travels and Patrons in America," *Antiques* 60 (November 1977): 972–977.

[14] For an early historiography of scholars' interest in Blackburn see Morgan and Foote, "Extension of Lawrence Park's Descriptive List," 15–23. Theodore Bolton and Harry Lorin Binsse, "Wollaston, an Early American Portrait Manufacturer: A Short Account of John Wollaston the Younger, Together with the First Catalogue of His Portraits," *Antiquarian* 16, no. 6 (June 1931): 46–51; quotations 46, 49. For the history of the reattribution of Theodore Atkinson, Jr., to Copley see Maureen C. O'Brien, "'The Best Portrait Joseph Blackburn [Never] Painted': John Singleton Copley's Portrait of Theodore Atkinson, Jr.," *RISD Museum Manual/ A Resource about Art and Its Making*, http://risdmuseum.org/manual/205_the_best_portrait_joseph_blackburn_never_painted_john_singleton_copleys_portrait_of_theodore_atkinson_jr, retrieved 15 January 2015.

[15] For the early history of the Jonathan Warner portrait see MFA Boston online catalogue, "Jonathan Warner," http://www.mfa.org/collections/object/colonel-jonathan-warner-30918, retrieved 4 December 2014. See also *Worlds Columbian Exposition 1893 Official Catalogue Part X Department K Fine Arts*, ed. M. P. Handy (Chicago: W. B. Gonkey Company, 1893), 59. For Blackburn's "nationality" see the National Gallery of Ireland e-catalogue: http://onlinecollection.nationalgallery.ie/view/people/asitem/B/78;jsessionid=1D0CA7096C9379105483C0EEB63C8234?t:state:flow=dbf29e1f-d046-45e2-813a-e8ea6cbaa926, retrieved 2 January 2015; entry for *Isaac Winslow and His Family*, MFA Boston, http://www.mfa.org/collections/object/isaac-winslow-and-his-family-32859, retrieved 2 January 2015.

[16] For John Wollaston and Benjamin West see especially Ann Uhry Abrams, *The Valiant Hero: Benjamin West and Grand-Style History Painting* (Washington, DC: Smithsonian Institution Press, 1985). For the relationship between Cosmo Alexander and Gilbert Stuart see Carrie Rebora Barratt and Ellen G. Miles, *Gilbert Stuart* (New Haven: Yale University Press for the Metropolitan Museum of Art, 2004), 18–20.

[17] For the nationalist trajectory of American art history and its changing international orientation see especially John Davis, "The End of the American Century: Current Scholarship on the Art of the United States," *Art Bulletin* 85 (September 2003): 543–580. For the new importance of empire in British art history see especially Douglas Fordham, "New Directions in British Art History of the Eighteenth Century," *Literature*

*Compass* 5, no. 5 (2008): 906–017; Tim Barringer, Geoff Quilley, and Douglas Fordham, "Introduction," *Art and the British Empire*, ed. Tim Barringer, Geoff Quilley, and Douglas Fordham (Manchester: Manchester University Press, 2007), 1–19.

For the model of the Atlantic world, see Bernard Bailyn, "The Idea of Atlantic History," *Itinerario* 20 (1996): 19–44. See also Alison Games, "Atlantic History: Definitions, Challenges, and Opportunities," *American Historical Review* 111, no. 3 (June 2006): 722–757. For the importance of transatlantic movement in John Singleton Copley's career see Jennifer L. Roberts, "Copley's Cargo: *Boy with a Squirrel* and the Dilemma of Transit," *American Art* 21, no. 2 (Summer 2007): 21–41. See also Emily Ballew Neff, *John Singleton Copley in England* (London: Merrell Holbertson, 1995). For "adventuring" see Harry D. Berg, "The Organization of Business in Colonial Philadelphia," *Pennsylvania History* 10 (July 1983): 155–177, esp. 163–164.

[18] Hereward Trott Watlington, "The Story of the Clayton Portraits," *Bermuda Historical Quarterly* 10, no. 1 (February 1953): 7–23. Watlington was the first to suggest that Jones brought Blackburn to Bermuda. The political conflicts of this period between Bermuda's assembly and governor are documented by William Frith Williams, *The Bermudas: From their Discovery to the Present Time* (London: Thomas Cautley Newby Publisher, 1848), 73–79. For Blackburn's Bermuda portraits see Morgan and Foote, "Extension of Lawrence Park's Descriptive List," 15–26. For Bermuda's trade and merchants see Michael J. Jarvis, *In the Eye of All Trade: Bermuda, Bermudians, and the Maritime Atlantic World, 1680–1783* (Chapel Hill: University of North Carolina Press for the Omohundro Institute of Early American History and Culture, 2010), esp. 134.

[19] For Blackburn's arrival in Newport and the Chesebrough family see Stevens, "Joseph Blackburn," 97.

[20] For Isaac Winslow's biography see the catalogue entry for Robert Feke's portrait of him at the MFA Boston: http://www.mfa.org/collections/object/isaac-winslow-32847, retrieved 24 June 2014. For *Isaac Winslow and His Family* see Wayne Craven, *Colonial American Portraiture* (Cambridge: Cambridge University Press, 1986), 297–301. For the Bowdoin portrait see V. Scott Dimond, *James Bowdoin III: Pursuing Style in the Age of Independence* (Brunswick, ME: Bowdoin College Museum of Art, 2008), 3–6; Craven, *Colonial American Portraiture*, 302–304. Quotation from James Henry Stark, *The Loyalists of Massachusetts and the Other Side of the American Revolution* (Salem, MA: Salem Press Co., 1910), 352.

[21] For the Warner portraits see *The Warner House: A Rich and Colorful History*, ed. Joyce Geary Volk (Portsmouth, NH: Warner House Association, 2006), 44–49. The missing portrait (that of Colonel John Warner) is now in the collection of the Museum of Fine Arts, Boston.

[22] It is worth mentioning that Blackburn's paintings had greater appeal among New Englanders than those of Smibert, Feke, Badger, and Greenwood. Jules Prown discovered that Blackburn averaged two times as many paintings per year as his predecessors. Prown also calculated that 60 percent of Blackburn's patrons in the region came from the mercantile class, a higher percentage than for previous artists. See Prown,

*Copley*, 1:25–26.

[23] Ellen Miles has demonstrated that Blackburn borrowed directly from a Thomas Hudson portrait, likely seen as a print engraved in 1753 by J. Aberry after Thomas Hudson's *Sir Watkin Williams-Wynn* (1749), for Blackburn's painting *Portrait of a Gentleman*, c. 1760. Blackburn's painting was formerly in the collection of the Corcoran Gallery of Art. See *Corcoran Gallery of Art: American Paintings to 1945*, ed. Sarah Cash (New York: Corcoran Gallery in association with Hudson Hills Press, 2011), 48–49.

For Thomas Gainsborough and Joshua Reynolds see especially *Thomas Gainsborough 1727–1788*, ed. Michael Rosenthal and Martin Myrone (London: Tate Publishing with the Museum of Fine Arts, Boston, 2002); David Mannings, *Sir Joshua Reynolds: A Complete Catalogue of His Paintings*, 2 vols. (New Haven: Yale University Press, 2000). For Thomas Hudson see Ellen Miles, "Thomas Hudson (1701–1779): Portraitist to the British Establishment" (PhD diss., Yale University, 1976).

Blackburn adopted a more Reynolds-inspired style upon his return to England. See for instance his portraits of Thomas Hughes and Elizabeth Hughes in the collection of the Wilson, Cheltenham's Art Gallery and Museum, viewable at the BBC Your Paintings website, http://www.bbc.co.uk/arts/yourpaintings/paintings/thomas-hughes-esq-17321794-61664, retrieved 8 January 2015.

[24] Margaretta M. Lovell, "'Such Furniture as Will Be Most Profitable': The Business of Cabinetmaking in Eighteenth-Century Newport," *Winterthur Portfolio* 26, no. 1 (1991): 27–62. For cabinetmakers as merchants see 38–39. The scholarship on Newport furniture is vast. See especially Morrison H. Heckscher with Lori Zabar, *John Townsend: Newport Cabinetmaker* (New Haven: Yale University Press for the Metropolitan Museum of Art, 2005).

[25] For the labeling of Newport furniture see Lovell, "Such Furniture," 48–49. For John Townsend's practice of signing and labeling his works see also Heckscher and Zabar, *John Townsend*, 61–64. For the Wollaston label see Bolton and Binsse, "John Wollaston," 48. The label appeared on a portrait of William Smith Jr., in a private collection; the authors noted that a similar label also appeared on the back of the portrait of William Smith, Senior, also in a private collection. For the Mary Sylvester portrait and her Newport connection see the Metropolitan Museum of Art online catalogue, http://www.metmuseum.org/collection/the-collection-online/search/10174?rpp=30&pg=1&ft=Mary+Sylvester&pos=1, retrieved 15 November 2014.

[26] For the aesthetic qualities of Newport furniture see Lovell, "Such Furniture," 49. Craven identifies Blackburn and Wollaston's style as entirely Rococo. See Craven, *Colonial American Portraiture*, 296.

[27] For the importance of letters for eighteenth-century transatlantic merchants see Toby L. Ditz, "Shipwrecked; or, Masculinity Imperiled: Mercantile Representations of Failure and the Gendered Self in Eighteenth-Century Philadelphia," *Journal of American History* 81, no. 1 (June 1994): 51–80, esp. 53–57; Konstantin Dierks, *In My Power: Letter Writing and Communications in Early America* (Philadelphia: University of Pennsylvania Press, 2009), 84–86, 91–93. For more about Jones's portrait and the importance of letters in

Blackburn's portraits of merchants see Jennifer Van Horn, *Civility in a New World: Material Culture and the Making of America* (Chapel Hill: University of North Carolina Press for the Omohundro Institute of Early American History and Culture, forthcoming).

28 For the Warners' Chinese export porcelain see *The Warner House*, 76. I am grateful to David A. Luther, professor of biology at George Mason University, for discussing this bird with me; email correspondence with author, 30 July 2014. Jennifer Roberts uses the term "transatlantic delegates" in relation to Copley's portraits; see Jennifer L. Roberts, *Transporting Visions: The Movement of Images in Early America* (Berkeley: University of California Press, 2014), 49.

29 In addition to these two portraits, Joseph Blackburn completed another group portrait in colonial America that also relates to themes of transference; see *The Four Children of Governor Gurdon Saltonstall*, 1762, now in the collection of the New Haven Museum. For the ways that business networks and exchange could influence the types of paintings that patrons favored see Melody Barnett Deusner, "Outside the Palace of Art: Global Networks of Aestheticism: Whistler, Aestheticism, and the Networked World," in *Palaces of Art: Whistler and the Art Worlds of Aestheticism*, ed. Linda Merrill and Lee Glazer (Washington DC: Smithsonian Institution Scholarly Press, 2013), 149–164. For the impact that themes of transference had upon Copley's Boston portraits see Roberts, *Transporting Visions*, 32–49.

30 For the formation of regional styles in early America see Philip Zea, "Diversity and Regionalism in Rural New England Furniture," *American Furniture*, Chipstone Foundation, 1995, at http://www.chipstone.org/publications/1995AF/index1995zea.html, retrieved 5 December 2014. For more about regional styles in relation to transatlantic portraiture see Van Horn, *Civility in a New World*. For the Bermuda sloop and Bermuda cedar see Jarvis, *In the Eye of All Trade*, 126–134. For the Bermuda house see Ed Chappell, "The Bermuda House," *Post-Medieval Archaeology* 45, no. 1 (2011): 93–143.

31 The Bermuda bluebird, as it is commonly known, is really the eastern bluebird (*Sialia sialis*). In the eighteenth and nineteenth centuries it was thought to be indigenous to the island, although recent scientific discoveries have challenged that belief. See Hannah Waters, "Bermuda Blue Birds Aren't Native: They Moved in 400 Years Ago," *Culturing Science*, http://blogs.scientificamerican.com/culturing-science/2013/04/08/bermuda-bluebird/, retrieved 24 June 2014. The Bermuda bluebird remains a species with strong cultural associations for Bermudians; see the Bermuda Bluebird Society, http://www.bermudabluebirdsociety.com, retrieved 8 January 2015. Blackburn's Bermuda portrait of Mrs. Thomas Jones (Mary Harvey), painted in 1752, also includes a bird, though this appears to be an exotic parrot rather than a local bird. For oysters in Bermuda see Addison Emery Verrill, *The Bermuda Islands: An Account of their Climate, Scenery and Productions . . .* (New Haven, CT: privately published, 1902), 297–298. Verrill quotes from a seventeenth-century account of a natural historian who found a hundred pearls in one oyster.

32 I have been unable to locate the present owner or current whereabouts of Blackburn's portraits of Charles and Grizzel Apthorp. For Andrew Oliver Jr.'s portrait see Carolyn Kinder Carr and Ellen G. Miles, *Capital Portraits: Treasures from Washington Private Collections* (Washington, DC: Smithsonian Institution Scholarly Press, 2011), 20–22. For John Smibert see especially Richard H. Saunders, *John Smibert: Colonial America's First Portrait Painter* (New Haven: Yale University Press, 1995). For Ralph Earl see Elizabeth Mankin Kornhauser, *Ralph Earl: The Face of the Young Republic* (New Haven: Yale University Press, 1991), 40–43, 57–58. For Earl's portraits featuring landscape scenes see especially Robert Blair St. George, *Conversing by Signs: Poetics of Implication in Colonial New England Culture* (Chapel Hill: University of North Carolina Press, 1998), 297–378.

33 Roberts, *Transporting Visions*, 23–24.

# Colonial Ambition Abroad
## Benjamin West's American Portraits in London

### *Kaylin Haverstock Weber*

The lure of London for many colonial Americans was enticing. London was America's capital city and the center of the British Empire, and it offered the greatest opportunities for education, business, diplomacy, and art.[1] Many of the colonial elite, planters and merchants, enjoyed life on both sides of the Atlantic in the decade before the American Revolution. The expatriate community of British colonials in London, particularly in the West End, was growing and thriving during these years, when London was *the* cultural center of the English-speaking world. In 1763 the young colonial artist Benjamin West arrived in the capital city. West became certainly the best-known colonial artist to make the journey abroad in hopes of elevating his own art and establishing his reputation. Though he intended to return home, he famously never did. "I took my easel on my back; And cross'd the seas to London!"[2] When the satirist Anthony Pasquin (aka John Williams) wrote this humorous characterization of West in 1811, nearly five decades after his arrival in England, he drew attention to the longevity of West's reputation as a colonial artist who journeyed across the Atlantic to make his career.

Benjamin West was extremely ambitious.[3] As a colonial American artist establishing himself on the other side of the Atlantic, he had a great deal to prove. As in his native colony of Pennsylvania, the most commercial and popular genre of painting in London was portraiture. However, in terms of academic art theory and artistic aspirations, history painting, defined as the depiction of biblical, mythological, and literary events and stories, outranked portraiture. Rather boldly, and without commissions for any paintings, West presented himself as a history painter from his first days in the mother country.[4] This was a risky decision, since being a history painter was essentially an academic ideal rather than a commercially viable practice.[5] Of his chosen path, he once wrote, "I have undertaken to whele the club of Hercules—in plain English I have imbarked on Historical painting."[6] The timing of his arrival was fortuitous,

as it coincided with a push to elevate British art and an academic focus on the superiority of history painting. West established his reputation as a history painter with his seminal painting *The Death of General Wolfe* (1770, National Gallery of Canada, Ottawa).[7] As is well chronicled, his meteoric rise from colonial portraitist to history painter to the king of England and second president of the Royal Academy of Art *is* exceptional. To so quickly join the ranks of the British art elite in London was unprecedented for a colonial artist.

Though West is not traditionally recognized for his portraiture, it is this genre of painting that enabled his success in history painting in the early years of his career, and sustained his livelihood until he became well known and enjoyed the patronage of George III. It is this early and brief period of his more than sixty-year career, from his arrival in London in 1763 to 1776, that is the focus of this essay. Within this period, I primarily explore his portraits of Americans living and traveling abroad. Indeed, a substantial amount of his portraiture in the first decade in London portrayed colonial Americans.[8] These portraits encapsulate a brief period before the American Revolution when wealthy colonial Americans enjoyed lives on both sides of the Atlantic and envisioned rising to the status of their aristocratic cousins in the mother country. By looking at these portraits, we can examine the lure of Europe and England, the development of colonial American communities abroad, and the progress of Benjamin West as a colonial American artist abroad. Additionally, we can explore the idea of colonial ambition not only on the part of West but on the part of his sitters and their families—the colonial merchant elite with aristocratic aspirations.

Benjamin West began his career in portraiture while a young man living in the British colony of Pennsylvania. In the 1750s, he painted simple, rather stiff provincial images of affluent colonists in their silk and lace finery set against landscapes, such as his portrait of the lovely Jane Galloway (fig. 1).[9] These early portraits, which

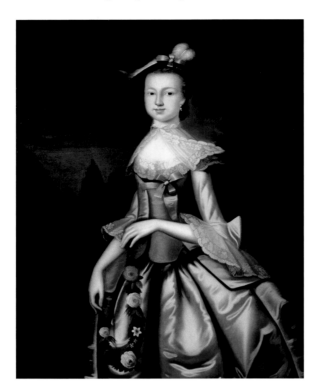

Fig. 1. Benjamin West, *Jane Galloway (Mrs. Joseph Shippen)*. Philadelphia, circa 1757. Oil on canvas, 49¾ x 39¼ in. (126.5 x 99.5 cm). Historical Society of Pennsylvania, © Philadelphia History Museum at the Atwater Kent / Courtesy of Historical Society of Pennsylvania Collection / Bridgeman Images. For a full page image see p. 47.

were influenced by artists such as John Wollaston (1720–1775) and his early teacher William Williams (1727–1791) (See Rather essay), brought him the notice of important early patrons, notably Chief Justice William Allen (1704–1780).[10] One of the wealthiest men in Pennsylvania, Allen was largely responsible for sending West to Italy and facilitating his first portrait commissions in Italy and England.[11] The intent of West's journey to Italy in 1760 was to build the requisite skills and knowledge to become a successful artist. At the time, the American colonies had no art academies or major art collections. While West received some training in Pennsylvania from artists such as Williams, in order to take the next step in his career he had to go abroad. According to his biographer John Galt (1779–1839), West felt "that he could not hope to attain eminence in his profession, without inspecting the great master-pieces of art in Europe, and comparing them with his own works in order to ascertain the extent of his [own] powers."[12] His trip to Italy had a profound influence on the development of his art.[13]

West left for Italy aboard the *Betty Sally* in 1760 accompanied by John Allen and Joseph Shippen, sons of two of his Philadelphia patrons. With this transatlantic journey, West became the first American-born artist to travel to Italy on a Grand Tour. Upon arrival, he became a focused artist in training, studying antiquities and the great old masters. Though plagued by bouts of ill health while there, he spent a great deal of time studying, sketching, and copying paintings by old masters such as Raphael, Titian, Correggio, and Guido Reni for his patrons back in Pennsylvania.[14] The extant copies are accomplished paintings revealing West's rapid assimilation of the art around him. For West, imitation was not only a way of fulfilling commissions for copies, but an inherent part of his learning process and later his pedagogy.[15]

While in Italy, West also developed an impressive international network of artists, collectors, antiquarians, and dealers, including Anton Raphael Mengs (1728–1779), Angelica Kauffman (1741–1807), Cardinal Alessandro Albani (1692–1779), Richard Dalton (c.1715–1791), and Thomas Jenkins (1722–1798), that would aid him while in Italy and during his first years in England. His novel reputation as the first colonial American to

take a Grand Tour opened many doors, and he was welcomed into this international community. As has been oft repeated and certainly embellished by West and his biographer John Galt, West at times proudly traded on the novelty of his North American roots, supposedly proclaiming, "My God, how like it is to a young Mohawk warrior!" when he first encountered the Apollo Belvedere.[16]

In Italy, West produced his first ambitious portrait in a European style (fig. 2). In his portrait of his traveling companion John Allen (1739–1778), West presents the eldest son of Chief Justice Allen on his Grand Tour of Italy.[17] It is an ambitious presentation for West, befitting a prominent colonial merchant family with aristocratic aspirations. It is quite revealing to look back to *Jane Galloway* (fig. 1), painted just a few years earlier, to see the monumental leap in skill West made in his first few years abroad. During the eighteenth century, portraiture was governed by conventions.[18] West was learning those conventions from more than the portrait mezzotints he had studied in America; he was now looking at countless original canvases. With a Baroque flair, West theatrically drapes John Allen in a swath of crimson silk drapery that falls from his left shoulder around his back down to his right hip. The bold folds and asymmetric angle of the drapery add a sense of movement and drama that was lacking in West's pre-European paintings. West presents Allen dressed in fashionable Van Dyck attire, a type of fancy dress or costume that became popular in British portraits in the 1750s.[19] West had been introduced to Angelica Kauffman in Italy. Like many eighteenth-century artists, she frequently dressed her sitters in Van Dyck costume, as in her intimate sketch of West (fig. 3).[20]

In the John Allen portrait, West exhibits the influence of another contemporary painter, Anton Raphael Mengs, his onetime teacher[21] and "Favorite Master."[22] His painting style in the Allen portrait appropriates elements of Mengs's adept draughtsmanship and his characteristic restrained and polished style.[23] His borrowings from established artists like Mengs served to elevate his portrait by fitting it into a tradition of grand manner portraiture. The luxurious dress, stately pose, simple background, and strong lighting suggest a grandeur and standing for the sitter as a man of noble style and taste. The frontality and

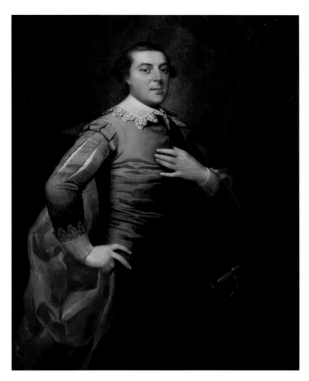

Fig. 2. Benjamin West, *John Allen*. Italy, circa 1760. Oil on canvas, 49⅛ x 39⅛ in. (125 x 99.5 cm). Private collection. From Helmut Von Erffa and Allen Staley, *The Paintings of Benjamin West* © 1986 (New Haven: Yale University Press), 16.

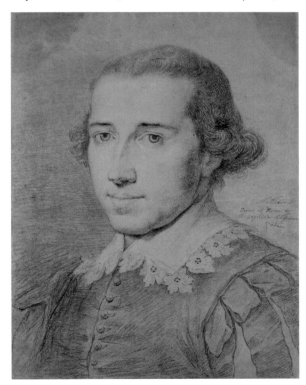

Fig. 3. Angelica Kauffman, *Benjamin West*. Italy, 1763. Black chalk on greenish-gray paper, 16½ x 12½ in. (41.9 cm x 31.8 cm). National Portrait Gallery, London. © National Portrait Gallery, London.

monumentality of this figure lend it a more powerful presence than anything West had produced previously. The sitter's particular features and realistic physiognomy indicate that West is studying from life, and his studies of anatomy in Italy are apparent.[24] The clarity of the drawing and rich color palette in the portrait reveal a more academic form of painting for West, who is rapidly absorbing the techniques of old master and contemporary compositions around him. With this portrait, the colonial American artist asserts his connection with Baroque portraiture as well as contemporary English and Grand Tour portraiture.

In the summer of 1763, West left Italy. After arriving in London, he wrote to Joseph Shippen that "I am at last arrived at the mother country, which we Americans are all so desirous to see, and which I could not but desire as much, or more than Italy itself."[25] When West arrived in London, his reputation as the talented and novel "American Raphael" preceded him and immediately opened doors to patronage networks and the artistic community.[26]

One of his first activities, aside from setting up a studio in a suitable location, was to venture out to visit the great country house collections. He visited the famous Raphael Cartoons at Hampton Court and the notable old master and contemporary collections at Longford, Blenheim, Corsham Court, Stourhead, and Wilton House.[27] In these houses, West was introduced to ancestral collections filled with works by Titian, Rubens, Peter Lely, and Anthony Van Dyck. West's access to the private collections of England was unprecedented for an American-born artist. Unlike many of his contemporaries in the colonies, whose primary artistic sources were mezzotint prints, by the time he was 25 he had seen at first hand masterpieces in oil by many great old masters and contemporary artists.

West parlayed his experiences with great art into his early history paintings, of course, but also into his portraits, many of which refer to old master prototypes and conventions. Though his aspiration was to be a history painter, he continued to paint portraits, particularly of Americans abroad, when he arrived in England.[28] The country was full of his countrymen. Many of his sitters hailed from important and influential colonial families, such as the Middletons and Izards of South Carolina

and his early patrons the Allens and Shippens of Pennsylvania.

One of the earliest paintings he produced in England was *The Cricketers* (fig. 4). Few pictures bring together West's powerful transatlantic connections in his first year in London or speak to the ambitions of the colonial Americans abroad so well as this group portrait.[29] West depicts the sons of several great colonial families engaged in a leisurely game of cricket set in an idyllic English landscape. Many of the colonies' most successful and ambitious families sent their sons to England to further their education, to enhance their families' reputations, to create aristocratic networks, and to grow their wealth. Formal education was greatly valued by colonial patriarchs as a means to create "elegant and learned men" who could return home to become social and political leaders.[30] With ambitions of aristocracy, the young colonial men were sent to the premier public schools of the English aristocracy, including Westminster and Eton, and then on to universities such as Cambridge and Oxford. Indeed, three of the five cricketers pictured in *The Cricketers* attended Cambridge.[31] Part of this education would have included an introduction, if they had not already had one in the colonies, to the game of cricket. Cricket was played in all of the colonies and was the most popular sport of the time in the English-speaking Atlantic world.[32] Traditionally, cricket was a noble and genteel pastime, originating centuries earlier as a game the lord of the manor would play with the tenants of his land.[33] King George III and his father, King George II (1683–1760), were major cricket enthusiasts, so the game flourished in eighteenth-century England and the colonies.[34] Whether the theme was chosen by West or the sitters, the painting presents these young men engaged in a quintessential gentlemanly pursuit. It is an image of youthful promise together with their families' aristocratic ambitions.

The five young colonial men, from left to right, are identified as James Allen (1742–1778) of Philadelphia, who was studying law at Middle Temple in London; Ralph Wormeley (1745–1806) of Virginia, who was studying at Trinity Hall, Cambridge; Andrew Allen (1740–1825), James's older brother, also studying law at Middle Temple; Ralph Izard (1741/42–1804) of South Carolina,

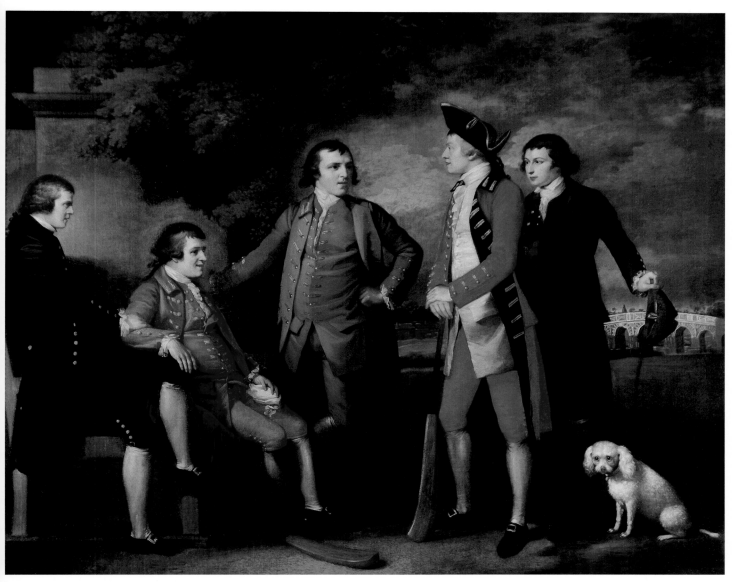

Fig. 4. Benjamin West, *The Cricketers*. England, 1764. Oil on canvas, 40 x 50 in. (101.6 x 127 cm). Private club collection, New York.

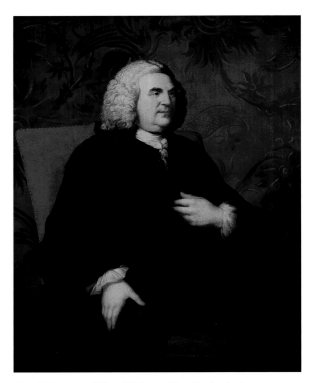

Fig. 5. Benjamin West, *William Allen.* England, circa 1763. Oil on canvas, 50 x 40 in. (127 x 101.6 cm). Private collection. From Helmut Von Erffa and Allen Staley, *The Paintings of Benjamin West* © 1986 (New Haven: Yale University Press), 21.

who was studying at Trinity Hall, Cambridge; and Arthur Middleton (1742–1787) of South Carolina, also at Cambridge.[35] The Allen men were sons of Chief Justice Allen, West's early patron, and Ralph Wormeley, Ralph Izard, and Arthur Middleton were sons of wealthy colonial planters.[36]

The young men are certainly not dressed for cricket; rather, they are wearing the latest gentlemanly fashions made of luxurious fabrics with brass buttons. The primary indication that they have been playing the game is the presence of two cricket bats strategically positioned. One bat is lying on the ground in front of Ralph Wormeley and the other is held by Ralph Izard, who wears a red suit and tricorne hat. The fact that Izard was holding one of the cricket bats is significant and may indicate that he was considered an accomplished cricketer.[37] The background of this painting is ambiguous. Positioned behind James Allen and Ralph Wormeley is a wide stone Classical pillar, and behind Arthur Middleton is a bridge with several distinctive arches. A number of scholars have suggested that this bridge is not a specific bridge relating to the boys' educational institutions, such as one over the river Cam at Cambridge, but perhaps a bridge such as old Walton Bridge near Hampton Court, which West would have seen.[38] The background appears to be all of West's invention, though using specific elements probably drawn from life, such as the bridge. Perhaps, as some scholars have suggested, it was simply his constructed idea of Cambridge.

With its full-length figures on a small scale, *The Cricketers* is conceived as a conversation piece, and is an obvious reference to the Grand Tour groupings of young titled British men traveling to Italy to finish their education.[39] In this genre, West is referring to works by contemporary English artists such as Nathaniel Dance, whom he met in Italy. An interesting visual correlation can be drawn between the various figures in West's *Cricketers* and Dance's Grand Tour painting of *James Grant and His Friends in Rome* (1760–1761, Philadelphia Museum of Art).[40] The conversation piece was uncommon in colonial art and was widely considered at the time a distinctly English eighteenth-century genre.[41] With *The Cricketers*, his first foray into the conversation piece genre, West was experimenting

and inserting himself into the art conventions and styles of his new surroundings in England. *The Cricketers* was commissioned by Chief Justice Allen, in whose family it descended. Once the painting was taken back to the colonies, it proved popular, and the Izard family commissioned a second version.[42]

West's close relationship with Chief Justice Allen, who was thought to have "powerful and extensive connections in the mother country," led to commissioned portraits of several other family members and friends in England.[43] At the time of West's arrival, Allen was living in Bath, and according to Galt, West spent at least a month with him.[44] While in Bath, West produced a portrait of his great American patron (fig. 5).[45] The portrait of William Allen suggests the influence of Thomas Gainsborough (1727–1788), the fashionable and influential British portraitist who was resident in Bath at the time.[46] Though West's portrayal of Allen, with its awkward hands and strange crimson damask background with no standard repeat, is not his most successful early portrait, he succeeds in capturing his respect for the stately gentleman and friend. It is also one of the first instances in which West uses an averted, thoughtful gaze for his sitter, which was quite fashionable in British portraiture at the time.

West was also commissioned to paint the chief justice's youngest daughter, Anne Allen.[47] The status of the Allen family, already one of Pennsylvania's wealthiest and most politically influential families, was further enhanced in 1766 when Anne (1746–1830) married John Penn (1729–1795), grandson of William Penn and the last colonial lieutenant governor of Pennsylvania. The portrait of Anne Allen (fig. 6) is West's first portrait of an American female sitter abroad and one of the first to include a dog. The portrait features the same triangular form and pose that West first used in his Raphaelesque portrait *Anne, Countess of Northampton and Her Daughter, Lady Elizabeth Compton* (1762, Bass Museum of Art, Miami) while in Italy.[48] The rich Venetian-inspired colors in Anne Allen's dress and cape as well as the transparent glazes used in the delicate lace and necklace are evidence of West's study of Italian art. The choice to refer to Italian prototypes is particularly appropriate for a sitter whose father financed

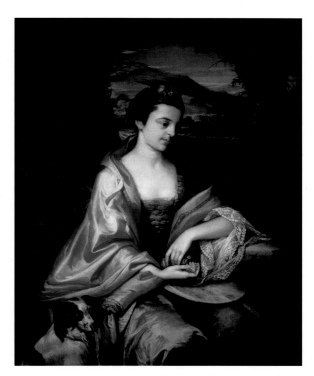

Fig. 6. Benjamin West, *Anne Allen (Mrs. John Penn)*. England, circa 1763. Oil on canvas, 50 x 40 in. (127 x 101.6 cm). Cincinnati Art Museum, Museum Purchase, The Fanny B. Lehmer Fund, 1998.33.

Fig. 7. Benjamin West, *Thomas Middleton of the Oaks*. England, 1770. Oil on canvas, 51¾ x 39½ in. (131.4 x 100.3 cm). Gift of Alicia Hopton Middleton; 1937.005.0014; © Image courtesy of the Gibbes Museum of Art / Carolina Art Association.

part of West's Italian sojourn. Within the land-scape stands a distinctly colonial-style two-story stone building, which could refer to the sitter's native Pennsylvania and perhaps more specifically to the Allen family's country residence, Mount Airy, outside Philadelphia. Additionally, parts of the foliage in the foreground around the sitter appear more North American in character than European; however, this foliage is paired with an Italianesque landscape in the background. In this portrait, West combines his and Allen's North American roots with grand European traditions.

In addition to the Allens, West soon enjoyed the patronage of another colonial American family abroad during this period, the Middletons of South Carolina. They were a prominent colonial family who, like the Allens, were comfortable on both sides of the Atlantic. West painted a portrait of Thomas Middleton (1753–1797) (fig. 7), the youngest son of Henry Middleton of Middleton Place (1717–1784). Like his older brother Arthur, one of the young men in *The Cricketers*, Thomas was sent to England to continue his education. He returned at the approach of the war in 1774. West's portrait of Thomas relates closely, in almost pendant form, to the artist's portrait of his older brother Arthur, which has also been thought to depict his first cousin, Thomas Middleton of Crowfield (fig. 8).[49] The young brothers' father, Henry Middleton, served briefly as president of the Continental Congress, and his older brother, William Middleton (Thomas Middleton of Crowfield's father), owned estates on both sides of the Atlantic: Crowfield, South Carolina, and Crowfield Hall, Suffolk, England.[50]

The portraits of these two young men were painted in the same year, and both sitters wear Van Dyck costume. Their fancy dress costumes are composed of knee breeches and a slashed doublet with a lace collar. Their mirror positions further support the supposition that they were painted as companion pictures. In the sitters' stances and choice of costume, the influence of Mengs is once more evident. West's use of Van Dyck costume here was undoubtedly intended to elevate the status of the sitters as well as West's own position. For West, it demonstrated his knowledge of earlier art by Van Dyck, whom he once described as "the Prince of Portrait Painters."[51] For the sitters, the

Fig. 8. Benjamin West, *Arthur Middleton II (?) (or Thomas Middleton of Crowfield)*. England, 1770. Oil on canvas, 49 x 39 in. (124.5 x 99 cm). The Middleton Place Foundation, Charleston, South Carolina.

Fig. 9. Benjamin West, *Henry Middleton (?) (or William Middleton)*. England, circa 1770. Oil on canvas, 49¼ x 39 in. (125 x 99 cm). The Middleton Place Foundation, Charleston, South Carolina.

Van Dyck reference provides a visual legacy to fit into and aligns their status with that of the English aristocracy. At this time, British country house collections were filled with ancestral portraits by the famous seventeenth-century Flemish artist. Portraying the Middleton men in the same manner as English aristocrats was sure to enhance their status once the portraits made their way home to the colonies. The two portraits resonate closely, as Maurie McInnis has observed, with a painting by Gainsborough painted the same year, *The Blue Boy (Master John Buttall)* (1770, Huntington Library and Art Gallery, San Marino).[52] This painting, which was already famous at the time, also depicts the sitter in Van Dyck costume.

West also painted a portrait of Henry Middleton (1717–1784) (or William Middleton [1710–1785]) (fig. 9), a patriarch of the Middleton family.[53] Henry was born in Charleston and educated in England. The wealthy colonial landowner traveled to England in about 1770. West depicts him wearing a fine gold waistcoat

and pants with floral emblems to suggest his social standing.[54] Wearing a wig and seated casually, Middleton is the image of elegant, relaxed style and power.

Perhaps the most successful and dynamic of the Middleton family pictures is the family portrait of Arthur Middleton, one of the young men pictured in *The Cricketers*, and his wife Mary Izard (1747–1814), a cousin of his friend Ralph Izard, and their infant son Henry (1770–1846) (fig. 10).[55] This complex and dynamic composition reveals a confident, established artist. By this time, West was established professionally, basking in the glorious reception of *The Death of General Wolfe* in 1770.[56] In this portrait, he presents us with a modern Holy Family, greatly influenced by Raphael. Raphael was one of West's favorite artists, whom he praised for his "fine fancey in the arraignment of his figures into groops, and those groops into a whole."[57] Here, the sitters are connected in an almost lyrical arrangement of touching arms. The boldly colored drapery also ties the

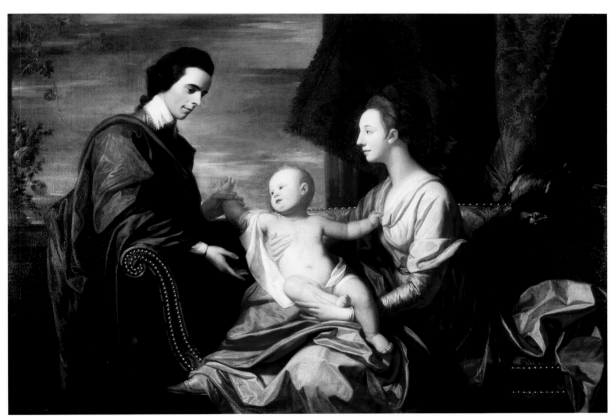

Fig. 10. Benjamin West, *Arthur Middleton, His Wife Mary Izard, and Their Son Henry Middleton*. England, circa 1770–71. Oil on canvas, 44¾ x 66 in. (113.5 x 167.5 cm). The Middleton Place Foundation, Charleston, South Carolina.

figures together, as do their gazes—the mother to the father, and the father to the son. West depicts the mother wearing Classical dress, adhering to academic theory espoused by his friend and Royal Academy president Joshua Reynolds (1723–1792). Reynolds famously advised artists to avoid contemporary dress to create a more timeless, universal picture. This composition resonates closely with a family group portrait West had produced a few years earlier of English baronet Sir William Young and his wife and child (1767, private collection).[58]

At the time of this portrait, the young, prosperous Arthur Middleton family was enjoying the privileged life of cultural tourists, spending nearly three years traveling around southern Europe and England, so the associations with old master works would have been welcomed and perhaps even requested. Their son Henry, whom West depicts as a chubby Christ-like infant, had been born in London near the end of their sojourn. The young colonial family returned home a year after this painting was produced, and Arthur went on to be one of the signers of the Declaration of Independence.[59]

West signed several of his early colonial American pictures produced in London with either "B.West, London" and the date or "B. West / Pinxit [or "painted"] London" and the date. For example, his portrait of William Allen's brother-in-law, *Governor James Hamilton* (1767, Independence Hall, Philadelphia), was signed, "B.West pinxit London/1767."[60] The second version of *The Cricketers* (fig. 4) was similarly signed "B. West—London/1764."[61] Undoubtedly, West knew these paintings were destined for homes across the Atlantic and saw them as a marketing opportunity to disseminate his reputation back home. The word "London" is prominent and is usually equal in size to his name. In some ways, he was simply mimicking the Grand Tour convention of naming the city of production, but in other ways he was perhaps building or advertising his

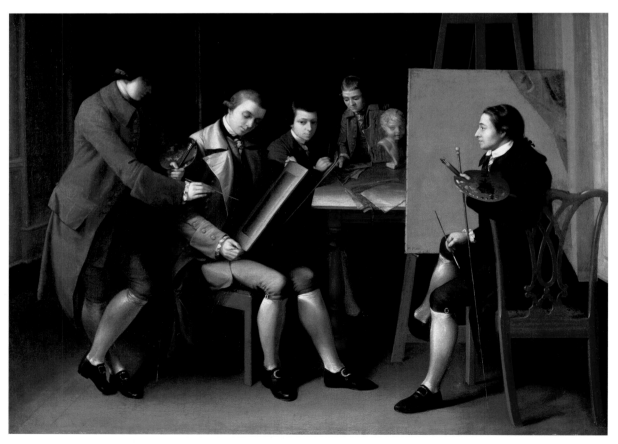

Fig. 11. Matthew Pratt, *The American School*. England, 1765. Oil on canvas, 36 x 50¼ in. (91.4 x 127.6 cm). The Metropolitan Museum of Art, Gift of Samuel P. Avery, 1897 (97.29.3) © The Metropolitan Museum of Art. Image Source: Art Resource, NY.

own name in association with the artistic center of the English-speaking world. The signatures including "London" are primarily a phenomenon of the first few years of his career abroad.

London, of course, had become his adopted home and the geographic location of his house and studio in the city's fashionable West End. There Americans abroad would sit for their portraits, and there West welcomed over thirty American students for training and guidance. Many other visitors came simply to catch a glimpse of the artist in his creative environment. West was famously open and forthcoming about his artistic practice and would often talk about his theories and practices in a lecture style for students and sitters present in his studio.[62] His studio also became the setting of his social life. Not unlike his ambitious colonial sitters, he fashioned himself a gentleman and created a home filled with an art collection to display his wealth and success.[63] West's studios at Bedford Street, Castle Street (which is the setting of Matthew Pratt's *The American School,* 1765 [fig. 11]), then Panton Square, and finally Newman Street, where he resided from 1774 until his death in 1820, became meccas for American artists as well as other colonial Americans visiting London. West's house (fig. 12) was a lively social place, full of activity and bustling with a wide range of people from both sides of the Atlantic. One has only to glance at Mrs. West's five-year diary to see the notable Americans dining with the Wests:[64] John and Abigail Adams, Francis Hopkinson, John Trumbull, and many more. Mrs. West frequently introduced colonial American flavors and

Fig. 12. Benjamin West, *West Family in the Studio Garden*. England, 1808–1809. Oil on canvas, 13½ x 16¼ in. (34.3 x 41.3 cm). National Portrait Gallery, Smithsonian Institution, Washington, DC. Image copyright © National Portrait Gallery, Smithsonian Institution / Art Resource, NY.

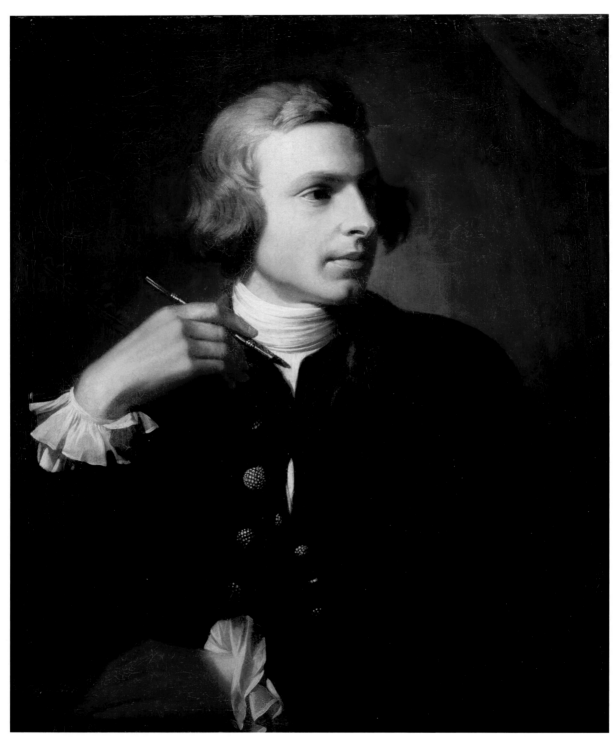

Fig. 13. Benjamin West, *Charles Willson Peale*. England, circa 1769. Oil on canvas, 28¼ x 23 in. (71.8 x 58.4 cm). The New-York Historical Society, 1867.293.

delicacies into her menus, as for example when she procured turkey during the holidays and served corn and squash.[65] She famously grew the yellow sweet corn in a corner of their garden at Newman Street. West's house and studio became a hub and central meeting place for many Americans in London; many even collected their mail there.[66]

By 1774, West's wealth and artistic standing as a royal history painter allowed him to focus on history painting and therefore to be selective in the portrait commissions he accepted. However, he continued to  paint occasional portraits of his friends and colleagues. In 1769, West painted a sensitive portrait of his student Charles Willson Peale (1741–1827) (fig.13) as a gift to the artist.[67] The young artist studied under the tutelage of West in London for about two years from 1767 to 1769.[68] Over the course of several decades, Peale and many other American students made pilgrimages to West's studio in hopes of elevating their own art. The portrait of Peale is a refreshingly casual study of a friend. In the portrait, West plays with dramatic, raking light from the left, casting a strong shadow over the figure, with a lovely strongly lit passage that illuminates just the small of Peale's wrist. West was a generous and kind teacher to Peale, and they developed a close friendship that continued long after Peale returned to the colonies. While a student, Peale came to West's studio nearly every day and sometimes aided him by posing for various figures in his paintings, including the figure of Regulus in his *The Departure of Regulus* (1769, The Royal Collection) and the hand resting on the table in his portrait of Governor James Hamilton (1767, Independence Hall, Philadelphia). Upon his return to the colonies, Charles Willson Peale established himself as one of America's foremost portrait painters. In this portrait, West portrays Peale gripping an accoutrement of his profession, clearly hinting at the great artistic potential of his American student.

In addition to dozens of portraits of American sitters, West painted a few self-portraits during this early period.[69] The self-portrait of 1776 (fig. 14) is fascinating to consider in the context of his colonial ambition. In this self-portrait, he depicts himself holding a board or a small easel upon which is a drawing  of the two standing figures from the right side of his most famous painting,

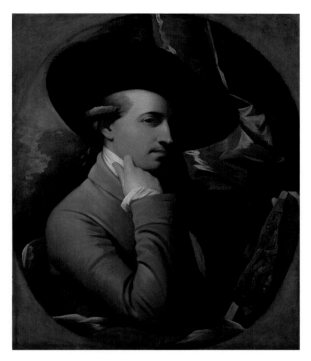

Fig. 14. Benjamin West, *Self-Portrait*. England, circa 1776. Oil on canvas, 30¼ x 25⅛ in. (76.8 x 63.8 cm). The Baltimore Museum of Art.

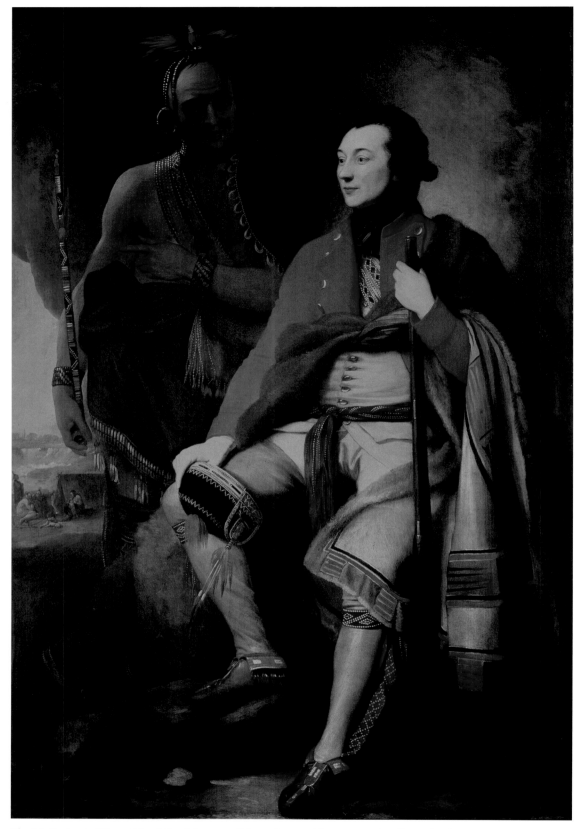

Fig. 15. Benjamin West, *Colonel Guy Johnson and Karonghyontye (Captain David Hill)*. England, 1776. Oil on canvas, 79½ x 54½ in. (202 x 138 cm). National Gallery of Art, Washington, Andrew W. Mellon Corporation, 1940.1.10. National Gallery of Art, Washington, D.C. / Art Resource, NY.

*The Death of General Wolfe.*[70] This ambitious, rather self-aggrandizing self-portrait dates after the exhibition of *Wolfe* at the Royal Academy in 1771 and after the commercially successful print by engraver William Woollett (1735–1785) was released in 1776. The large hat and the unusual angle of the figure owe a conspicuous debt to a self-portrait by Rubens in the Royal Collection that West, as the history painter to the king, would have known firsthand. West portrays himself as a modern old master. This befits an artist whose moniker "the American Raphael" in itself melds the old and new worlds.

The most exceptional portrait that West painted during this early period was *Colonel Guy Johnson and Karonghyontye (Captain David Hill)* (fig. 15).[71] In 1775–1776, Guy Johnson traveled to London with David Hill and an entourage of Native Americans and others involved in colonial Indian affairs.[72] This portrait, painted at West's studio while Johnson was in London, commemorates his new, elevated status as the superintendent of Indian affairs in the northern colonies. He succeeded his uncle William, who had died in 1774. In the painting, West positions Johnson and Hill closely together, creating a visual and emblematic statement of the alliance between the British and the Iroquois Confederacy. As Emily Neff has observed, West depicts Johnson wearing middle-ground clothing, a combination of European and Native American clothing that signified involvement in cultural interactions and carried diplomatic symbols of peace, respect, and friendship.[73]

In this portrait, West promotes his knowledge of North America. He uses objects from his personal collection, such as an engraving of Cohoes Falls to depict the falls in the background, as well as Native American moccasins for the moccasins worn by Johnson and the garter used as a hat band in the hat he holds at his knee.[74] He positions Johnson sitting on a boulder in the American wilderness.[75] These elements bring authenticity to the painting, and correspond with the kind of authoritative references he was making in his contemporary history paintings at the time. This portrait is as much a statement of West's new-world authority, which distinguished him from his native-born contemporaries in London, as it is a public announcement of Johnson's new position.

The painting represents a specific and brief moment in history when there was potential for a peaceful and effective diplomatic alliance between the British and Native Americans. Shortly after this portrait was painted the strategic alliance it depicted crumbled. This was West's last painting to include a Native American.[76]

Within a few years after their production, all of West's images of colonial Americans abroad represented a bygone British Atlantic world. For example, when *The Cricketers* was painted it was an image of the promise and prosperity of young colonial men abroad. But we know that they all suffered the Loyalist/Patriot divisions brought about by the American Revolution. The Allen family remained loyal. Andrew Allen joined the British Army, lost all of his property, and moved back permanently to London. His brother James, also a Loyalist, attempted to stay out of politics by retiring to the countryside when war broke out, but he died in 1778.[77] Wormeley, Middleton, and Izard declared their loyalty to the Patriot cause and also lost a great deal.[78]

And what about the fate of the artist of *The Cricketers*? Benjamin West was astute enough to know that taking sides politically would lose him his royal job and patronage networks in London, so he purposefully maintained neutrality. As the story goes, he remained in London until he died in 1820, never returning home.

*The Cricketers* and many of West's early portraits of colonial Americans abroad are powerful reminders of the relationship between America and England on the eve of the American Revolution—and the cultural and family relationships that remained afterwards, but significantly changed. These images also foster our understanding of the Atlantic world and the ocean that Benjamin Franklin described as a highway of ideas and goods linking the old world to the new. The colonial Americans in these paintings by West were crisscrossing the Atlantic Ocean for education, for business, for diplomacy, and for pleasure. Their portraits are statements of the privileged life and status once enjoyed on both sides of the Atlantic, images of the colonial ambitions shared by the artist who painted their likenesses.

## Notes

1 See Julie Flavell, *When London Was the Capital of America* (New Haven and London: Yale University Press, 2010).

2 Anthony Pasquin, "Royal Academy Dinner; A Pictorial Vision," in *The Morning Herald*, 30 April 1811, reprinted in *The Spirit of the Public Journals*, vol. 14 (1811), 206–207.

3 Joseph Farington's diaries provide numerous characterizations of West's overly ambitious nature and inflated sense of self. For example, on 1 December 1807 Farington wrote, "To such lengths does West's self love carry Him." Kathryn Cave, ed., *The Diary of Joseph Farington* (New Haven and London: Yale University Press, 1982), 8:3154.

4 West sent two history paintings, *Cymon and Iphigenia* and *Angelica and Medoro*, and one portrait of General Monckton to his first public exhibition at the Society of Artists show of 1764 in London. See Algernon Graves, *The Society of Artists of Great Britain, 1760–1791, the Free Society of Artists, 1761–1783: A Complete Dictionary of Contributors and Their Work from the Foundation of the Societies to 1791* (London: George Bell & Sons, 1907), and Helmut Von Erffa and Allen Staley, *The Paintings of Benjamin West* (New Haven and London: Yale University Press, 1986), 33.

5 West, his compatriot John Singleton Copley (1738–1815), and several other British contemporaries helped propel history painting to eventually find an audience in eighteenth-century London. Even so, history painting was not as commercially accepted as portraiture. Additionally, history painting never found as much acceptance in the United States. For a general bibliography about West's history paintings, see Von Erffa and Staley, *The Paintings of Benjamin West*, and Emily Neff with Kaylin Weber, *American Adversaries: West and Copley in a Transatlantic World* (Houston: Museum of Fine Arts, Houston, distributed by Yale University Press, 2013).

6 Letter from Benjamin West to John Green, 10 September 1771, in Benjamin West, "Letter from Benjamin West," *Journal of the Archives of American Art* 4 (January 1964): 11–12. The author has retained the original spellings.

7 For the most recent scholarship on West and his compatriot John Singleton Copley's contemporary history paintings, see Neff with Weber, *American Adversaries*.

8 Von Erffa and Staley, *The Paintings of Benjamin West*, 24.

9 Von Erffa and Staley, *The Paintings of Benjamin West*, 508 (cat. no. 622). For more about West's early instruction, see Susan Rather, "Benjamin West's Professional Endgame and the Historical Conundrum of William Williams," *William and Mary Quarterly* 59, no. 4 (Oct. 2002): 821–864; and Ann Uhry Abrams, "A New Light on Benjamin West's Pennsylvania Instruction," *Winterthur Portfolio* 17, no. 4 (Winter 1982): 243–257. The sitter in this portrait, Jane Galloway, would later become Mrs. Joseph Shippen, her husband being the son of one of West's great Pennsylvania supporters and also one of his traveling companions in Italy.

10 William Allen served as chief justice of Pennsylvania from 1750 to 1774.

11 Von Erffa and Staley, *The Paintings of Benjamin West*, 13.

12 John Galt, *The Life, Studies, and Works of Benjamin West, Esq.*, 2 vols. (London: T. Cadell and W. Davies, 1820), 1:76.

13 See Christopher Lloyd, "Benjamin West and Italy," in Emily Neff with Kaylin Weber, *American Adversaries*, 150–159. See also Allen Staley, "Benjamin West in Italy," in *The Italian*

*Presence in American Art, 1760–1860*, ed. Irma Jaffe (New York: Fordham University Press, 1989), 1–8.

14 Von Erffa and Staley, *The Paintings of Benjamin West*, 447 (cat. no. 516). For example, West's *Salome with the Head of St. John the Baptist* (1763, Ferens Art Gallery, Hull) is a copy of a painting by Guido Reni made for Chief Justice Allen and his brother-in-law Governor James Hamilton (c. 1710–1783). West painted a portrait of Governor James Hamilton in 1767 when he was in England. See Von Erffa and Staley, *The Paintings of Benjamin West*, 514 (cat. no. 633).

15 West would advocate the importance of copying in the learning process to his students and academicians. For more information about his studio practice and pedagogy, see Kaylin H. Weber, "The Studio and Art Collection of the 'American Raphael': Benjamin West, P.R.A. (1738–1820)" (PhD diss., University of Glasgow, 2013), especially Chapter 3; and Jenny Carson, "Art Theory and Production in the Studio of Benjamin West" (PhD diss., City University of New York, 2000), especially Chapter 2.

16 Galt, *Life, Studies, and Works*, 1:105–106. West first recounted this event at a lecture in 1794 at the Royal Academy. One of the most thorough assessments of the context and production of the first volume of the Galt biography is Susan Rather, "Benjamin West, John Galt, and the Biography of 1816," *Art Bulletin* 86, no. 2 (June 2004): 324–345.

17 Von Erffa and Staley, *The Paintings of Benjamin West*, 486 (cat. no. 582).

18 Michael Quick, ed., *American Portraiture in the Grand Manner, 1720–1920* (Los Angeles: Los Angeles Museum of Art, 1981), 15. For more on portraiture conventions in eighteenth-century Britain, see Marcia Pointon, *Hanging the Head: Portraiture and Social Formation in Eighteenth-Century England* (New Haven and London: Yale University Press, 1993).

19 Van Dyck costume in eighteenth-century portraiture is based on the fashions in seventeenth-century portraiture by the leading aristocratic portraitist, Sir Anthony Van Dyck. Pointon, *Hanging the Head*, 23–24.

20 For the context of the West sketch by Kauffman, see Peter Walch, "An Early Neoclassical Sketchbook by Angelica Kauffman," *Burlington Magazine* 119, no. 887 (February 1977): 102.

21 Allen Staley, "Benjamin West in Italy," in Jaffe, *The Italian Presence in American Art*, 1.

22 Letter from Benjamin West (London) to Joseph Shippen, 1 Sept. 1763, published in Edgar P. Richardson, "West's Voyage to Italy, 1760, and William Allen," *Pennsylvania Magazine of History and Biography* 102 (Jan. 1978): 21–22.

23 In fact, West's Italian portraits show such resonance with contemporary works that one was said to have been confused for the work of Mengs. Galt, *Life, Studies, and Works*, 1:119–121, and Von Erffa and Staley, *The Paintings of Benjamin West*, 17.

24 For West's study of anatomy, see Allen Staley, "Benjamin West in Italy," in Jaffe, *The Italian Presence in American Art*, 2.

25 Richardson, "West's Voyage to Italy," 23; Von Erffa and Staley, *The Paintings of Benjamin West*, 23; and Neff with Weber, *American Adversaries*, 158.

26 Helmut von Erffa, "Benjamin West: The Early Years in

[27] Galt, *Life, Studies, and Works*, 2:5.

[28] Von Erffa and Staley, *The Paintings of Benjamin West*, 24.

[29] Von Erffa and Staley, *The Paintings of Benjamin West*, 571 (*The Cricketers*, cat. nos. 726 and 727). One version (no. 726) was painted for the Allen family and the other version (no. 727) for the Izard family.

[30] Maurie McInnis, *In Pursuit of Refinement: Charlestonians Abroad, 1740–1860* (Columbia: University of South Carolina Press, 1999), 13.

[31] Alan Simpson, "Colonial Cricketers in London," *Colonial Williamsburg Journal* 15, no. 3 (Spring 1993): 30.

[32] Flavell, *When London Was the Capital of America*, 25.

[33] Simpson, "Colonial Cricketers," 31.

[34] Ibid., 31.

[35] The figure on the far right has been variously identified as either Arthur Middleton or a member of the Jamaican branch of the Beckford family. See Von Erffa and Staley, *The Paintings of Benjamin West*, 24–26; and McInnis, *In Pursuit of Refinement*, 100–103.

[36] McInnis, *In Pursuit of Refinement*, 100.

[37] Anne Izard Deas, ed., *Correspondence of Mr. Ralph Izard of South Carolina* (New York: Charles Francis, 1844), i–iv, quoted in McInnis, *In Pursuit of Refinement*, 100.

[38] See Simpson, "Colonial Cricketers."

[39] Allen Staley, *Benjamin West: American Painter at the English Court* (Baltimore: Baltimore Museum of Art, 1989), 31.

[40] Von Erffa and Staley, *The Paintings of Benjamin West*, 25.

[41] McInnis, *In Pursuit of Refinement*, 28.

[42] Ibid., 100, and Von Erffa and Staley, *The Paintings of Benjamin West*, 571. The painting illustrated in this essay is the second version.

[43] Galt, *Life, Studies, and Works*, 2:4.

[44] Ibid., 5.

[45] Von Erffa and Staley, *The Paintings of Benjamin West*, 21 and 484 (cat. no. 581).

[46] Ibid., 21. As Allen Staley has observed, there is a clear stylistic connection between West's portrait of William Allen and Gainsborough's portrait of Thomas Coward (c. 1760–1764, Birmingham Museums Trust).

[47] Von Erffa and Staley, *The Paintings of Benjamin West*, 486–487 (cat. no. 584).

[48] Von Erffa and Staley, *The Paintings of Benjamin West*, 538 (cat. no. 676). As Allen Staley has observed, the portrait of Anne, Countess of Northampton, the wife of the English ambassador in Venice, and her daughter was clearly inspired by Renaissance prototypes of Madonnas, in particular Raphael's *Madonna della Sedia* (Pitti Palace, Florence).

[49] McInnis, *In Pursuit of Refinement*, 104. The identity of this sitter has been debated by scholars and Middleton family descendants. The current attribution conforms with the attribution of the present owner (the Middleton Place Foundation).

[50] Von Erffa and Staley, *The Paintings of Benjamin West*, 529.

[51] Letter from Benjamin West to John Singleton Copley, 20 June 1767, in *Letters and Papers of John Singleton Copley and Henry Pelham, 1739–1776*, ed. Guernsey Jones (Boston: Massachusetts Historical Society, 1914), 56–57.

[52] McInnis, *In Pursuit of Refinement*, 104–105.

[53] Von Erffa and Staley, *The Paintings of Benjamin West*, 529 (cat. no. 659). There is debate about the sitter in this portrait as well. The Middleton descendants identify him as Henry Middleton, and Von Erffa and Staley identify him as William Middleton. See discussion, ibid.

[54] The waistcoat survives in the Middleton family today. I am grateful to Dottie Stone at Middleton Place for providing me with this information.

[55] Von Erffa and Staley, *The Paintings of Benjamin West*, 531–532 (cat. no. 661).

[56] West's *Death of Wolfe* was first exhibited in his studio in 1770 and publicly at the Royal Academy the following year.

[57] Letter from Benjamin West to John Singleton Copley, 6 Jan. 1793, in *Letters and Papers of John Singleton Copley and Henry Pelham*, 194–197. The author has retained the original spelling. In homage to the Italian artist, West also named his first son Raphael.

[58] Von Erffa and Staley, *The Paintings of Benjamin West*, 28 and 569 (cat. no. 723).

[59] McInnis, *In Pursuit of Refinement*, 106.

[60] Von Erffa and Staley, *The Paintings of Benjamin West*, 514.

[61] Ibid., 571.

[62] West's open policy in his studio was in stark contrast to those of his contemporaries, particularly Reynolds, who according to his assistant, James Northcote, was secretive and kept himself away from his clients, students, and public while he worked. James Northcote, *The Life of Sir Joshua Reynolds*, 2nd ed., 2 vols. (London, 1818), 1:241–242. The exception to West's normal openness, of course, is his involvement in the disastrous "Venetian Secret," in which he attempted to conceal his experiments with a fraudulent old-master formula. For more about this episode, see John Gage, *Colour and Meaning: Art, Science and Symbolism* (London: Thames and Hudson, 1999); Angus Trumble, Mark Aronson, and Helen Cooper, *Benjamin West and the Venetian Secret* (New Haven: Yale Center for British Art, 2008), and Rosie Dias, "Venetian Secrets: Benjamin West and the Contexts of Colour at the Royal Academy," in Sarah Monks, John Barrell, and Mark Hallett, eds., *Living with the Royal Academy: Artistic Ideals and Experiences in England, 1768–1848* (Burlington, VT: Ashgate, 2013).

[63] For more about West's house and the art collection that filled it, see Weber, "The Studio and Art Collection," and Kaylin H. Weber, "A Temple of History Painting: West's Newman Street Studio and Art Collection," in Neff with Weber, *American Adversaries*, 14–49.

[64] Mrs. West's 5-Year Account Book (1785–1789), SAFE 037, Friends Historical Library, Swarthmore College, Pennsylvania.

[65] On 21 December 1786, Mrs. West noted the purchase of "Turkey 7/2 Fowls 3/6 0-20-6." Mrs. West's 5-Year Account Book (1785–1789), SAFE 037, Friends Historical Library, Swarthmore College, Pennsylvania. For Mrs. West's sweet corn grown in her garden, see the diary entry for 4 October 1784 in *Samuel Shoemaker's Diary*, Historical Society of Pennsylvania, Philadelphia, 242.

[66] Robert Alberts, *Benjamin West: A Biography* (Boston: Houghton Mifflin, 1978), 167.

[67] Von Erffa and Staley, *The Paintings of Benjamin West*, 542 (cat. no. 680).

[68] Dorinda Evans, *Benjamin West and His American Students* (Washington, DC: Smithsonian Institution Press, 1980), 37–47.

[69] West painted a group family portrait, *The West Family*, c. 1772, Yale Center for British Art, New Haven, which included a self-portrait of the artist on the far right with his wife and two sons as well as his father and half-brother, Thomas. See Von Erffa and Staley, *The Paintings of Benjamin West*, 462 (cat. no. 546).

[70] Von Erffa and Staley, *The Paintings of Benjamin West*, 451.

[71] Ibid., 211–217. For the literature relating to this painting, see Emily Ballew Neff, "At the Wood's Edge: Benjamin West's 'The Death of Wolfe' and the Middle Ground," in Neff with Weber, *American Adversaries*, 99 (n. 9).

[72] Neff, "At the Wood's Edge," 95.

[73] Ibid., 94–97.

[74] J. C. H. King, "Woodland Artifacts from the Studio of Benjamin West, 1738–1820," *American Indian Art Magazine* 17, no. 1 (Winter 1991): 34–47.

[75] Neff, "At the Wood's Edge," 95.

[76] Ibid., 98.

[77] McInnis, *In Pursuit of Refinement*, 102.

[78] Ibid.

# The New England Portraits of Ralph Earl
## Fashioning a Style for the New Citizens of the Young Republic

*Elizabeth Mankin Kornhauser*

When visitors first encounter the life-size portrait of the small-town shopkeeper Elijah Boardman, painted by American artist Ralph Earl (1751–1801), they often do a double-take (fig. 1). Boardman stares out at the viewer with his seductive gaze, drawing them into the composition as though they had actually entered his mercantile shop and are being invited to buy the attractive inventory of imported fabrics that he offers in his back storeroom. This essay focuses on this astonishing portrait, which was inspired by the newfound freedoms gained by American citizens following the Revolution but appears remarkably progressive and modern for a work painted in rural Connecticut in 1789.

As an itinerant portrait painter, Earl traveled through small Connecticut towns at a time when the United States was beginning to flourish in the post-Revolutionary era. Here he produced his finest works, getting to know his patrons intimately as he lived under their roofs while he was painting their portraits. Earl fashioned a brilliantly observant style that was appropriate for the new citizens of the United States. He internalized the lives of those he painted and, in the process, captured and confirmed their hopes and values. The artist formed a particularly close friendship with Elijah Boardman, which led to many portrait commissions. It is the richness of their relationship that informed his extraordinary portrait.

Coming of age in turbulent times, Earl managed to transform his dramatic life experiences into lessons that allowed him to develop his uniquely astute style to suit the restrained tastes of the new citizens of the young republic. He was born and raised in Worcester County, Massachusetts, the son of farmers. With an avid determination to become a painter, against all odds, he fled from his agrarian roots to establish himself as a portrait painter in New Haven, Connecticut, on the eve of the Revolution.[1]

In the early 1770s, the sophistication of American portraiture reached new heights in the works of John Singleton Copley (1738–1815).[2]

Like most native-born American artists who came of age before the Revolution, Earl was profoundly influenced by Copley's portraits. Copley understood that an accomplished portraitist must do more than exhibit technical skill, which he demonstrated in abundance. The artist must also internalize the values of those he painted. Copley entered into and incorporated the social, economic, and political habits of his patrons, whether merchant or craftsman, Tory or Whig. In 1774, just before his departure for London, Copley painted the successful merchant Adam Babcock and his wife Abigail Babcock, of New Haven, Connecticut. In *Mrs. Adam* [Abigail] *Babcock* (fig. 2), Abigail is dressed in an imaginary Oriental costume with an ermine-trimmed cloak. She holds a beautiful garnet bracelet in her hands. This portrait provides direct evidence that Earl studied the colonial works of Copley, as he based his earliest known portrait, *Mrs. Henry* [Elizabeth Prescott] *Daggett*, c. 1774–1775 (fig. 3), on the Babcock portrait. Demonstrating a lack of formal training, Earl nevertheless appropriates Copley's fantastic costume elements and emulates his muted palette and strong contrasts of light and shade.

Copley frequently used English mezzotint prints as templates for his own pictures in an effort to please his clients, who sought anglophilic presentations of themselves. In his portraits of *Jeremiah Lee* and *Mrs. Jeremiah* [Abigail] *Lee*, 1769 (figs. 4 and 5), for example, he provides a catalogue of compelling images that could fulfill the Lees' fantasies of themselves as English aristocrats, despite the fact that they were staunch Patriots. Lee holds business papers in his hand as he leans on an extraordinary marble-topped pier table with gilded figures of a nude female torso on the legs—a table that would not have been found in the colonies. Rather, it is derived from the English mezzotint portrait *Queen Caroline*, 1739, by John Faber Jr. after J. Vanderbank.[3] The plainness of the Lees' features and the lack of elegance in their poses clash with the elaborate settings in which they are placed, which are more appropriate to a grand-scale

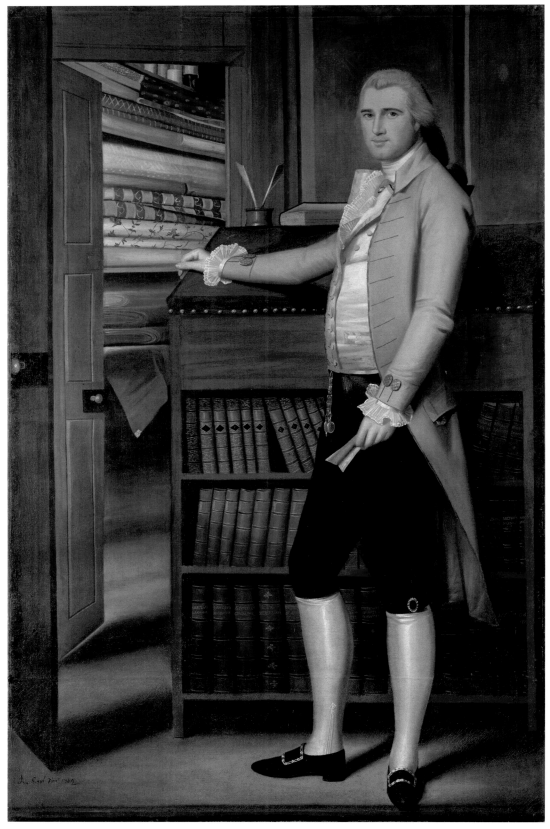

Fig. 1. Ralph Earl, *Elijah Boardman*. New Milford, Connecticut, 1789. Oil on canvas, 83 x 51 in. (210.8 x 129.5 cm). The Metropolitan Museum of Art, Bequest of Susan W. Tyler, 1979 (1979.395). Image © The Metropolitan Museum of Art, New York.

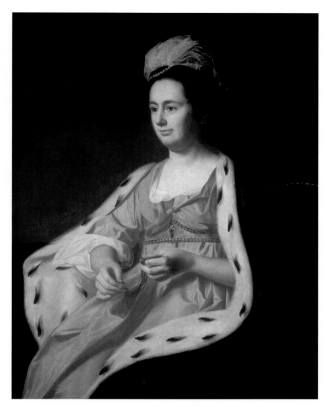

Fig. 2. John Singleton Copley, *Mrs. Adam Babcock*. Boston, Massachusetts, 1774. Oil on canvas, 50 x 40 in. (127.0 x 101.6 cm). National Gallery of Art, Washington, DC.

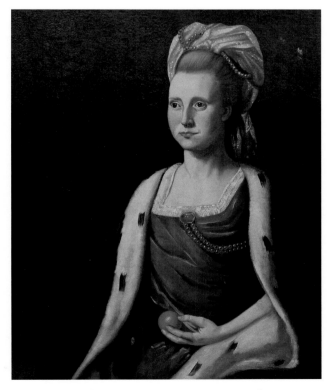

Fig. 3. Ralph Earl, *Mrs. Henry Daggett*. New Haven, Connecticut, circa 1774–1775. Oil on canvas, 29 x 25 in. (73.7 x 63.5 cm). Stowe-Day Foundation, Harriet Beecher Stowe Center, Hartford, CT.

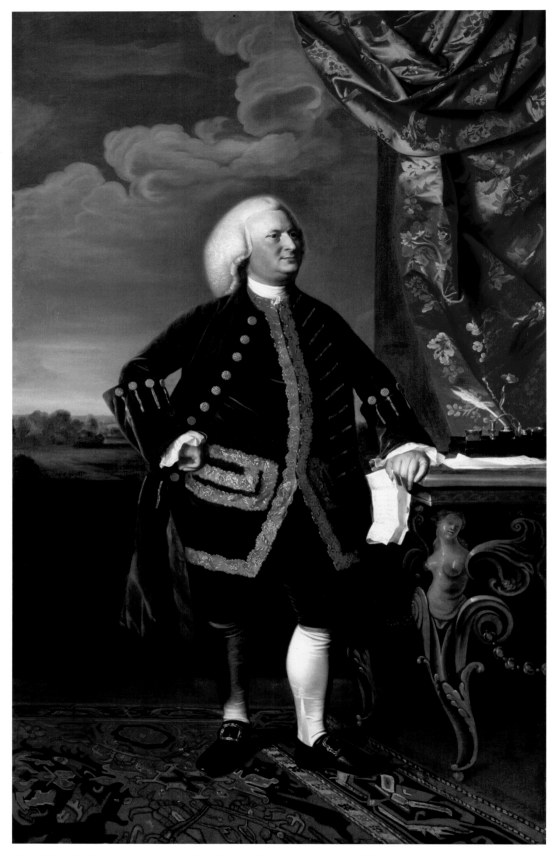

Fig. 4. John Singleton Copley, *Jeremiah Lee*. Boston, Massachusetts, 1769. Oil on canvas, 95 x 59 in. (241.3 x 149.9 cm). Wadsworth Atheneum Museum of Art, Hartford, CT.

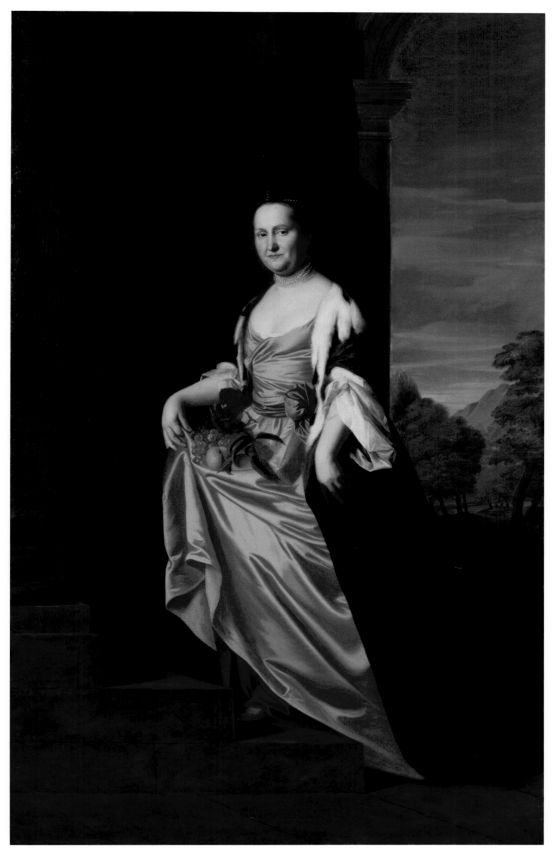

Fig. 5. John Singleton Copley, *Mrs. Jeremiah Lee*. Boston, Massachusetts, 1769. Oil on canvas, 95 x 59 in. (241.3 x 149.9 cm). Wadsworth Atheneum Museum of Art, Hartford, CT.

English country house than their Marblehead, Massachusetts, mansion. Earl was impressed with Copley's life-size, elaborate colonial portraits and would revisit this full-length format later in his career.

Copley painted portraits of Loyalists and Patriots alike before his departure for London. His 1768 portrait of the prominent Boston silversmith Paul Revere (fig. 6), who would later make his legendary ride to alert the Patriots that the British were coming, captured the qualities that made Revere an American hero: physical strength, moral certainty, intelligence, and dedication to a cause. He is presented here as an artisan who, like Copley himself, took pride in the work of his hands. It is an idealized view of labor in the American colonies that offers a record of Revere's powerful physical presence but also suggests the dignity and value of the artisan's work.

Likewise, for his portrait of Samuel Adams, painted in 1770–1772 (fig. 7), Copley presents his subject as a political figure engaged in the role of a radical Patriot. With a grim look of defiance, Adams points to the charter and seal granted by King William and Queen Mary to the colony of Massachusetts. In his other hand he clenches a statement prepared by the outraged citizens of Boston.

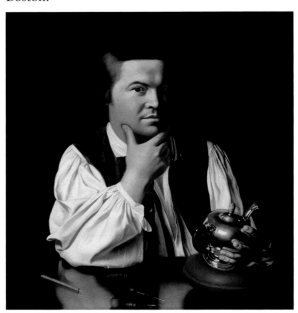

Fig. 6. John Singleton Copley, *Paul Revere*. Boston, Massachusetts, 1768. Oil on canvas, 35⅛ x 28½ in. (89.22 x 72.39 cm). Museum of Fine Arts, Boston.

It was this direct and politically charged style of portraiture by Copley that inspired Earl's first significant work, the portrait of the Connecticut Patriot *Roger Sherman*, 1775–1776 (fig. 8). Sherman's impressive record as a Patriot included participation at the First Continental Congress in Philadelphia, in 1774, when he signed the Articles of Association. He would later help to draft the Declaration of Independence. Sherman had Earl commemorate his participation in the congress in a simple but monumental portrait that captures his Yankee values of self-control, honesty, frugality, piety, and industry. Portrayed at full length, he is dressed in simple, austere attire and chooses not to wear a wig. According to costume expert Aileen Ribeiro, many American men deliberately dispensed with wigs as an egalitarian gesture during the Revolution, a rejection of the Old World.[4] Sherman is seated in a distinctive green-painted Windsor chair, the only prop in the entire composition, which is a regional type found in Philadelphia, thereby signaling the importance of his patriotic role in that city.[5]

Despite his seemingly patriotic endeavors, when drafted to serve in the Connecticut militia, Earl refused and was declared a Loyalist. To avoid imprisonment, he fled to London in 1778, deserting his first wife, Sarah Gates Earl, and their two children. With the assistance of the British officer Captain John Money, who disguised him as his servant, Earl was taken on board ship to England, where he spent the next eight years. Earl divided his time between the countryside of Norwich, where John Money lived and provided him with portrait commissions from his local friends and neighbors, and London, where he claimed to be a part of the entourage of American artists in the London studio of Benjamin West. While Earl remained on the periphery of West's studio, he successfully exhibited a number of impressive portraits at the Royal Academy and maintained a residence in Leicester Square. He exhibited the portrait *Colonel George Onslow*, 1783 (private collection), at the Royal Academy that year, and painted the military hero Admiral Richard Kempenfelt (1782 or 1783, National Portrait Gallery, London) in a traditional British military portrait format.

While in London, Earl was able to obtain the latest artist's materials for his portraits. He

purchased high-quality canvas fabrics and could order them in almost any width to accommodate his life-size full-length portraits. Colormen provided bolts of primed and prestretched fabric for these works, which he routinely exhibited at the Royal Academy. For many of his English portraits, Earl personally applied the more fashionable smooth, cool, white priming to his canvas and used expensive pigments and surface glazes. For example, Earl's portrait *A Gentleman with a Gun and Two Dogs* (1784, Worcester Art Museum) demonstrates the artist's mastery of conventional English portraiture in both composition and technique, including the subtle glazing that shows the sheen on the hunting boots.

Earl became the first of West's students to return to the United States after the war. In 1785, with his second wife, Ann Whiteside Earl of Norwich, England, he arrived in Boston, introducing his fashionable British portrait style to the America public. He quickly established a residence in New York City, then the leading art center in the United States. However, his ambitious start came to a sudden halt when he was confined in debtor's prison from September 1786 until January 1788. During his incarceration he attracted the support of a recently formed benevolent organization, the Society for Relief of Distressed Debtors. Composed of the most illustrious New York families, this group came to the artist's aid by engaging him to paint portraits of members and their friends and families while he was in prison. With such elegant works as *Mrs. Alexander Hamilton* (1787, Museum of the City of New York), as well as a series of portraits of recent heroes of the American Revolution, images that celebrated his sitters' membership in the newly formed Society of the Cincinnati, he earned enough money to obtain his release.

Earl's court-appointed guardian, the Connecticut native Dr. Mason Fitch Cogswell, convinced the artist to leave New York City and follow him to Connecticut, where Cogswell provided him with commissions. Earl modified his artistic ambitions, moving away from his English experience in order to ply his trade as an itinerant artist in the agriculture-based society of Connecticut. At a time when Americans were beginning to forge a new identity as citizens of a new

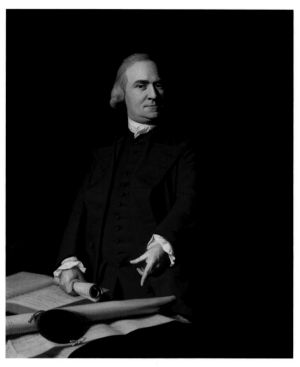

Fig. 7. John Singleton Copley, *Samuel Adams*. Boston, Massachusetts, 1770–1772. Oil on canvas, 50 x 40¼ in. (127.0 x 102.2 cm). Museum of Fine Arts, Boston.

Fig. 8. Ralph Earl, *Roger Sherman*. New Haven, Connecticut, 1775–1776. Oil on canvas, 64⅝ x 49⅝ in. (164.2 x 126.1 cm). Yale University Art Gallery, New Haven, CT.

republic, Earl moved away from British aristocratic imagery, developing a style and technique suited to the restrained tastes, republican virtues, and pious values of the Connecticut inhabitants. He found his greatest success in this region, where, with Cogswell's impressive connections, he painted for the next ten years, from 1788 to 1798.

Elijah Boardman (1760–1823) became one of Earl's most important Connecticut patrons. He was the grandson of Rev. Daniel Boardman, the first Congregational minister of New Milford, and was the third son of Sherman and Sarah Bostwick Boardman, who raised their children on a substantial farm beside the Housatonic River. As a young man, Elijah studied with the town minister, Rev. Nathaniel Taylor, and at age sixteen, he served in the Connecticut militia during the Revolution. After the war he trained for a career as a shopkeeper by working as a clerk in New Haven. He opened his own store in New Milford in 1781, in the southern half of a saltbox house on Town Street. His elder brother Daniel Boardman (1757–1833), who graduated from Yale that year, joined him in a partnership that would last for the next eleven years. Both brothers, who were not yet married when their portraits were painted, must have hung the portraits in their shop on Town Street.

A series of letters between Earl and Elijah Boardman attests to the exceptionally close relationship between them. Artist and patron together devised a story line for this portrait that incorporates an encyclopedia of significant objects in the composition, exploding beyond the boundaries of traditional portraiture of the day. Boardman's portrait not only emphasized his trade as a shopkeeper but told the larger story of his life. He stands at his green felt-covered counting desk, outside the door to the storeroom that contains bolts of fabric and spools of thread. The inventory displayed emphasizes the exotic imported fabrics he was able to offer his clients. Elijah wears a beautifully coiffured wig that is tied at the back and cascades down his back. He is dressed in the latest fashion, with formal elegance in a satin waistcoat and matching jeweled knee and shoe buckles as a visible sartorial testimony to the fine fabrics on sale in his shop, as much as to say: if you purchase my fine imported fabrics, you can look like me.[6]

Elijah and Daniel Boardman advertised in the local newspaper that "At their Store in New Milford, [they] Have for Sale a very large and general Assortment of European, East & West-India Goods."[7] They also advertised rum, sugar, molasses, and indigo from the West Indies. The fabrics seen through the door on the shelves have been identified: on the top shelf are spools of silk ribbon, on the shelf below a selection of patterned fabrics including a brown patterned cotton calico and a red-spotted bolt that is likely a tie-dyed Indian bandanna fabric. On the next shelf are fine white-on-white fabrics, followed by bolts of green taffeta, cotton chintz, and a gold-colored satin. The bottom shelf holds the "Super Broad-Cloth" woolens that the brothers advertised, and the fabric hangs down to reveal what may be an English excise tax stamp that announces to the viewer that these are high-quality imported goods.[8]

As a complement to the inventory of exotic fabrics offered for sale, Earl carefully titled the spines of the books that appear on the shelves of Boardman's high counting desk, which speak to his intelligence and worldliness, with titles ranging from Milton's *Paradise Lost* and Shakespeare's plays to Guthrie's *Geography*, Cook's *Voyages*, Johnson's *Dictionary*, and the *London Magazine*. Boardman's probate inventory at the time of his death verifies his ownership of these books (two hundred titles are listed).[9] Finally, Earl brings his subject to life with his technical proficiency, painting a trompe l'oeil detail of the life-size figure of Boardman with his left foot stepping off the floor boards, seemingly out of the picture, to greet his customers. Earl placed an advertisement offering his services as a portrait painter in the *Litchfield Monitor* that boasted, "Some of his paintings are admirably finished, and display that similarity and expression, as would seem to start them into life—though inanimate they speak."[10]

Earl's portrait of *Daniel Boardman* (fig. 9), also at full length, shows Elijah's elder brother in equally elegant attire, wearing his own powdered hair, holding an expensive beaver hat, and leaning on an ivory-capped cane while gracefully posed in a landscape. The background includes a detailed rendering of New Milford viewed from the southeast, with the Housatonic River winding toward the town center. The attention paid to

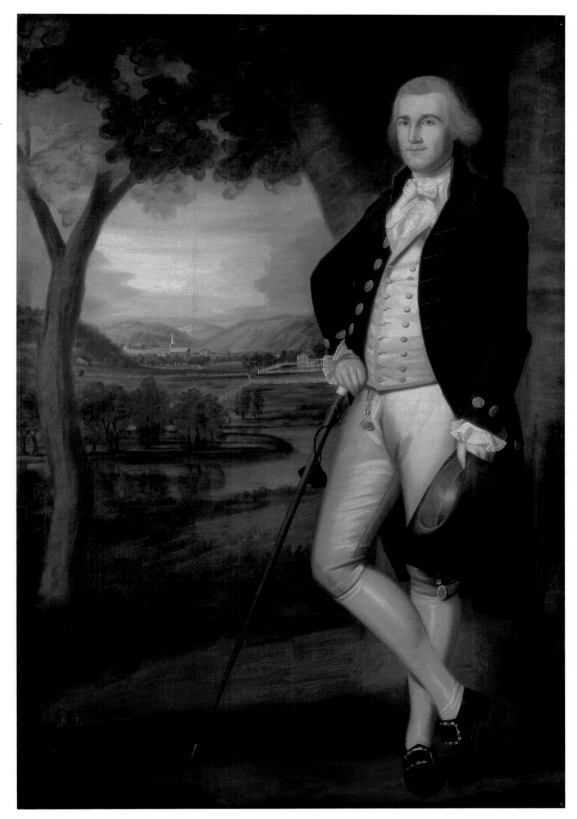

Fig. 9. Ralph Earl, *Daniel Boardman*. New Milford, Connecticut, 1789. Oil on canvas, 81⅝ x 55¼ in. (207.3 x 137.8 cm). National Gallery of Art, Washington, DC.

the landscape likely was intended to symbolize the extensive landholdings owned by the Boardman brothers, who rose to prominence in the post-Revolutionary era. In the same year Earl also painted the younger sister of the two Boardman brothers, *Esther Boardman*, 1789 (fig. 10). She is also dressed in the latest fashion, wearing the new informal wraparound gown called a *lèvite*, made of green silk. Her strong features are softened by delicate pink flesh tones. She is seated in a landscape, holding a book on her lap, with a view of the town of New Milford, seen from the northwest, in the distance.[11]

Earl had to make do with art supplies available in the small Connecticut towns to which he traveled. Unable to obtain the high quality preprimed canvas that he could acquire from colorman shops in London and New York, he is known to have used a variety of supports including bed ticking. Most of his Connecticut portraits were painted on a coarse nappy woven fabric, and he was unable to get canvas wider than thirty-six inches. Thus his full-length portraits display the

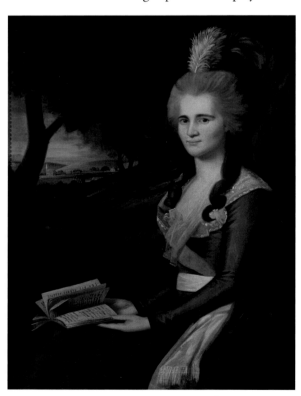

Fig. 10. Ralph Earl, *Esther Boardman*. New Milford, Connecticut, 1789. Oil on canvas, 42½ x 32 in. (108.1 x 81.3 cm). Metropolitan Museum of Art, New York.

seams of a pieced canvas that he had sewn together to achieve the grand scale he desired. Earl was also unable to find the latest pigment colors, which he had used for his English work, and thus resorted to working with simpler, primary colors. The recent discovery of ninety-nine business ledgers belonging to Elijah Boardman and now in the collection of the Litchfield Historical Society, Litchfield, Connecticut, provides fascinating evidence that Earl purchased his art supplies directly from Boardman's shop while he was living with the Boardman family and painting their portraits. A series of entries dating from February 1789 to January 1790 lists the many purchases made by Ralph Earl from the Boardman shop, including the following pigments: Spanish White, Spanish Brown, White Lead,  King's Yellow, and Vermillion.[12] Earl often signed and dated his portraits in bright red vermillion pigment, as at lower left in his portrait of Esther Boardman (see fig. 10). He also acquired a canvas called "Russia Sheeting," a strong, coarse linen fabric that he used for his Connecticut portraits.[13] One entry lists the cost for "sewing canvas," confirming that he used pieced canvases for the full-length portraits of Elijah and Daniel Boardman. The seams in the canvases are clearly visible.[14] The artist also purchased "Paper" and "ink and powder," "Spirits of Turpentine," "glue," "whiting" for the priming coat, and "Copal varnish," all used to create his Connecticut portraits.[15] Earl also bought goods from the store for his wife Ann Whiteside Earl and son Ralph E. W. Earl (1785 or 1788–1838), who traveled with him and boarded with the family. Listed are such personal items as rum, snuff, a tea loaf of sugar, clothes for himself and family including a day vest and three large buttons, silk, thread, shoes, a cambric handkerchief, and a primer for young Ralph.[16]

Just as Boardman set out to corner the market for consumer goods, Earl managed to corner the market for portraits in Litchfield County. He would complete sixteen portraits of the extended Boardman family.[17] In 1792, three years after his portrait was painted, Elijah Boardman married Mary Anna Whiting. In the same year, Elijah built a new house with a shop next door on the main street, called Town Street, in New Milford. Soon after the completion of the house, in

October 1794, the Boardmans' first child, William Whiting, was born. It was likely this momentous event, adding to the pride he felt in completing his mansion house and new shop, that inspired Boardman to write his friend Ralph Earl on April 3, 1795, requesting a portrait of his wife and son. He wrote, "I have promised Mrs. Boardman the pleasure of having her Portrait taken by your inimitable hand—our little son also—the features of neither as [sic] so ugly as to wound the imagination or cram [sic] the hand of the portrayer."[18] The finished work, *Mrs. Elijah Boardman and Son* (1795, Virginia Scott Steele Collection, Henry E. Huntington Library and Art Gallery), was painted on a grand scale to match the earlier full-length portrait of her husband. It served as an elegant complement and hung alongside her husband's portrait in their new mansion house. Earl was also asked to paint a view of the new mansion, *Houses Fronting New Milford Green* (fig. 11), which provided the details of the fashionable Palladian style house with its imposing front entry, just off the main street. To the right is the new mercantile shop owned by Elijah, and further to the right appears the early saltbox house called the Bostwick house, where the original shop of Daniel and Elijah had been located. The neatly tended grounds of the Boardman house have a gazebo on the side lawn, which ran down to the Housatonic River behind the house. Earl included the recently planted saplings on Town Street. The pink and blue sky and hazy sunlight imbue the thriving village scene with an overall sense of well-being.

One of the fascinating aspects of Earl's career

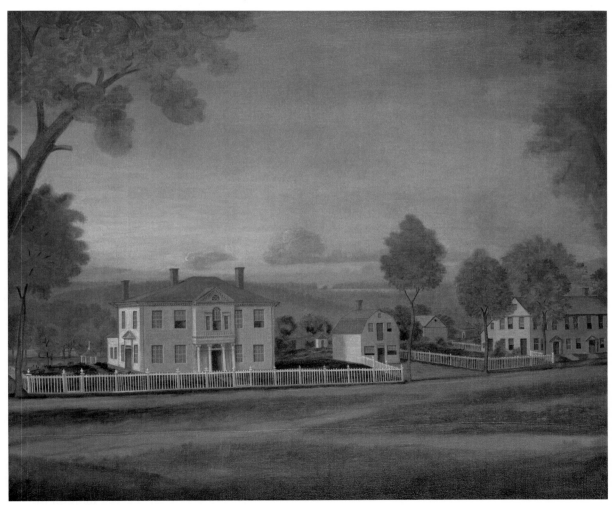

Fig. 11. Ralph Earl, *Houses Fronting New Milford Green*. New Milford, Connecticut, 1796. Oil on canvas, 48 x 54⅛ in. (121.9 x 137.5 cm). Wadsworth Atheneum Museum of Art, Hartford, CT.

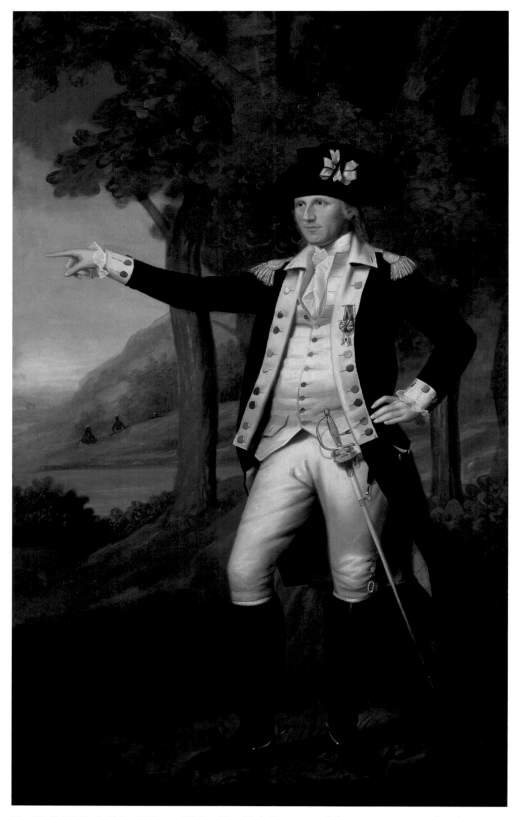

Fig. 12. Ralph Earl, *Colonel Marinus Willett*. New York City, 1791. Oil on canvas, 91¼ x 56 in. (231.8 x 142.2 cm). Metropolitan Museum of Art, New York.

as a portrait painter is that he continued to return to New York City on occasion during his decade based in Connecticut. There he would switch gears and move back to a more formal, British style. Earl's striking change in composition and technique from one region to the next is amply seen in his formal military portrait of *Colonel Marinus Willett* (fig. 12), whom Earl had first encountered during his years in debtor's prison.[19] In this portrait Earl turned to the formal style he developed in London, using fluid brushwork and surface glazes. The figure is gracefully posed in a formal stance derived from British military portrait prototypes. Colonel Willett wears his regimental uniform, which includes a dark blue coat on which hangs the eagle badge of the Society of the Cincinnati. Earl meticulously rendered the sheathed smallsword that Willett prominently wears at his waist, one presented by the Continental Congress in honor of his meritorious actions against the British at Fort Stanwix in 1777.[20]

In 1794 Earl once again left Connecticut briefly for New York City, where he painted a number of portraits that demonstrate his flexibility as a portraitist. The return to a more elegant style is seen in the formal portrait of a prominent city merchant, *Benjamin Judah* (1760–1831) (fig. 13). The Judahs were one of the most notable Jewish families in the city. Benjamin's grandfather Baruch Judah helped establish the first synagogue in New York, Congregation Shearith Israel. His father, Samuel, was a successful merchant and ardent Patriot during the war. Benjamin expanded the family trade connections established by his father and was a member of the prestigious Marine Society of New York. Judah is formally posed and dressed in fashionable, even flamboyant, style. The receipt on which he rests his right hand is inscribed in German marks, emphasizing his world trade connections and urbanity.[21]

Again moving away from the more conventional formal British portrait style, Earl would continue to refine innovative compositions in a plain style for his portraits of Connecticut citizens. His monumental double portrait *Oliver Ellsworth and Abigail Wolcott Ellsworth* (fig. 14), painted at their home in Windsor, Connecticut, in 1792, celebrates this couple's roles in the formation

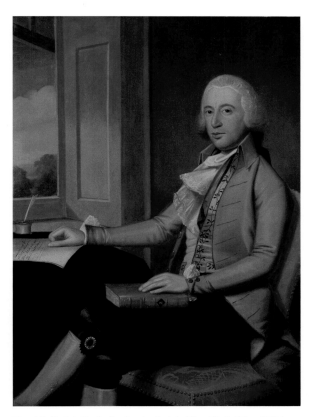

Fig. 13. Ralph Earl, *Benjamin Judah*. New York City, 1794. Oil on canvas, 48⅝ x 34½ in. (123.5 x 87.6 cm). Wadsworth Atheneum Museum of Art, Hartford, CT.

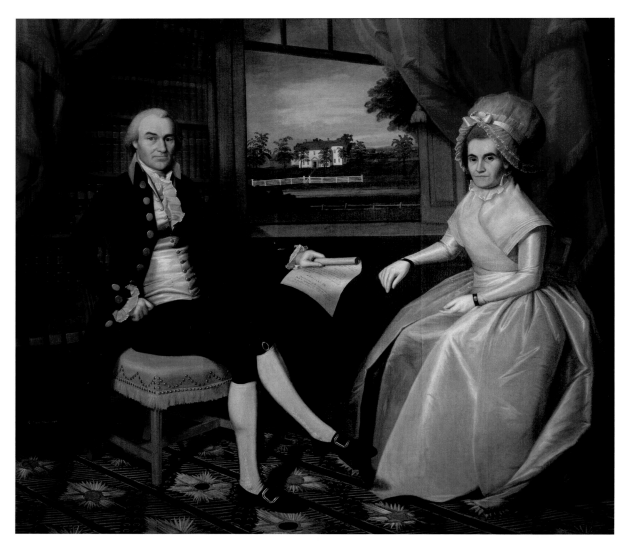

Fig. 14. Ralph Earl, *Oliver Ellsworth and Abigail Wolcott Ellsworth*. Windsor, Connecticut, 1792. Oil on canvas, 76 x 86¼ in. (193.0 x 220.4 cm). Wadsworth Atheneum Museum of Art, Hartford, CT.

of the new nation—Oliver as an ardent Patriot and leader of the new republic and Abigail as the keeper of their domestic world. Seated in their recently renovated parlor, Oliver holds a copy of the newly ratified U.S. Constitution, for which Oliver wrote Article VII, the words of which appear on the document he holds in his left hand. Abigail, who was only thirty-six when this portrait was painted, looks older than her years. During the Revolution, when her husband spent lengthy periods in Philadelphia, Abigail raised and educated their nine children and ran the family farm. The couple had recently modernized and enlarged their colonial house, adding a new south wing, in which they are shown seated. Through the window, Earl, in a clever bit of artistic license, shows the house they are seated in to celebrate the new addition, and he includes the thirteen elm trees recently planted in a gesture of patriotism to symbolize the colonies that made up the new United States. The Connecticut River is hinted at in the distant

landscape. The Ellsworths' portrait, with its many references to their accomplishments and symbols of their stature in the new republic, served as a model for many emerging itinerant portrait painters who began their careers at this time.[22]

In 1798, Earl once again left Connecticut, moving north to Vermont and Massachusetts in search of new portrait commissions. During his visit to Bennington, Vermont, he painted a series of impressive portraits that became even more simplified in a style that suited his rural patrons. His grand-scale group portrait *Mrs. Noah Smith and Her Children* (fig. 15) represents a rare family portrait (Earl also painted her husband, *Noah Smith*, 1798, The Art Institute of Chicago). Earl incorporates his favorite brightly patterned ingrain carpet, bright red curtain, and a landscape background into the composition, setting the five children along the red upholstered sofa, with Mrs. Smith at right holding the youngest child. His broadly painted, carefully detailed and

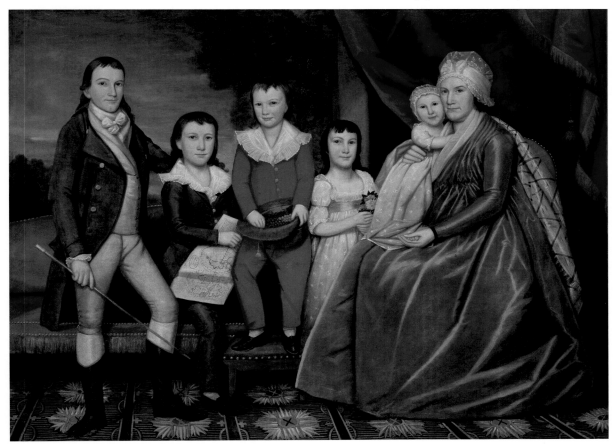

Fig. 15. Ralph Earl, *Mrs. Noah Smith and Her Children*. Bennington, Vermont, 1798. Oil on canvas, 64 x 85¼ in. (162.6 x 217.8 cm). Metropolitan Museum of Art, New York.

personalized composition, using bright primary colors, would be imitated long after the artist's death in 1801, by successive generations of itinerant portrait painters in New England well into the nineteenth century.[23] In choosing to concentrate his talents on a segment of American society that had rarely received the attentions of a highly gifted and trained artist, Earl has provided us with enduring images of the modest New England gentry who rose to positions of prominence during the formative years of the new nation.[24]

## Notes

[1] For complete biographical information for Ralph Earl, see Elizabeth Mankin Kornhauser, *Ralph Earl: Artist-Entrepreneur* (Ann Arbor, MI: University Microfilms International, 1989); Elizabeth Mankin Kornhauser, with Richard Bushman, Stephen H. Kornhauser, and Aileen Ribeiro, *Ralph Earl: The Face of the Young Republic*, exh. cat. (New Haven: Yale University Press, 1991); Elizabeth Mankin Kornhauser, "'By Your Inimitable Hand': Elijah Boardman's Patronage of Ralph Earl," *American Art Journal* 23, no. 1 (1991): 4–20.

[2] Carrie Rebora Barratt and Paul Stati with Erica E. Hirshler, Theodore E. Stebbins Jr., and Carol Troyen, *John Singleton Copley in America* (New York: The Metropolitan Museum of Art with Harry Abrams, 1995).

[3] Entry for *Jeremiah Lee* and *Mrs. Jeremiah Lee*, in Elizabeth Mankin Kornhauser et al., *American Paintings before 1945 in the Wadsworth Atheneum*, vol. 1 (New Haven and London: Yale University Press for the Wadsworth Atheneum, 1996), 261–264.

[4] Aileen Ribeiro, "Costume Note" for *Roger Sherman* entry, in Kornhauser, *Ralph Earl: The Face of the Young Republic*, 109.

[5] Kornhauser, *Ralph Earl: The Face of the Young Republic,* entry for *Roger Sherman*, 109–110.

[6] Ibid., entry for Elijah Boardman, 154–156.

[7] *Connecticut Courant* no. 1209, 24 March 1788, 4.

[8] Amelia Peck, et al., eds., *Interwoven Globe: The Worldwide Textile Trade, 1500–1800*, exh. cat. (New York: The Metropolitan Museum of Art with Yale University Press, 2014), 288–290.

[9] Elijah Boardman, Probate Inventory, New Milford, Connecticut, 1824, no. 288, Connecticut State Library, Hartford, CT.

[10] *Litchfield Weekly Monitor*, 21 June 1790, Connecticut Historical Society, Hartford, CT.

[11] Kornhauser, *Ralph Earl: The Face of the Young Republic*, 157–158.

[12] *Elijah Boardman Papers, 1782–1853, Balance Book, 1795–1796*, Litchfield Historical Society, Litchfield, Connecticut.

[13] Stephen H. Kornhauser, "Ralph Earl's Working Methods and Materials," in Elizabeth Mankin Kornhauser et al., *Ralph Earl: The Face of the Young Republic*, 86.

[14] Ibid., 87.

[15] For a discussion of Earl's working methods and his use of these materials, see Stephen H. Kornhauser, "Ralph Earl's Working Methods and Materials," 85–91.

[16] *Elijah Boardman Papers, Balance Book, 1795–1796*, 158–160.

[17] Kornhauser, *Ralph Earl: The Face of the Young Republic,* 101–253.

[18] Elijah Boardman to Ralph Earl, 3 April 1795, private collection, reproduced in Kornhauser, "By Your Inimitable Hand," 6.

[19] Kornhauser, *Ralph Earl: The Face of the Young Republic,* 176–177.

[20] Ibid., 176–177.

[21] Ibid., 196–197.

[22] Ibid., 180–181.

[23] Ibid., 219–221.

[24] Elizabeth Mankin Kornhauser, "Ralph Earl as an Itinerant Artist: Pattern of Patronage," in *Itinerancy in New England and New York: Annual Proceedings of the Dublin Seminar for New England Folk Life, 1984*, ed. Peter Benes (Boston: Boston University Press 1986), 172–180.

# Spanish Presence in a Fledgling Republic
## Portraiture in Hispanic America and the United States

*Michael A. Brown*

**Spain through the American Prism**

In many ways, the long-standing American fascination with Spain and Hispanic culture is fraught with contradictions. To this day, American perceptions of Spain are often rooted in, on one hand, themes that became known as the "Black Legend" of Spain: its culture as overly religious, superstitious, sinister, backwards, and bloodthirsty—epitomized by the Inquisition and bullfighting; and on the other hand, themes of otherworldly, exotic beauty as manifested in Flamenco music and costume, or the architecture of the Alhambra.[1] It is sometimes easy to forget that a century before the first Puritans arrived in Massachusetts, the Spanish were establishing colonies in Santo Domingo (Dominican Republic); Havana (Cuba); San Juan de Puerto Rico; and subsequently St. Helena Island, South Carolina; St. Augustine, Florida; and Santa Fe, New Mexico. These were not merely military strongholds and fortresses, but commercial centers with cathedrals, monasteries, hospitals, and schools. Art and music were integral parts of this colonial project. All this notwithstanding, as Richard L. Kagan has discussed in several important essays, early United States scholars and politicians viewed Spain as the antithesis of the American republic; to Whig writers like the Hispanist William H. Prescott, Spain represented a powerful but unevolved past while the United States was the progressive future.[2] James D. Fernández has further honed Kagan's paradigm by adding "Longfellow's law," which he defines as "U.S. interest in Spain is and always has been largely mediated by U.S. interest in Latin America."[3]

Since the seminal publication in 2006 of John H. Elliott's *Empires of the Atlantic World*, there has been a sea change in the scholarly approach to the art of the Spanish viceroyalties in the Americas.[4] Elliott's framework, supported unwaveringly by a masterful synthesis of scholarship, for the first time demonstrated how similar the British and Spanish colonial enterprises were while not discounting the many differences between the two. Recent exhibitions such as *Pintura de los Reinos: identidades compartidas en el mundo hispánico* (Madrid, Palacio Real and Museo Nacional del Prado) and *Behind Closed Doors: Art in the Spanish American Home, 1492–1898* (Brooklyn Museum) were significantly shaped by Elliott's global paradigm.[5] With scholarly efforts supported and coordinated by the Center for the History of Collecting at the Frick Art Reference Library, the historic appreciation of Spanish culture and art throughout the United States is beginning to be well documented and better understood. Likewise, the Mayer Center for Pre-Columbian and Spanish Colonial Art has hosted symposia organized by the Denver Art Museum, documenting in a series of published proceedings the important artistic interchange throughout the Pacific world. Turning such a global paradigm to the genre of portrait painting in New Spain and New England, one finds remarkable affinities across traditionally disparate cultural lines.

**The Early History of
Spanish Painting in the United States**

The earliest collections of Spanish paintings to arrive in the early United States came with Joseph Bonaparte in 1815, and in the following year with the family of Richard Worsam Meade. These collections predated the Spanish, Mexican, and South American objects that Frederic Edwin Church brought back to Philadelphia and New York by midcentury, and also predated the renowned hispanophilia of Washington Irving, who first traveled to Spain in 1826 and began publishing his "Spanish" works shortly thereafter.[6] Bonaparte, installed by his brother Napoleon as the "Intruder King" of Spain in 1808, was forced to flee first to France in 1813, initially carrying 1500 crates in his entourage, and subsequently, assuming his title le Comte de Survilliers, to the east coast of the United States. Arriving with considerably fewer plundered artifacts, Bonaparte nevertheless retained nearly 200 paintings, many Spanish, at his eventual exile residence in New Jersey. Among

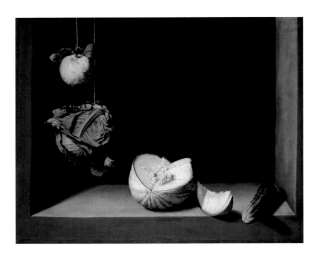

Fig. 1. Juan Sánchez Cotán, *Quince, Cabbage, Melon, and Cucumber*. Spain, circa 1602. Oil on canvas, 27⅛ x 33¼ in. (69 x 84.5 cm). The San Diego Museum of Art, Gift of Anne R. and Amy Putnam, 1945.43.

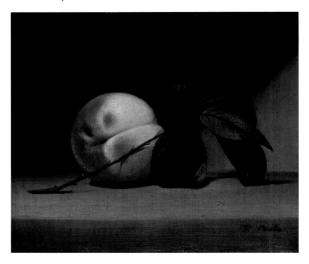

Fig. 2. Raphaelle Peale, *Still Life with a Peach*. Philadelphia, circa 1816. Oil on canvas, 7⅜ in. x 8⅜ in. (18.73 x 21.27 cm). The San Diego Museum of Art, Museum purchase through the Earle W. Grant Acquisition Fund, 1981.38.1.

these was Juan Sánchez Cotán's undisputed masterpiece of still-life painting, *Quince, Cabbage, Melon and Cucumber* (fig. 1).

American entrepreneur Richard Worsam Meade's Spanish endeavors were hardly less dramatic. Sensing economic opportunity, he had relocated his family to Cádiz from Pennsylvania in 1804, and served during the Peninsular and Napoleonic Wars as something of a gunrunner to the Spanish forces and *de facto* U.S. consul.[7] After Meade amassed a small fortune consisting mainly of IOUs from an impoverished Spanish Crown and a collection of Spanish paintings, his wife, children, and belongings (including several now-lost paintings by Bartolomé Esteban Murillo) arrived in Philadelphia in 1816, while Meade himself languished in a Madrid prison cell thanks to his efforts to collect his debts from the Spanish court.

Beginning in 1816, Spanish paintings from both the Meades and Bonaparte were exhibited at the Pennsylvania Academy of the Fine Arts in Philadelphia, not far from Bonaparte's stately home Breeze Point in Bordentown, New Jersey. The reception of these works is indicated by the reactions of two prominent American artists of the day. In 1826, the painter Thomas Sully, while unconvinced of the quality of many of the Spanish works he saw, wrote effusively of Murillo's portraits that "there the flesh was rich and natural."[8] Along with the Murillos and works by other Spanish masters, the academy's 1818 exhibition featured Sánchez Cotán's still life, which since 1945 has been in the collection of the San Diego Museum of Art.[9] This painting, inventoried in the artist's studio in 1603, was owned shortly thereafter by the archbishop of Toledo and then sold to the royal collection of Philip III and kept in the Pardo Palace, from which Joseph Bonaparte confiscated the painting during his illegitimate and plunderous reign.[10] The American painter Raphaelle Peale (1774–1825), who exhibited his own work at the academy the same year, must have seen the painting, as it had an immediate impact on his still-life compositions (fig. 2).

Further evidence points to a sustained interest in the Hispanic world in New England and the Northeast through the nineteenth century. For example, a major auction of Mexican paintings took

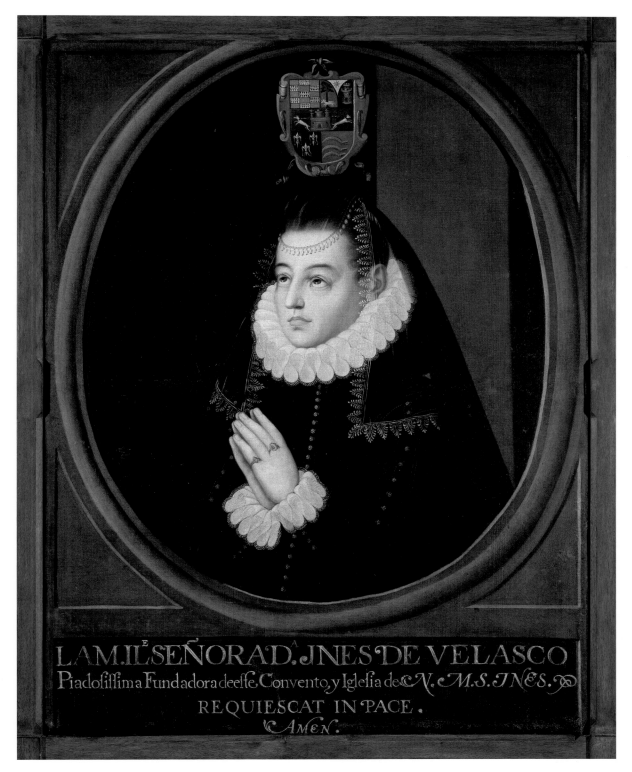

Fig. 3. Baltasar Echave Orio (?), *Portrait of Doña Inéz de Velasco*. Mexico City, early 17th century. Oil on canvas, 40⁹⁄₁₆ x 31⅛ in. (103 x 79 cm). Isabella Stewart Gardner Museum, Boston (P33e13).

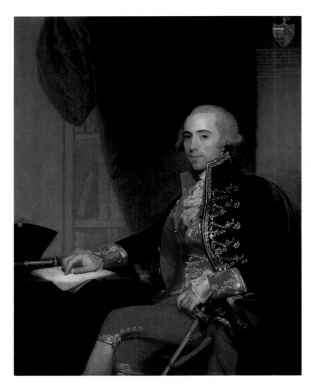

Fig. 4. Gilbert Stuart, *Josef de Jaudenes y Nebot*. New York, 1794. Oil on canvas, 50¾ x 39¾ in. (128.9 x 99.1 cm). The Metropolitan Museum of Art, Rogers Fund, 1907 (07.75). © The Metropolitan Museum of Art. Image source: Art Resource, NY.

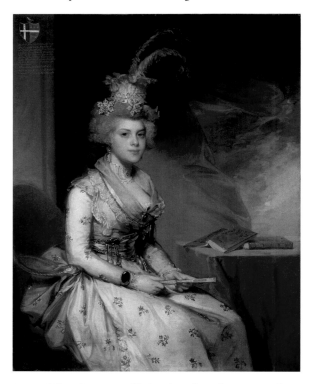

Fig. 5. Gilbert Stuart, *Matilda Staughton de Jaudenes*. New York, 1794. Oil on canvas, 50¾ x 39¾ in. (128.9 x 99.1 cm). The Metropolitan Museum of Art, Rogers Fund, 1907 (07.75). © The Metropolitan Museum of Art. Image source: Art Resource, NY.

place in Boston in 1871, at which Isabella Stewart Gardner purchased a pair of portraits mistakenly attributed to Miguel Cabrera (1695?–1768) in the auction catalog (fig. 3).[11] Rather, the Gardner portraits date much earlier and, according to the inscription, commemorate Doña Inéz de Velasco and her husband Diego Caballero, for their foundation of the convent of Santa Inéz in Mexico City in 1600.[12]

The convent, like many other religious institutions in Mexico, was dissolved by the government in 1861 following the enactment of the "Laws of Reform," with many collections dispersed and sold at auction. The portrait of Doña Inéz—which I recently located hanging in the curatorial offices of the Isabella Stewart Gardner Museum—not only sheds light on the early interest in Spanish colonial painting in the Northeast, but also solves a longstanding mystery of the identity of Baltasar Echave Orio's renowned female donor portrait in the Museo Nacional de Arte in Mexico City.[13]

Gardner's bold acquisition predates the turn-of-the-century collecting activities of Dr. Robert H. Lamborn (1835–1895), Charles A. Ficke (1850–1931), and Daniel C. Stapleton (1858–1920), whose collections now grace the principal art museums of Philadelphia, Davenport, and Denver, respectively. Midwesterners such as Ficke and Stapleton both made frequent visits to the Northeast, where they encountered Hispanist collectors like Gardner and Archer Milton Huntington, and it seems likely that further research may reveal other early collectors in the area. The Boston auction of 1871 may be the tip of the iceberg. With 150 Mexican colonial objects sold in that auction alone, it stands to reason that hundreds of Spanish colonial paintings and artifacts were circulating in the Northeast from this date or earlier. Furthermore, interest in Hispanic art and culture continued to grow after the conclusion of the Spanish-American War in 1898, which helped to foster the decades-long architecture and design movement in the United States known as the Spanish Revival.

If 1815 is the earliest date that a Spanish painting can be documented in the young republic, and the interest in Hispanic art continued throughout the nineteenth century, one is tempted to ask whether the artistic exchange between the

two nations went back any earlier—and what of the long-standing presence of the Spanish in the Southeast and Southwest? The evidence of an earlier Spanish influence in the Northeast colonies remains hypothetical, but several cases point in this direction, not least of which might be Benjamin West's reverence for Velázquez, made unmistakably clear in his acquisition of a painting by the Spanish master in 1798.[14]

### Portraiture in the Atlantic World: A Shared Visual Language

Gilbert Stuart's well-known pair of portraits of Matilda Stoughton and her husband, the young Spanish diplomat Josef de Jaudenes y Nebot, painted in New York in 1794, sheds a hint of light on the question (figs. 4 and 5). The composition, costume, and palette are as close to prevailing Spanish academic and court tastes as Stuart ever came, and the intended audience is made clear by the addition of Spanish biographical inscriptions and coats-of-arms—features seldom found in American or British portraits of the era. The Spanish character of Stuart's pendants becomes all the more evident in comparison to the contemporaneous portrait by Francisco José de Goya y Lucientes (1746–1828), *Vicente María de Vera de Aragón, Duque de la Roca,* 1795 (fig. 6), or that of the sculptor and architect Manuel Tolsá by Rafael Ximeno y Planes (1759–1825), an artist who had trained at the Valencia and Madrid royal academies and at this date was director of painting at the Academy of San Carlos in Mexico City (fig. 7).[15] Jaudenes y Nebot quite likely knew Ximeno y Planes's work, as the latter had served as *pintor de cámara* to Charles IV before relocating to Mexico, and Jaudenes was certainly aware of the prevailing taste regarding portraiture at the Royal Academy in Madrid, from which Ximeno had emerged in 1790.[16] Some indication of Jaudenes y Nebot's prescient artistic sensibilities is attested by his selection of the Italian academician José Perovani for a commissioned portrait of George Washington, which Jaudenes presented to Manuel Godoy, Spain's minister of state and protector of the Royal Academy of San Fernando (fig. 8).[17] Perovani, who had arrived in Philadelphia in 1795 before working in Cuba, would later serve as *académico de mérito* of painting at the Academy of San Carlos in

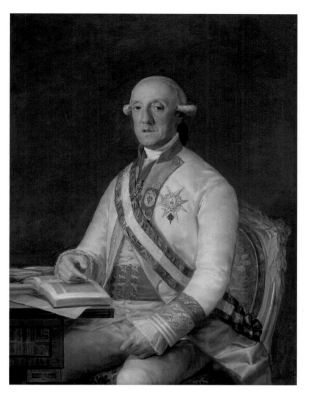

Fig. 6. Francisco de Goya, *Vicente María de Vera de Aragón, Duque de la Roca*. Madrid, Spain, circa 1795. Oil on canvas, 42⅝ in. x 32½ in. (108.27 cm x 82.55 cm). The San Diego Museum of Art, Gift of Anne R. and Amy Putnam, 1938.244.

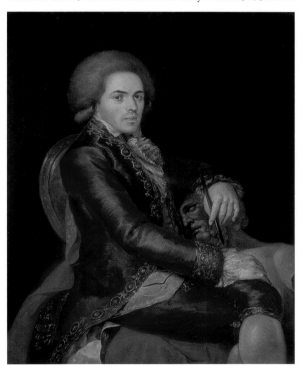

Fig. 7. Rafael Ximeno y Planes, *The Artist Manuel Tolsá*. Mexico City, 1795. Oil on canvas, 40⅝ x 32¼ in. (103 x 82 cm). Museo Nacional de Arte, Mexico City © D.R. Museo Nacional de Arte / Instituto Nacional de Bellas Artes y Literatura, 2016.

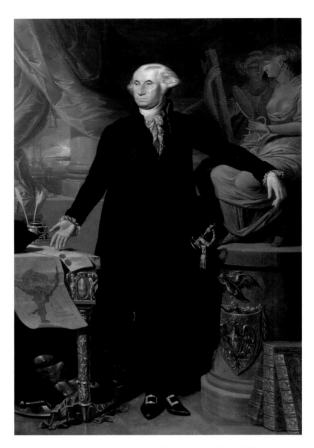

Fig. 8. José de Perovani, *George Washington*. Philadelphia, circa 1795. Oil on canvas, 86½ x 51 in. (219.7 x 129.5 cm). Museo de la Academia de Bellas Artes de San Fernando, Madrid.

Mexico City.[18] The fact that by the 1790s, if not earlier, there was a common interchange of artists and artistic tastes among Madrid, Philadelphia, New York, Havana, and Mexico City is a strong indicator that the presence of Spanish styles in the nascent American artistic imagination was more powerful than we may have thought.

Considering the sum of these introductory anecdotes, it becomes clear that, as with our overlong ignorance of Spain's tide-turning participation in the American Revolutionary War, the Hispanic presence in the British colonies and fledgling republic was much earlier and more profound than has been acknowledged commonly, if at all.[19] Furthermore, the visual evidence of the tradition of portrait painting suggests a mutual artistic awareness throughout the Atlantic world.

Bearing in mind the powerful presence of Spain among early U.S. intelligentsia, a comparison of official portraits such as those of George Washington and Matías de Gálvez begins to take on new significance (figs. 9 and 10). Painted by Gilbert Stuart in 1796 and Andrés López in 1791, respectively, both of these state portraits exemplify academic and court taste of the 1790s.[20] Dressed in scarlet and navy blue with gold trim, Gálvez is portrayed as the epitome of an enlightened, just ruler. In the composition, he is positioned between his official state duties represented in the writing desk, on which rest his letters, quills, and a leather-bound volume (the 1791 statutes of the Royal Academy of San Carlos), with his staff of office firmly grasped in his proper right hand, and the background scene populated by a diverse group of academy students, to which his left hand points. In this imagining, artistic pursuits are equally important with his political responsibilities. Likewise, in Washington's full-length likeness, the republic's first president is attired in sober black, with white lace collar and cuffs, proper left hand resting on his sword (surely an allusion to his military rank of general), while he gestures with his right. His writing table, studiously disheveled, is ostentatiously covered in crimson wool or silk drapery, with ink pot and bound volumes nearby (including the U.S. Constitution resting against the gold table leg). Stuart's portrait was commissioned by Senator William Bingham and Anne Bingham as a gift for the Dublin-born statesman William

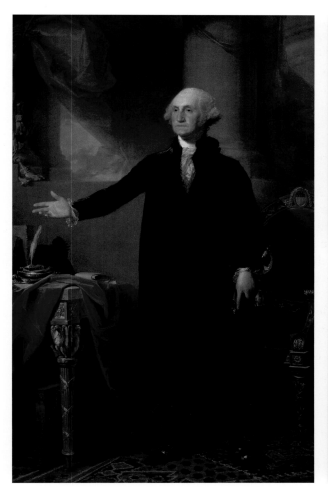

Fig. 9. Gilbert Stuart, *George Washington (Lansdowne Portrait)*. New York, 1796. Oil on canvas, 97½ x 62½ in. (247.7 x 158.8 cm). National Portrait Gallery, Smithsonian Institution; acquired as a gift to the nation through the generosity of the Donald W. Reynolds Foundation, NPG.2001.13. Photo: National Portrait Gallery, Smithsonian Institution/Art Resource, NY.

Fig. 10. Andrés López, *Viceroy Matias de Gálvez as Viceprotector of the Royal Academy of San Carlos*. Mexico City, 1791. Oil on canvas, 89 x 61 in. (226 x 155 cm). Museo de Arte Virreinal, Tepotzotlán, Mexico. For a full page image see p. 130.

Fig. 11. *Pierre van Cortlandt*. New York, circa 1731. Oil on canvas, 57 x 41⁹⁄₁₆ in. (144.8 x 105.5 cm). Brooklyn Museum, Dick S. Ramsay Fund, 41.151.

Petty FitzMaurice, first marquess of Landsdowne, who as prime minister of Great Britain supported American independence.

The similarities between the portraits of the two heads of state are difficult to overlook. If a certain Spanish quality characterizes Stuart's likeness of Washington, especially in the black dress and abundant red drapery, this would hardly have been a surprise considering the place of Hispanism in American thought during the early decades of the republic. Thomas Jefferson began promoting the study of Spanish language and culture and was able to make changes to the curriculum to include modern languages at the College of William and Mary in 1779 (and later at the University of Virginia).[21] In a letter of 1788 to his nephew, Jefferson would write prophetically that knowledge of Spain and its "language, manners and situation, might eventually and even probably become more useful to yourself and country than that of any other. . . . The womb of time is big with events to take place between us and them."[22]

A closer look at several other examples of portraiture, of both colonial and early federal periods, serves to point out the fundamental similarity in the development of the genre in New Spain and New England. The main difference, straightforward but significant, was that painting, including portraiture, served as a crucial tool in Spain's colonial enterprise from the earliest moments after military conquest, and thus orthodox styles and training strategies were established much earlier than in the northern colonies. A comparison of the portraits of Pierre van Cortlandt of circa 1731 (fig. 11) and *Don Francisco de Orense y Moctezuma, Count of Villalobos* of 1761 (fig. 12) points out immediately the fundamental similarities in taste between New York and Mexico City. Both young men are depicted in fashionable attire standing in grand architectural interiors with marble flooring and great swags of red drapery, attended by their loyal, alert hunting hounds, with views to vast expanses of native landscapes in the background.

That the Van Cortlandt painting is based closely on a print by the British portraitist Sir Godfrey Kneller suggests that styles in the genre were shared among London, Madrid, New York, and Mexico, in spite of the traditional enmity between Spain and Britain.[23] Indeed, it was common to

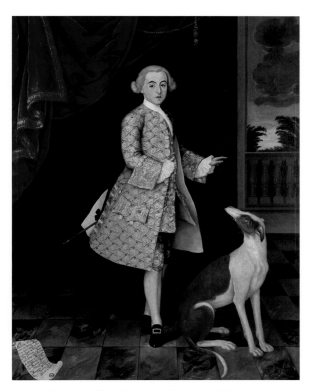

Fig. 12. *Portrait of Don Francisco de Orense y Moctezuma, Count of Villalobos.* Mexico City, 1761. Oil on canvas, 74 x 59 in. (188 x 150 cm). Denver Art Museum, Gift of the Collection of Frederick and Jan Mayer, 2011.427. For a full page image see p. 124.

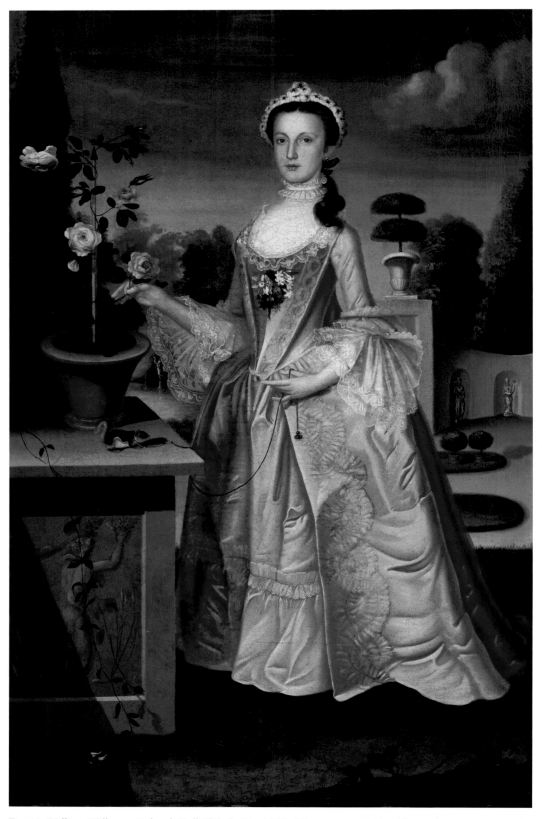

Fig. 13. William Williams, *Deborah Hall*. Philadephia, 1766. Oil on canvas, 71⅜ x 46⅜ in. (181.3 x 117.8 cm). Brooklyn Museum, Dick S. Ramsay, 42.45. See also p. 53.

find English clocks and other luxury goods in Spanish colonial portraiture, as in Ignacio Estrada's 1788 likeness of the Catalan merchant *Don Juan Sastre y Subirats* (see p. 137, and detail, p. 2). The presence of this contraband mantel clock on proud display served to indicate not merely the sitter's wealth and sophistication, but also his political allegiances, in that England had thrown itself behind Catalonia's independence movement.[24]

William Williams's elegant portrait of *Deborah Hall* indicates how portraiture in the British colonies advanced following the arrival in Boston of internationally trained Scottish master John Smibert (see p. 66), who taught a generation of leading portraitists in the eighteenth century (fig. 13).[25] The likeness of the young society lady in a fashionable pink "open robe" gown demonstrates the sophisticated iconography at the artist's (and sitter's) disposal: she is surrounded by overt symbols of beauty, virtue, and refined education.[26] The presence of the relief sculpture of Apollo's unrequited pursuit of Daphne accomplishes the twin goal of emphasizing both her chaste virtue and her Classical liberal education. Closely related iconographic strategies are applied in the compositions of the *Young Woman with a Harpsichord*, painted in Mexico City around 1735–50 (fig. 14 ), and José Campeche's *Lady on Horseback*, painted in 1785 in San Juan, Puerto Rico (fig. 15). Each young woman has mastered a vital and virtuous skill: musical performance and horsemanship—realms, certainly, of the wealthy, powerful, and highly educated. These worthy pursuits, and their depiction in painted portraiture, served to reflect not only the virtue of the sitter but also that of her family for posterity.

A similar interpretation may be made of portraits such as that of Henriette Luard by the Connecticut painter Ralph Earl (fig. 16), who had relocated to London during the Revolutionary War to train with Benjamin West. Earl's treatment of his fashionable young subject follows a convention traditionally reserved for male sitters, in which the subject is set within a study seated at a desk surrounded by books and writing utensils. In Earl's portrait, she is depicted most likely in her father's library, surrounded by books ranging from Roman histories to volumes of Alexander Pope's poetry. Fashionably dressed, meeting the viewer's gaze with a confident and beguiling expression, Henriette Luard appears

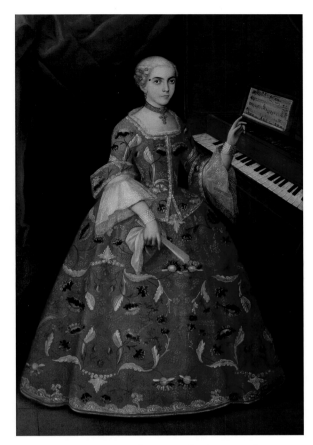

Fig. 14. *Young Woman with a Harpsichord*. Mexico City, 1735–1750. Oil on canvas, 61⅝ x 40⅜ in. (156.5 x 102.6 cm). Denver Art Museum, Gift of the Collection of Frederick and Jan Mayer, 2014.209. For a full page image see p. 114.

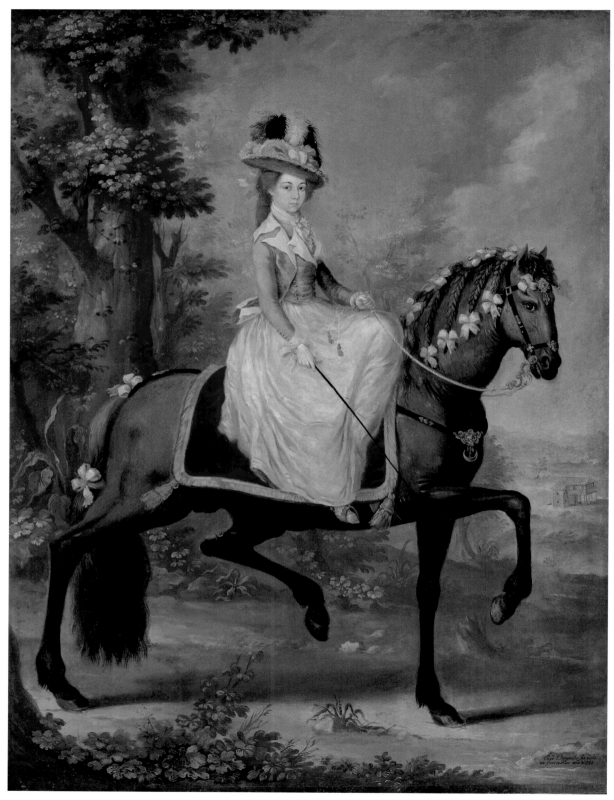

Fig. 15. José Campeche, *Lady on Horseback*. San Juan, Puerto Rico, 1785. Oil on wood panel, 15¾ x 11⅞ in. (40 x 30 cm). Museo de Arte do Ponce, The Luis A Ferré Foundation, Inc., 66.0605.

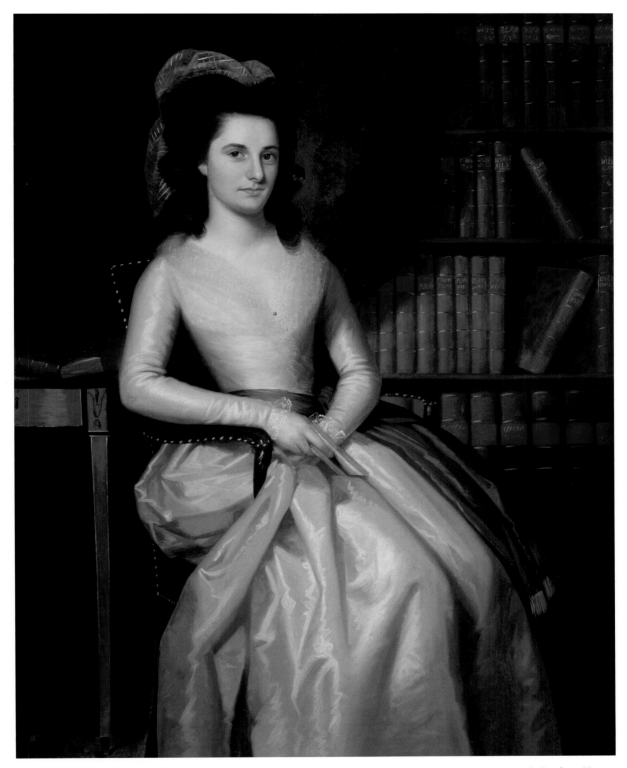

Fig. 16. Ralph Earl, *Portrait of Henriette Luard*. Connecticut, 1783. Oil on canvas, 50 x 36½ in (127 x 92.7 cm). Brigham Young University Museum of Art, purchased with funds provided by Ira and Mary Lou Fulton, 2003.

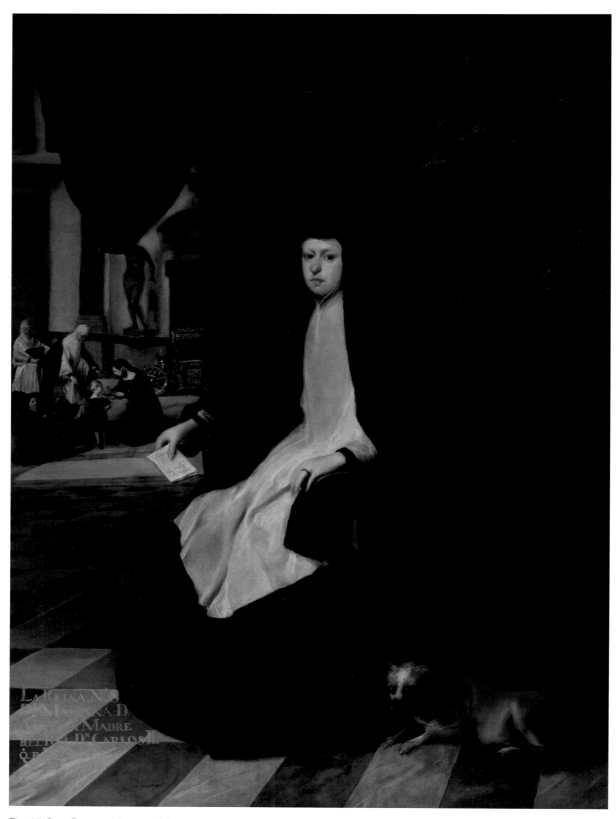

Fig. 17. Juan Bautista Martínez del Mazo, *Queen Mariana in Mourning*. Madrid, Spain, 1666. Oil on canvas, 77½ x 57½ in. (196.8 x 146 cm). National Gallery, London, Presented by Rosalind, the Countess of Carlisle, 1913 NG2926.

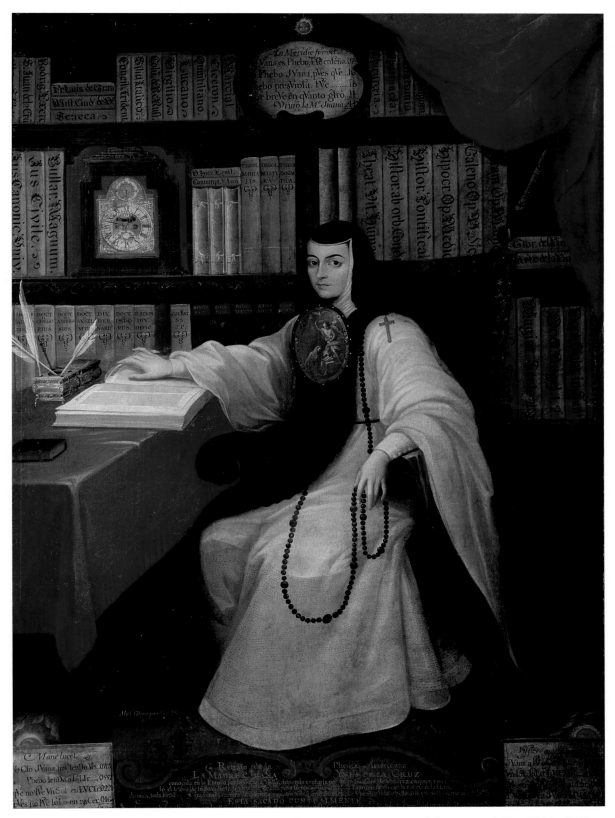

Fig. 18. Miguel Cabrera, *Sor Juana Inés de la Cruz in her Study*. Mexico City, circa 1750. Oil on canvas, 81½ x 58¼ in. (207 x 148 cm). Museo Nacional de Historia, Castillo de Chapultepec.

comfortable in her own learning, having paused with a finger keeping her place in the volume on her lap.

This use of the time-honored composition of the "gentleman scholar" type, so often chosen for likenesses of statesmen and prelates, was unusual for a woman in the Anglo-American world but had particularly dramatic earlier parallels in the Hispanic world. In particular, likenesses of Philip IV's widow, Doña Mariana de Austria (1634–1696), by Juan Bautista Martínez del Mazo (fig. 17) and Juan Carreño de Miranda (Madrid, Museo del Prado) both depict the mourning queen in the disposition of a seated scholar.[27] In fact, these portraits also show Mariana de Austria in her administrative role as queen regent before her son, Charles II, reached the age of majority.[28] A number of portraits of the Mexican poet and scholar Sor Juana Inés de la Cruz (1648–1695) survive showing this renowned woman of letters seated in her study, surrounded by books, inkpots, and quills, and luxury items such as mantel clocks and oil paintings (fig. 18). In the seated version by Miguel Cabrera, the volumes in Sor Juana's library range from legal treatises to works of theology and philosophy. A common composition for portraits of archbishops, which probably originated in early Renaissance paintings and prints of Saint Jerome in his study, the allusion in Cabrera's portrait characterizes Sor Juana, at least in visual terms, as the equivalent of a doctor of the Church.

Although the patron or patrons of the portrait remain unknown, Cabrera's work was completed more than a half-century after Sor Juana's death and may be seen as one of many concerted efforts to restore her reputation and promote her fame and beatification. In earlier portraits she is also shown with books, but Cabrera inserts a title into her library that seems to indicate a personal connection between artist and poet, namely, the two volumes of Francisco Pacheco's treatise on painting, *Arte de la Pintura* (published posthumously in Madrid in 1649).[29] Sadly, in 1694, the year before her death while tending to victims of plague, Sor Juana had been stripped of her library and ordered to cease her literary pursuits by Church leaders concerned that her work was unnatural for her gender. With this in mind it is particularly appropriate that she is portrayed in a composition heretofore restricted—at least in Mexico—to depictions of officers such as those responsible for her censure.

### Conclusions

With recent exhibitions devoted to the arts of viceregal Latin America tending to cast a revisionist eye on the development of painting and culture after the Spanish conquest, and with public collections such as, especially, the Brooklyn Museum and the Museum of Fine Arts, Boston, rearranging their collections so that European and American works of art are exhibited together or near each other to reflect a coherent, global context, scholars need to reassess our understanding of the development of portraiture throughout the Atlantic world. In 2011, I wrote that "among the first conclusions to be drawn is that the portrait in New Spain did not develop the same way as it did in Spain, France, England . . . [yet] paradoxically, European models nevertheless were essential to the development of the genre in Spain's American dominions."[30] Instead of approaching the portraiture of each Atlantic constituent, including New England and New Spain, as having developed either in a vacuum or most significantly in the shadow of "la Madre patria," we might better understand the genre's development as a shared cultural endeavor, in which British, Spanish, and American innovations were understood throughout the region. In this paradigm, the biases that separate sworn enemies like England and Spain may be understood to have supported important cultural interchange, often promoted and cultivated by political situations across the Atlantic in the colonies and fledgling republics of the American continents. In this way, Gilbert Stuart's portrait of the first president of the United States, who happens to be surrounded by enormous swags of drapery almost certainly dyed with American cochineal from Spanish commercial concerns in New Spain, reflects an understanding—at least in the American imagination—of Spain and its portraiture tradition. Likewise, the immediate and lasting appeal in Philadelphia of a Spanish still life featuring a humble quince and cabbage, or the prominence of English clocks and watches in portraits throughout New Spain and the Viceroyalty of Peru, suggests a shared cultural awareness throughout the Atlantic world that need no longer be ignored.

## Notes

[1] See Charles Gibson, ed., *The Black Legend: Anti-Spanish Attitudes in the Old World and the New* (New York: Knopf, 1971); and Ricardo García Carcel, *La leyenda negra: Historia y opinión* (Madrid: Alianza Editorial, 1992).

[2] See Richard L. Kagan, ed., *Spain in America: The Origins of Hispanism in the United States* (Urbana and Chicago: University of Illinois Press, 2002), 3–5, 22, 44, note 6.

[3] James D. Fernández, "'Longfellow's Law': The Place of Latin America and Spain in U.S. Hispanism, circa 1915," in Kagan, *Spain in America*, 124.

[4] J. H. Elliott, *Empires of the Atlantic World: Britain and Spain in America 1492–1830* (New Haven and London: Yale University Press, 2006). Among the many reviews of the book, please see Jorge Cañizares-Esguerra, *Southwestern Historical Quarterly* 111, no. 1 (July 2007): 88–89.

[5] *Pintura de los Reinos: identidades compartidas en el mundo hispánico*, coord. Cándida Fernández de Calderón (México: Fomento Cultural Banamex, 2010); see also the related publication *Pintura de los Reinos: identidades compartidas, territorios del mundo hispánico, siglos XVI–XVIII*, ed. Juana Gutiérrez Haces and Jonathan Brown, 4 vols. (México: Fomento Cultural Banamex and Grupo Financiero Banamex, 2008–2009); for the Brooklyn exhibition, see Richard Aste, ed., *Behind Closed Doors: Art in the Spanish American Home 1492–1898* (New York: Brooklyn Museum and Monacelli Press, 2012).

[6] Richard L. Kagan, "The 'Spanish Turn': The Discovery of Spanish Art in the United States, 1887–1920," in *Collecting Spanish Art: Spain's Golden Age and America's Gilded Age*, ed. Inge Reist and José Luis Colomer (New York: Frick Collection in association with Centro de Estudios Europa Hispánica, Madrid, and Center for Spain in America, 2012).

[7] Kagan, "The 'Spanish Turn,'" 22; M. Elizabeth Boone, *Vistas de España: American Views of Art and Life in Spain, 1860–1914* (New Haven: Yale University Press, 2007), 40.

[8] Suzanne L. Stratton-Pruitt, "Early Collecting of Bartolomé Esteban Murillo's Painting in the United States (1825–1925)," in *Collecting Spanish Art: Spain's Golden Age and America's Gilded Age*, ed. Inge Reist and José Luis Colomer (New York: Frick Collection in association with Centro Estudios Europa Hispánica, Madrid, and Center for Spain in America, New York: 2012), 281.

[9] John Marciari, *Italian, Spanish, and French Paintings before 1850 in the San Diego Museum of Art* (San Diego: San Diego Museum of Art, 2015), 198–205.

[10] Sarah Schroth and Ronni Baer, *El Greco to Velázquez: Art during the Reign of Philip III* (Boston: Museum of Fine Arts, 2008), 268.

[11] The paintings were published in Leonard and Company Auctioneers, *Catalogue of Rare Original Paintings Collected in 1861 from the Convents and Churches of Mexico Suppressed by the Government* (Boston: W. F. Brown Printers, 1871), nos. 114 and 115.

[12] At the Isabella Stewart Gardner Museum, curator Nathaniel Silver first showed me the portraits and then swiftly facilitated their photography, and Gianfranco Pocobene undertook a surface cleaning at very short notice. I offer my sincere thanks to both, and greatly appreciate the enthusiasm and support of the curatorial and conservation staff at the Gardner.

[13] This painting is widely published in surveys of Mexican painting; see Rogelio Ruíz Gomar, Nelly Sigaut, and Jaime Cuadriello, *Catálogo comentado del acervo del Museo Nacional de Arte: Nueva España Tomo II* (México: Museo Nacional de Arte and Universitaria Autónoma Nacional de México, 2004), 303; and Donna Pierce, *Painting a New World: Mexican Art and Life 1521–1821* (Denver: Denver Art Museum, 2004), fig. 23.

[14] Marjorie Trusted, "Access to Collections of Spanish Art in Britain and Ireland in the Eighteenth and Nineteenth Centuries," in *Spanish Art in Britain and Ireland, 1750–1920: Studies in Reception*, ed. Nigel Glendinning and Hilary McCartney (Woodbridge, UK: Tamesis, 2010), 73–75.

[15] For a discussion of the Goya portrait, see Marciari, *Italian, Spanish, and French Paintings*, 304–307.

[16] Michael A. Brown, "Portraiture in New Spain, 1600–1800: Painters, Patrons and Politics in Viceregal Mexico" (PhD diss., New York University, 2011), 182ff.

[17] My thanks to Priscilla Muller for alerting me of the existence of this portrait and to Isadora Rose de Viejo for sharing her research.

[18] Inmaculada Rodríguez Moya, *El retrato en México, 1781–1867: héroes, ciudadanos y emperadores para una nueva nación* (Seville: Universidad de Sevilla, 2006), 106.

[19] For the most cogent discussion of Spain's participation in the Revolutionary War, see Thomas E. Chávez, *Spain and the Independence of the United States: An Intrinsic Gift* (Albuquerque: University of New Mexico Press, 2002).

[20] For the dating of the Gálvez portrait, see my entry in *Painting a New World: Mexican Art and Life 1521–1821*, ed. Donna Pierce (Denver, CO: Denver Art Museum, 2004), 247–249.

[21] Rolena Adorno, "Washington Irving's Romantic Hispanism and Its Columbian Legacies," in Kagan, *Spain in America*, 94.

[22] Kagan, *Spain in America*, 6.

[23] Teresa A. Carbone, *American Paintings in the Brooklyn Museum: Artists Born by 1876*, 2 vols. (New York: Brooklyn Museum; London: D. Giles, 2006), 2:1106–1108.

[24] Brown, "Portraiture in New Spain," 145–146. The clock in question is inscribed "*DavHubert London*" in reference to David Hubert II, among the most sought-after clockmakers in Europe. That Hubert maintained an agent in Spain indicates the lucrative nature of the Spanish market.

[25] For Smibert, see Richard H. Saunders, *John Smibert: Colonial America's First Portrait Painter* (New Haven: Yale University Press and Barra Foundation, 1995).

[26] Carbone, *American Paintings in the Brooklyn Museum*, 2:1088; and Richard H. Saunders and Ellen G. Miles, *American Colonial Portraits, 1700–1776* (Washington, DC: Smithsonian Institution Press for the National Portrait Gallery, 1987), 225–226.

[27] For both works, see Gabriele Finaldi's entry in *El retrato español en el Prado del Greco a Goya*, ed. Leticia Ruiz Gómez (Madrid: Museo Nacional del Prado and Ministerio de Cultura, 2006), 104–105.

[28] Laura R. Bass, *The Drama of the Portrait: Theater and Visual Culture in Early Modern Spain* (University Park, PA: Pennsylvania State University Press, 2008), 98.

[29] Ilona Katzew, "Valiant Styles: New Spanish Painting, 1700–1785," in *Painting in Latin America, 1550–1820*, ed. Luisa Elena Alcalá and Jonathan Brown (New Haven and London: Yale University Press, 2014), 182–183.

[30] Brown, "Portraiture in New Spain," 195.